The Tree Climbing Cure

ENVIRONMENTAL CULTURES SERIES

Series Editors:

Greg Garrard, University of British Columbia, Canada
Richard Kerridge, Bath Spa University, UK

Editorial Board:

Frances Bellarsi, Université Libre de Bruxelles, Belgium
Mandy Bloomfield, Plymouth University, UK
Lily Chen, Shanghai Normal University, China
Christa Grewe-Volpp, University of Mannheim, Germany
Stephanie LeMenager, University of Oregon, USA
Timothy Morton, Rice University, USA
Pablo Mukherjee, University of Warwick, UK

Bloomsbury's *Environmental Cultures* series makes available to students and scholars at all levels the latest cutting-edge research on the diverse ways in which culture has responded to the age of environmental crisis. Publishing ambitious and innovative literary ecocriticism that crosses disciplines, national boundaries, and media, books in the series explore and test the challenges of ecocriticism to conventional forms of cultural study.

Titles available:

Bodies of Water, Astrida Neimanis
Cities and Wetlands, Rod Giblett
Civil Rights and the Environment in African-American Literature,
1895–1941, John Claborn
Climate Change Scepticism, Greg Garrard, George Handley,
Axel Goodbody, Stephanie Posthumus
Climate Crisis and the 21ˢᵗ-Century British Novel, Astrid Bracke
Cognitive Ecopoetics, Sharon Lattig
Colonialism, Culture, Whales, Graham Huggan
Contemporary Fiction and Climate Uncertainty, Marco Caracciolo

The Tree Climbing Cure

Finding Wellbeing in Trees in European and North American Literature and Art

Andy Brown

BLOOMSBURY ACADEMIC
LONDON • NEW YORK • OXFORD • NEW DELHI • SYDNEY

BLOOMSBURY ACADEMIC
Bloomsbury Publishing Plc
50 Bedford Square, London, WC1B 3DP, UK
1385 Broadway, New York, NY 10018, USA
29 Earlsfort Terrace, Dublin 2, Ireland

BLOOMSBURY, BLOOMSBURY ACADEMIC and the Diana logo
are trademarks of Bloomsbury Publishing Plc

First published in Great Britain 2023

A catalogue record for this book is available from the British Library.

Library of Congress Control Number: 2022941961

ISBN: HB: 978-1-3503-2729-0
 PB: 978-1-3503-2728-3
 ePDF: 978-1-3503-2730-6
 eBook: 978-1-3503-2731-3

Series: Environmental Cultures

Typeset by Integra Software Services Pvt. Ltd.
Printed and bound in Great Britain

To find out more about our authors and books visit www.bloomsbury.com
and sign up for our newsletters.

CONTENTS

LIST OF ILLUSTRATIONS

ACKNOWLEDGEMENTS

With many thanks to Roselle Angwin, Sarah Charles, Miriam Darlington, Sally Flint and Marcus Vergette, for their time and input to the interview and discussion materials in this book. Thanks also to Bysshe Coffey for advice on matters relating to Shelley; to my editor at Bloomsbury, Ben Doyle, for his support and enthusiasm for the project, and to editorial assistant, Ellie Jardine, for invaluable assistance in the production of this book. Special thanks are due to the Department of English, University of Exeter, for a period of study leave in which I was able to research this work and write the initial draft. I could have achieved none of this without the unstinting support of my wife, Natasha Charles, who has listened attentively to me talk about this obsession for nearly two years, and who listened to me reading out my early drafts during Covid-19 lockdown, offering insightful comments and boundless encouragement. *Merci ma chérie, tu es mon chêne, mon refuge, le sommet de mon ascension.*

Introduction: #manintree

In March 2016, a young American man named Cody Lee Miller climbed an eighty-foot sequoia tree next to the well-known department store, Macy's, in downtown Seattle. Miller remained up in the tree for twenty-five hours, clinging to the trunk, throwing debris down on nearby buildings and passers-by, causing damage to the tree, to neighbouring property, and endangering onlookers. Responses ranged from supportive and caring, to derisory and hateful, with some journalists and members of the public laughing openly at Miller's expense on news broadcasts and social media. The subsequent news reports, live streaming and Twitter and Facebook responses caused the hashtag *#manintree* to trend.[1] Miller eventually came down from his perch and was arrested and charged. Given a history of mental health problems, however, he was found incompetent to stand trial. His treatment in the judicial system, and the media coverage of the incident, sparked extensive debate about the adequacy of mental health provision in the United States.

This book does not attempt to critique the ins and outs of the media coverage of Miller's case, nor does it involve itself with political debates concerning mental health funding in Europe and North America. Much of the political debate has already been recently handled, in the UK at least, in such books as Isabel Hardman's *The Natural Health Service* (2020), which discusses a small-p political manifesto for national mental wellbeing through therapeutic engagements with the natural world,[2] and Samantha Walton's *Everybody Needs Beauty: In Search of the Nature Cure* (2021), with its balanced scepticism about the wellbeing benefits of such activities as wild swimming, gardening, walking in forests and mountains, therapeutic farming, recreational park use, and the pros and cons of accessing nature virtually through Apps and computer games.[3] What is of central focus in *The Tree Climbing Cure*, instead, is the act that Miller chose in his time of mental distress – that is, *he climbed a tree*. More specifically, *The Tree Climbing Cure* asks how such acts of tree climbing relate to literary and

artistic representations of tree climbers, and to the relationship between trees, climbing, and mental and physical wellbeing.

Cody Lee Miller described his own tree climb as a 'cry for help', having found himself constantly in and out of police custody and struggling with his own mental health.[4] In youth, he had been diagnosed with ADHD (attention-deficit hyperactivity disorder), although his mother reported that her son's behavioural problems amounted then to little more than hyperactivity. As his behaviour intensified and he found himself in trouble with the police, Cody Lee Miller's mother tried repeatedly to get him help and medication. She had previously found knives hidden in the house, and sent him to live with his grandmother, whom he physically threatened. Following his climb, Miller was held at Western State Hospital and diagnosed with paranoid schizophrenia. Eventually he was sentenced to two years of supervision and was housed in supported housing.

Cody Lee Miller's case prompts many questions, not least concerning the relationship between his tree climbing and his mental health. In her book *Holy Trees and Other Ecological Surprises*, Lucy Goodison writes, 'It is an idiosyncrasy of our culture that belief in an invisible supreme supernatural being is a respectable part of religious experience, while communicating with trees may be taken as a sign of mental disorder.'[5] Believing in an invisible god is universally acceptable, but adults who commune with, or take to the trees must be mentally disturbed, the everyday logic goes. In climbing his tree, Miller encapsulates this commonly held notion that only 'mad' people, or children, climb trees. As climbing specialist Jack Cooke notes: 'There seems to be a common perception that climbing trees is not at all respectable [...] it's "just not what grown-ups do". Long labelled the preserve of children by the unimaginative, an adult in a tree is drunk, deranged, suicidal – or a combination of all three.'[6] Social norms seem to prescribe that 'normal', rational, balanced adults simply do not climb trees, unless it is for a job, or part of some organized recreational activity.

What then *is* the symbolic status of the relationship between tree climbing, mental health and development? What might Cody Lee Miller have been working through while he was up in the sequoia tree in downtown Seattle? Of course, one can never know for sure without his testimony, but it is the contention of *The Tree Climbing Cure* that a study of fictional tree climbers in literature and art can throw useful light upon tree climbing as a problem-solving strategy, as well as speaking to mental health and wellbeing as it relates to nature and, specifically, trees.

The Tree Climbing Cure, therefore, explores how tree climbers have been represented in poems, novels, nature writing, and works of art in Europe and North America, finding parallels between these representations and the real world of the recreational and occasional tree climber. The book argues for the curative and restorative value of tree climbing, examining when and why tree climbers climb, and what tree climbing can do for (and say about) the climber's mental health and wellbeing. Bringing together research

into poetry, novels and paintings, with the science of nature, wellbeing and mental health, *The Tree Climbing Cure* shows how, frequently, writers and artists depict their tree climbing characters in mental distress, at a point of conflict in their lives, or simply poised to make some change. People often climb trees, these poems, novels and artworks seem to suggest, at times of decision-making, psychological distress, conflict, protest, family breakdown and rebellion, just as much as they do in times of pleasure-seeking, or freedom-seeking, spiritual quest, childish regress, or simply taking some adventurous exercise. Time and again novelists, poets and artists represent their climbers in this 'conflicted' way. *The Tree Climbing Cure* addresses these conflicted representations and argues for the restorative value of tree climbing. Examining the notable congruity between climbing trees and the contented mind, this book proposes that while many tree climbers are commonly described as being 'mad', 'crazy' or (paradoxically) 'out of their tree', there are some very tangible benefits to be experienced in tree climbing. Engaging with myth, folklore, psychology and storytelling, *The Tree Climbing Cure* also examines the close relationship between tree climbing and imagination, and questions some long-standing, problematic gendered injunctions about women climbing trees, showing that the recurring image of the climber speaks of the long human journey from the trees towards enlightenment and intellectual, physical and psychological wellbeing.

For the first time, *The Tree Climbing Cure* casts a surveying eye across European and North American tree climbing literature and art and brings it together in one place, making it an original compendium of what might be imagined as 'tree climbing studies'. Other very recent collections of essays, such as Carmen Concilio and Daniela Fargione's 2021 comprehensive edition, *Trees in Literatures and the Arts: Humanarboreal Perspectives in the Anthropocene*, bring together extensive materials on the relationships between humans and trees in the wider Arts, but in those pages the references to tree climbing amounts to only a couple of examples. *The Tree Climbing Cure,* instead, focuses on a great number of tree climbing episodes in poetry, fiction, non-fiction and art and, while it does not attempt to be a complete compendium of all literary and artistic tree climbers, it does aim to show through its selected examples that tree climbing (and time among trees more generally) is restorative in many ways: for the scientifically researched benefits of being outdoors in nature; restorative for the 'return to childhood' and physical benefits of childhood play and adventure; restorative for the physical and psychological benefits of climbing in adulthood, and for the transgressive and symbolic rebellion of the act of tree climbing. Climbing trees has the ability to reconnect people to the symbolic, the fairy-tale, and the archetypal, carrying mythic and spiritual connotations. It also offers a 'safe space' in the everyday flow of life and, more specifically, in traumatic and post-traumatic situations. It may play a role in, and serve as a metaphor for, the process of 'individuation' (the psychological process described by Carl Jung as the formation of a stable and integrated adult personality),

and may also be seen as an act of rebellion by eco-activists and women climbers, reclaiming an activity and relationship with nature that has been proscribed against since biblical times. At its most simple, tree climbing can offer an opportunity for the 'mindfulness' of being in the moment, absorbed in nothing more than what is happening right now, second by second, in the attentive art of climbing upwards. In discussing these themes, this book attempts a rooted and branching map of real-world, literary and artistic tree climbing: rooted in the science of nature and wellbeing, the chapters function as notional 'branches' of examples through which the reader may make their improvisatory climb.

Given the centrality of the tree to its concerns, *The Tree Climbing Cure* focuses solely on tree climbing, rather than the wider matter of climbing per se. In the broader field of climbing literature, writings about mountaineering and rock climbing abound. The celebrated North American Transcendentalist, Henry David Thoreau (1817–1862), was a well-known mountain climber and walker before he settled at Walden Pond,[7] while John Muir (1838–1914), the American activist, writer and founder of the National Parks, writes in detail of *The Mountains of California* (1894). More recently, Robert Macfarlane's *Mountains of the Mind: A History of Fascination* (2003) outlines a history of rock climbing and its literature, which includes books such as *The Living Mountain* (1977) by the Scots writer Nan Shepherd recounting her experiences of walking the Cairngorms of Scotland. The selected writings of American landscape writer Barry Lopez engage variously with mountain-scapes, while the contemporary British poet, climber and writer Helen Mort retells the forgotten and overlooked narratives of women mountaineers in *No Map Could Show Them* (2016). Books like Mort's build on a tradition of British poets engaging with mountain climbing, including such works as David Craig's 1987, *Native Stones: A Book About Climbing*, while a myriad number of technical books exist on the sport, techniques and philosophies of rock climbing. The more extreme end of the modern sport is captured in the 2018 Academy Award-winning documentary, *Free Solo*, about Alex Honnold, a young American free climber who climbed the 3,200 foot rockface known as El Capitan in Yosemite National Park, without the safety net of climbing ropes and harnesses. Other current writings on gender and rock climbing are challenging what Samantha Walton describes as 'the bravado of the sport, changing the face of mountaineering from a brute struggle' into a more 'thoughtful, even mindful enterprise',[8] while papers from the British Mountaineering Council indicate the positive mental wellbeing that can result from rock climbing, particularly for women, through the work of community groups such as *Vertigirls*.[9] *The Tree Climbing Cure* leaves this oeuvre of rock climbing on the ground and focuses solely on the matter of climbing trees.

Along with tree climbers both fictional and real who may be 'conflicted', such as Cody Lee Miller, there are also writers to be encountered in the tree climbing literature whose climbs are a response, in part, to the mental

health of others. American writer, naturalist and activist, Janisse Ray, was raised on a junkyard on the outskirts of a small town, Baxley, in Appling County, South Georgia. In her book, *Ecology of a Cracker Childhood*, Ray writes of the coastal landscape of the region around her home, one of original longleaf pine woods. But the junkyard itself was dangerous, strewn with metal and glass, with poisonous chemicals and oil. Mental illness ran in Ray's family – 'the mental illness that came streaking through bloodlines'[10] – in particular, her father and grandfather, both of whom were men with tempers and given to beating their children with belts and pole handles. 'Almost every night I wet the bed,' Ray writes.[11] Climbing trees was one of her ways of escaping from, and transcending, these perils. Ray describes how she climbed the tall chinaberry tree in the yard, where she would sit and wait, 'listening for something – a sound, a resonance – that came from far away, from the past and from the ground. When it came, the sun would hold its breath, the tree would shiver, and I would leap toward the sky, hoping finally for wings'.[12] For many climbers in literature, as in life, whether coping with their own mental health, or coping with the mental health of others, the climb can be one of these kinds of leaps towards the sky. In the cases discussed herein, family conflict will play a pivotal role.

There are, of course, lots of 'sane' and 'balanced' people who regularly climb trees for recreation and pleasure, and a large number who make their living climbing trees for work: arborists (tree surgeons), lumberjacks, arboriculturists in cultivated plantations, animal rescue workers, botanists, researchers, dendrologists and wildlife cameramen all climb trees. Fruit and coconut pickers ascend into the canopy freestyle to collect their harvest, sometimes aided by a simple strap tied between the ankles. Richard Preston's non-fiction book, *The Wild Trees*, recounts the stories of a group of daring professionals who climb California's coastal giant redwoods. Botanists, lichenologists, arborists and tree surgeons all populate Preston's book with tales of extraordinary adventurousness: the tallest redwoods are up to 380 feet in height – pushing close to a forty-storey building. At the top of the leader of one such redwood (the vertical stem at the top of the trunk), one of Preston's climbers finds himself warming his body in the sunlight: 'It was as if he were waking up from a sleep, as if his life up to then had been a dream, and this was real. He felt as if he had left time behind.'[13] Questions of 'dreaming', 'time', 'leaving things behind' and 'awakening' will recur in the reading of novels, poems and artworks in these pages, and yet, while *The Tree Climbing Cure* discusses one or two of these kinds of professional climbers, the more pertinent characters here are those *occasional tree climbers*, people who go up into the trees on a free climb – no ropes, no saddles, no carabiners – just bare feet and an urge to get up into the canopy. Like Preston's professional climber, many fictional tree climbers have personal awakenings, or spiritual epiphanies while up in the branches. Of course, the spiritual associations of trees are wide-reaching, as examples discussed here will show. Religious ascetics, such

as Indian sadhus, often live in tree hollows, just as Western 'Stylite Saints' stood on the top of symbolic 'tree' pillars for long periods of time, often years, as part of their regimes of spiritual endurance. In this contemporary age, however, discussions of spiritual endurance are more likely to be expressed in the more secular and everyday language of developing a centred and lasting sense of wellbeing. In a study of wellbeing and nature, the psychologist Joachim Wohlwill wrote that 'natural environments experienced in solitude seemed especially restorative to people who are mentally fatigued or socially stressed'.[14] In light of this, what does the natural, solitude-giving crown of the tree offer to the tired, stressed or conflicted climber, in reality, fiction, poetry and art?

In recent years, the numbers of recreational-technical tree climbers have expanded rapidly; climbers who do their climbing through registered tree climbing organizations, such as *Tree Climbers International*, founded by Peter 'Treeman' Jenkins in 1983, or *Tree Climbing Japan*, founded in 1997 by John Gathright, to help physically disabled people leave their wheelchairs and challenge themselves to climb. Recreational-technical climbers climb trees with ropes and helmets, harnesses and hammocks. Organizations like *The Global Organization of Tree Climbers* have formed and incorporated themselves as charitable, non-profit organizations providing training curricula and safe climbing guidelines worldwide. There are also recreational free climbers, who use no equipment at all, just the time-honoured tools of the human body – arms, legs, hands and, very often, bare feet. There are national tree climbing championships in the United States and several artists have climbed a tree every day for a year, including Todd Smith from Kentucky; Henrik G. Dahle, a self-confessed utopian environmentalist living in southern Portugal; Leo Murray, an animator, climate change campaigner and social entrepreneur; and artist Cecylia Malik in Poland. Malik's work in particular forms part of later discussions about women's tree climbing.

But there are also people who do not climb trees and who dislike nature. Who feel uncomfortable outdoors. Who have phobias about insects, spiders and birds. Who are sensitive to heat and sunlight. Who just don't like forests and trees, and who fear heights. According to Florence Williams in *Nature Fix: Why Nature Makes Us Happier, Healthier and More Creative*, 'about 15 to 20 per cent of people just don't dig it'.[15] There are also a great many people who have no easy access to trees and green spaces. It is, therefore, by no means a given that all people will think of going into nature (nor even that they have adequate access to natural spaces) to help improve their sense of wellbeing, let alone climb a tree. Climbing a tree may simply be something for which a person has neither the inclination, time, nor access. And yet tree climbing bears fascinating relationships to questions of making time, snatching a moment from the busy pace of modern life and slowing time down. Tree climbing is exploratory; an improvisation. Or, to give that

word its other meaning, climbing a tree involves 'extemporization'. It takes the climber *ex tempore* ... out of time. The world of work, responsibility, politics and news falls away. Time stops. The climber can concentrate on what they are doing in the here and now.

Wider questions about the human relationship to time recur in tree climbing images and narratives, as *The Tree Climbing Cure* will show. Trees live on an alternative timescale to people – their development is longer; their age of sexual maturity is much later. Their lifespan far exceeds that of a single human being, often running to at least several hundred years. Tree climbing enthusiast, Jack Cooke, thinks of a tree as 'a vegetable clock that keeps ticking to an alternative rhythm',[16] while Janisse Ray describes how forests are 'a slow-ticking biological clock' and their processes 'a centuries-long game.'[17] In his popular account of tree ecology, *The Hidden Life of Trees*, Peter Wohlleben tells of a spruce tree in Dalarna, Sweden, estimated to be 9,550 years old.[18] Before the discovery of this spruce tree, bristlecone pines were considered to be the world's oldest living trees, at over 4,000 years old: one bristlecone, named Methuselah after the oldest-living biblical figure, stands in the White Mountains of Inyo County, Eastern California, and is over 4,850 years old. In his paean to Britain's vanishing ancient woodlands, *Oak and Ash and Thorn*, Peter Fiennes presents many of Britain's ancient yew trees, such as the Ankerwycke Yew that can be found in a meadow just across the river from Runneymede, where Magna Carta was signed. The yew had already been standing there for a thousand years as the signatories put their marks on that historic document. And there are other yew trees in Britain that were saplings as far back as Bronze Age Britain, when the totemic white horse at Uffington was cut into the rolling chalky hillside of Oxfordshire. Climbing yew trees as old as the Ankerwycke Yew can make a climber feel that they are not only climbing upwards in space, but backwards in time and, indeed, accounts in *The Tree Climbing Cure* show that many climbers report a sense of journeying through time: back into their childhood and, perhaps, even reconnecting in deep time with the ancestral arboreal hominids from whom humankind are descended. The British writer and naturalist, Richard Mabey, for example, grew up around cedar trees – on Cedar Road in fact – and recalls the giant specimens growing there: 'We went up them like lemurs,'[19] Mabey writes, describing how 'Two stories up in a cedar was like being in the loft of an abandoned barn [...] We spent whole afternoons up them, posing on branches, gossiping, doing mindless things with pieces of wood, dreaming of the savage life.'[20] Such carefree memories of childhood climbing present the 'mindlessness' of tree climbing in its best sense – utterly in the moment, without preoccupations; a wholly relaxed form of attention. But these memories also evoke ideas of human evolution ('We went up them like lemurs') that place the moment of childhood tree climbing within the context of a far longer time span.

Another common reason tree climbers often give for their activities when asked, or a reason that is given in climbing poems and novels, is to find solitude, or to find what Rudyard Kipling calls the 'misty solitudes', in his 1910 poem 'The Way Through the Woods'.[21] It is in this 'solitude' that the subject matter of *The Tree Climbing Cure* begins: not only in sympathy with Cody Lee Miller's solitary climb and 'cry for help', but in the kinship of tree climbing, nature, poetry and the grateful feelings of solitude that the literature and art brings to the fore. It is a feeling foregrounded, for example, in a much later poem than Kipling's, 'Ash Tree', by the British poet Richard Evans:

To squeeze in you must first stand sideways:
drop in one leg. Then slide – jumper catching
on the lip of the bark – to the charcoal dark of the hollow.
Stillness. Silence. A continent's
shift in time and place.[22]

Evans goes on to ask his reader to 'Hold on to this' when the modern world becomes noisy, when car alarms and traffic and the bin men clatter the waste bins early in the morning. 'Hold the liquorice dark of the wood; the musk and sea-shore smell,' Evans writes. Not only is it the solitude that is so solving of the cacophony of modern living, but it is also the shift in time back to a simpler childhood, away from the adult world of cars and bin men. And, for Evans, it is also the smell that is so crucial in people's encounters with trees, holding one of the answers to why being inside trees, or at least amongst them, is so good for health and wellbeing, as the scientific evidence encountered in the following chapter will elucidate.

One of the modern writers perhaps most associated with this kind of childhood nostalgia is the Welsh poet, Dylan Thomas. Although there are no poems overtly describing tree climbing in his collected works, Thomas's poetry abounds in the language of children, birthdays and coming of age. Where this language *does* come together with the activity of tree climbing, however, is in his poem 'Being But Men' (1932), which begins with the line, 'Being but men, we walked into the trees / Afraid'. As adults, Thomas suggests, people are limited and fearful of the unexpected; of the dark 'rooks' the poem goes on to describe, with all their 'wings and cries'. Childhood for Thomas, on the other hand, is confident and fearless, qualities that are captured in the action of climbing a tree:

If we were children we might climb,
Catch the rooks sleeping, and break no twig,
And, after the soft ascent,
Thrust out our heads above the branches
To wonder at the unfailing stars.[23]

Thomas's poem is a romantic countering of innocence with experience, echoing William Blake's *Songs of Innocence*, in which that visionary poet wrote of 'the green woods' laughing 'with the voice of joy'.[24] In the twentieth century, Thomas's poem presents the woods of adulthood as fearful, but those of childhood as full of freedom and wonderment, qualities that Thomas describes as being 'the aim and the end' of life. But 'we' are adults, Thomas reminds and, as the poem's ending repeats, 'being but men, we walked into the trees'. Tree climbing is intrinsically child-like, Thomas suggests. It is informal and free. It is outside of adult mores and strictures. Climbing a tree as a child shifts perspectives and deranges the rules of the adult world: children hang upside down from branches, swing with their hair dangling down and laugh. Climbing a tree is a mild form of rebellion and of estrangement; it takes the dull, everyday world and it turns it on its head, making one see familiar things in a new light, from a different perspective. It also connects the climber to the green force of nature; an energy that Thomas writes of elsewhere as the force that 'drives the flower' up through greenery, and which also 'Drives my green age'. Climbing a tree as a child then, Thomas suggests in his poem 'Being But Men', makes the child understand and feel that the force responsible for growth in nature is intimately connected with the force that makes the child themselves grow.[25] This process of physical and psychological growth – of 'individuation' (Jung) – is that by which the child becomes a balanced and integrated adult, and is central to many literary and artistic representations of tree climbers. Thomas's poem offers the revelation and reminder, in the everyday drudgery of adulthood responsibility, to hold onto that living green force encountered in childhood, and to embrace the defamiliarization that tree climbing offers. Perhaps this is why tree climbing is celebrated in childhood, but is also commonly coloured with thoughts of immaturity, derangement and madness in adulthood, as media coverage of Cody Lee Miller's case attests.

Tree climbers, then, appear to be simultaneously trusted (when it is the right person – a child, for example – climbing at the right age and time, in the right place), but also deeply mistrusted. In the simple act of climbing upwards, of clinging to branches and overturning restrictive adult codes, the climber solves something practical in the physical climb, as well as solving something within themselves in the metaphoric inner climb. Through the discussion of poems, novels and artworks; interviews with practitioners; investigation into the scientific underpinnings of wellbeing in nature; explorations of gender and tree climbing; readings of myths, legends and fairy tales; evolutionary theory, and the occurrence of tree climbers in scenarios as diverse as arboriculture, tree protest and nest robbing, *The Tree Climbing Cure* offers some answers to why the simple image of a person climbing a tree both encapsulates and disturbs ideas of innocence, experience and wellbeing.

Notes

1 Jessica Lee. '#ManInTree: Why It Went Viral'. https://www.seattletimes.com/seattle-news/manintree-why-it-went-viral/
2 See Isabel Hardman. *The Natural Health Service.*
3 See Samantha Walton. *Everybody Needs Beauty: In Search of the Nature Cure.*
4 Daniel Person. 'How #ManInTree Showed Us the Reality of Mental Health Treatment in 2016'. https://www.seattleweekly.com/news/how-manintree-showed-us-the-weaknesses-and-strengths-of-mental-health-treatment-in-2016/
5 In Peter Fiennes. *Oak and Ash and Thorn*, p.153.
6 Jack Cooke. *The Tree Climber's Guide*, p.5.
7 In Samantha Walton. *Everybody Needs Beauty: In Search of the Nature Cure*, p.66.
8 Ibid, p.63.
9 2 February 2017. https://thebmc.co.uk/Positive-mental-wellbeing-through-rock-climbing.
10 Ibid, p.41.
11 Ibid, p.10.
12 Ibid, p.9.
13 Richard Preston. 'Nameless', in *The Wild Trees.*
14 In Florence Williams. *Nature Fix: Why Nature Makes Us Happier, Healthier and More Creative*, p.145.
15 Ibid, pp.144–5.
16 Jack Cooke. *The Tree Climber's Guide: Adventures in the Urban Canopy*, p.204.
17 Janisse Ray. *Ecology of a Cracker Childhood*, p.156.
18 Peter Wohlleben. *The Hidden Life of Trees*, p.81.
19 Richard Mabey. *Beechcombings*, p.33.
20 Ibid, p.33.
21 Rudyard Kipling, 'The Way through the Woods', from the Kipling Society, http://www.kiplingsociety.co.uk/poems_woods.htm.
22 Richard Evans, in Michael Mckimm. *The Tree Line: Poems for Trees, Woods & People*, pp.95–6.
23 Ibid, p.31.
24 William Blake. 'Laughing Song', in *The Complete Poems*, p.109.
25 Dylan Thomas. 'The Force That Through the Green Fuse Drives the Flower', in *The Poems*, p.77.

1

A personal preface to this study: Cedars, oaks, maples, fruit trees and Covid-19

I should confess that, in my mid-fifties, I am not much of a tree climber anymore. I have a very bad back (the result of a scoliosis in infancy and accidents in my twenties) and I suffer from mild acrophobia – the fear of heights. My interest in tree climbing comes from climbing trees as a child and, later, working with trees as an ecologist, a teacher and a gardener, as well as from a lifetime's reading about trees, and the people who climb them. This personal preface offers a brief coverage of this climbing trajectory.

I was lucky to grow up surrounded by trees, in the suburbs of London, and within hearing distance of the M25 motorway. Back in the Second World War, our town, Watford, had been a 'countryside' site for children evacuated from central London; now it is virtually part of the capital. We faced the city and our backs were turned towards the parks and woods of Hertfordshire but, whenever I could, I would spin myself around to face the green belt instead. In doing so, I first learned the real benefits of time spent amongst trees.

We were privileged to have a good-sized garden. Beyond it lay Cassiobury Park – 190 acres of wooded grassland created from the estate of Lord Essex in 1909. At the garden's end there were iron railings, which our father loosened, so we could slip behind the boundary yew tree, lift a bar and escape into the park. We had been strictly instructed never to put the weird-looking yew berries into our mouths. Red and hollow with a dark nub inside, yew berries look frightening for a good reason: they contain alkaloid compounds akin to morphine and strychnine that can kill. My mother, enamoured with the family set of *Encyclopaedia Britannica,* also pointed out that yew trees

were sacred to Hecate, Greek goddess of magic, witchcraft and necromancy. And the railings? We weren't in prison – not by any stretch – but once the bars were lifted, we were free. It was the 1970s, and children used to play outside. 'Just be home in time for tea', was as strict as it ever got.

At the bottom of the park ran the River Gade, and the Grand Union Canal, beyond which stood Whippendell Woods – an ancient woodland and site of special scientific interest since the late 1950s – named from the Anglo Saxon 'Wippa denu', meaning 'Wippa's valley', possibly being 'Wibba', one of the Anglo-Saxon Mercian Kings from *c*.600 CE. To my childhood self, the woods were intuitively 'lovely, dark and deep', a phrase I would soon learn from the American poet Robert Frost.[1] Whippendell is rich in oak, beech, ash and silver birch trees, with hawthorn, hazel, holly and hornbeam aplenty. I frequently watched deer there and, at dusk, was transfixed by the flitting of bats and the lumbering sounds of badgers in the undergrowth. I learned to watch birds too: all the common wild and garden varieties, with jays, green and spotted woodpeckers, and sparrow hawks. And when I was home from the woods, I would lie in bed listening to the calls of tawny owls cutting through the hum of the M25 and the late-night trains rattling into London.

Cassiobury Park was blessed with some incredibly large Cedars of Lebanon, American pin oaks and many species of common domestic trees, but there were three trees that I was particularly attached to and often climbed. The first was a young cedar, growing right behind our house. It was small back then, perhaps just twenty feet tall, but is sizeable these forty-five years later. With distinctive black-brown, fissured bark, downy twigs, heady scent and dark grey-green needles, the young cedar tree was a sensory delight to climb. The branches of cedar trees hang in layers and, in a young specimen, make an easy scaffold. The lowest branches were within climbing reach, and you could gain a good height without much exertion. At the end of the branches the pinecones stood proud, barrel-shaped with flat tops and papery scales that oozed sap. They made fantastic 'grenades' that hurt when they hit you and left resinous smears on your clothes. The drier cones would explode on impact in a puff of scales and pollen dust. This was the first tree I learned to climb, and its balms – the cones, the scent, the easy climb and the great vantage point – outweighed the barked shins and the sticky stains on your clothing. What I didn't know at the time was that cedar wood oil has notable aromatherapeutic benefits – a warming effect on the skin; grounding and calming effects on the mood and reported aphrodisiac properties. Not much interest to me aged ten, but still. These properties form a significant part of the discussion in the following chapter of this book.

The second of my trees was an English oak tree – *Quercus robur*, the pedunculate oak – standing in the park's grassland a hundred metres beyond our garden. This oak tree – *our* oak tree, for surely nobody else knew about it – was an old specimen. Three of us couldn't link our hands around it to measure its circumference, making it at least a couple of hundred years

old. 'It is said that an oak tree takes three hundred years to grow,' writes naturalist Peter Fiennes, 'three hundred to stand still and three hundred years to die',[2] going on to catalogue the equal three hundred species that are said to subsist on the oak tree: deer, squirrels, moths, weevils, butterflies, bees, beetles, wasps, aphids, fungi, woodpeckers and jays, countless other birds, and larger mammals like badger and boar. Oak forests support more forms of life than any other native forest: a mature oak tree will support over 280 species of insect alone. Up in that oak tree, surrounded by squirrels, birds and the hum of insects, I appreciated that fecundity at first hand. But what made *my* oak tree special was neither its age, nor its great richness, but the perfect hollow in its trunk. Like the poet William Cowper's oak tree – the celebrated 'Yardley Oak' of his eponymous poem of 1791/2 – my oak tree was 'A shattered veteran, hollow-trunked [...] a cave for owls to roost in.'[3] Once a friend or sister had bunked-you-up, you could slip a hand over the lip and pull yourself in. Inside the hollow – a cave, just as Cowper describes his oak – you could peer out like some wise old owl. The walls of the hollow were softly rotting and, pressing your fingers into the damp wood, out came the sweet, musty odour of decay. Underfoot, the floor of the hollow was also soft; the sound muffled and intimate. The rising musk of the oak's underworld graced your lips. We took turns. It meant you didn't get long inside the hollow but, what minutes you did have, you savoured.

My third climbing tree lay deeper in the heart of Whippendell Woods. These forty-five years on it is no longer there, but I remember this forked field maple standing at the entrance to an open area of wooded grassland known as Strawberry Fields, with clumps of birch and alder, and grassy rides of tormentil and wild strawberry. The setting was memorable, but the tree was even more so: some six feet above the ground, the trunk of this field maple forked, and lodged there at head height sat a large piece of Hertfordshire Puddingstone that the tree had hefted as it grew. Puddingstone is a sedimentary rock made of rounded flint pebbles fixed in a silica matrix, so named because the pebbles resemble plums in a pudding. To a child it was a wonder of the world, lifted to the light by the tree. With one hand on each of the risers, a foot lodged against the main trunk, a tug with both arms, some upward motion provided by the foot ... you were in, with your friends smiling below you. And there, beneath your feet ... a stone. Of the earth and, yet, somehow raised into the air by the vigour of nature – Dylan Thomas's green force again driving up the stone and driving 'my green age'.

Leaving these childhood trees behind, I went to study for a BSc in Ecology at Leeds University and later still, a postgraduate project at York University, where I published my first scientific paper. My research team was examining 'The Wildlife Amenity of Farm Woodlands' in the Vale of York since, at the time, the UK government was paying farmers to 'set aside' land from agricultural production and to put it, instead, into forestry plantation. I was responsible for researching how local 'islands' of woodland in a 'sea' of agricultural land could best be optimized, in terms of their shape, size,

connectedness and floral diversity – a science known as Island Biogeography. The aim was to unearth the wildlife benefits of different kinds of woodland 'islands', as well as for other aspects of their public amenity and recreation, and to make a planning model for policymakers. Wandering around those woods in the Vale of York, recording detailed inventories of their trees and vegetation, measuring their exact shape and size, I often found myself climbing the trees and sitting above ground to eat my packed lunch, or simply to take a break from research. Once I'd vanished upwards and stopped tramping around, the wildlife would return, and I enjoyed many lunch hours watching small mammals, deer and woodland birds of all kinds, at least until I made my noisy way back down again.

My first teaching post brought me to Devon where I taught in several primary schools, specializing in environmental work, often taking my classes out into nearby woodlands to learn, and to climb – the benefits of outdoor learning will be touched upon throughout the pages of *The Tree Climbing Cure*. I was also writing creatively at the time and began seeing my work published. My 'writing career' (if such a tenuous thing can ever be said to truly exist) started to take off and, following six years as a Centre Director of the Arvon Foundation's Creative Writing courses at Totleigh Barton in Devon, I moved to Exeter University where I established the Creative Writing Programme with Professor Helen Taylor. Throughout this time, I've tried to pursue literary interests that tie in with my origins in ecology, my experiences in teaching and my more recent interests in the medical humanities.

Throughout my adult life I have also been lucky enough to live in places where I've been able to plant trees. I've been particularly interested in planting local apple tree varieties and, when I ran the Arvon Foundation Writing Centre, we planted a small orchard of local varieties: Pig's Snout, Tom Putt and Slack-ma-Girdle. Such names. I've also planted fruit trees at my get-away in Brittany – apples, plums, pears, figs, cherries and the delicious local Claude Reine gages. At our new home in Devon, I've planted a couple of plums, a fig, a greengage and two apple trees to complement those already growing in the garden. It is in this garden that I now do my tree climbing.

The Tree Climbing Cure has been written while under lockdown during the ongoing Covid-19 pandemic since 2020. Just before the outbreak, we moved into a new home on the edge of Dartmoor, having recently re-married. The garden has espalier pear and apple trees, and an established cherry – *Merton Glory*, an early-season variety, with large heart-shaped fruits that blush between yellow and light pink, sweet and delicious. There's a Victoria plum tree that took a hammering in winter winds and has needed surgery to save it, and an old apple tree that has been left to go wild by previous owners. Careful pruning these last two years has brought it back to shape and health. There's also a large damson tree that overhangs the end wall. Like the apple tree further up, it had been left to grow hopelessly

wild and congested and, as a result, I have been up in the trees a great deal during lockdown. The pandemic hit the UK in March 2020 and March is, at least, a good time for pruning apple trees. Summer pruning will check a tree's growth. Winter pruning allows for growth in the coming year. The tree's buds are still dormant in March. It always amazes me that soft leaves and delicate blossoms will burst out of those knotty twigs and branches, those compact and hard buds, but they do. Deep maroon and pale pink blossoms that erupt with a soft scent. The flower buds are fat and round, set on the thicker twigs and branches. The leaf buds are thinner and pointed in shape. If the tree is a young one, the idea is to take the central shooting stem and keep it, removing all the others, cutting just above the buds, and taking the young shoots down to half their length. Older trees are treated differently, thinning out the outer edges of the tree and opening up the crown so that the air and light can penetrate more easily. Insects too. There's a sort of counter-intuitive logic to it and, when I first did this, I thought that pruning the tree back would mean less of a yield, although it doesn't work quite that way. Pruning out the crown of the tree keeps the heart of the tree open. Which is a nice enough metaphor for a man who has recently just married. Pruning branches does of course mean less fruit, but the fruit that remains will be all the better for it – in essence, larger, juicier apples. Our trees being older specimens, I've been climbing in the branches a good deal across the pandemic lockdowns, thinning out the edges and opening the trees' crowns. I've been happy to forgo one season's crop for the promise of what will come the following year, and to have healthy and vigorous trees that look as though they've been given a new lease of life. Which is also a decent enough metaphor after marrying.

Coincidentally – and in a Covid-timely manner – the BBC recently ran a news article on their online platform, titled 'You Can Leave Your Problems on the Ground'. This two-and-a-half-minute video reports on a Hampshire company that teaches tree climbing skills with ropes and all the necessary kit and tackle, and which has begun to see a re-surge in interest and business as the first lockdown restrictions were lifted in this country. Participants in the film comment how the experience is 'like being a kid again ... like being out playing'.[4] The climbing tutor, Syd Howell, talks about leaving 'your problems on the ground' and being 'in the moment ... communing with a big, beautiful, living thing that's holding you up ... you can feel the life in them'. For the participants, time passes unnoticed in the canopy. Business meetings in the diary seem to get forgotten and missed. The BBC's end line is that 'tree climbers say their sport can help people's mental health' and, anecdotally, sitting in the branches of my apple and damson trees while pruning the deadwood, getting a different perspective on the garden and the lockdown, I certainly feel that I might not have borne the restrictions of this pandemic so well had I been stuck indoors the whole time; had I not been able to climb. I realize that this is a position of extraordinary privilege, and am aware just how stressful and difficult lockdown has been for many

others who have no access to outdoor space. But the lesson of my own experience, the evidence of scientific research and those anecdotal stories such as that run by the BBC, all point in the same direction: getting out amongst the greenery *is* good for you, and being up in the branches is good for our mental and physical health when, and if, you can.

The Tree Climbing Cure is, therefore, the culmination of this personal journey and brings together a passion for nature and ecology – and trees in particular – with an interest in mental health and wellbeing, and how literature and art can inform the ways in which we think about wellbeing. I hope that it might be seen as a small fruit on the great branch of literary ecology – a genre of writing that finds expression in what the celebrated British nature writer, Roger Deakin, calls 'The intimate kinship of poetry and ecology'.[5]

Notes

1 Robert Frost. From 'Stopping by Woods on a Snowy Evening', p.1232.
2 Peter Fiennes. *Oak and Ash and Thorn*, p.101.
3 William Cowper. 'Yardley Oak'. https://www.carcanet.co.uk/cgi-bin/
 scribe?showdoc=21;doctype=2
4 Ben Moore. All quotes from 'You Can Leave Your Problems on the Ground'.
 https://www.bbc.co.uk/news/av/uk-england-hampshire-53090381/coronavirus-
 social-tree-climbing-boosts-mental-health
5 Roger Deakin. *Wildwood: A Journey through Trees*, p.28.

2

The science of nature and wellbeing

In European and North American culture, at least, a popular, anecdotal feeling exists that being outdoors in nature – perhaps doing such innocent things as climbing a tree – is 'good for you', both physically and mentally. The Introduction made a few caveats to this opinion, concerning some people's dislike of nature, or lack of access to it, but there is a weight of popular, anecdotal feeling which suggests that 'nature is good for you'. And yet, the evidence is more than simply anecdotal. Increasingly, scientific research, psychological theory and a host of other disciplines from mental health therapeutics to ecopsychology are proving the important links between nature and human wellbeing. The psychiatrist and psychotherapist Sue Stuart-Smith calls it 'the evolutionary fit between brain and nature'.[1] Hildegard of Bingen, the twelfth-century abbess and mystic, had a more esoteric name for the close affinity between the growth force of nature and the human spirit. She called it *viriditas*, echoing both 'veritas' truth, and 'viridity' greenness. Centuries later, Dylan Thomas alludes to it in his phrase about the force that drives 'through the green fuse'. More recently the hypothesis has been popularized in the term *biophilia*, as it was first named by the psychoanalyst Erich Fromm in 1964,[2] and later developed and popularized by the Harvard naturalist Edward O. Wilson in his 1984 book of that name.[3] *Biophilia* is the innate need to connect to nature – people are hard-wired through their DNA, the argument goes, to connect with their natural surroundings. The human brain evolved in nature, and it is (despite the majority of people now living in cities and mega-cities) still attuned to that evolution. The opposite of *biophilia*, known as *biophobia*, inversely points to the innate relationship between the mind and nature. Consider those people who do *not* like nature; who have phobias about snakes and

spiders, for example. These phobias are, likely, vestiges of important survival mechanisms for human ancestors and, so, inversely acknowledge the same connection between the mind and nature, what Samantha Walton calls 'the pull and tug between nature, the body and the self'.[4]

American ecologist and natural history writer, Robert Michael Pyle, is an ardent believer that a lived experience of nature, of the outdoors, can never be replaced by vicarious experience (watching nature programmes on TV, for example): 'One of the greatest causes of the ecological crisis,' he writes in his 1993 memoir *The Thunder Tree*, 'is the state of personal alienation from nature in which many people live'.[5] The 'entertainment' of televised nature, Pyle argues, 'loses its ability to arouse our deeper instincts'.[6] There is of course, a deeper debate to be had here about who, exactly, has the privilege of access to the natural world and, as studies have shown, that picture is skewed against people of poorer economic standing and those from minority ethnic backgrounds. It would be harsh to lay any kind of blame for 'the ecological crisis', and the 'apathy toward environmental concerns', as Pyle calls it,[7] at the feet of those who, through no fault of their own, do not have open access to the outdoors. But Pyle does recognize that access to green spaces are 'the bandages and the balm' to the problem of human estrangement from nature.[8] Pyle's proposed solution is to celebrate and seek out the natural wildness that can be found in urban wildlands: 'We must save not only the wilderness but the vacant lots, the ditches as well as the canyonlands, and the woodlots along with the old growth. We must become believers in the world.'[9] In the *Afterword* to the 2011 edition of his book, Pyle writes that 'We need to keep some of the so-called vacant lots, some big old hollow trees, some brush and scrub. We need the Country in the City, and the balm of the "accidental wild"',[10] invoking the medicinal, curative language of nature as 'balm', to re-open access to the 'wildling fringes of our towns, to love and enjoy the natural fragments, and to keep them present, connected, and lively around us'.[11]

Learning from Pyle's celebrated *The Thunder Tree*, and developing some of its notions, the author and journalist Richard Louv's well-known book, *Last Child in the Woods*, points to the increasing levels of what he calls 'nature deficit disorder', a condition linked to the lack of nature in young people's lives, and increases in psychological conditions such as depression, as well as obesity, lack of vitamin D and growing incidences of short sightedness in young people. Sunlight, Louv's research shows, is essential for retinal development. The bright glow from a desktop or laptop monitor, or any other hand-held device, is not. Writer Isabel Hardman discusses such research in her recent book, *The Natural Health Service,* agreeing with wider research that promotes outdoor activity for young people. Similarly, according to the extensive research of Lucy Jones in her recent book, *Losing Eden: Why Our Minds Need the Wild*, 'Three-quarters of children (aged five to twelve) in the UK now spend less time outdoors than prison inmates', who are allowed a statutory hour.[12] Such deprivation has led to a new

lexicon – phrases such as Robert Michael Pyle's 'the extinction of experience' (a dwindling of nature experiences from generation to generation), 'shifting baseline syndrome' (how people do not notice environmental change and become accustomed to changes such as the loss of a species), and Richard Louv's 'nature deficit disorder' have all entered the language. Pyle coined the term 'the extinction of experience' in *The Thunder Tree*, by which he intended readers to understand that the extinction and loss of a local species 'endangers our experience of nature'.[13] In other words, as Pyle puts it, 'What is the extinction of the condor to a child who has never known a wren?'[14] Pyle's emphasis on local species also pre-empts another recent nature-deficit condition, since people may now also be described as suffering from 'species loneliness' as they become increasingly estranged from other species. Individuals may also suffer with other 'psychoterratic syndromes' such as 'solastalgia' (a nostalgia for places lost through climate change, or climate-change distress), 'eco-anxiety', 'climate despair', 'Anthropocene Disorder' and 'global dread', all of which have been added to the increasingly long list of conditions now affecting people since the turn of the millennium.

To see whether climbing itself has any positive effects on health and wellbeing, John Gathright and fellow researchers in Japan devised a test to compare climbing a living tree with climbing a concrete tower in the same Japanese forest. They found that climbers' bodies were more relaxed after tree climbing than after climbing the tower.[15] Results of psychological tests also showed that tree climbers exhibited greater vitality and reduced tension, confusion and fatigue when compared to tower climbing. Tree climbing, therefore, has been shown to have distinct physical and psychological benefits compared to other kinds of climbing. In Japan, where the practice of 'forest bathing' has proven so popular – taking a 'bath' in the natural aromas and ambience of a local forest – Gathright founded the non-profit organization, *Tree Climbing Japan*,[16] to run tree climbing tuition, along with Tree Climbing Based Rehabilitation and Tree Assisted Therapy programmes. Gathright also founded *Treehab*, another non-profit organization offering rehabilitation therapy through tree climbing for children with disabilities. Between 2000 and 2005, over 26,000 people of varying ages and abilities participated in these activities across Japan.[17] Gathright comments, 'Little miracles were happening all over Japan up in the trees,' as the participants reported feeling less pain, and decreased feelings of depression.[18] Tree Assisted Therapy focuses on climbing the tree, of course, but it also involves ice-breaker activities, forest appreciation discussions and engagement with conservation issues. Participants collect leaves, undertake breathing exercise and participate in acts of respect towards nature. During their ascent, climbers observe and reflect on nature and themselves. On descent, there are group presentations and discussions about the climbers' experiences.[19] In interviews and through the use of questionnaires, participants reported that these activities, as well as the tree climb itself, 'had both psychological and physiological benefits, enhanced

their awareness of environmental concerns, and inspired them to participate in forest rejuvenation projects.'[20] Pain and fatigue were reduced, vitality and clarity of mind increased, as did the participants' sense of self-worth and a desire to be more environmentally conscious. What is more, participants of Tree Assisted Therapy programmes have been shown to experience greater increases in wellbeing and environmental awareness than control groups in a simple tree climbing programmes.[21]

In the light of the growth in scientific research in this area, there has been an explosion of 'nature therapies' in recent decades. And yet the idea that nature is a good therapy has been part of Western health culture from the monastic hospital gardens of medieval Europe, through to twenty-first century 'gardening therapy' schemes, with much else in between. As Richard Mabey writes, 'The idea of a "nature cure" goes back as far as written history. If you expose yourself to the healing currents of the outdoors, the theory goes, your ill-health will be rinsed away.'[22] Mabey goes on to cite pilgrimages to shrines; the kind of restorative trips to the countryside, or seaside, that were prescribed to sufferers of tuberculosis; patients at sanatoria being left out to air in their wheelchairs and so on. 'The idea was to submit to nature, to hope that it would "take you out of yourself", dissolve the membrane between you and the world of health to which you naturally belonged.'[23]

Similar narratives to Mabey's are now appearing with regularity. Following some serious bouts of depression, drug and alcohol abuse, Lucy Jones writes, in *Losing Eden*, how: 'Nature picked me up by the scruff of my neck, and I rested in her teeth for a while. The world glowed, and it cooled my mind. Nature softened the edges and sharp angles and stroked my hair and held my hand.'[24] Addictions aside, a cursory look at present-day habits supports the commonly held notion that spending time in nature, or up a tree, really will do some good. The number of people out walking on the UK's coasts, moors and mountains, byways and public footpaths has been exploding: according to Sport England's comprehensive survey of sport and recreation participation in Britain in 2008, 9.1 million adults in England (over 20 per cent of the population) were walking recreationally each month.[25] Furthermore, Natural England – the UK government's adviser on the natural environment – conducted a more recent study in 2019 showing the significant value of coastal walking for health and wellbeing, with 97 per cent of people feeling refreshed and revitalized as a result of their visit.[26] Going for a walk is a highly beneficial complement to medication – research shows that spending time walking the coast, or among trees and greenery, translates into fewer prescriptions of antidepressants. People take less time off work after spending time in nature. A study from the University of Exeter in 2019 shows that just two hours a week in nature is associated with good health and wellbeing.[27] Lucy Jones notes that 'People with depression, anxiety, schizophrenia and other neuropsychiatric disorders have been found to have higher levels of inflammation biomarkers [cytokines]', and 'people with dysregulated immune systems are more likely

to have psychiatric disorders'.[28] Overactive cytokine production is strongly associated with depression, disease and ill-health. Time among the trees, research shows, can significantly lower cytokine (and hence inflammation) levels – again, just two hours a week is all it may take.

There are, of course, dissenting voices. Novelist John Fowles was dismissive of the idea of nature as therapy: 'I do not believe nature is to be reached that way either, by turning it into a therapy, a free clinic for admirers of their own sensitivity. The subtlest of our alienations from it, the most difficult to comprehend, is our need to use it in some way, to derive some personal yield.'[29] Nature is not to be 'used', Fowles argues. It is to be taken on its own terms, at its own pace and in its own way. Like John Fowles, Samantha Walton's recent book, *Everybody Needs Beauty: In Search of the Nature Cure*, takes an often sceptical approach to the subject matter. While Walton is often 'impressed with what science tells us about the nature cure', she is also sceptical 'about some of the bold claims made by the researchers. There's a danger in assuming any one treatment will work for everyone, and that we all experience sickness and healing in the same way.'[30] Walton notes that we are afforded the privileged position of celebrating the nature cure 'when we no longer feel like it's going to kill us every second'[31] and, like John Fowles, is wary of reducing nature to a therapeutic tool; 'nothing more than a healing aesthetic'.[32] The wellness industry, Walton argues has a propensity to repackage nature 'as a charm for the privileged'.[33] *Everybody needs beauty* Walton's book title asserts – the nature cure is not, or should not be, reduced to the status of a marketable utility tool.

These caveats aside, scientific evidence points to the fact that, on the whole, people like to be – and greatly benefit from being – outdoors in nature. This chapter investigates that scientific evidence and argues that the multiply sensory activity of tree climbing – which involves sight, hearing, touch, smell and taste, as well as other subtle senses such as motor-sensory functioning, balance and kinaesthesis (the sense of self movement and body position) – can not only be a healing experience in itself but also accounts in part for why so many tree climbers (both in reality and the imagined spaces of poems, novels and artworks) may be drawn in a time of personal dilemma to climb up into the branches of a tree.

<p style="text-align:center">*</p>

A mass of empirical and theoretical evidence supports the idea that natural surroundings and outdoor exercise reduce stress, enhance wellbeing and promote better health in manifold ways.[34] Comprehensive summaries, such as Matilda van den Bosch and William Bird's *Oxford Textbook of Nature and Public Health: The Role of Nature in Improving the Health of a Population*, offer far-reaching and persuasive data, as does Lucy Jones's *Losing Eden*, while books such as Theodore Roszak's *Ecopsychology: Restoring the*

Earth, Healing the Mind (1995) present the material from a 'Deep Ecology', or 'Earth-Centred' point of view. There is not room here to rehearse all the psychological and physiological benefits listed in these studies, save to say that the research points to positive benefits in many areas, not least the psychological and physical factors connected with the benefits of simply being outdoors in moderate sunlight – vitamin D production, the regulation of the sleep-waking cycle and retinal development.

The main benefits of being active and outdoors in nature, the research shows, include:

- boosting energy
- stress reduction, through lowering the 'stress hormones' adrenaline and cortisol
- weight loss and reduced obesity
- enhanced gut microbial biodiversity, and improved functioning of the immune system
- nerve regeneration
- enhanced psycho-physiological responses including improved concentration, memory, positive feelings, vitality, existential wellbeing, positive self-image and sense of meaningfulness
- enhanced social connectedness when sharing nature with others
- enhanced problem-solving ability and creativity
- reduced blood pressure and heart rate
- improved cardiovascular and metabolic health
- reduced blood sugar levels
- a calming of the autonomic nervous system (the unconscious control of bodily functions)
- increased parasympathetic nervous activity (responsible for the body's rest and digestion responses when relaxing)
- reduced anger, aggression, anxiety, depression, fatigue and confusion
- improved pain thresholds
- increased levels of 'good' anti-inflammatory cytokines, and decreased levels of 'bad' inflammatory cytokines
- and suggested preventative effects on cancers through anti-cancer protein production.[35]

The evidence from the research seems to support what Robert Macfarlane writes in his nature/travel memoir, *The Wild Places*, 'We are fallen in mostly broken pieces [...] but the wild can still return us to ourselves.'[36] This is not just Romantic wishful thinking on Macfarlane's part; the scientific findings support the case.

There is, however, always the possibility of a placebo effect: 'How much of the great outdoors is merely a placebo that works because people want it to?' Isabel Hardman asks.[37] It's a vital question, echoed by Samantha Walton in *Everybody Needs Beauty*. Through idealized representations, in Western art and literature, for example, people have learned to think that nature is beautiful and, furthermore, have learned the attitude that nature is 'good for us'. Philosophies such as those of the American Transcendentalists – Ralph Waldo Emerson, Henry David Thoreau, Margaret Fuller and others – reinforce the notion that time spent in nature improves a person both spiritually and morally. Recent evidence seems to suggest that it is more than just a placebo effect but, even if there *is* a strong placebo effect, then that, in itself, might be no bad thing. Either way, being outdoors, up a tree, *is* beneficial, or *feels* beneficial, so long as you don't fall. Writers have been saying it for centuries, but the scientific evidence now backs up the subjective and imaginative response to trees, nature and greenery. It cannot cure you, Isabel Hardman points out but, as part of a holistic approach to physical and mental wellbeing, it can be very good for you indeed.[38] Perhaps this is another reason why climbers such as Cody Lee Miller intuitively head for a tree in times of distress?

In this book's introduction, Richard Evans's poem recalled the 'liquorice dark' smell of the woods, and it turns out that this scent is more than just a poetic device. Forest bathing ('*shinrinyoku*', in Japanese and '*salim yok*' in Korean) is the common practice of taking recreation in forests to 'bathe' in the phytoncides (woody aromatic compounds) released by evergreen trees. In a wide-ranging study, Dr Qing Li shows how such practices enhance human immune responses, reducing adrenaline levels (stress hormones) and, again, showing possible preventive effects on cancer development.[39] Trees produce these phytoncides for a number of reasons: they act like anti-freeze, protecting delicate evergreen leaves in harsh winters, and they are antibacterial and disinfectant in the trees' tissues. They also act as messages between trees in the forest. In this sense, trees may also be said to have a 'sense of smell' themselves: phytoncides and other aromatics are warning chemicals. Trees know which insects are eating them, through the 'taste' of the insects' saliva and can mobilize communicative chemicals to warn other nearby trees, as well as encouraging the specific predators of those insects to attend.

For human forest goers, the phytoncides work in antibacterial and aromatherapeutic ways. People report feeling less stressed, less anxious, even less depressed, because the phytoncides enhance the action of the natural 'feel-good' chemicals: the body's levels of dopamine (the 'pleasure' hormone), oxytocin, serotonin (regulating mood, sleep and temperature) and beta-endorphins (the brain's natural opioids) all rise when people spend time in forests and breathe in these scents. Adrenaline and cortisol ('stress hormones') levels also drop.[40] Trees also produce aromatic perfumes when they blossom, affecting people's mood through the sense of smell. According

to Sue Stuart-Smith, 'the fragrance of the rose reduces the breakdown of our endogenous opioids creating a feeling of lingering calm'.[41] In other words, the scent of roses acts physiologically to stop the body removing its own feel-good chemicals. There is, hence, some scientific grounding for the rose's romantic connotations. Woodland and forest perfumes also work in the same way.

One study, at the Department of Psychiatry at Mie University in Japan, 'has shown that the citrus fragrance of the phytoncide D-limonene is more effective than antidepressants for lifting mood and ensuring emotional wellbeing in patients with mental health disorders', Dr Qing Li reports.[42] The essential oils from coniferous trees combat atopic skin diseases, lower cortisol levels, help reduce asthma (although tree pollens, on the other hand, can exacerbate asthma too), stimulate respiration and act as mild sedatives. Another Japanese study found that 'smelling cedar wood was associated with parasympathetic nervous activity, decreased heart rate and thus a state of physiological relaxation'.[43] The scent complex in the brain is close to the back of the nasal passages, so that scent can trigger an almost immediate response in the amygdala, triggering fast emotional responses, flight-or-fight responses and memories. As Florence Williams writes in her study of why nature makes people happier and healthier, 'the nose is a direct pathway to the brain'.[44] Yet Samantha Walton is sceptical about the politics of forest bathing, even while the science of it shows persuasive scientific underpinning. 'In the last decade', Walton writes, 'dedicated forest-bathing centres have started popping up across Europe and the US. Based on the Japanese *shinrin-yoku* trend', with 'sixty-two recognized forest-bathing sites around Japan' alone.[45] And yet Walton acknowledges that forest bathing was launched as a government initiative 'to encourage workers to manage stress at the weekends', a political origin that 'alters its meaning and its politics as a form of quasi-enforced self-care'.[46] If this is true in Japan, then in Western locations, at least, the practice is *not* government led and is, perhaps, free from such worries of governmental, policy-led interference. Furthermore, fiction and science are beginning to overlap in reporting the same thing: forest scents *are* good for people. In Richard Powers's Pulitzer Prize-winning novel, *The Overstory*, for example, dendrologist Dr Patricia Westerford sniffs at fallen gum leaves: 'a child's whiff of heaven', as Powers describes it. Dr Westerford also reflects on the medicinal qualities of trees: 'the priestly tulip trees still boost her immune system, while beeches lift her mood and focus her thoughts. Under these giants, she's smarter, clearer.'[47] Such restorative effects are reflected time and again in poets' and novelists' explorations of the olfactory senses of their tree climbing characters.

In 1920, in Fiesole, Tuscany, D.H. Lawrence wrote the poem 'Tuscan Cypresses', which explores ancient Etruscan culture and the ways in which the long-standing cypress trees act as witnesses to a lost race of people:

There in the deeps
That churn the frankincense and ooze the myrrh,

Cypress shadowy,
Such an aroma of lost human life![48]

The poem evokes the heady aromatics of the trees standing in the Tuscan heat, and uses it to describe the lingering 'scent' of the lost Etruscan civilization. As such, the poem evokes time and culture, as much as it does the actual scent of the trees. The reader feels the contrasting heat of the day and the shade of the trees, almost smelling their aromatic compounds in the air. The cicadas are animated and present in their insistent chirruping. Lawrence spent a lot of time in Italy and wrote some of his major works, including *Lady Chatterley's Lover*, while living there. Between 1920 and 1922 he rented a villa outside the town of Taormina, Sicily, where he wrote a group of poems about trees, including 'Bare Fig-Trees' and 'Bare Almond-Trees'. The poem about the fig trees touches again on the nature of scent, as well as the relationship of trees to time.[49] Larence describes the tree as a 'candelabrum', evoking not only the shape of the branches, but associating the tree with light, scent and sanctity, if that scented candelabrum can be pictured standing on an altar. Lawrence also evokes, again, the actual scent of the tree – this time its 'flesh-scent' – to humanize the tree and help convey his thoughts on time, which the tree measures on a vastly different scale. Something heady in the heated scent of the tree brings on thoughts of timelessness – 'dull Eternity' and 'stale Infinity' are invoked. Sitting beneath the tree makes these things come clear just as, one could argue, would climbing up into its branches. Were the reader to do so, surrounded by those potent scents, Lawrence suggests they would benefit from the aromatherapeutic compounds of the trees. For Lawrence, as he writes elsewhere in his psychoanalytic book *Fantasia on the Unconscious*, 'The piney sweetness' is both 'rousing and defiant'.[50]

The contemporary English poet Tony Harrison has also written poetry about the scents of trees. His long poem, 'Cypress & Cedar' (1983), explores the scent of these two types of wood. The poem begins and ends with the smell of cedar wood emanating from the poet's pencil: 'A smell comes off my pencil as I write,' Harrison narrates.[51] In this way, the aromatics of wood are *inscribed* into the fabric of the poem from the beginning. The poet and his partner sit in their 'swampland' house in the southern United States, each one seated in one of two chairs, one made of cypress wood, the other cedar. It is a tender scene of the familiarity of lovers, although the line 'both scents battle for the same night air' introduces some tension to the moment, carried by the opposing scents. The poet bought the two chairs from 'the local sawyer, Bob', whose hand 'leaves powerful smells on mine' when the poet shakes hands with him. Harrison chooses a cypress chair and a cedar one at the timber yard – 'one fragrant as a perfume, and one rank / and malodorous from its swampland ooze', the cypress wood giving off such a bad smell that the sawyer's wife 'won't sleep with him on cypress days', although she will on the days he works the sweet-smelling cedar wood.

Bringing his new chairs home, the poet discovers that as 'I sit in mine, and you sit in your chair. / A sweetness hangs round yours, a foul smell mine'.

He clearly has the cypress chair, and she the cedar one. The poet uses the opposite scents as a way of commenting, without saying anything overt, on the relative qualities of each person's mood. The poem develops its theme. The forest bathing expert, Qing Li, notes that 'The fragrance of cedar wood is said to relax the nerves and calm the spirit. Aromatherapists use it to stimulate emotional strength and to promote feelings of self-acceptance'.[52] And there is certainly a relaxed and calm spirit around the smell of the cedar wood in Harrison's poem. As it develops, there are many references to the scents of the trees: 'Pet lovers who can't stand the stink of cat / buy sacks of litter that's been "cedarized" / and from ancient times the odour's been much prized.' The poet's partner keeps all her clothes in a cedar-wood chest – 'such a fragrance comes from your doffed bras' – the scent of cedar wood being long-trusted as a repellent for insects and clothes moths.

Harrison's poem, then, is a meditation on intimacy and opposites: cypress and cedar wood; man and woman; day and night; sobriety and drunkenness; peace and fear; hope and 'writer's despair'; and tenderness versus the harsh realities of rural farm work (in the poem, some hogs are gelded in the night, producing unearthly-sounding squeals). The two chairs become symbolic carriers of the poet's love for his partner:

We sit here in distinctly scented chairs
You, love, in the cedar, me the cypress chair.
Though tomorrow night I might well sit in yours
And you in mine, the blended scent's the same.

The poem ends with a request that he be buried in cedar wood 'to balance the smell like cypress from inside'. As with D.H. Lawrence's poems, Harrison's poem uses the aromatic compounds of the trees to help him ruminate on experience, something that similarly happens when entering a forest and inhaling, deeply, the aromatherapeutic compounds that fill the air. Forest scents, in reality *and* in poetry, calm the body's physiology and thus help people to sort out what is going on inside their heads. It is surely no coincidence that Cody Lee Miller found himself climbing up an aromatic evergreen tree – a giant sequoia – whose phytoncide chemicals would have been working on his physiology in ways he was probably unaware of.

*

Leaving forest scents behind, what of the multi-sensory benefits that are claimed for tree climbing? When climbing trees, the sound in the leaves also has notable calming effects on the mind, much like the calming effects of the sound of water in a stream, or as recorded on one of the popular meditation apps that play loops of natural sound effects to help people focus and still their minds. On describing Silver Pines in the Yosemite Valley, American

naturalist, writer and activist John Muir wrote how the species 'gives forth the finest music to the wind. After listening to it in all kinds of winds, night and day, season after season, I think I could approximate to my position on the mountains by this pine-music alone. If you would catch the tones of separate needles, climb a tree.'[53] Here the music of the trees is not only an aesthetic pleasure in itself, it is also an accurate form of musical compass. Muir famously climbed a forest tree during a mountain storm to 'get my ear close to the Æolian music of its topmost needles' and left a remarkable description of his time in the branches: 'There is always something deeply exciting, not only in the sounds of winds in the woods, which exert more or less influence over every mind, but in their varied waterlike flow as manifested by the movements of the trees, especially those of the conifers.' He goes on to call pine trees 'the best interpreters of winds', as though they were woodwind instruments themselves being blown by the winds of the storm.[54]

Like John Muir, American naturalist and writer Janisse Ray also enjoyed the thrill of tree climbing during stormy weather. Just before a storm hit, Ray describes how she would run for a tree 'and climb halfway, straddling a stout limb and facing the wind that whipped my face and billowed out my skirt, pushing against me. The tree shook and swayed and I hung on, laughing for what I knew as joy.'[55] Ray also describes how she took great pleasure in listening to the pine trees of her childhood forests 'sing'. She writes: 'The horizontal limbs of flattened crowns hold the wind as if they are vessels, singing bowls, and air stirs in them like a whistling kettle. I lie in thick grasses covered with sun and listen to the music made there [...] Rustle, whisper, shiver, whinny. Aria, chorus, ballad, chant, Lullaby.'[56] Writing earlier in the twentieth century, and echoing both Muir's sense of musicality in the pines and Ray's sense of musical joy, D.H. Lawrence, again, describes the 'noise of the needles' of pine trees, which he describes as 'keen with aeons of sharpness'.[57]

There are, of course, also often birds perched or roosting in the branches of trees. Studies using birdsong 'consistently show improvements in mood and mental alertness', Florence Williams reports.[58] The research is supported more anecdotally by a recent *Springwatch* video for BBC South, May 2020, in which the British naturalist, author and TV presenter, Chris Packham, is to be found walking in woods near his home. 'This old droveway avenue of trees is where I feel most connected,' Packham narrates.[59] 'I've grown up in this environment. This is oak, hazel, beech woodland. The sights, the sounds, the smells of this are all familiar to me, so I just feel really comfortable here.' The multi-sensory nature of the woodland sets Packham in a grounded reality. When the birds start singing en masse, Packham comments, 'Just listen. It's just layers. Layers of birdsong [...] It's an orchestra of therapy.' Packham's evidently ecstatic reaction to his surroundings, along with his choice of language, echoes the scientific findings. And Chris Packham does, indeed, appear remarkably comfortable and relaxed in his natural

environment, enveloped in birdsong, as though he were enjoying some kind of curative treatment. When he hears the first cuckoo of the season, his reverie is palpable. 'It's fantastic,' he says, 'it's a treat. That's a sparkling little jewel to add to my collection of springtime events.' The infectious energy and enthusiasm Packham conveys to his viewers is entirely wrapped up in the kind of sensory language that the research and 'forest bathing' trips, point to. 'I am seizing this spring with both hands,' he says. 'And ears and eyes and nose.'

Chris Packham's recording was made in the middle of the Coronavirus pandemic of 2020 and so, on that day, the skies were devoid of any other noise: no aeroplanes and no rumble of traffic on the nearby link road. Perhaps then, the therapeutic effects of nature and birdsong were doubled that day? 'Like nature has been distilled back into its primal form,' Packham comments. Perhaps, following the Coronavirus lockdowns and restrictions, what might be most beneficial would be to get back out into nature a little bit more and a little bit more regularly, where possible? To listen to birdsong and to engage hands, ears, eyes and noses, as Packham exhorts his viewers to do. While the lungs of Covid-19 sufferers are struggling in intensive care units across the world, perhaps it should be to trees, to nature's lungs, that people might hereafter turn if at all they have the chance to do so? Research shows that the air under trees is cleaner and more beneficial, because trees act as air filters, removing up to 20,000 tonnes of particulate matter per square mile each year.[60] This means that not only are soot, pollutants, dust and other particles removed from the air beneath trees, but oxygen levels are higher. The air is more breathable and enlivening, accounting for reduced blood pressure and heart rate, improved cardiovascular function and reduced blood sugar levels, as summarized in the aforementioned research.

The colour green also has notable effects on human psychological states – the eyes' photoreceptors are particularly receptive to sunlight and green wavelengths, which help to stimulate calming alpha waves in the brain. A 2010 study on the influence of light wavelengths on sleep also shows that green and blue light have an important role to play in controlling bodily circadian rhythms and might, therefore, have a therapeutic role to play in the treatment of sleep disorders, seasonal affective disorder and dementia, as well as the use of light as a 'drowsiness counter-measure, particularly during night shift work'.[61] These studies form part of the field of 'Colour Psychology' – the study of different hues and how they determine human behaviour – which has grown in recent years, mainly being used in branding, marketing and advertising, education, business productivity and office design, but also forming part of the wider field of environmental psychology. A 2016 study at Regents University, London, exposed a group of subjects to live plants, views of nature and green colours, along with a control group exposed to none of these, and asked them to complete

creative tasks. Results show that visual creativity increased with exposure to natural views, plants and the colour green.[62] Research has also shown that the presence of potted plants can lower stress levels and discomfort in hospital settings.[63] Green has also been shown to help with reading: in reading tests, some students have been able to read faster and more clearly with a green overlay, leading to greater understanding.

The science behind why the colour green is beneficial lies in the pituitary gland, which is stimulated by the mid-range frequency of the colour to release the hormones oxytocin and norepinephrine, which are instrumental to the body's 'relaxation response' via the parasympathetic nervous system. This relaxes the muscles and increases the level of histamine in the blood, which in turn dilates the blood vessels, leading to smoother muscle contractions. The colour green, therefore, calms the body and mind and relieves feelings of stress, but also leaves the muscles feeling invigorated. People feel ready for being outdoors. Ready to climb.

Green wavelengths, which sit in the middle of the visible spectrum, are commonly considered to be among the 'cool colours'. These wavelengths are also received by the retina of the eye in such a way as to require no adjustment and are, therefore, more easeful on the retina than, say, the 'hot' colours, such as red and orange. Green is literally restful for the eye, the secret to which lies in the two types of cells in the retina: the rods and cones. Rods are mainly used in low light conditions, differentiating light and dark, whereas cones are used for brighter light conditions and differentiate the colours of the spectrum. These cells send their impulses to the brain when stimulated by light of differing wavelengths. Some are more sensitive to wavelengths from either end of the spectrum, but all the rods and cones are affected by green wavelengths, making green easily detectable, as well as being restful for the retina. This ease of reception perhaps accounts for why the human eye is able to differentiate more shades of green than any other colour.

Green wavelengths sit in the centre of the colour spectrum and might therefore be considered 'balanced'. It is unsurprising that people generally report feeling these balancing effects when surrounded by greenery – greenness indicates the presence of vegetation, of food and water and, for our distant ancestors, must have been both alluring and reassuring. It does not take a great imaginative leap to see how early humans would have begun to associate the colour, through nature, to ideas of plenitude, fertility and lushness, and that the pangs of hunger could be put aside. Other positive associations such as wellbeing and restfulness might have accompanied the experience, and may have led to the mind associating the colour with good luck, in most Western Cultures at least. And yet green is also used to represent queasiness and sickness, jealousy and envy, as well as other negative associations such as decay and corruption, although green is not alone in this – all colours, in fact, have both positive and negative

associations that play out culturally. But, where they exist, the more positive associations of green have also been exploited culturally. In the theatre there is a 'Green Room', a restful space also used by guests waiting to appear on TV. This rest room, decorated green, traditionally helps people to relax before a performance, or an interview. These positive associations even stretch to traffic management, where the 'green light' gives the go-ahead to drive on. Giving the 'green light' to an idea or a plan has hence been appropriated into general parlance.

It isn't just the light, the smells and the sounds that are beneficial when people go into forests and woods. Taste may play a part too. Deeper down in the soil, research shows that the bacteria found there, *Mycobacterium vaccae* (*M.vaccae*), can boost serotonin levels in the brain – serotonin being that 'happy chemical' in the brain, which modulates the mood, cognition, sense of reward, and learning and memory. It can also reduce brain inflammation and regulate the immune system.[64] This bacterium, along with the other billion microbes found in just one teaspoon of garden soil, may account for the enhanced biomes of bacteria in the guts of gardeners and people who work in nature. Beneficial microorganisms in the soil can have anti-viral effects too. In fact, the smell and taste of the soil, containing the bacterium *M.vaccae*, is known as 'geosmin', to which humans are very sensitive: people can detect geosmin at five parts per trillion, an acute sensitivity to the chemical. Researchers think that, during human evolution, 'it was this chemical that helped us to find food'.[65] As Isabella Tree writes in *Wilding*, her account of re-wilding their Sussex farm, Knepp Castle: 'the air provided by nature is loaded with microbes produced by plants, fungi and bacteria that are beneficial to health and boost the immune system.'[66] Several studies have also attributed healthful properties to soil compounds like actinomycetes [bacteria] 'which the human nose can detect at concentrations of 10 parts per trillion',[67] and which 'tipped our ancestors off to sources of water'[68] and food sources and, therefore, served a vital evolutionary function for *Homo sapiens*. The praises of soil bacteria ring throughout the literature. Peter Fiennes notes that 'The simple act of plunging your hands into the soil of a forest can alleviate depression: it's thought that traces of hope (there's a scientific word for it …) enter the bloodstream through tiny cuts in the skin'.[69] 'Hope', 'geosmin', '*M.Vaccae*' … the proof of the matter is that woodland soil is good for the body and restorative for the mind.

In the surreal Beatnik novel, *Another Roadside Attraction* (1971), American novelist Tom Robbins has one of his protagonists, the sexually precocious Amanda, climb to the top of a big spruce tree, while pregnant, 'the better to absorb the Skagit twilight', in Washington State, USA.[70] As she climbs, Amanda cradles her belly like a bowling ball. She rests in the trees and thinks 'of many things. She thought of Life and said to herself, "It's okay. I want more of it." She thought of Death and said to herself, "If I fall out of this frigging treetop, I'll soon enough learn its secrets."' It's a common enough reflection on mortality, made the more poignant

because of her pregnancy, and because of where she is sitting. It is among the most affirmative and positive representations of women climbing in tree climbing literature. But, connecting to the discussion here of geosmin, Amanda goes on to consider how:

> Although the surface of our planet is two-thirds water, we call it the Earth. We say we are earthlings, not waterlings. Our blood is closer to seawater than our bones to soil, but that's no matter. The sea is the cradle we all rocked out of, but it's to dust that we go. From the time that water invented us, we began to seek out dirt. The further we separate ourselves from the dirt, the further we separate ourselves from ourselves. Alienation is a disease of the unsoiled.

It's a salutary thought. Becoming connected to the natural world necessitates getting the hands dirty – Amanda needs to climb a tree and get bark and lichen underneath her nails. She needs to inhale the geosmin.

One could, equally, just breathe deeply and inhale the forest air. There are, research shows, a great many more negative ions in the air outdoors – negative charged ions that have an energizing and refreshing effect on the body. A study at the University of Exeter, UK, 'found that people who live where there are trees and green spaces are less anxious and depressed – and that the positive effects of trees on people's wellbeing lasts longer than short term boosts'.[71] Through these combined effects, the alpha waves of the brain – dominant during calm flowing thought, meditative states and 'the zone' that artists and sports people frequently report on – are stimulated, leading to better mental coordination, calm alertness and mind/body integration. Philosopher Drew Leder calls such a state 'bodily absence', when self-consciousness of the body disappears because of intense focus on the activity.

All this research points to what people know by anecdotal experience: woodlands and forests are multiply sensory environments whereas, in daily indoor life, people tend to rely upon sight and sound as the main senses. If one walks among trees and simply brushes a hand across their trunks, let alone climbs a tree, the textures of the bark and the leaves and pine needles beneath the feet come alive; one hears the rustling branches and the movements and sounds of animals; smells the aromatic compounds of the woodland, the plant resins and the mulch of humus on the ground. The air has a taste and, visually, one's perspective is changed. Put simply, among trees people are more connected to the natural world through their senses than they would be indoors. As Isabel Hardman notes, woodlands 'have a special effect on the soul',[72] and, if that sounds too esoteric, then neuroscience is there to back up the feeling: activity in the prefrontal part of the brain – the complex thinking part – is reduced in woodlands, leading to a greater sense of relaxation. Research shows that a special form of 'soft fascination' – a form of 'involuntary' attention that requires no mental effort – is the kind of attention that people pay to the natural world.[73]

In 1980, Rachel and Stephen Kaplan, from the University of Michigan, developed the idea of Attention Restoration Theory (ART) that differentiates between Direct Attention (which takes effort, and can be stressful if over-directed) and Effortless or Restored Attention, which comes about through this form of 'soft fascination'. It is, perhaps, something akin to the Buddhist notion of *Wu Wei* – using minimal effort, or not 'over-trying'. In nature, as D.H. Lawrence's poem of Etruscan trees asserted, things just *are*, which is an enormous sense of relief and consolation for anyone who is trying to work something through in their mind. And working things through in the mind, as Cody lee Miller must have been doing in his sequoia, is exactly what many of the tree climbing characters in literature are doing. It is this kind of soft fascination in nature that gives the mind a more creative, 'bottom up' experience – 'it frees up the top-down part of your brain in a way that allows it to recover' from the more stressful modes of logical, top-down thinking that people are asked to employ in everyday life.[74]

Novelist John Fowles gets close to this kind of thinking in his discussion of the creative, artistic impulse in his book essay, *The Tree*. Fowles argues that creativity is 'a process of retreat from the normal world [...] and part of that retreat must be into a 'wild', or ordinarily repressed and socially hidden self: into a place always a complexity beyond daily reality, never fully comprehensible or explicable, always more potential than realized; yet where no one will ever penetrate as far as we have.'[75]

Although he does not write about climbing trees per se in *The Tree*, Fowles's description of the way that creativity works sounds as though he might equally be talking about tree climbing itself; the language he uses is remarkably like that used by tree climbers and fictional tree climbing characters. An ascent into a tree is a retreat into the wild. What emerges in a climb is an ordinarily repressed and socially hidden self that is allowed to flourish in the branches of the tree. Climbing gets people beyond the responsibilities and patterns of daily reality and, in the canopy, they can explore a place where no one else has ever been. As the American arborist and photographer, Sean O'Connor, says, trees are 'like a new frontier', speaking about the giant redwoods he climbs to photograph and measure, 'because no other humans have been up there'.[76] Creative in both his climbing and his photography, perhaps O'Connor captures something fundamental to both activities: creativity and tree climbing are forms of this 'softened attention' of which the science speaks.

One of the key factors in nature that softens the attention is the prevalence of fractal patterns – forms of endlessly repeating complex patterns to which the senses have been attuned through evolution. Professor Richard Taylor, Oregon, has shown that 'we are hard wired to respond to the kind of fractals found in nature – and that looking at these kinds of natural patterns can reduce our stress by as much as 60 per cent'.[77] These fractal patterns that repeat themselves at different scales, from the macro to the nano, 'engage the parahippocampus, which is involved with regulating emotions and is also

highly active while listening to music'.[78] The visual complexity of nature – its fractal patterning – stimulates the brain's neuroplasticity, its ability to adapt and adjust itself, and might, paradoxically, lead to the relaxed simplicity experienced in activities such as 'forest bathing' and tree climbing.

It's not only attention that improves while people are out among trees. Memory and cognitive abilities are also improved. A study from the University of North Florida in 2015 shows that tree climbing can increase cognitive abilities. Drs Ross and Tracy Alloway show that 'working memory' – used to retrieve information from the short-term memory while actively engaged in another task – is improved by 50 per cent when doing a task that is physically demanding, such as walking on a beam or climbing a tree.[79] The ability to remember and to cognitively process is improved by climbing trees. No wonder so many characters in stories and poems go up into the branches when they have something to work out in their heads. It isn't just literary fancy; it is borne out again by the scientific research.

These scientific findings concerning physical and mental responses to nature lie behind the increasing number of 'green prescribing schemes', in which doctors can prescribe courses of gardening, or green exercise, to patients. As Isabel Hardman writes, 'Social prescribing is becoming more and more popular in primary care as doctors try to make medicine about the lives that their patients lead and not just about the pills they pop.'[80] Hardman cites many research studies that have shown how gardening, cycling, running, wild swimming, time with animals (dogs, horses, chickens and others), and other outdoor activities have significant reductions in symptoms of depression and anxiety, promoting improved self-esteem, attention, sleep, positive mood and general physical health. Extensive studies of such 'green exercise' at the University of Essex have shown it to be more effective at lowering stress and mood than gym-based exercise.[81] And, as Isabel Hardman notes, 'There are many studies demonstrating the links between exercise and improved brain plasticity'[82] – in other words, outdoor exercise can change the way the brain responds to things, including one's own thought processes and habits. The UK charity, Mind, also carried out a large-scale survey of such green prescribing schemes and reported that 94 per cent of participants noted benefits.[83] Mind, itself, 'funded 130 ecotherapy projects in England between 2009 and 2013'.[84] Scotland has initiated a programme called 'Branching Out', which uses woodland activities for patients with mental health problems. Ireland has 'Woodlands for Health'.[85] Both New Zealand and South Korea have strong 'green prescription' programmes and government investment schemes. Prison rehabilitation programmes employing gardening skills have also been shown to have similarly strong effects on rates of re-offending, and studies with children with ADHD show marked improvements in the children's wellbeing and learning. In *Wilding*, Isabella Tree comments on the research that shows how 'Low levels of self-discipline, impulsive behaviour, aggression, hyperactivity and inattention in young people all improve through contact with nature. Studies on children who were being bullied, punished,

relocated or suffering from family strife all showed that they benefited from closeness to nature, both in levels of stress and self-worth.'[86] Research with British 'forest schools', German *Waldkindergarten* and Scandinavian outdoor education programmes, also shows that 'kids in forest kindergartens tend to get sick less often than their indoor peers, and they host a healthier, more diverse array of microbacteria in their bodies'.[87]

Similarly, psychological programmes for service men and women with post-conflict PTSD also show significant benefits from contact with nature. As the psychiatrist and author Oliver Sacks sums up, 'In many cases, gardens and nature are more powerful than any medication.'[88] Given that depression is now a leading cause of illness worldwide – according to the World Health Organization, more than 264 million people are affected by depression – societies might do well to heed Oliver Sacks's words.[89] As a US Forest Service study of the extensive ash tree dieback in America shows, mortality rates from cardiovascular and respiratory tract disease were higher in places where trees had been affected by the disease. A study in Toronto also shows that the higher the density of trees in any given urban neighbourhood, the lower the incidence of heart and metabolic disease.[90] Other studies show that 'Living in greener neighbourhoods is associated with slower cognitive decline in elderly people,'[91] and with living longer. Rates of income-related mortality are lower in areas with more green space,[92] and research around housing schemes in the United States shows that people are more likely to congregate around areas with trees than not, enhancing social interactions. Relationships, like trees, grow. Violence and anti-social behaviour are reduced in the presence of trees and greenery.[93] As urban planners switch on to the message, such research is fuelling the green urbanism of biophilic city movements worldwide. Forest bathing expert, Dr Qing Li, concludes, 'Our health and the health of the forest go hand in hand. When trees die, we die. If our forests are unhealthy, then so are we. You can't have a healthy population without healthy forests.'[94]

※

Trees, to state the obvious, are much larger than people. They are indifferent to the outcomes of human conflicts, both internal to our own minds and external conflicts in real-world situations. Nature, writes Isabel Hardman, 'has nothing to do with the patient', adding that trees 'don't care at all'. They won't let you down and they offer no platitudes 'about how what doesn't kill you makes you stronger, or how a positive attitude is all you need to feel better'.[95] Given this emotional distance of trees and their sense of scale (as when one gazes at the stars, for example, and has feelings of insignificance in the universe) people gain some paradoxical sense of consolation: when climbing a tree, or sitting inside its hollow trunk, things fall into perspective. As Richard Mabey writes in *Beechcombings*, 'no one expects gratitude from trees.'[96] It is a sentiment that crops up over and over in the literary ecology.

Peter Fiennes, for example, writes that 'Nature doesn't care. She'll shrug once we're gone.'[97] Perhaps this is all that Cody Lee Miller was after while up in the sequoia? A little natural indifference. Nature and trees have no interest in the outcomes of human deliberations and inner conflicts. This is paradoxically liberating. Nature has the quality of what the Victorian nature writer Richard Jefferies (1848–87), called the 'ultra-human'. Writing in the 1920s, D.H. Lawrence describes how 'I am glad to be with the profound indifference of faceless trees. Their rudimentariness cannot know why we care for the things we care for,'[98] capturing the profound difference and indifference of trees. More recently, John Fowles describes the quality as 'a kind of coldness, I would rather say a stillness, an empty space' that is 'outside and beyond us, truly alien'.[99] But rather than it being 'outside and beyond us', perhaps some vestige of this natural indifference remains within? Perhaps climbing a tree somehow brings together that outer and inner experience, helping to put small human concerns into their rightful place in the wider context? Finding oneself in the canopy of a tree can be a way of experiencing what Fowles calls the 'unusable' quality of nature. It just *is*. And that is very connecting. As American naturalist and writer Janisse Ray states, amongst trees 'I can see my place as human in a natural order more grand, whole, and functional than I've ever witnessed, and I am humbled, not frightened, by it. Comforted.'[100] Perhaps this feeling helps explain why climbers turn to the real world of trees – and why authors send their troubled characters up into the trees of poems and novels, or to sit underneath them in a moment of calm – rather than retreating inside their own heads, for it is in these non-human spaces that they can find meaning and understanding and begin to sort out their problems in the embracing, indifferent arms of nature. In her study of nineteenth-century English novels, *Trees in Nineteenth-Century English Fiction*, for example, Anna Burton notes how 'Steven King argues that in literature, characters often visit woodland or sit under a tree canopy to help calm tempers, bring balance to a troubled mind, and cure headaches', going on to show how this is certainly true of Elizabeth Gaskell's heroines 'as they frequently take refuge under trees, and particularly during times of turmoil', giving examples from Gaskell's novels, *Ruth* and *Wives and Daughters*, while finding similar behaviours in Jane Austen's heroines.[101]

Lest this sound like idealistic wish-fulfilment, Samantha Walton's balanced scepticism serves to hold conceptions of the nature cure that are 'easy, too idealistic'[102] in check. Of the potential curative effects of wild swimming, for example, Walton writes, 'I love swimming, but I'm wary of the dream that it will only take a plunge into cold water to be transformed',[103] a salutary distrust that could also be applied to the climbing of trees. 'What about the people for whom the water cure will never "work", who love to swim, but who still want to take their medication?'[104] Walton asks. A simple substitution of 'tree climbing' into this sentence (*What about people for whom tree climbing will never 'work'?*) suffices to make the point: tree climbing per se is not the whole answer, nor the answer for everyone in every case. People of colour in the UK, for example, Walton writes 'are less likely to

exercise outdoors because of legitimate fears about safety',[105] and economic status, poverty, inequality and factors relating to a person's general health strongly determine an individual's ability to access green spaces both within urban environments and without. 'If the "nature cure" is to be anything other than an ableist, classist hobby,' Walton writes, 'it needs to start from a position of access and openness.'[106] In tree climbing circles, at least, the work of inclusive groups such as John Gathright's *Tree Climbing Japan* manages to achieve this open access. Obstacles to access are being removed, and the potential idealism of alternative green proscribing schemes that form the 'nature cure' is being underpinned by persuasive scientific research, as well as moves to democratize the opportunities it offers.

Notes

1 Sue Stuart-Smith. *The Well Gardened Mind,* p.285.
2 In Erich Fromm. *The Heart of Man.*
3 In E.O. Wilson. *Biophilia.*
4 Samantha Walton. *Everybody Needs Beauty ...* , p.30.
5 Robert Michael Pyle. *The Thunder Tree*, p.134.
6 Ibid, p.135.
7 Ibid, p.136.
8 Ibid, p.141.
9 Ibid, p.141.
10 Ibid, p.201.
11 Ibid, p.203.
12 Lucy Jones. *Losing Eden,* p.55.
13 Robert Michael Pyle. *The Thunder Tree*, p.134.
14 Ibid, p.136.
15 Gathright, Tamada and Morita, 2006.
16 Tree Climbing Japan. https://www.treeclimbing.jp/welcome.html
17 Ibid.
18 'Treehab: The Healing Power of Climbing Trees'. *Americanforests.org*, Spring/Summer 2014. See also https://treeclimbing.jp/Treehab.html and John Gathright in his TedxTalk https://www.youtube.com/watch?v=GSmaUPREKIU
19 Gathright *et al*. 2008.
20 Ibid.
21 Ibid.
22 Richard Mabey. *Nature Cure,* p.223.
23 Ibid, p.224.
24 Lucy Jones. *Losing Eden,* p.17.
25 Sport England. 'Active People Survey 2007/08'. http://direct.sportengland.org/media/1123/2007-2008sport_england_annual_report.pdf
26 Natural England. 'The Economic and Health Impacts of Walking on English Coastal Paths'.
27 Mathew P. White *et al*. 'Spending at Least 120 Minutes a Week in Nature Is Associated with Good Health and Wellbeing'. https://doi.org/10.1038/s41598-019-44097-31

28 Lucy Jones. *Losing Eden,* pp.27–8.
29 John Fowles. *The Tree*, p.43.
30 Samantha Walton. *Everybody Needs Beauty*, p.8.
31 Ibid, p.108.
32 Ibid, p.231.
33 Ibid, p.266.
34 See the summaries in Gathright, Tamada and Morita, 2006, 2008.
35 Summarized from chapters in Matilda van den Bosch and William Bird. *Oxford Textbook of Nature and Public Health.*
36 Robert Macfarlane. *The Wild Places*, p.320.
37 Isabel Hardman. *The Natural Health Service*, p.197.
38 Ibid, p.193.
39 In Qing Li. *Into the Forest.*
40 Ibid, and also in Matilda van den Bosch and William Bird. *Oxford Textbook of Nature and Public Health.*
41 Sue Stuart-Smith. *The Well Gardened Mind*, p.142.
42 Qing Li, *Into the Forest …*, p.98.
43 Cited in Lucy Jones. *Losing Eden,* p.93.
44 Florence Williams. *Nature Fix*, p.74.
45 Samantha Walton. *Everybody Needs Beauty …*, pp.93–8.
46 Ibid, p.99.
47 Richard Powers. *The Overstoy*, p.547.
48 D.H. Lawrence. From 'Cypresses'. *Selected Poems*, p.58.
49 D.H. Lawrence. From 'Bare Fig-Trees'. *Selected Poems*, pp.59–60.
50 D.H. Lawrence. *Fantasia on the Unconscious*, p.28.
51 All quotes from this poem in Tony Harrison. 'Cypress & Cedar'. *Selected Poems*, pp.230–4.
52 Qing Li. *Into the Forest …*, p.187.
53 John Muir. *The Mountains of California*. Ch. 8. 'The Forests'.
54 Ibid. Ch. 10. 'A Wind-storm in the Forests'.
55 Janisse Ray. *Ecology of a Cracker Childhood*, p.12.
56 Ibid, pp.67–8.
57 D.H. Lawrence. *Pan in America*, p.107.
58 Florence Williams. *Nature Fix*, p.99.
59 All quotes from this podcast taken from Chris Packham. *Springwatch.*
60 In Peter Wohlleben. *The Hidden Life of Trees,* p.221.
61 Joshua J. Gooley *et al.* 'Spectral Responses of the Human Circadian System Depend on the Irradiance and Duration of Exposure to Light', pp.31–3. https://stm.sciencemag.org/content/2/31/31ra33.abstract
62 Sylvie Studente, Nina Seppala and Neomi Sadowska. 'Facilitating Creative Thinking in the Classroom', pp.1–8. https://www.sciencedirect.com/science/article/abs/pii/S1871187115300250
63 In Isabel Hardman. *The Natural Health Service*, p.46.
64 In both Sue Stuart-Smith. *The Well Gardened Mind*, and also Qing Li. *Into the Forest ….*
65 Qing Li. *Into the Forest …*, p.195.
66 Isabella Tree. *Wilding,* p.295.
67 Florence Williams. *Nature Fix*, p.28.
68 Ibid, p.63.

69 Peter Fiennes. *Oak and Ash and Thorn*, p.148.
70 All quotes here from Tom Robbins. *Another Roadside Attraction*, pp.77–9.
71 Cited in Qing Li. *Into the Forest …*, p.114.
72 Isabel Hardman. *The Natural Health Service*, p.59.
73 Stephen Kaplan. 'The Restorative Effects of Nature – Toward an Integrative Framework', pp.169–82.
74 In Florence Williams. *Nature Fix*, p.51.
75 John Fowles. *The Tree*, p.79.
76 In Evelyn Schlatter. 'Ascending Giants'. https://www.hcn.org/issues/368/17647.
77 In Qing Li. *Into the Forest …*, p.176.
78 In Florence Williams. *Nature Fix*, p.115.
79 Ross G. Alloway and Tracy Packham Alloway. 'The Working Memory Benefits of Proprioceptively Demanding Training', pp.766–75. https://journals.sagepub.com/doi/10.2466/22.PMS.120v18x1
80 Isabel Hardman. *The Natural Health Service*, p.19.
81 University of Essex. 'How We Started the Green Exercise Revolution'. https://www.essex.ac.uk/research/showcase/how-we-started-the-green-exercise-revolution
82 Isabel Hardman. *The Natural Health Service*, p.79.
83 R. Bragg, C. Wood and J. Barton. *Ecominds Effects on Mental Wellbeing: An Evaluation for* MIND. https://www.scie-socialcareonline.org.uk/ecominds-effects-on-mental-wellbeing-an-evaluation-for-mind/r/a11G00000030djIIAQ
84 Lucy Jones. *Losing Eden,* p.99.
85 Isabel Hardman. *The Natural Health Service*, p.93.
86 Isabella Tree. *Wilding*, p.295.
87 Florence Williams. *Nature Fix*, p.235.
88 Oliver Sacks. 'Why We Need Gardens', p.245.
89 World Health Organisation. 'Depression Factsheet'.
90 In Florence Williams. *Nature Fix*, pp.250–1.
91 Lucy Jones. *Losing Eden,* p.85.
92 Ibid, p.130.
93 Cited in ibid, p.119.
94 Qing Li. *Into the Forest …*, p.277.
95 Isabel Hardman. *The Natural Health Service*, pp.86–7.
96 Richard Mabey. *Beechcombings*, p.x.
97 Peter Fiennes. *Oak and Ash and Thorn*, p.247.
98 D.H. Lawrence. *Fantasia on the Unconscious*, p.30.
99 John Fowles. *The Tree*, p.44.
100 Janisse Ray. *Ecology of a Cracker Childhood*, p.69.
101 Anna Burton. *Trees in Nineteenth-Century English Fiction,* pp.103, 105.
102 Samantha Walton. *Everybody Needs Beauty …*, p.22.
103 Ibid, p.42.
104 Ibid, p.45.
105 Ibid, p.112.
106 Ibid, p.80.

3

Trees and the mind

The common Western notion that people share of a 'special place', a 'happy place' or a 'refuge' that they can go to, either in reality or in the mind, is nothing new. The image of such a hidden place of safety has been utilized by Cognitive Behavioural therapists (as well as teachers of meditation), to encourage their patients to identify and mentally conjure up a safe place from which they can begin to ground themselves, to re-build and to recover from trauma. The proper name for such a physical space is a *latibule*. In a tree, the climber experiences solitude, albeit a solitude experienced with other non-human beings who cannot fully be known and who cannot know us: birds, mammals, insects and so on. Trees offer up their canopies as such spaces of refuge and un-knowing, but they also offer other latibules in the form of confined spaces within the hollows in their trunks, for example. The tree hollow is a quiet, protected space in which one can be more in tune with one's own thinking. Problem-solving and thinking-things-through become easier when there is an externalized model of the inside of the head – Cognitive Behavioural Therapy, again, encourages people to objectify the mind in such a way. The hollow tree, therefore, becomes an externalized projection for what is going on within the mind, and this fusing of the internal and the external seems to make thought patterns clearer.

This chapter examines parallels between trees and the mind, and discusses some aspects of neurobiology, Darwin's 'root-brain' hypothesis, and popular science's fascination with trees and woods as 'thinking' entities, in works such as Peter Wohlleben's *The Hidden Life of Trees*. It argues that the tree canopy (or tree hollow) makes a metaphoric representation of the mind, fusing awareness of 'inside' and 'outside' and, accordingly, affords not only 'a place to think' and 'work through' problems and conflicts, but also offers a fruitful metaphor *for the space of thinking itself*. Through a discussion of the Celtic representation of liminality in the shape of *idir eathara* – the 'space between' – and discussions of the amount of *time* that

climbers spend in these 'in between' spaces of tree canopy and hollow, this chapter argues that climbing a tree makes a metaphoric representation for the psychological changes characters are seeking in their time of mental fragility. Western cultures are shown to share a common 'mistrust' of adult tree climbers and their perceived mental fragility, which is shown to be embedded in English phrasing: when English speakers wish to talk about the mind, or to comment on someone's mental state or motives, certain forms of language are embedded that make them turn to idiomatically symbolic metaphors about trees and woods. The chapter concludes that poems, novels and artworks of tree climbing reclaim this language and turn it, instead, into positive representations.

<p style="text-align:center">*</p>

In his nature memoir, *Nature Cure*, documenting his recovery from serious depression, nature writer Richard Mabey describes how, as a child, he used to burrow inside hollow trees: 'If I ignored the scratching and burrowed in deep enough, they all seemed to have spaces inside where the mass of twigs had left a calm hollow [...] scented with the spicy aromas of damp clay and torn roots.'[1] Here again are described the calming, therapeutic, aromatic scents identified in forest bathing research. In his adventures, Mabey was thrilled by the feeling of being hidden and un-findable. Such hollows were places of 'security and adventure', or 'retreats to look out from as much as be in, breathing spaces for gathering myself or rehearsing'. Indeed, the research shows that 'if you want to solve problems in your life, self-reflect and jolt your creativity, it's better to go alone [in nature], in a safe place'[2] which, perhaps, accounts for why crawling into a hollow, or climbing into the canopy to try to resolve problems, is such a common practice in European and North American literature and art, as well as in life.

Research librarian and poet, Swithun Cooper, narrates a scene in his poem 'A Redwood' from the point of view of someone who has found their way inside an ancient, giant redwood tree, which has been hollowed out by a fire to leave the living tree growing up around the charred-out, living hollow. Such redwood trees can live for a very long time (the oldest known is over 3,200 years old) and may reach up to 85 metres tall. They belong to the same family of trees that Cody Lee Miller climbed in Seattle. 'I am now on the inside,' Cooper writes, after squeezing himself inside the hollow of the trunk.[3] An unknown 'you' – a friend or a partner – paces around the outside of the tree trunk until, 'A rustle – and through the split bark, you climb in beside me.' The bed-like phrasing of 'climb in beside me' suggests intimacy and sensuality and, with that climbing in, the enclosed space of the hollow tree fuses both the 'inside' and the 'outside', making for a shared, secret space, a *latibule*, for the couple to be in. The reader's emotions are evoked to rush in and fill that sensuous space. The tree hollow is a green room;

a symbol of being 'inside the outside'. This image of the green bedroom that is both inside and outside stretches back to Classical narratives. The Greek hero Odysseus built his and his wife Penelope's marital bed, a 'tree-house', around a living olive tree. The episode is found in Book XXIII of Homer's epic, *The Odyssey*. After Odysseus has returned home to Ithaca after his years of wandering, he slays all the suitors he has discovered in his home. His wife, Penelope, still not recognizing her husband, tells the maid, Eurykleia, to make up a bed for the newcomer, but to move the bed outside of the bedchamber. It is a test. Odysseus immediately replies that the bed cannot be moved since it was hewn from an olive tree, with the fixed trunk providing the bedstead. As soon as Odysseus describes how he built the bed, Penelope knows for sure that it is her husband and rushes to him in reunion. Robert Fitzgerald's translation of Homer renders the episode in the following way:

> An old trunk of olive
> grew like a pillar on the building plot,
> and I laid out our bedroom round that tree.[4]

The symbolism of the moment is pertinent: the marital bed is a living 'tree-house'. It is a sanctified, natural space, constructed within the home ... nature brought indoors or, rather, a home and a marital bed *built around* nature. The ecological and etymological meanings of the Greek word *oikos* (*ecos*), meaning *home*, resonate behind the symbol. Nature *is* home, both the word and the image insist. This place of love, union and reunion *is* home as much as it is living ecosystem. The olive tree is permanent and stable, like their marriage. It is immovable. It grows, like their marriage. It is rooted, like their marriage. This bed is both very much part of nature and of the place where the couple feel most at home, secretly knowledgeable of each other.

This kind of safe space within a hollow tree, which fuses an inside-outside into a room, is abundant in Western literature. In his 1993 memoir of growing up outside of Denver, USA, American ecologist and natural history writer Robert Michael Pyle describes how, 'When people connect with nature, it happens *somewhere*. Almost everyone who cares deeply about the outdoors can identify a particular place where contact occurred.'[5] Pyle writes how such places of encounter exist 'where the borders between ourselves and other creatures break down, where the earth gets under our nails and a sense of place gets under our skin'.[6] For Pyle, his place of initiation was a hollow tree – *The Thunder Tree* of his work's title, in fact. In 1953, his family had moved to the outskirts east of Denver. Shortly after moving, he and a friend were caught outdoors in a ferocious hailstorm – the great Hoffman Heights hailstorm of July 1954 – when his friend was struck on the head by a giant hailstone. The young boys sought refuge in a hollow cottonwood tree. Pyle describes the action and how they 'stumbled to the old hollow cottonwood and clutched at its furrowed brown bark, the smooth white edge of its

heartwood cleft, glassy wet. Its tattered leaves slapped our faces'. The boys crawled inside the burned-out hollow, and waited it out until the storm had passed, the friend 'using his battered back like the operculum of a snail' to keep out the storm.[7] When his friend's body went limp, Pyle thought he might be dead, killed by the giant hailstone's blow to the head. Fortunately, the episode turned out fine, but the hollow tree became totemic for Pyle: 'nothing could get me out of there', he writes, recalling the 'damp, off-sweet smell of the burned and rotting wood' which left 'a permanent brand of scent.'[8] *The Thunder Tree* becomes a place Pyle thinks of as 'the centre of the known universe'.[9] Much later in life, the author returns to his family home east of Denver and visits the tree, climbing inside its hollow interior. 'Once again the wet char smell filled my nostrils. I felt as protected as ever, and for a little while both the changed-up scene and my personal concerns faded into the furrows of the cottonwood bark, all wounds snow-gauzed.'[10] Here, both the aromatic scent of the tree's hollow and the ultra-human effects of nature help place his personal concerns in context, bandaging his personal sense of loss with the 'gauze' of snow falling gently around the hollow tree. Yet later still, when Pyle returned on a home visit in 1979, he discovers the tree has been felled – 'a hole in the horizon' – and is 'incredulous, then inconsolable. It was the first time my father had seen me cry for years'.[11] The overwhelming sense of loss of this hollow, protective home in nature, is visceral in Pyle's account.

One of the more notable recent examples in literary fiction of the protective, hollow tree is found in David Guterson's widely acclaimed 1994 novel *Snow Falling on Cedars*. Set in 1954 on the fictional island of San Piedro, in Puget Sound off the north Washington coast, Guterson's poetic whodunit follows the case of a Japanese American man, Kabuo Miyamoto, who stands accused of the murder of a local white American fisherman, Carl Heine. As such, the novel plays out the anti-Japanese sentiments in America following the bombing of Pearl Harbour during the Second World War and the internment of Japanese Americans in concentration camps during the war, such as the infamous Manzanar camp in California, where more than 120,000 Japanese Americans were interred.

The hollow tree in question in Guterson's novel is a cedar tree, where the Japanese-American girl Hatsue Imada (who later marries the accused man, Kabuo) and her white American boyfriend, Ishmael Chambers, enact their fledgling – and ultimately doomed – high school romance. 'The inside of the tree felt private,' Guterson writes. Ishmael 'felt they would never be discovered here'.[12] As their illicit romance takes shape there are, dotted throughout the novel, reminders of the heady scent and enclosing privacy of the hollowed tree. 'The tree produced a cedar perfume that permeated their skin and clothes,' Guterson writes, offering 'the temporary illusion that the rest of the world had disappeared; there was nobody and nothing but the two of them'.[13] Once again, the sensory focus on smell recalls the positive benefits experience in forest bathing trips. Inside *their* hollow cedar tree,

Hatsue and Ishmael share 'intense' and 'overwrought' teenage thoughts, experience the first fumbling of teenage sexual contact and, eventually, an intense scene of love-making that ultimately gets broken off all too soon and hurtfully.

As with many of the fictional characters in *The Tree Climbing Cure*, Guterson's protagonists take solace within the safety of a tree, both together but also on their own. 'I come here to think,' Hatsue tells Ishmael, when he finds that she has been to their tree alone.[14] When Ishmael asks her what she thinks about, she doesn't know; just 'all sorts of things. You know, a place to think.' Hatsue finds that 'she felt herself at the heart of things' when inside the tree; it softened and muted the sounds of forest winds about her.[15] The tree is her safe harbour to sit and think. Later in the novel, however, the hollow cedar tree ultimately also becomes a trap. The ill-fated lovers, from two opposing races (in classic *Romeo and Juliet* style), can only meet within the privacy of the secret tree, away from society's prying eyes. 'We're trapped inside this tree,' says Hatsue.[16] At the novel's end, after Hatsue has married Kabuo Miyamoto, and Ishmael has reflected on his thwarted love for the Japanese girl, Ishmael revisits the hollow cedar tree of their youth now that he has grown into manhood: 'he came to realize that he did not belong here, he had no place in the tree any longer,' Guterson writes. 'Some much younger people should find this tree, hold to it tightly as their deepest secret, as he and Hatsue had. For them it might stave off what he could not help but see with clarity: that the world was silent and cold and bare and that in this lay its terrible beauty.'[17] Here Guterson captures that sense of 'ultra-humanity' and the indifference of trees that is one of their great consoling qualities. Ishmael may no longer belong in the hollow tree himself, but others will and, in its silence and secrecy, in its thinking space and its non-humanness, they too will find their solace.

Why do these hollow, inside-outside images of trees (and caves too, although that is another story entirely) recur so often? In his book, *A Leg to Stand On*, the psychiatrist Oliver Sacks writes that when people are sick they need an 'in between' place, a 'quiet place, a haven, a shelter'.[18] The psychoanalyst Donald Winnicott calls such places 'transitional' areas.[19] The enclosed space of the hollow tree, and the space of the treetop canopy itself, which is both enclosed and open at the same time, might perhaps usefully be thought of as a 'third space' of this kind, in which inner and outer become fused. As tree climbing enthusiast Jack Cooke writes, in a tree's canopy, 'we are of neither earth nor sky', rather 'suspended between two elements'.[20]

The ancient Celts had a phrase for this kind of mythical, liminal space; this in-between-ness. In Celtic lore it was called *idir eathara,* and conceived of as a boundary neither of one place nor another: not a division between places but an actual space of transformation *between* them. In 'Poetry and a Sense of Place', the Scottish poet and novelist John Burnside discusses this Celtic 'boundary that is neither one place nor another' in relation to questions of how humans, animals and environment are interrelated. For Burnside, the

spaces evoked by *idir eathara* are magical spaces 'where identity unfolds, and is capable of transformation'.[21] In his later poem of the same name, 'Idir Eathara', in the 2007 collection *Gift Songs*, Burnside writes that the spirits of the dead, perhaps, inhabit such a liminal space, 'their faces glimpsed and lost / along the treeline'.[22] But tree climbers are very much alive and, for real tree climbers as well as for those imagined in novels and poems, a tree's canopy or a hollow trunk *is* such a transitional and transformative space. As nature writer Roger Deakin writes, 'To enter into a wood is to pass into a different world in which we ourselves are transformed'[23] and it is in these spaces where the magic happens.

It is impossible to know whether any 'magic' happened in Cody Lee Miller's climb into the sequoia tree in Seattle, but there was certainly time enough for it to happen: Miller spent twenty-five hours up in the branches, an unusually long stretch that must have, at least in part, accounted for the sustained interest in his actions. But time and trees are interlinked in many more ways than the simple duration of the climb into them. To examine just how long it takes for people to respond beneficially to nature, Dave Strayer, a US neurobiologist and educator, takes his student neuroscientists into the desert on his advanced psychology module at the University of Utah. Tests of his outward-bound participants show 'a 50 per cent improvement in creativity after just a few days in nature'.[24] In fact, a Finnish study shows that people require just five hours a month exposure to nature to feel its health-improving benefits.[25] If a character can stay up in a tree for that amount of time or longer, their levels of wellbeing will only increase. Florence Williams calls this a 'dose curve', with beneficial effects increasing over time and when combined with exercise.[26]

In literature there are many characters, like the narrator of Robert Frost's poem 'Birches', who want only 'to get away from earth a while / and then come back',[27] making a quick climb up into a tree and then coming back down to earth. These types of tree climbing narratives show only incidental scenes of tree climbing, or stories in which the tree climb lasts for some time, but in which the climbing itself is simply adventurous in nature, or offers little symbolic meaning to the greater narrative. For example, Brian Aldiss's 1962 science fiction novel, *Hothouse*, is set millions of years in the future. The action takes place in the branches of a colossal banyan tree that now covers one entire face of the globe, 'the longest lived organism ever to flourish on this little world'.[28] It has persisted and spread because the Earth is now constantly turned to the sun, which has, by now, grown larger and hotter than in the present day. 'Everywhere, in a thousand forms and guises, the plants ruled,' Aldiss writes.[29] Set in this far 'hothouse' future, the earth has a locked orbit and is attached to the moon by giant spider-like plants that spin webs between Earth and its moon. The humans of the novel live in the branches of the giant banyan tree, plagued by giant insects and by carnivorous vegetation. They are continually climbing. In some senses, the banyan forest could equally be the primordial forest of

the Carboniferous, with its giant insect fauna. It is, as Aldiss describes it, 'the all-conquering vegetable world'.[30] But in *Hothouse*, the tree canopies are simply the setting for the plot, offering little in the way of psychological analysis although much, perhaps, in terms of speculations about futuristic human relationships with nature. If you set your fiction in the branches of a world-covering banyan tree, your characters simply have to climb.

A few other select examples of such brief tree climbing narratives might include B.B.'s *Brendon Chase*, in which the young runaway boy, Robin, makes a climb up a tall fir tree in pursuit of a honey buzzard's nest. In fairy tales, all children are familiar with *Jack and the Beanstalk* – not so much a tree, of course, but a symbolic achievement in climbing vegetable matter nonetheless. In fact, *The Complete Fairy Tales* of the Brothers Grimm abounds in tree climbing escapades. Oscar Wilde lends tree climbing a symbolic meaning in his classic short story *The Selfish Giant* (1888), when the eponymous giant knocks down the wall surrounding his wintery garden and assists the one remaining little boy in climbing into the branches of one of his peach trees, signalling the return of Spring – the blossom and the other children simultaneously return to the previously forbidden garden. And in other classic works, there are tentative tree-house building adventures in *The Swiss Family Robinson*, by Johann David Wyss (1812), and visionary inhabitation of treehouses in Kenneth Brower's *The Starship and the Canoe* (1978), as well as many tree fantasies in Enid Blyton's expansive oeuvre, such as *The Magic Treehouse*, *The Enchanted Wood* and the *Faraway Tree* stories. In Roald Dahl's *The Minpins*, the hero Billy is chased through the foreboding Forest of Sin by the Bloodsucking, Toothplucking, Stonechucking Spittler. Billy climbs a tree, getting higher and higher until he is utterly exhausted. At the highest point, hundreds of tiny doors open in the canopy and out come the Minpins – a self-sufficient society who live closely in balance with nature. In A.A. Milne's *Winnie the Pooh* episode 'Tiggers Don't Climb Trees', Tigger does, contrary to the title, make a precarious, short ascent. In J.M. Barrie's *Peter Pan*, Peter 'fits' Wendy and her brothers into trees in *Neverland*, where they are to live under the ground amongst the roots and trunks, with all of the Lost Boys. *Tom Brown* and his friends spend days climbing trees and raiding birds' nests in his eponymous *Schooldays*. In antiquity, the god of Sleep climbs a tall pine tree in Book XIV of Homer's *The Iliad*, the better to watch the beguilement of Zeus by the goddess Hera, at a pivotal turning point in the battle. And, in the twentieth century, there is frequent tree climbing action in the *Tarzan* stories of Edgar Rice Burroughs (and in subsequent film adaptations), as well as in other 'civilising' stories such as François Truffaut's 1970 film *L'enfant Sauvage* (*The Wild Child*), to name but a few.

Rather than these incidental stories and poems of *brief* tree climbs, or being up in a tree, in *The Tree Climbing Cure* it is those examples of tree climbing in which some significant psychological change is enacted, which offer more in thinking about the relationship between trees, climbing and

the mind; climbing episodes in which decisions are made and taken, and in which the liminal space of the tree's canopy – that 'in between' *idir eathara* – becomes a symbolic space for the development of the character, either through some inner or external conflict, or for some psychological reason that needs 'working through'. In such stories as these, the climber goes up into the branches and stays there for a sustained period of time, because of some disruption or conflict. As Sue Stuart-Smith writes, 'It may be that our innate neurological response to nature is revealed more clearly when the nervous system is disordered'.[31] Cody Lee Miller's nerves were clearly disordered when he made his day-long climb, and many characters in literature display similar nervous disorders, or are conflicted in some way or another. What is of interest are these tree-climbers' responses to such disorder and conflict, and what they may say about mental health and people's relationship to nature. In some cases, such as Giles Winterborne in Thomas Hardy's 1887 novel *The Woodlanders*, the climber may go into the tree for just a few hours. For others, such as Sampath Chawla in Kiran Desai's 1998 novel *Hullabaloo in the Guava Orchard*, the character remains up in the canopy for much longer periods of time. Desai's novel is also based on a real-life story – that of a man named Kapila Pradhan who lived up a tree for fifteen years. And for some literary characters, such as the young Count Cosimo in Italo Calvino's notable 1957 novel *The Baron in the Trees (Il Barone Rampante)*, they spend the best part of a lifetime up in the branches. Each one of these characters makes a conscious decision to go up into a tree at a time of family conflict, or mental distress even and, like Miller, stays there for some length of time to work through that conflict.

Conversely, there are novels such as William Faulkner's *The Sound and the Fury* (1929), in which the character makes but a fleeting climb up into a tree, and yet that brief interlude away from firm ground provides an entire Freudian backstory that plays out in the complex psychologies of the multiple narrators. The tree climbing scene in Faulkner's novel happens almost by hearsay, yet is pivotal to the author's motives for writing the novel, as well as the psychological themes of the plot itself. What can a study of such characters – their psychology, their conflicts and their mental wellbeing – add to understandings of the relationship between trees, nature and mental health?

For a long time, trees have been associated with Western (anglophone) ideas of mental health. The phrase 'out of your tree' means to be 'insane' or 'crazy'[32] or, more colloquially, 'to be intoxicated by drink or drugs'.[33] It originates from the first half of the nineteenth century. The metaphor draws clear parallels between 'tree' and 'mind' and implies either an inherent, or a self-inflicted, derangement of the senses. But it isn't just negative connotations that are used to draw parallels between trees and minds. John Fowles writes that 'If I cherish trees beyond all personal (and perhaps rather peculiar) need and liking of them, it is because of this, their natural correspondence with the greener, more mysterious processes of mind'.[34] In what ways then might the mind be said to be 'like a tree'?

Both physically and at a cellular level the brain's cells might certainly be said to *look like* a tree, 'with a full canopy. There's a trunk, which is the cell's nucleus; there's a root system, embodied in a single axon; and there are the branches, called dendrites' [from the Greek, *dendron*, tree].[35] At a more macro level, the central nervous system might also replicate this visual similarity with the spinal cord (trunk), brain (canopy) and nerves (roots/branches). Sue Stuart-Smith notes how 'neuronal arbours and plants grow according to the operation of the same three mathematical laws',[36] citing a 2017 research study of plant shoot architecture. The fact that 'neurogenesis' (the growth and development of nervous tissue) shares mathematical similarities with plant growth, makes for a powerful metaphor linking the mind with trees.

In her poem 'Spruce Sonogram', poet Elizabeth-Jane Burnett writes that 'Darwin said root tips act like the brain', placing each word of that phrase on its own separate line, mimicking a 'spinal column' of words.[37] Burnett alludes here to Charles Darwin's 1880 book *The Power of Movement in Plants*, in which Darwin wrote, in the book's final sentence: 'the tip of the radicle [...] acts like the brain of one of the lower animals; the brain being seated within the anterior end of the body, receiving impressions from the sense-organs, and directing the several movements',[38] since the root displays not only sensitivity, but is also responsible for directing communication between plants, as well as the movement of other parts of the plant. Trees send electrical impulses through their roots to communicate (there is a form of 'nerve cell' at the roots' tips that passes these impulses, hence the comparisons with animal 'brains'). The 'nervous system' analogy goes further. Peter Wohlleben argues that trees experience pain – when insects eat their leaves and stems, those tissues immediately respond with chemical changes, sending out 'electrical signals, just as human tissue does when it is hurt'.[39] Wohlleben also argues that trees have memories that enable them to know the passing of time, count the number of warm days, and make decisions about when to drop their leaves or to reproduce, for example. Trees can learn – Wohlleben cites the research of Dr Monica Gagliano with Mimosa trees.

Other researchers have since been reinvestigating Darwin's 'root-brain' hypothesis, with astonishing conclusions about the chemical ecology and communicative complexity of higher plants. František Baluška and others at the University of Bonn, Germany, conclude that plants are able to 'share information about their physiological state' and, perhaps more astonishingly, that 'plants recognize self from nonself; and roots even secrete signalling exudates which mediate kin recognition'.[40] That is to say, plants know which bit of plant material is themself, which belongs to another plant and, what is more, which bits belong to their offspring. Such powerful metaphors (plant sensitivity and 'knowledge'; the idea that nerves are analogous to roots/branches) help to buttress the relationship between trees and the mind. In terms of language, trees provide a whole set

of metaphors for bodies, minds, families and for the evolution of life itself. Trees also provide metaphors to describe people – think of Gabriel Oak in Thomas Hardy's *Far From the Madding Crowd*: a dependable and strong man who stays the course in pursuit of the seemingly capricious Bathsheba Everdene. Trees also stand as metaphors for such vague entities as national characteristics: 'Heart of oak are our ships, / Heart of oak are our men,' wrote David Garrick in his 1759 sea shanty, now the official march of the British Royal Navy. As metaphors, trees are bound up with other abstract institutions, such as monarchy. Trees are 'regal', as many British pubs called The Royal Oak attest. Of course, the latter derives from the (alleged) story of Charles II hiding in *the* Royal Oak – an English oak tree at Boscobel, in Shropshire – to escape from Cromwell's Roundheads following the battle of Worcester in 1651. Charles purportedly told Samuel Pepys in 1680 that, while hiding in the tree, a Parliamentarian soldier passed directly beneath him. As Peter Fiennes writes of his own memories as a child playing hide-and-seek in the woods, 'you should always remember to look up when looking for people in woods.'[41]

What is more, the number of tree-related phrases in the English language is extensive, many of them involving a psychological angle – it is not a large step from the Old English word *wōd*, meaning 'crazy, insane', to its later derivative *wodes* and then to the modern derivation 'wood'. When one tries to deal with a problem, or difficulty, or is forced to face the disparaging and taunting remarks of someone else, one is said to try and 'rise above it'. And what better vantage point to rise above things, than from the branches of a tree? On the other hand, one might find themselves 'up a tree', or variously 'up a gum tree', depending on where home is, because of being caught in a difficult or embarrassing situation. The artist Paula Rego embodies the phrase in her 2002 lithograph 'Up the Tree', housed in the Metropolitan Museum of Art.[42] Rego (born 1935) is an eminent Portuguese-born artist now living in London. She studied at the Slade School of Fine Art and was the first artist-in-residence at the National Gallery, London. Her work is often influenced by folk tales, storybooks and nursery rhymes, and is well-known for the strong surrealist and magical realist elements in her imagery, often depicting women and girls in unfeminine poses and scenarios. The animalistic *Dog Women* series (1994), for example, or the *Dancing Ostriches* paintings (1995), depict women in animalistic poses or, in the latter paintings, present groups of muscular, heavy-set ballerinas dressed in striking black tutus. Freudian psychoanalysts have read much into Rego's work, as have feminists, for her un-idealized portrayals of women: one sequence of *Abortion* works pulls no punches. In *The Guardian*, Adrian Searle reviews Rego's 2019 solo show at Milton Keynes Gallery as 'a monumental show of sex, anger and pain'.[43]

The lithograph, 'Up the Tree', comes from a series of images Rego produced in 2002, based on Charlotte Brontë's novel, *Jane Eyre*. Rego's

sequence, 'Jane Eyre – The Guardians', depicts key characters and episodes from the novel, elaborating on, as critic Aline Ferreira describes it, 'the latent meanings of the work and expanding them in new directions.'[44] The lithograph 'Up the Tree' itself, depicts a heavy-set and matronly Jane, seemingly hanging in the branches of a bare branched tree, wearing a voluminous black Victorian gown, beneath which her feet are splayed in a heavy pair of laced black boots. Jane looks down in an ordinary manner, unsurprised to find herself floating in the branches of a tree. She seems outlandishly oversized, taking up a large proportion of the paper. The overall effect is surreal and dream-like, emphasized by the dark, night-time background. What is more, the tree, with its strong vertical trunk and two horizontal branches, looks much like a crucifix, with all its connotations of pain, punishment, sacrifice and redemption: emotions and states that Jane herself experiences in the novel.

Rego's image depicts a moment in the story when Jane knows that she must leave Thornfield Hall, leaving behind her betrothal to the man she loves, Mr Rochester, who is, she has found out, already married. Thus, Jane finds herself 'up a tree' – in an embarrassing and difficult situation – and has to leave Thornfield Hall, to salvage something of her own dignity while the world looks on in judgement, wagging its moralistic Victorian finger. There are also connotations of 'the witch' at play here in Rego's image, for what other women in folklore can be found floating around in the air, at night, dressed in black? Jane has not so much climbed the tree in Rego's lithograph, as floated up into its branches in a symbolic dream, or through her own act of magic. As Aline Ferreira shows, Rego saw Jane at this stage of the novel as being 'a bit of a witch' herself. Ferreira provides Rego's own explanation for the genesis of the lithograph, for which the artist asked her model to sit on a piece of scaffolding in her studio. Rego then drew her up a tree:

> I don't know what she's doing there. I thought she might have got up there to safety. This is Jane trying to escape. She goes on the heath at night to get away from the Hall. She's also a bit of a witch there. [...] Although it all seems to come from the novel, I jump over the theme, because I feel like drawing. It also has to do with the clothes.[45]

Many of Rego's paintings show women in restrictive or expressive clothing, a common enough trope in representations of women tree climbers in art and literature. As critic Paul Coldwell writes, the lithograph 'Up the Tree' continues 'a long running preoccupation with the expressive power of skirts as containers of secrets.'[46] Whether or not Jane is 'trying to escape' Thornfield Hall and her embarrassing predicament, as Rego puts it; whether she is being a 'bit of a witch' as she wanders lost on the heath; or whether she is simply estranged from reality in this surreal predicament,

in the lithograph (as well as in the novel), Jane can certainly be said to 'be up a tree'. She is in a tricky and embarrassing situation – betrothed to a man she loves, but who is already married to Bertha, the shadowy 'mad woman in the attic'.

A writer who has written several poems based on the art of Paula Rego is the English poet and editor Sally Flint. Rego's works 'Children', 'Stray Dogs' and 'Flying Children' have each prompted poems in Flint's collection, *Pieces of Us*. But Flint has also published a poem based on another of the English language's rich tree metaphors, 'Out of the Woods'. Sally Flint's poem takes that everyday phrase – which, in contradistinction to 'Up A Tree', means to be safe, or out of danger/difficulty – and applies it to a new relationship; in this case, the poet addresses it to a prematurely born child, the poet's grandson, who was in an incubator at the time of writing the poem. Flint writes that the 'Out of the Woods' feeling was both a desire to lift him away from the medical world and to bring him 'into the woods' of her own childhood, so that he could reach up like a sapling and flourish.[47] Flint's poem tells of 'the trees I played in as a child; / leaves breaking into a canopy of green', suggesting a return to childhood growth and potential, and perhaps that the adult narrator has also passed through dangers or difficulties in life. The new relationship is a positive step forward: 'Already we're interweaving / branches, building a den'. The poem ends with an image of strong oak trees and the new 'capacity / to climb to the top'.[48] Flint writes in correspondence how 'children don't have the same freedom to explore as I did decades ago. I wanted my tiny grandson to understand he too would gain strength from being close to nature'.[49]

To be 'out of the woods' in a more general sense suggests the proverbial and perhaps atavistic 'darkness' of the forest. As Dante Algieri wrote at the start of the *Inferno* in 1308, which begins his epic *Divine Comedy*: 'One day, in the middle of life's journey / I found myself in a dark wood'. From such an image of the darkness of a suggested mid-life crisis begins the most famous descent into hell in literature. To be 'out of the woods', the phrase suggests, is a sweet release from life's psychological difficulties. Much more recently, in *The Hobbit* (1937), J.R.R. Tolkien has Bilbo Baggins and his Dwarf companions lost and disoriented in the toxic interior of Mirkwood. When Bilbo climbs the trees to look beyond the stifling canopy, he looks to see how far they have to go to escape the wood and, while his head is poking through the canopy, he is surrounded by countless butterflies flitting in the sunshine: 'Bilbo's eyes were nearly blinded by the light.'[50] Bilbo is thus momentarily relieved from the depressive, 'murky' interior but, has to return to the ground to tell his companions just how far they have to travel: 'His heart is lightened by the sight of the sun and the feel of the wind', but 'the forest goes on for ever and ever and ever in all directions' and it will be some time before they are 'out of the woods'. It is tempting to suggest that Cody Lee Miller must have been in some metaphorical 'Mirkwood' of his own

and that his ascent, in part at least, echoes Bilbo's desire for air, for bearings and for a 'long view' out of present circumstances.

On the other hand, one might also perhaps suggest that, in their quest to re-inhabit the Lonely Mountain, the Dwarves of *The Hobbit* story are 'barking up the wrong tree', another of the language's tree-and-mind-related phrases, meaning to pursue a futile course of action. Reading tree-related poetry, the phrase or concept is a common one. In Carolyn Oulton's poem 'The New Term', the narrator is left at a new boarding school while her parents drive away. In a threat of some kind of 'initiation ceremony', one of the older girls tells the narrator that they will 'make me climb / the tallest pine and leave // me there all night'. But this bully is surely *barking up the wrong tree* for, little does she know that the narrator loves to climb trees – 'trees / were places to read letters, / hide invisible friends in' – and that she thinks of forests, and indeed books, as 'my kingdom'.[51] Do your worst by me, the poem retorts; I love climbing trees, and you're barking up the wrong one.

There are, of course, many other such tree-related phrases, including: 'to be *rooted* to the spot' (to be paralysed by fear, and immovable as a tree); to live 'in our neck of the woods' (to be local and, therefore, 'one of us'); 'to cherry pick' (to choose the best carefully); 'to be out on a limb' (to be unsupported, as in, sitting at the end of a fragile, isolated branch); 'to charm the birds from the trees' (to act extremely charmingly); 'to touch wood', or 'knock-on-wood' (to dispel or avoid bad luck, from the pagan belief that malevolent spirits inhabited wood); 'to shake like a leaf' (to shake violently, with fear); 'to go back to the woods' (to live a simple, carefree life); 'the tree is known by its fruit' (people will judge your character by what you do), and 'you can't see the wood for the trees' (to be so over-involved in the details of something that you cannot see the bigger picture) and so on. To return to the idea that people also mistrust tree climbers who must be 'out of their tree' (a punning phrase used to describe Cody Lee Miller in some of the media reports), there are also a number of well-known pejoratives associated with trees. Consider the imperative 'Go climb a tree!', meaning 'Get lost!' and, when describing a child who displays the same negative traits as their parents, the phrase 'the apple never falls far from the tree'. And how many well-meaning environmentalists are mocked for being 'tree huggers' as a term of disparagement? The phrase 'tree hugger' is used in reference to the practice of embracing a tree to prevent it from being felled, originating from the Chipko Andolan passive resistance forest movement in India in the 1970s. It has noble origins, but today it has become part of derogatory slang and is used to put down any 'hippy' environmentalist. In this latter sense there is an implication that 'tree huggers' are irrational and, paradoxically, 'out of their own tree' – a theme picked up in a later chapter in this book – despite the fact that they are often very much *in* their tree.

*

In 2018 the filmmaker Thomas Riedelsheimer filmed and produced a
feature-length documentary about the British sculptor and nature artist,
Andy Goldsworthy. The film, *Leaning In to the Wind*, was shot over
four years from 2013, and portrays Goldsworthy's art and performance
practice in a series of visually stunning *tableaux vivants*, accompanied
by the mystical, atmospheric music and soundscapes of composer
Fred Frith. *Leaning In to the Wind* is both meditative and melancholy,
given Goldsworthy's slow delivery and downplayed Northern English
demeanour, as well as the continual references to what is ephemeral in
human experience, not least the experience of dying. Often Goldsworthy
can be seen lying on the pavements of Edinburgh, or on granite outcrops
somewhere on top of a moor during a rainstorm, making a 'rain shadow'.
The rain falls, but obviously not where he is lying. When he gets up to
leave, the artist's human outline remains in a dry patch on the ground,
present and then slowly vanishing as more rain moistens the rock or the
pavement. These ephemeral 'rain shadow' prints have something of the
pochoir handprints of Neolithic caves about them except, of course, that
Goldsworthy's prints vanish nearly instantly and do not endure, imbuing
the works with a certain melancholy.

Trees feature strongly in Goldsworthy's work, both living trees and
dead. There are clay-covered trunks and branches set in the vaults of
a chapel-like building in Brazil. A fallen elm tree, close to his home in
Scotland, has been the subject of many sculptures in recent years, its cracks
packed with snow, or with yellow elm leaves; the fissures in the trunk
accentuated with shocking bursts of vivid colour: 'This hum of colour', as
the artist calls it. Goldsworthy anticipates 'working with this tree for the
rest of my life ... the remains of that tree will outlive me'.[52] In an interview
for *GARAGE* magazine online, the interviewer asks Goldsworthy: 'One of
the threads throughout the movie is you climbing trees. Is this something
you're prone to?' To which Goldsworthy replies, 'Yes, I've climbed trees
since I was a child. In fact, I climbed one yesterday, but I've got to stop
because I'm getting too old for it now.'[53] In Dumfriesshire, Scotland,
Goldsworthy 'swims' through a hedge planted alongside a road, set against
the stark grey backdrop of the sky.[54] The artist 'swims' (or rather crawls
laboriously) through the hedge, suspended about six feet off the ground.
The bare branches look like some runic script carved against the sky at
dusk. The artist is horizontal in the branches. Frith's music is minimalist
and haunting. The artist makes slow and arduous progress. It is almost
excruciating to watch. Why is he doing this? Is he 'working with nature'
here? Or against it? Is nature working against him; testing his limits;
keeping him in balance? Or is Goldsworthy just 'trying to make sense of
the world', as he says several times throughout the film: 'What I make,
makes sense of my life'. Acknowledging the shift in perspective that being

in the hedge, or the tree, gives him, Goldsworthy voices something that many tree climbers say: being in the hedge/tree 'gives you another way of looking'. In fact, Goldsworthy cracked a rib while crawling through the hedge and came out of it 'hypothermic', and so this shift in perspective was hard-earned. Hedge walking is 'pretty brutal', he admits. 'I came out of one or two of those feeling pretty beaten up. But what a beautiful thing to do. Swimming through a hedge.'[55] Perhaps this is also part of the tree climbing experience for many tree climbers; the danger; a kind of 'nothing ventured nothing gained' mentality? The possibility of coming back down to earth with a bump. 'I think learning to fall is important,' Goldsworthy says in the film, as if to confirm as much.

In contrast to the bare 'hypothermic' hedge of Dumfries, in Edinburgh Goldsworthy can be seen crawling through a hedge in full leaf, while passers-by stroll past on their daily business, the bushes shaking, the artist groaning and huffing, hidden in the greenery, the passers-by mildly amused to see him emerge at the end of the bushes. Goldsworthy also negotiates other tangled and inhospitable structures in the film, such as the bare branches of a mangrove swamp. In some scenes he can be found hiding among the roots of tropical trees, as if hiding from a marauding wild animal. 'You can identify with the protective space', he says, 'finding sanctuary'. By 'entering the tree,' he philosophizes, 'I am part of this tree.' Such climbing into a tree – into the *latibule* – is a form of conversation for Goldsworthy. As the artist comments in an article in *The Guardian*:

> The intention of my work has always been to understand my relationship with the land. I don't go out to improve what is there. But I do feel this need to be a participant, working with it, learning about it. Art has an amazing ability to open your eyes to what's around you – such as the hedge. Maybe that's what art is. It just takes you somewhere you've never thought of going, whether it's in the mind or the world.[56]

It is notable here that Goldsworthy says 'in the mind or the world', given earlier discussions about the mind-like symbolism of the tree's canopy. One might even substitute the phrase 'tree climbing' for 'art' in his closing remarks: perhaps that is what tree climbing is, a chance to go somewhere you've never thought of going, in the mind, or in the world. A real tree, or a tree in a story, poem or in a work of art.

In another scene in the film, Goldsworthy can be seen lying down high in the branches of a tree, his shadow cast on the green grass beneath him, yet another ephemeral mark afforded by the shift in perspective. The effect is both meditative and estranging. Looking up into the branches of the tree to see the artist silhouetted against the sky has an almost inverse effect of the 'rain shadows' – these 'tree shadows' have an uncanny sense of timelessness about them, speaking back through time to more primitive ideas of the 'inspirited

tree' – the god or spirit who dwells in the tree – as well as recalling much darker episodes in human history, such as hangings and public displays of estranged bodies in 'inhuman' positions: crucifixes, gibbets and scaffolds. To reiterate: people do not normally expect to see a man in a tree. The branches of a tree are, for most people 'somewhere you have never thought of going', as Goldsworthy notes in his comments about art.

But when one does come across someone in a tree, whether in life, in art, or in the pages of a book, it evokes mixed feelings – celebratory and transcendental feelings, as well as dark and weird ones – that have the ability to transport the mind to that unusual and estranged place. Looking at Goldsworthy in a hedge or tree it is hard not to question the advisedness of his actions, although 'advisedness' has never been a critical consideration in either literature or art. And yet Goldsworthy's artful practice invokes the 'sanctuary' of nature and the tree's embrace, as well as the shift in perspective that both tree climbing and art provide. Climbing into the 'protective space' of those branches and becoming 'part of this tree', as he describes it, is both liberating *and* transgressive. As he so humorously says in *Leaning In to the Wind*: 'The things that I do ... your mother would really tell you off!'

It is to this sense of mental liberation and transgression that the following chapter turns, to discuss further the 'advisedness' of adult tree climbing and perceptions about the mental stability and wellbeing of the climber.

Notes

1 Richard Mabey. *Nature Cure*, p.25.
2 In Florence Williams. *Nature Fix*, p.167.
3 All citations from this poem, Swithun Cooper. In Michael Mckimm, ed. *The Tree Line*, p.33.
4 Robert Fitzgerald. *The Odyssey*, p.435.
5 Robert Michael Pyle. *The Thunder Tree*, p.1.
6 Ibid, pp.2–3.
7 Ibid, p.15.
8 Ibid, p.16.
9 Ibid, p.87.
10 Ibid, pp.156–7.
11 Ibid, p.185.
12 David Guterson. *Snow Falling on Cedars*, p.97.
13 Ibid, pp.149–50.
14 Ibid, p.97.
15 Ibid, p.186.
16 Ibid, p.181.
17 Ibid, p.389.
18 Oliver Sacks. *A Leg to Stand On*, pp.133–5.
19 D.W. Winnicott. 'Transitional Objects and Transitional Phenomena', pp.89–97.
20 Jack Cooke. *The Tree Climber's Guide*, p.205.

21 John Burnside. 'Poetry and a Sense of Place', p.202.
22 John Burnside. From 'Idir Eathara'. *Gift Songs,* p.70.
23 Roger Deakin. *Wildwood,* p.x.
24 In Florence Williams. *Nature Fix,* p.36.
25 *Journal of Environmental Psychology.* In Florence Williams. *Nature Fix*, p.141.
26 Ibid, p.151.
27 Robert Frost. 'Birches', p.1233.
28 Brian Aldiss. *Hothouse*, p.11.
29 Ibid, p.48.
30 Ibid, p.7.
31 Sue Stuart-Smith. *The Well Gardened Mind,* p.263.
32 Merriam-Webster Dictionary online.
33 Urban Dictionary online.
34 John Fowles. *The Tree*, p.80.
35 University of Iowa. 'Cellular Tree with Healthy Branches'. www.sciencedaily.com/releases/2016/04/160427150908.htm
36 Sue Stuart-Smith. *The Well Gardened Mind*, p.32.
37 Elizabeth-Jane Burnett. In Michael Mckimm, ed. *The Tree Line: Poems for Trees, Woods & People*, p.43.
38 Charles Darwin. *The Power of Movement in Plants.* http://darwin-online.org.uk/
39 Peter Wohlleben. *The Hidden Life of Trees,* p.8.
40 František Baluška *et al.* 'The "Root-Brain" Hypothesis of Charles and Francis Darwin', pp.1121–7. https://www.ncbi.nlm.nih.gov/pmc/articles/PMC2819436/
41 Peter Fiennes. *Oak and Ash and Thorn,* p.143.
42 https://www.metmuseum.org/art/collection/search/492818
43 Adrian Searle. 'Paula Rego Review – A Monumental Show of Sex, Anger and Pain'. https://www.theguardian.com/artanddesign/2019/jun/12/paula-rego-obedience-defiance-milton-keynes-gallery
44 Aline Ferreira. 'Paula Rego's Visual Adaptations of *Jane Eyre*', pp.305–6.
45 Ibid.
46 Paul Coldwell. 'Paula Rego – Printmaker'. https://ualresearchonline.arts.ac.uk/id/eprint/817/1/Paula_Rego.pdf
47 Sally Flint, private correspondence.
48 Sally Flint. 'Out of the Woods'. In Michael Mckimm. *The Tree Line,* p.93.
49 Sally Flint, private correspondence.
50 All excerpts from J.R.R. Tolkien. *The Hobbit*, pp.129–38.
51 Carolyn Oulton. From 'The New Term', in Michael Mckimm. *The Tree Line,* p.94.
52 Andy Goldsworthy quotes from Thomas Riedelsheimer. *Leaning in to the Wind.*
53 Paul Laster. 'If Andy Goldsworthy Climbs a Tree and There's No One There to Hear Him ...', *GARAGE* https://garage.vice.com/en_us/article/evqg9m/if-andy-goldsworthy-climbs-a-tree-and-theres-no-one-there-to-hear-him
54 https://garage.vice.com/en_us/article/evqg9m/if-andy-goldsworthy-climbs-a-tree-and-theres-no-one-there-to-hear-him
55 *Patrick* Barkham. *Branching Out.* https://www.theguardian.com/artanddesign/2018/aug/03
56 Ibid.

4

The climbing cure

As Andy Goldsworthy commented about his art practice, making art about tree climbing and hedge walking, 'your mother would really tell you off'. It's a common trope in tree climbing stories – characters are often found climbing into the branches of trees because of some conflict with parents at home. The novel that people most commonly name as soon as a discussion of literary tree climbers arises is the Italian author Italo Calvino's 1957 work, *The Baron in the Trees* (*Il Barone Rampante*). Unsurprisingly, Calvino's novel begins with a family conflict that triggers the tree climbing. Examining this and a number of other tree climbing novels, as well as several long sequences of poems, this chapter shows how authors commonly represent tree climbers as suffering familial conflicts, or elsewhere in their relationships and professional affairs. An adult in a tree, the commonly disparaging wisdom says, is either mad, deranged or drunk ('out of their tree') but, through a discussion of these works – Calvino's *The Baron in the Trees*; Amanda Dalton's poetry sequence *Room of Leaves*; Kieran Desai's 1998 novel *Hullaballoo in the Guava Orchard*; Seamus Heaney's poetry collection *Sweeney Astray*; Flann O'Brien's novel *At Swim Two Birds*, and Laura Beatty's novel, *Pollard* – the chapter returns to the scientific evidence around trees and wellbeing, and suggest that these fictionalized tree climbers are climbing their way out of conflict, mental distress and even 'madness'. Such characters are not only looking for help and consolation in the way that Cody Lee Miller's climb was 'a cry for help', but are also internalizing nature in the manner discussed in the previous chapter, and therefore benefitting from the healing and health-giving properties of trees and forests discussed in Chapter 2.

*

Italo Calvino's novel, *The Baron in the Trees*, is set in the fictional village of Ombrosa, beginning one day, in June, 1767. Events are narrated by Biagio, the younger brother of the protagonist, the adolescent baron Cosimo Piovasco di Rondò. The inciting incident of the novel comes early, when the twelve-year-old Cosimo fights with his overbearing father: Cosimo has refused to eat the snail soup that has been served up to him at the family meal. In his anger and stubbornness, Cosimo climbs a holm oak tree in the garden of the palace and refuses to ever come back down. The rest of the novel takes place in the trees: in fact, Cosimo spends the rest of his life up there, staying true to his word. It is a feat of tree climbing unparalleled in the world of tree climbing literature.

The snail soup episode is just one of many 'accumulating family resentments' that drives Cosimo up into the trees.[1] When Cosimo leaves the table (and his uneaten soup) behind, he is dressed in his most formal clothes and headdress, with powdered hair and a rapier sword at his waist – the most unlikely climbing outfit. But he climbs 'up the knobbly old tree, moving his arms and legs along the branches with the sureness and speed which came to him from years of practice'.[2] Biagio, the younger brother narrator, is unsurprised that Cosimo's reaction to their father's unfair attack on him is to climb up on the holm oak, since the two brothers were so used to climbing the tree together to find 'a good perch on which to pause and look down at the world'.[3] The image of the treetop as a place of pause and higher viewpoint is so obvious and common among tree climbing narratives that it hardly bears mention. But it is so common precisely because it is an engrained characteristic, in evolutionary ancestral terms, in psychological terms, and in mythic and cultural terms.

Given what is known about the health-giving qualities of forest aromatics through forest bathing studies, it is notable that Cosimo begins to explore the treetops and the garden above which they hang, by the smells and scents that waft up to him: 'an integral part of the mystery of the place.'[4] Smell becomes a kind of map for the young adventurer. The logistics of Cosimo's retreat are also soon taken care of: food, bedding, clothing and other things that he requires are handed up to him. The problem of his toilet is solved by an obliging alder tree growing over a river, and even his school lessons are brought to him: Cosimo sits in the canopy listening to the lectures of his tutor on the ground below him.

But his father continues to display the commonplace disparagement that society at large has for people who climb trees: '"He's mad! He has a devil in him! […] The only thing is to exorcise him".'[5] Even Biagio worries about his brother's wild moods that cause such consternation among the family. But Biagio also notes that the calmer 'urge to enter into a difficult element […] was still working inside him unsatisfied, making him long for a more intimate

link, a relationship which would bind him to each leaf and chip and tuft and twig.'[6] It's not only a more intimate relationship with nature that Cosimo is seeking here; it's a lament for the loss of intimacy in his relationship with his father. 'Cosimo could not yet recognize it,' narrates Biagio, 'and was trying to satisfy it by probing deeper.'[7] The father demands that Cosimo descend to take up the duties of his station, but the stubborn young Cosimo refuses. '"Do you intend to grow up like an American savage?"'[8] the old Baron demands, to which Cosimo remains silent.

Biagio also feels, in his own heart, his brother's longing: 'I found a longing coming over me to imitate him,' he says, 'and go and live up there too; such is its strength and certainty that a tree has in being a tree, its stubbornness in being hard and heavy, expressed even in its leaves.'[9] Trees just *are*, Biagio seems to suggest, with that commonplace 'ultra-human' reassurance. Biagio wants to be like Cosimo 'who spent his nights listening to the sap germinating from cells, the circles marking the years inside the trunks,' and engaged with all the minute life of mould, insects, birds, caterpillars, the 'toccata of sounds' that so soothes the canopy dweller.[10] Again, the health-giving sonic qualities of the forest bathing experience are borne out in Calvino's narrative. That 'toccata of sounds' prefigures remarkably well the naturalist Chris Packham's comments, cited earlier, about a woodland housing an 'orchestra of therapy'.

The remainder of Cosimo's life is lived in the trees. He becomes the official Baron when their father dies and does indeed take up his official duties, albeit from the canopy. The adventures include pirates and brigands and love affairs – he makes love with his lover, Viola, 'suspended in the void, propping or gripping themselves on branches, she flings herself on him almost flying.'[11] Treetops are often depicted as erotic places, as are tree hollows, as discussed in *Snow Falling on Cedars*. In Calvino's tale there is also a meeting with Emperor Napoleon, another with the elderly French philosopher Voltaire, and explorations into philosophy and constitutional politics, Freemasonry and the countless nested 'stories within stories' for which Calvino is so well known.

Beyond the age of sixty-five, Cosimo goes into old age and decline. When his time comes to die, however, he still refuses Biagio's invitation to come down from the trees. Instead, an aeronautic balloon passes over his tree one day and Cosimo simply leaps upwards, attaching himself to the balloon's anchor rope, vanishing into thin air. He eventually falls from the balloon's rope somewhere over the sea. 'So vanished Cosimo, without giving us even the satisfaction of seeing him return to earth a corpse.'[12] His final epitaph includes the words 'Cosimo Piovasco di Rondò – Lived on trees – Ever loved earth – Went into the Sky'.

While this sublimation holds a romantic allure, it is the question of madness, however – the question of Cosimo's mental health – that dominates the end of the novel. 'It had always been said at Ombrosa that Cosimo was mad',[13] Biagio says and many of Cosimo's behaviours would seem to

support it: he burbles in incomprehensible languages; he adorns his head with the pelt of a wild cat he has killed and, later, decorates his entire suit with feathers. He imitates the habits of birds and makes elaborate speeches in defence of them, printing stories of his own composition and distributing them publicly. Biagio comments: 'It was at this very period of dementia that he learnt the art of printing,'[14] and, shortly after, 'my brother was not only quite mad, but getting imbecile too, which was more serious and sad, for madness is a force of nature, for good or evil, while imbecility is a weakness of nature, without any counterpart.'[15]

Cosimo is, then, a symbol of liberty pursued to its ends, wherever that pursuit may take him. In his case, into the trees. Up in the branches, like many climbers, Cosimo becomes a symbol of unfettered individuality; of childhood individuation representing a growth *away from* the father. But the flipside of this freedom is mental illness and the judgements of society that follow. Cosimo passes from impassioned youth, through 'mad' adulthood, into dementia in the trees, but the reader is with him every climbing step of the way. In the end, it is the individual will that triumphs – Cosimo completes the tree climber's ultimate wish; he moves from earth, to canopy, to air and sublimates himself. He is never once tied down by what is expected of him. And for that, this symbolic tree climber speaks centrally to the key concerns of *The Tree Climbing Cure*: how does nature help one to find and keep hold of mental wellbeing; how does the symbolic act of tree climbing both speak about, and help cure, the harms that are common to the vulnerable human mind?

<div align="center">*</div>

Amanda Dalton's sequence of poems *Room of Leaves* first appeared in her 1999 collection, *How to Disappear*, and was later adapted and dramatized for broadcast on Radio 4. Dalton's sequence tells the story of Grace, jilted at the altar on her wedding day by her wandering sweetheart, Frank. Grace subsequently 'goes mad', to use the common parlance, and makes a room of leaves and coloured umbrellas in the garden trees of her mother's bungalow. Grace takes their redundant wedding gifts and leaves them wrapped up, tying them with ribbons to the trees. 'I will be lighter and abstract as air,' she says of her flight into her 'room of leaves'.[16]

So it is that Grace, like Cosimo, lives the remainder of her life out in the trees, eventually dying in a fatal fall. Her damaged body is finally discovered by the police. The sequence of poems begins at its ending, with an autopsy report, in which Grace's body is described in forensic detail. This tree climbing/falling device frames the entire sequence, but it is the poem 'Nest' that contains the key tree climbing material. In a short article about voice and character, Dalton describes how this was the first poem she wrote for the sequence. All she had to begin with was the first line, and

went from there, trying to find 'a vocabulary and state of mind for her, to understand her reasoning at the turning point where she decides to set up home outside.'[17] Grace addresses the poem to her deserting husband, Frank. It is a painful and poignant picture of her grief, her mental distress and her irrational retreat into the trees. She wants to escape, to vanish, but feels trapped. In other poems, Grace hears her mother calling *'Come down from there, come down'*, or sees the food left for her in her mother's bungalow as a trap: 'Once you're in you never get back out', she comments. But it is in the trees that she feels safest, as the reader learns in the poem 'Waiting to Be Pale as a Star':

Here is better. Nothing here
To break between you and the sky.
Here you can shiver and know that it keeps you alive.
Here you can wait for as long as it takes …

In one poem, 'What They Say', the reader is presented with a list of the neighbours' comments about Grace's behaviour. They are, unsurprisingly, in light of comments about various tree climbers and their mental health, disparaging comments. Grace is variously: 'This crazy woman' who sometimes 'stands quietly in fields', or 'breaks open a sour roar / that splits her throat and empties hedges'. She 'gathers dead leaves for confetti' and sometimes 'stands in trees'. In face of all this neighbourhood gossip, her mother 'hung her head in the street for shame' (from 'What They Say'). The stigmas of mental health are hard to shake off. In the original *The Guardian* article, Dalton says that the real woman's neighbours complained about her running around with white flour all over her face. Clearly what she needed was care. Not judgement. Dalton's sequence therefore contains many of the key elements found in tree climbing representations: madness; family and social conflict; social judgement; wanting or needing to escape or disappear; and the question of time. Grace is willing to stay in the trees for 'as long as it takes' – like Cosimo, that could be the best part of a lifetime.

These recurring themes are found time and again in tree climbing literature. Indian novelist Kiran Desai's short comic novel, *Hullaballoo in the Guava Orchard*, published in 1998, presents the reader with extended tree climbing as a result of family conflict. Desai's disillusioned protagonist, Sampath Chawla, lives in the fictional monsoon-prone village of Shahkot, northern India. Sampath works an unsatisfactory day job at the local GPO where, in his idleness, he steams open people's letters and learns about the intimate lives of the locals. He is depressed and frustrated, feeling trapped by his overbearing parents, his family and his job, and by his lack of professional prospects. 'How he hated his life. It was a never-ending flow of misery. It was a prison he had been born into [...] He felt bitter at heart. Surely, he thought, his surroundings were detrimental to his mental health.'[18] He disgraces himself at his boss's daughter's wedding party, by pulling down

his underwear while cavorting drunkenly in a water fountain. He sounds, on the face of it, like many fictionalized tree climbers – at odds with his family and the wider world and, drunkenly, 'out of his tree'.

Often, when he returns home, Sampath climbs up onto the roof of the family home to be alone and, one such day, climbs up there only to have his mother keep calling up to him and handing-up fruit. Finally, she hands him a guava which, for some reason, enrages him so much, he squeezes it until it explodes. It's a moment of epiphany in which Sampath 'felt his body fill with a green coolness, his heart swell with a mysterious wild sweetness. He felt an awake clear sap flowing through him, something quite unlike human blood. How do such things happen? He could have sworn a strange force had entered him, that something new was circulating within him.'[19] The reader is reminded here of Hildegard von Bingen's *viriditas*, and Dylan Thomas's poem 'The force that through the green fuse …', as Desai evokes the generative (and regenerative) powers of nature, as well as the parallelism between person and plant. The next day Sampath catches a bus out of town while his family are at another wedding party, sure not to take him with them again for fear of another of his public outbursts. While on the bus, he is suddenly overcome by a strange feeling and leaps out of the window, running across the hills towards an old orchard on a hill. The other passengers watch in disbelief as Sampath begins to climb: 'before him he saw a tree, an ancient tree, silence held between its branches like a prayer. He reached its base and feverishly, without pausing, he began to climb.'[20]

In this moment, Sampath Chawla becomes an Indian Cody Lee Miller: he has already felt mentally unwell in his home, his job and his circumstances. He has had previous peculiar outbursts – the wedding disgrace and the habitual roof climbing, as well as the steaming open of other people's letters at the GPO. His decision to climb the guava tree comes at a time of mental distress and family conflict. Like many such climbers, Sampath's is an impromptu calling. It is the inviting silence between the branches that calls to him; the offer of a prayer-like refuge, an 'in-between space', a *latibule*. When he reaches the top of the tree 'the burgeoning of spirits that had carried him so far away and so high up fell from him like a gust of wind that comes out of nowhere, rustles through the trees and melts into nothing like a ghost'.[21] The immediacy of the tree climbing cure is startlingly dramatic.

Thus, Sampath Chawla finds himself at the top of a magnificent old guava tree. Subconsciously, the fruit that his mother handed him and which he made explode in his rage, becomes symbolic of his destination. 'Sampath felt his breathing slow and a wave of peace and contentment overtook him.' He begins to notice the sensory brilliance of the world around him: the sunlight, the breeze, the 'scents all about him. How beautiful it was here, how exactly as it should be.'[22] Desai describes the rich bird and insect-life around him, the luxuriant fruits, the wonderful sense of silence. 'Oh, if he

could exchange his life for this luxury of stillness,' he thinks.[23] He realizes he has attained the right place – a place that is described with all the multi-sensory benefits of treetops that researchers in environmental psychology have described. And it is here that he finally falls asleep.

The Chawla family are unsurprisingly distressed to find that their son has moved into a guava tee. They go to the orchard and try to talk him down. 'We had better take you to the doctor straight away,' says his grandmother. In their eyes he is clearly ill. People in their right minds don't climb trees: 'Only monkeys climb up trees,' says his father.[24] It is 'preposterous' that Sampath should have left home on a bus, but then to be sitting there up a tree a few days later was, to the family, more preposterous still. But Sampath feels far from mad. He feels calm and serene. And he won't climb down to his family only to be caught and driven off to the insane asylum. The doctor is called and climbs up into the branches to assess Sampath, taking his blood pressure and checking his vital signs. '"He is a crazy person,"' the doctor concludes. The diagnosis is as expected: only lunatics climb into trees. '"Our son is afflicted,"' the family complain to a holy man, but when the sadhu asks what his symptoms are – shouting, apoplectic fits, tearing his hair out? – the family can only say '"He is sitting up a tree."' The sadhu's prescription is comedic. '"Arrange a marriage for him. Then you can rest in peace. You will have no further problems."'[25]

What follows is a picaresque, comedic novel of great charm. Sampath becomes a guru – because he has previously read everyone's letters at the GPO, he knows everyone's business. Thus, when the villagers come to see the new holy man sitting in his tree, he already has knowledge of their lives and problems and can, therefore, make insightful suggestions. People are, unsurprisingly, amazed by his 'insight'. Sampath gives 'The Sermon of the Guava Tree' to a throng of local people, in a clear parody of the Buddha's enlightened sermon under the Bodhi tree. His transformation from lazy GPO worker to enlightened holy man is complete. As the local paper christens him in a headline, Sampath Chawla is now 'The Baba of Shahkot in His Tree Abode'.[26] A spy from the Atheist Society inveigles himself into the growing camp that has formed to hear Sampath's daily 'teachings' – a strange mix of his knowledge of local goings on and of gnomic, rhetorical utterances, such as 'Wrestle not the sweet vendor's daughter', or 'Every plum has its own beginning. Every pea its own end'.[27]

A troupe of monkeys moves into the branches alongside him, and the man and the monkeys sit grooming each other. Sampath thus becomes a kind of St Francis with a special affinity for wild animals – his second epithet is 'Monkey Baba' or 'Tree Baba'. With a strange twist, then, Sampath progresses rapidly from lunatic to enlightened one. This is, of course, Desai's playful humanist critique of 'irrational' Indian asceticism, undermining the 'insights' and 'profound utterances' of seers and prophets as little more than the kind of tricks of insight that Sampath can pull off simply because he

has already read everyone's letters. The novel's *Atheist Society* concludes: 'This madman belongs in a lunatic asylum and just look at how everybody is running to him bringing him presents.'[28]

The debunking of sham gurus aside, what is significant here is the treetop location of the drama. 'A true hermit lived in a tree,' Sampath reflects. His new home becomes of great importance to him: 'Here, sitting not too high and not too low, he had seen the world in absolute clarity for the first time.'[29] The guava tree's canopy is that common place of refuge and sanctuary, of stillness and calm. Sampath sits in the guava tree 'encased in absolute stillness like a fossil captured within a quiet moment of amber.'[30] Being up there returns him to himself. All he desires is to be 'claimed by' nature: 'If he stayed here long enough within reach of its sights and sounds, might it not enter him in the manner landscape enters everything that lives within it?'[31] His early feelings of being in the orchard are ones of rapture; it is like a love affair. He blooms and he blossoms. His joy and his playfulness shine.

But, as the title suggests, the proper hullaballoo is surely coming, and it is presumably going to be more than simply setting the protagonist in a tree. The conflict isn't long in arriving – the monkeys get a taste for alcohol. They break into a local liquor supply and fetch the alcohol back to the trees. Scenes of debauchery ensue. Political debate follows over what to do about the rumpus in the orchard. Sampath begins to lose interest in his fickle followers and in being a guru: his acolytes aren't *really* interested in what he has to say anyway. They become divided over the monkeys' drinking shenanigans, moving out of the orchard, going back to their homes in Shahkot. Sampath's sermons dwindle. The gatherings cease. He begins to slip back into his old silences and unhappy manner. Spiritual advertising hoardings spring up around his orchard; his cult has become commoditized. A large garbage heap appears under the trees. The claustrophobia of small-town life creeps back into him. Having initially escaped by climbing a tree, he now, rather ironically, has to escape again. But how?

It is then that Sampath gazes up to the mountains and sees his way out: up there 'there were no villages, no houses, no people … '[32] Sampath's real problem is simply one of misanthropy – all he wants is to be left alone. And thus it is that this comic parody ends. Sampath picks a guava fruit: a 'perfect Buddha shape [...] Beautiful, distant fruit, growing softer as the days went by, as the nights passed on; beautiful fruit filled with an undiscovered constellation of young stars.'[33] He sits holding it in his palm, long into the night and, when his family come to his tree the following morning, they find that Sampath has vanished. There, in his place, lies one single guava much larger than the others, with a mark on it that mirrors the birthmark on Sampath's own skin; ironically, the very fruit that set his whole transformation off in the first place. Just like Cosimo in Calvino's novel, the conclusion of Desai's novel is to have Sampath sublimate into nature; the practice of tree climbing is both the ladder to, and the metaphor for, this sublimation.

*

What each of these narratives reveals is that common collective trope: an adult in a tree is mad, deranged or drunk. It's a persistent opinion that stretches back into the roots of storytelling. Irish poet Seamus Heaney's version of the medieval Irish folk myth, *Buile Suibhne*, is centred upon such a notion, reinventing the old myth for modern readers. *Buile Suibhne* was first published in manuscript form between 1671 and 1674 but was composed as part of the oral tradition as 'dating back to the time of the Battle of Moira (A.D. 637), the battle where Sweeney went mad and was transformed, in fulfilment of St. Ronan's curse, into a bird of the air,' Heaney tells us.[34] The medieval manuscript has written roots somewhere between 1200 and 1500.

In the folk myth, Sweeney, the seventh-century Ulster King of Dal-Arie, finds himself in conflict with the priest Ronan Finn. Sweeney throws Ronan's psalter into a lake, from where it is rescued by an otter, before Sweeney kills one of Ronan's acolytes prior to the battle of Moira. Sweeney then throws a spear at Ronan and pierces the sacred bell that he wears around his neck. It is this chain of conflicts and events that brings Ronan to curse Sweeney to take the form of a bird and, eventually, to be slain by a spear himself. After the Battle of Moira has concluded, Sweeney is metamorphosed into a bird who lives in the canopies of Ireland's trees, and it is his wanderings and sorrows that are described in alternating passages of prose and poetry: the prose passages give the details of the story – the 'what happens' – while the verse embodies the mad king's inner psychological journey. One might equally say that in all these tree climbing narratives, whatever the duration of the ascent, the climb into the tree denotes the outward journey of the characters, while the dwelling in the tree represents the inner, psychological journey towards cure, and sublimation in nature.

Heaney tells how the battle of Moira drove the king's 'mind and senses wild'. St. Ronan's curse comes straight after: 'He shall roam Ireland, mad and bare./ He shall find death on the point of a spear.'[35] The king is to become 'bird-brain among the branches'. The vengeful priest goes on: 'may the mad spasms strike / you, Sweeney, forever'.[36] As a result, Sweeney levitates 'in a frantic and cumbersome motion / like a bird of the air',[37] and Ronan's curse is fulfilled. This is, therefore, no straightforward tree climb; Sweeney had been cursed with madness, transformed into a frantic and cumbersome bird and banished to the trees. The narrative goes on to tell of the mad king's 'fits and trips, why he of all men was subject to such frenzies'.[38] He is 'Mad Sweeney / roosting alone up in the ivy',[39] frequently referred to with any number of synonyms: he is 'mad', 'lunatic', 'sick', 'raving and moaning', 'a starved, pinched, raving madman' and 'a derelict doomed to loneliness',[40] although he also confesses:

I would live happy
in an ivy bush

high in some twisted tree
and never come out.[41]

In fact, Sweeney, like so many tree climbers, even admits: 'I need woods /
for consolation.'[42] They are his 'haven', his *latibule*, where he forages 'the
whole store of the oak wood'.[43] In these utterances, the king does not seem
so 'mad'. Rather, he sounds just like any xylophile (someone who loves
woods), tree climbing enthusiast, or forest bather, who finds consolation in
the woods and their health-giving properties.

Sweeney wanders between the trees, eventually 'trekking through glens, /
until he found the pleasures of Glen Bolcain'.[44] Heaney then writes in prose
how: 'That place is a natural asylum where all the madmen of Ireland used
to assemble once their year in madness was complete.'[45] The king is aware
of his own affliction. 'I am a madman myself'[46] and 'I am the bare figure
of pain.'[47]

In his own introduction to the work, Seamus Heaney alludes to 'the green
spirit of the hedges embodied in Sweeney',[48] making the mad king a version
of that pagan symbol, the Green Man. In writing about 'Early Irish Nature
Poetry' in his essay 'The God in the Trees', Heaney writes:

> I want to suggest that this early poetry is sustained by a deep unconscious
> affiliation to the old mysteries of the grove, even while ardently
> proclaiming its fidelity to the new religion. After all, there is no reason
> why literature should not bear these traces as well as the architecture: the
> old religion kept budding out on the roofs of cathedrals all over Europe,
> in the shape of those roof-bosses which art historians call 'green men' or
> 'foliate heads', human faces growing out of and into leaves and acorns
> and branches.[49]

The reader can imagine the tormented king Sweeney's twisted face,
almost pouring out the words of his poem as though he were the Green
Man himself. And this pouring out of language is nowhere more apparent
than in Heaney's well-known catalogue of Irish trees from the Irish myth. In
this litany, the 'green' king sings the praises of the trees of Ireland's woods.
It begins:

> The bushy leafy oak tree
> is the highest in the wood,
> the forking shoots of hazel
> hide sweet hazel-nuts.

> The alder is my darling,
> all thornless in the gap,
> some milk of human kindness
> coursing in its sap.

This lyrical, ballad-like poem includes verses on apple trees, mountain rowan, yew trees, holly, aspen and other non-tree species including vetches, briars and ivy. Heaney's stanza about the birch tree, for example, romanticizes the species and captures its graceful billowing in the wind, 'the queen of trees'.[50] The trees of the mad king's litany are named and spoken to directly. The poet and critic Ciaran Carson describes how 'in their personification, the trees become cyphers for Sweeney's state of mind; nature is internalized'[51] and, perhaps, this is something people commonly do with trees (and with nature more widely): they become *their* birch trees when they think of them; *their* oak trees when they climb them. The tree climber's ascent is into the external branches of the tree, but their journey is into the internal tree; the tree of the mind.

Such internalization can be seen in the remarkable paintings that Van Gogh made while he was a self-admitted patient at the Saint-Paul asylum in Saint-Remy-de-Provence, from May 1889 until May 1890, just months before he took his own life in July 1890. The paintings Van Gogh made of the gardens, the irises it contained, the asylum itself, the wheat field he could see from his room, as well as the portraits of some of the individuals there in the asylum, also include some remarkable pictures of *his* trees, that twist and contort in the Mediterranean sun; their branches seemingly alive, curling like smoke or fire. They have a chaotic, fractal quality to them with their energetic brushstrokes and dynamic patterning. There can be few other trees in art that are so remarkably and instantly recognizably the artist's own. These trees are what Richard Mabey calls 'those total immersions in the chaotic creativity of nature which make no concessions to our tidy-minded perceptions'.[52] In Van Gogh's paintings, the external nature of the trees is internalized – the viewer can feel the sap coursing through the trunks and branches, the buzzing vibrations of the heat – just as much as the artist's internal feelings are projected onto the external world. The trees seem to curl and whip with a wild, natural energy and seem to buzz with an internal, synaptic energy that offers something (as close to we are ever likely to get) to a direct access to Van Gogh's mind's eye way of seeing. Yes, at the time, Van Gogh was 'mad' – suffering from psychotic episodes and delusions – but *his* trees echo Ciaran Carson's comments on Seamus Heaney's *Sweeney Astray*: the trees become cyphers for the artist's state of mind; nature is internalized.

The Irish satirist Flann O'Brien also writes of King Sweeney's madness in his farcical and satirical first novel, *At Swim-Two-Birds*. The place name, Swim Two Birds, is an ancient ford on the River Shannon in West Ireland. In the novel, an unnamed student of Irish literature recounts the details of his life living with his uncle who works in the *Guinness* brewery in Dublin. The student tells a number of co-synchronous stories, in which characters from one story invent characters in another. He also retells versions of Irish myths, namely those of Finn Mac Cool, and that of the mad King Sweeney. The novel is metafictional, self-consciously pointing towards its own written-ness, and

also includes found material, as well as O'Brien's own satirical translations of the Middle Irish *Buile Suibhne*, or 'Sweeney's frenzy', as O'Brien calls it.[53] O'Brien's novel recounts the details of the Sweeney myth and weaves it in and out of his fictional author's own writings and narratives. His version of the Ballad of the Trees is rather different to Heaney's:

> O leafy-oak, clumpy-leaved,
> you are high above trees,
> O hazlet, little clumpy-branch –
> the nut-smell of hazels.

> O alder, O alder-friend
> Delightful your colour,
> You don't prickle me or tear
> in the place you are.[54]

Despite its differences, O'Brien's catalogue of Irish trees is still another pouring out of language; another Green Man-like exhortation of the powerfully beautiful qualities of trees, and the internalization and personalization of nature. Once again, as with Van Gogh's asylum trees and the trees of many tree climbers, these trees are very much *my* oak and *my* alder and are, as such, cyphers for what is going on inside the mind.

*

To conclude, these recurring themes – family conflict, madness, seeking a sanctuary, tree-mind parallels and the internalisation of trees – all find common expression in English novelist Laura Beatty's book, *Pollard*. In Beatty's novel story, the protagonist, Anne, spends a good deal of time among the trees of her mind: she leaves an unhappy family home aged fifteen and goes to live in the woods. Anne's family house is airless and full of shouting. Her parents and siblings are neglectful, and she is almost an outsider in her own home: 'Visitors would cock their heads at Anne's height and ask her parents, Where d'you get her then? Must've been a tall milkman.'[55] People, and specifically her family, 'were her problem, or rather one of her problems, because sometimes the problems grew in her head, as thick as the trees.'[56] Anne is shunned by her own family because of her physical differences to them – she is tall and 'wide', they are all small – and because of her inwardness, quietness and, what would be described commonly as her 'learning difficulties'. To her parents she is 'a bit of a freak'.[57] As a result, she does not allow herself to have feelings at home because 'Long ago she had learnt that they were of no consequence',[58] or rather, the feelings she does have at home are 'the old feelings of claustrophobia and unhappiness'.[59] Having had enough of her family, she suddenly leaves the

house that had never really been a home, unnoticed: 'She walked out quick, like she always did, only she thought they might have heard her heart, it was so loud. Nobody stopped her.'[60]

The old pattern of fictional tree climbers having childhood problems at home is reinforced. Their retreat into the woods and up the trees is a reaction to family conflict. Anne is no different. She is *#womanintree*, moving into the woods where, eventually, she builds herself a shack beside an ancient pollarded ash tree: 'the wood drew her. So many tall things and so happy. Inside Anne's head the world was all upwards. It was breezy tops and lower filtered light, and movement. There was no clumsiness in the wood, as far as she could see. She carried the feel of it around with her, as an alternative. It took her over.'[61] The woods make her slower and quieter than she had been before at home. The wood becomes a new home. 'The slim verticals of its timber-grown trees were her private rhythm.'[62] As opposed to the oppressive environment of home, Anne feels fine in the woods. She lies down and breathes 'the loamy air at the trees' feet', presumably filling her senses with those beneficial soil bacteria *M.vaccae* that scientists have proved to have beneficial effects on wellbeing.[63]

Although *Pollard* is not strictly a novel of tree *climbing*, Anne's retreat into the woods shares common features with the characters in other novels who do climb trees: an unhappy family home; mental health issues; the solace and comfort of nature, and its healing properties. Anne lives in the woods, 'sitting against the tree waiting for something to make sense.'[64] She speaks to her pollarded tree: 'In her mind and when she talked to it in her thoughts, the pollard was always female,' Beatty writes. 'What are you doing, ash tree? Her fingers asked its mossy bulges. Nothing any more. Just sitting it out. And, Me neither, she would answer. Sitting it out. Me too.'[65] Talking to trees in this way, and living among them, Anne is, of course, mocked for being crazy. 'That's our resident mental case. Doolally [...] away with the fairies,' Sue the café owner says when Anne turns up 'to be in the steam and smell' of the café and civilization.[66] Later, the builders of a new aerial walkway through the woods call her 'the lady from la-la land'.[67] While she certainly has learning difficulties, and has shunned conventional family life for a retreat into the woods, people are only too keen to turn their derision upon her – essentially a victim of dysfunctional family circumstances – rather than turning their criticism upon a system that has let her down, as is often the case. The 'life imitating art' quality, or vice versa, of Anne's story and Cody Lee Miller's real-life drama are unnervingly close.

Notes

1 Italo Calvino. *The Baron in the Trees*, p.78.
2 Ibid, pp.85–6.
3 Ibid, p.86.
4 Ibid, p.89.

5 Ibid, p.111.
6 Ibid, p.121.
7 Ibid.
8 Ibid, p.121.
9 Ibid, p.141.
10 Ibid, pp.141–2.
11 Ibid, p.230.
12 Ibid, p.283.
13 Ibid, p.249.
14 Ibid, p.249.
15 Ibid, p.250.
16 All lines here from Amanda Dalton. 'Room of Leaves'. In *How to Disappear*, pp.28–46.
17 Amanda Dalton. *The Creative Writing Coursebook*, pp.110–16.
18 Kiran Desai. *Hullabaloo in the Guava Orchard*, p.43.
19 Ibid, pp.46–7.
20 Ibid, p.49.
21 Ibid, p.50.
22 Ibid, p.50.
23 Ibid, p.51.
24 Ibid, p.55.
25 Ibid, p.57.
26 Ibid, p.119.
27 Ibid, p.153.
28 Ibid, p.120.
29 Ibid, p.142.
30 Ibid, p.202.
31 Ibid, p.143.
32 Ibid, p.185.
33 Ibid, p.204.
34 Seamus Heaney. *Sweeney Astray*, p.i.
35 Ibid, p.5.
36 Ibid, p.8.
37 Ibid, p.9.
38 Ibid, p.3.
39 Ibid, p.22.
40 Ibid, p.68.
41 Ibid, p.41.
42 Ibid, p.55.
43 Ibid, p.65.
44 Ibid, p.13.
45 Ibid, p.13.
46 Ibid, p.56.
47 Ibid, p.70.
48 Ibid, p.*iv.*
49 Seamus Heaney. 'The God in the Trees', p.186.
50 All quotes from 'The Ballad of the Trees'. From Seamus Heaney. *Sweeney Astray*, pp.36–8.
51 Ciaran Carson. 'Sweeney Astray: Escaping from Limbo', p.145.

52 Richard Mabey. *Nature Cure*, p.160.
53 Flann O'Brien. *At Swim-Two-Birds*, p.64.
54 Ibid, p.71.
55 Laura Beatty. *Pollard*, p.18.
56 Ibid, p.19.
57 Ibid, p.37.
58 Ibid, p.30.
59 Ibid, p.155.
60 Ibid, p.21.
61 Ibid, p.19.
62 Ibid, p.19.
63 Ibid, p.20.
64 Ibid, p.65.
65 Ibid, p.148.
66 Ibid, p.64.
67 Ibid, p.260.

5

The family tree

Building on preceding discussions of family conflict as a common motivation in the representations of literary tree climbers, this chapter extends the discussion to the wider metaphor of the 'family tree', which finds its expression in both creative and scientific writings. Trees often offer a sense of belonging to a place, or a sense of endurance and continuity. To use the language of British-Jamaican artist, Hurvin Anderson, trees offer a sense of 'rootstock', of a sense of belonging to a lineage of generations. Trees also possess qualities that may map, metaphorically, onto positive family relationships: steadfastness, resilience, togetherness, shelter and so forth. Such generational and familial metaphors find their expression in the scientific research of Suzanne Simard, Professor of Forest Ecology at the University of British Columbia, who has researched 'maternal instincts' in trees, while other researchers and writers comment on the 'social lives' of trees in an interconnected 'wood wide web'. In their interconnected communities, trees offer multiple ecosystem services, including air and water filtration, oxygenation, and play a role in forest and oceanic food chains. These processes play out on vast time scales, which are acknowledged in the writings of poets, novelists and essayists. The different conception of time afforded by trees leads many writers to explore evolutionary urges in tree climbing. From poets such as David Wagoner, to Eco-Buddhist writers such as Stephanie Kaza, questions of ancestry (both evolutionary and familial) extend the time scale of tree climbing adventures. Furthermore, with its extended scenes of primordial tree climbing, William Golding's 1961 novel, *The Inheritors*, speaks back to the Darwinian 'family tree' in its explorations of the conflicts between *Homo sapiens* and *Homo neanderthalensis*, and develops the image of the climbed canopy as an emblematic space in which more enlightened

decisions can be made. This chapter takes us, then, from family conflict to family community, lineage and ancestry, and leads eventually to those beings who are, perhaps, most commonly associated with the freedoms of tree climbing: children.

*

On 16 October 1987, gale force winds reaching speeds of over 100 miles an hour tore through southern England. Buildings were destroyed. Roofs were lifted and thrown aside. Cars were flattened by falling trees. Once firmly anchored to the ground, many large trees were uprooted and tossed through the air like pieces of balsa wood, bringing down buildings and destroying infrastructure. Hundreds of people were left without power for days. Eighteen people lost their lives. This was the 'Great Storm', amounting to the destruction of around 15 million trees. There was more than £1 billion worth of damage. There was also an infamous weather forecast in which the BBC weather forecaster, Michael Fish, told viewers: 'apparently earlier on a woman rang the BBC and said she'd heard that there was a hurricane on the way. Well, if you're watching, don't worry, there isn't ... but having said that, the weather will become very windy.'[1]

While 'hurricanes' only occur in the tropics, the Great Storm was certainly a 'hurricane-like' event – the highest gust in the UK was recorded as 122 mph at Gorleston-on-Sea, on the Norfolk coast, south of Great Yarmouth. Richard Mabey begins his 2008 book, *Beechcombings*, with some thoughts on the storm and how it 'wasn't what was supposed to have happened. Trees were monuments to security, emblems of continuity and peace in an unstable world.'[2] Hurricanes are, of course, tropical storms gone ferocious and the one experienced in the UK in 1987 was by no means exceptional in the long list of hurricanes that have wreaked havoc in other parts of the world. Once the wind speed passes 74 mph the storm's status is upgraded from 'tropical storm' to 'hurricane' – a form of cyclone, a rapidly rotating storm system that eats up everything in its path. On average, a hurricane season in the Caribbean produces around a dozen named storms, of which half will be hurricanes. In Jamaica, hurricanes Emily, Charley, Ivan, Dennis, and Gilbert have all caused major destruction and deaths in the last couple of decades.

The British-Jamaican artist Hurvin Anderson has painted several pictures that might be designated as 'family trees' of a sort, exploring ideas of the artist's heritage. Anderson's paintings 'Cloning' and 'Rootstock'[3] present images of Jamaican children climbing in trees. While in Montego Bay, Anderson saw some children climbing in a mango tree and was reminded of his brother climbing trees to scrump apples back in Birmingham in the UK where they grew up. Painted both from photographs and memory, 'Rootstock' captures a blend of the actual moment of climbing, and

nostalgic memories of childhood. The colours are lively and tropical, although muted by the greys of the trees themselves – the limbs are sketched-in only as grey stripes; the leaves are painted in a palette of greens that range from bright lime to dense and dark. Blobs of fruit seem to hang effortlessly, and the boy too appears effortless in his climbing. He is unhurried in his fruit picking. If scrumping apples in England might have been an urgent affair for Anderson and his brother, needing to pick the fruit before the tree's owner caught them, then this Jamaican child seems comfortably unhurried in his efforts. The tree feels like his own special domain – barefoot and easefully hunched over to grasp the branch, or the fruit, before him.

A horizontal line that bisects the painting in the upper third of the canvas is suggestive of a window perhaps, or a film of some kind – photographic film maybe? Or perhaps it represents some other more psychological division such as 'then' and 'now'; 'representation' and 'reality'; 'memory' and the 'lived-in moment'; 'youth' and 'age'; the groundedness of earth and the freedom of the canopy? 'Inside' and 'outside', those two realms that are brought together by the liminal space of the canopy. And who can't resist the time-honoured metaphor of fruit picking: 'innocence' and 'experience', or 'knowledge'? The painting's title, 'Rootstock', also offers metaphors. In the practice of grafting two plants together to create a new fruit tree, a 'rootstock' is the plant onto which the new variety is grafted. In this sense, Anderson might be commenting on his Jamaican heritage and his upbringing in Birmingham; a re-grafting of cultures, if you will. The more general meaning of 'rootstock' is that part of the plant which is underground – a plant's root system – and again, in this sense, Anderson's painting certainly seems to be celebrating his heritage, finding kinship in his rootedness and the tree climbing activities of children on both sides of the Atlantic.

Anderson's 'Rootstock' echoes Richard Mabey's comment that trees are 'emblems of continuity'. Both Anderson and Mabey seem to be saying that trees endure, just as people would like their own 'roots' to be durable. Or, at least, trees are supposed to endure. They are strong and immovable. They weather drought and storms. And they persist. For hundreds of years. Trees are survivors. They often grow in extreme environments where the wind has driven their seed; in a random location unlike the home ground where the parent tree grows; a distant and inhospitable place where some bird or animal has deposited their seeds in a pile of droppings, down the edge of an embankment, on a scree slope, or on waste land.

These qualities of steadfastness, survival and immovability are qualities often admired in people. As Stephanie Kaza writes in her Buddhist reflections on trees, 'the resilience of trees is something I have always counted on. It supports a certain confidence that life will go on, noticed or unnoticed.'[4] Trees can literally and emotionally provide shelter, the way that family

elders shelter and protect their young. In fact, scientists and foresters talk of 'mother trees' and 'tree parents' living alongside their sapling offspring. Dr Suzanne Simard's research first discovered 'maternal behaviour' in trees: mother trees passing nutrients to their sapling offspring through their roots and mycorrhizal systems – the underground networks of fungi that live a mutually beneficial life with the trees' roots.[5] In his exploration of his own relationship to trees and how they play a role in his creativity, novelist John Fowles writes in *The Tree* that trees' capacity to reproduce, their longevity and their 'passive, patient nature of their system of self-preservation' are some of the qualities that have led people to associate something 'protective, maternal, even womb-like in their silent depths.'[6] This takes the science into maternal symbolism, but such symbolism springs from observable qualities of trees in the natural world. Climbing the rootstock, climbing the tree, the climber is perhaps, in some atavistic sense, symbolically returning to their birth, to their origins.

Scientific research shows that trees are social organisms. They pass nutrients from parent to offspring and from healthy individuals to sick individuals within the forest ecosystem. They share resources – food and water – and communicate through their roots, using electrical impulses, which likens their root tips to some kind of 'brain', as discussed previously. They also fill the air with aromatic compounds that communicate information about predators, and which serve insecticidal purposes. In human terms then, trees 'look out for each other'. As John Fowles also comments, 'evolution did not intend trees to grow singly. Far more than ourselves they are social creatures.'[7]

Trees are rooted to the ground; they have a vertical axis and their head, their canopy, extends above in a florescence of leaves and branches. Humans too are bound to the earth, rooted to the ground, to home and loved ones, to cultural traditions. People stand vertical as trees do, and the head, like the canopy of a tree, 'crowns' the body. Coming back down to ground level and thinking of their roots, trees have complex mycorrhizal relationships with networks of fungi in the soil that also allow them to communicate with each other, to recognize each other and other trees of the same species, and even to know which nearby roots belong to their own offspring. In his comprehensive study, *The Hidden Life of Trees*, Peter Wohlleben writes, 'The fungal connections transmit signals from one tree to the next, helping the trees exchange news about insects, drought, and other dangers.'[8] Scientists have christened this web of connections 'the wood wide web', which Wohlleben says is 'something like the forest Internet'.[9] He also calls this interconnectivity the forest's 'social security' system.[10] This interconnectedness leads to the conclusion that 'a tree can be only as strong as the forest that surrounds it'.[11] A forest is a super-organism, akin to a human community. Wohlleben's metaphor begs obvious human questions and, in light of his 'social security' comments about healthy trees feeding sick trees with shared resources, prompts a human parallel: an individual

person is only as strong as the community that surrounds them. In light of Cody Lee Miller's ascent into the sequoia tree and the subsequent debates about political funding for mental health care in the United States, as well as the perceived crisis of mental health care and social care funding in the United Kingdom, one might be tempted to suggest that people are not doing quite as well as the trees.

There is, however, a definite reciprocity between humans and trees: as Colin Tudge writes, 'without trees our species would not have come into being at all.'[12] At the most basic level, trees 'breathe out' oxygen which humans breathe in, exhaling carbon dioxide which trees then metabolize in the processes of photosynthesis. Metaphors of trees being 'the lungs of the earth' abound in literature, as in American poet Michael Cadnum's poem, 'Climbing A Tree' (1988) that 'It is never high enough' – the challenge of the climb is always there. But more than this:

you want to climb breath
to the place where it cannot hold
the past but lets it go, empty
of everything but the wet
wood of the bones, the dark
heaven of the lungs.[13]

Cadnum's tree and human body become one here; the human lungs and the canopy of the tree are equated. It's a common enough image, poignantly expressed, with allusions to shedding the burdens of the past to find a kind of 'heaven' in the tree's breathing crown. (Novelist John Fowles, writes in *The Tree* that 'Slinking into trees was always slinking into heaven'.[14]) So it is that trees and people 'breathe' mutually. In their breathing, trees cleanse the air and water, purifying the air of pollutants, filtering rivers, keeping the oceans alive by circulating water and putting vital nutrients back into the streams that flow to the sea, feeding the plankton that float there in their trillions. The decomposition of humus on the forest floor leaches into rivers and is vital in the life cycle of coastal phytoplankton, which are the foundation of the oceanic food chain. Without trees, then, there would be no fisheries. But they also provide people with more direct foodstuffs in the form of nuts, berries and fruits, as well as yielding materials for clothing and medicines. The sorbic acid found in the rowan tree is anti-fungal and anti-bacterial. Willow trees have long been used in traditional medicine to treat fever, headaches, toothache and rheumatism: the compound salicin, found in willow, has analgesic and fever-reducing effects. It is known as salicylic acid, the main constituent of aspirin. It is also found in the plant 'meadowsweet' which has also been used for its analgesic properties. The botulin in birch trees is anti-viral and anti-bacterial and is used in skin care products. Trees also yield building materials, fuels and other materials – lignin, cellulose, paper pulp and so forth. Forests stabilize the soil and help prevent erosion,

soil loss and flooding. The Amazon rainforest and the tropical forests of
the Indian subcontinent control the global climate. Trees store carbon and
lock up carbon dioxide. They have become iconic in understanding this
Anthropocene epoch of global warming. The vast strata of coal that has been
burnt for centuries is made from the fossilized remains of Carboniferous-age
trees. The timescale is unimaginably large; the time it takes to burn it, on the
other hand, is comparatively miniscule.

Trees are bound up in the imagination and the long history of humanity
in manifold ways, and that is partly because of the complex and ancient
relationships between trees and time. Arborists and dendrochronologists
count their extensive lifespans in rings of wood. The rings in the trunk of
a tree contain cells from each one of those years – they do not regenerate
their tissues in the same way humans do (there are no living cells in your
body today that were alive on this same day seven years ago, nor will there
be in another seven years ... people certainly feel a 'self', but the body
is constantly changing, so where does the 'self' reside?). The science of
dendrochronology allows researchers to date tree growth rings to the year in
which they were formed, with applications in archaeology and climatology.
More metaphorically, because trees do not regenerate these tissues, they
persist through time in a more constant way than humans do with their
ever-changing bodies. Perhaps that is one of the great consolations people
take from trees. Being up in the branches of a tree 'changes your mind-set,
your sense of time,' says Harv Teitelbaum, the founder of *Tree Climbing
Colorado*, a US tree climbing business that provides climbing experiences for
adults and children. 'Tree climbers talk a lot about tree time,' he continues,
'the concept that time slows down in a tree. It is a totally different perception
to look down on the trunk, to feel the tree move, the universe move.'[15]
And as Buddhist author Stephanie Kaza writes, being in the company of
trees 'is a way of marking slow time, of putting my feet in the context of
years instead of minutes'.[16] There is something 'other' about trees and time
that speaks to the human understanding of time and mortality. This is as
equally true of mythologized or fictional trees as it is of actual trees: in
her study of Early Modern writers and trees, Victoria Bladen points to 'the
link between the tree of life and temporality', suggesting that the motif of
the tree of life transcends time and connects past, present and future: 'This
characteristic derives from its biblical origins, where the tree features in both
Eden and Revelation, spanning sacred histories and futures.'[17] Similarly, in
writing about *The Mountains of California*, American naturalist John Muir
described the esoteric relationship between trees and time, acknowledging
that 'For knowledge of this kind one must dwell with the trees and grow
with them, without any reference to time in the almanac sense'.[18] More
recently, Samantha Walton describes how 'The freedom of the forest for
me has always rested in a sense of being out of time,'[19] while Lucy Jones
expresses the similar notion in *Losing Eden*: 'To stand with an ancient oak
is a lesson in patience,' she writes, 'in the slow-burn, in trust, in taking things

one day at a time. It is to be in the presence of eternity and infinity.'[20] Human understanding of time, self and trees are, it appears from these multifarious examples, deeply interwoven.

In one of his well-known poems, British poet Philip Larkin conveys something of these matters in his poem 'The Trees' (1967): 'The trees are coming into leaf,' Larkin begins, 'Like something almost being said.' Here, human speech is mapped onto nature through the personification of trees. Larkin uses his short poem to enquire into the processes of ageing and grieving. The trees accrete their age into their own trunks in concentric rings: 'Their yearly trick of looking new / Is written down in rings of grain.'[21] The ending of the poem is remarkably upbeat for a poet renowned for some miserabilist attitudes: 'Last year is dead, they seem to say,' Larkin begins in his downbeat mode, but then concludes, in as positive an attitude as is ever likely to be found in Larkin's poetry, 'Begin afresh, afresh, afresh.' This ending is a long way from Larkin's celebrated lines, 'They fuck you up, your mum and dad. / They may not mean to, but they do' – that infamously jaded comment on family ties for which he is remembered.[22] The more upbeat ending of 'The Trees', with its promise of rebirth and regrowth, points to something that scientific research has shown: nature not only self-regenerates on an annual basis, but people regenerate when they spend time in nature; people come back from their time in the trees 'afresh, afresh, afresh'.

Novelist John Fowles comments further on the relationship of trees to time in *The Tree*. For Fowles, trees are living out 'a drama, but of a time span humanity cannot conceive. A pastness, a presentness [...] there are tenses human language has yet to invent.'[23] But trees seem to have already invented these tenses, Fowles suggests. They live through time in a different way to people. They 'warp time, or rather create a variety of times: here dense and abrupt, there calm and sinuous,' he writes.[24] So it is that trees mark time in a variety of ways, not just in their rings of wood. They denote the changing of the seasons in bud burst and leaf fall. Trees also have an individual sense of time, and can measure the number of days that have passed at a certain temperature, enabling them to 'decide' when to come out of winter dormancy and start growing again in the spring, and when to blossom. As Colin Tudge writes, 'trees do not respond simply to the here and now. They anticipate what is to happen next.'[25] And they 'remember' the past: trees are aware of the passing of seasons and can anticipate the turn of the seasons through sensitivity to temperature and the relative length of nights and days.

It is, perhaps the fact that woodlands and forests inhabit the same spaces over vast tracts of time and that they live much longer lives, that attracts people to attaching myths and stories to them. Trees live on one spot for hundreds of years, while a climber's visits to the same spot barely register on the tree's timeline. The climber goes up into the branches and is soon gone. A climber is a visitor, but trees, according to tree climbing professional James Aldred are 'living ambassadors from the past.'[26] It is as if trees are some sort of threshold to a deeper understanding of the self and its relationship

to time. As novelist Laura Beatty writes in her novel, *Pollard*, 'Trees take a longer view. They are intimate with the constituents of their ancestors, feeling with fine-haired fingers through the mould and matter.'[27] Trees are here, everywhere; even in cities they are just there, lining the roads and giving parks and green spaces shape and structure. And yet they occupy these same spaces for much longer periods of time than the city's human inhabitants. Trees are irrepressible. There is no holding them back. Those sinuous roots that are even now buckling up pavements and tarmac in cities, towns and suburbs, will always have their way. There is nothing to be done about that but to try and keep things in order; try to hold nature's irrepressible force in balance with the relatively brief span of a human lifetime. And that is both terrifying and reassuring at the same time. 'Whole civilisations may come and go,' writes Richard Mabey, 'in the lifetime of a single veteran beech,'[28] and it doesn't take long, indeed, for trees to have their way: in little over half a century, a field or grassland can develop through varying stages of development to become woodland. The process, known as 'succession', begins with annual plants yielding to perennial plants and grasses. In a few years, low-level shrubs take hold, followed by softwood trees such as pines. An understory forms beneath the pines, and eventually these trees yield space to hardwood species. The woodland finds its way.

The timescales of trees speak to humanity in other ways. As a species, modern humans are descended from ancestral apes who 'came down from the trees' about 5 million years ago, to begin inhabiting the savannahs in the long journey of human evolution. Is there perhaps something atavistic in the human relationship to and imagining of trees? Might there be something in the evolutionary make-up that keeps people connected to trees, even 5 million years after our human ancestors climbed down from them? Might present-day tree climbers be fulfilling some ancient urge, even at a subconscious level, to 'return to the trees' or, perhaps, be enacting some primal quality of the brain's limbic system; that part of the brain which controls memory, emotion and arousal, exerts a strong instinctual influence upon behaviour and, at around 150 million years old, represents one of the most evolutionarily ancient parts of the mammalian brain? Our personal families are close to us in time and space, but the human family stretches back deep through time and place.

In *The Secret Life of Trees*, Colin Tudge suggests that such atavistic throwbacks are written into human evolutionary make up, since the human ancestors of the primordial forests slept high in the branches out of harm's way from predators, spending '80 million years or so (so some zoologists calculate) in the trees'.[29] Climbing devotee Jack Cooke also writes of tree climbing as a form of ancestral memory; 'a powerful homing instinct'. For these ancestors, 'the tree tops were their temple and tabernacle', writes Cooke.[30] Another documenter of tree climbing, Richard Preston, writes in *The Wild Trees*, that human beings are the only primates that don't

spend regular time in the trees: 'All other primates are arboreal or partially arboreal creatures,' Preston writes. He goes on: 'Humans are the only primates I know of that have an inborn fear of heights. Other primates, when they are frightened, instinctively run up a tree, where they feel safe and at home.'[31] Comparing present-day hunter-gatherers' tree climbing abilities with those of primates, research shows that 'the biological and adaptive significance of human climbing has been underestimated, and that some humans are surprisingly competent in trees,' and that while humans later evolved to walk on the savannah, the loss of tree climbing abilities was minimal. In other words, climbers can still ascend a tree like the ancestors, and search out that inviting *latibule*.[32]

In her chapter 'Held by a Living Being', environmentalist and Buddhist, Stephanie Kaza, finds herself standing beneath an Oregon oak. Kaza is 'overcome with a desire to leave the ground and climb up in the tree; all nerve circuitry has reverted to animal mode. Let me be a monkey,' she writes, 'let me follow my ancestral monkey instincts and see what they know about trees.'[33] The subsequent climb is full of descriptions of 'primate arms' and 'primate urges' although, in her self-acknowledged cumbersome and out-of-condition state, Kaza confesses that 'I am evolutionarily out of shape' and 'look more like a sloth than an agile monkey.' The climb reminds her of the limits of her capabilities, and 'the limiting aspects of mortality'. However, with a bit of ingenuity and the help of a carefully placed pile of rocks, Kaza makes it up into the tree, where 'familiar feelings of being in a tree come alive'. The climb has satisfied her 'ancestral animal' and evokes a number of memories of climbing other trees as a child, remembering the 'intoxicating smells' and feeling 'completely at home off the ground, fulfilled in my arboreal habitat'. Kaza repeatedly refers to the tree's crown as 'home' and uses the language of 'healing' to describe her feelings: 'I am enfolded by the tree, embraced, upheld. I can feel the healing power in trees that I knew instinctively as a child.' The epiphany is a spiritual one as much as physical. The climb is, for Kaza, a kind of union with the tree: 'at home with my animal body, at ease with our time together'.

These ancestral recognitions are described in poetry too. In his poem 'Climbing a Tree', American poet David Wagoner climbs up into a mature maple tree, 'almost as mature / As I'm supposed to be', to rescue his daughter's kite that has become stuck in the branches. The implied childishness in 'as I'm supposed to be', prepares for the regression that occurs, since the narrator soon finds himself climbing the tree, like a child, to rescue the kite, and comes:

Crotch to crotch with the home of our ancestors
Who, at the edges of forests in the evening,
After foraging the strange, wide-open savannah,
Returned to spend the night high among birds[34]

Going up into the branches successfully collapses over 2 million years of human evolution into that one moment and image. Forced to leave the kite high in the branches above the 'dangerous grassland' where they have been flying it, they walk home with the young girl wailing for her loss, and the father contrastingly satisfied with his reconnection to the ancestors. In a second poem, 'Tree House', in the same collection, Wagoner also uses tree climbing to take the reader back to a much more ancient version of the human. In 'Tree House', a neighbour's boy builds a tree house 'With a floor like a life-raft' – a literal description, but also a life-sustaining metaphor – staying up there all summer, through into the 'wind, then rain and frost' of autumn and winter. The 'life raft' image suggests that the boy needs rescuing form something; perhaps the overly insistent calls of his mother and his father 'slamming the door' – an image that seems to conceal some latent aggression. Despite his parents' calls to bring him in, the boy stays there after sunset,

> ... becoming someone else
> That wasn't a boy in a tree,
> Not just a pair of eyes
> Or a shape in a different stillness,
> But something older, waiting
> To be changed in a growing place
> With only one way down
> And with only one way in.[35]

The suggestion is that the boy might have 'become animal' in his imagination, transforming into an owl, or a monkey ('a pair of eyes', or 'a shape in a different stillness'). But his transformation is more than that; it is 'older' than that. The reader sees him 'turning dark, being overcast', lurking in the shadows of humanity's past. He has gone into the tree to be 'changed' by the atavistic experience. There is only one way down – the literal trunk – and then that enigmatic last line: 'only one way in'. Into what? His humanity? His adulthood? His masculinity? His individual identity (that Jungian 'individuation'), free from the calls of his parents? Or, quite literally, is there only one way back into the house? The poet leaves these possibilities open, having made the suggestion that the boy has realized his true ancestry, beyond that of his parents.

<p style="text-align:center">*</p>

In William Golding's 1961 novel, *The Inheritors*, these evolutionary themes are played out in the struggle between two different species of hominids: *Homo neanderthalensis* and *Homo sapiens*. Golding explores the fate of a group of Neanderthals at the hands of a group of Sapiens, who have come

into the Neanderthals' territory to occupy a river island there. The invasive humans – referred to as 'the other' throughout the novel – kill several of the Neanderthal group and steal one of their infants, named Liku, as a plaything for one of their women. Golding's Neanderthal protagonist, Lok, climbs trees on a couple of occasions in the novel, notably towards the climax of the action, when he and his partner, Fa, try to steal Liku back from the *Homo sapiens*. But the first reference to tree climbing comes when Lok observes one of the new humans climbing a birch tree as a point of vantage from which to peer into the distance: 'It moved up the birch tree with sloth-like deliberation,' Lok reports, before leaping away from rock to rock when Lok disturbs it by calling out.[36] Returning to his tribe, Lok reports: '"I have seen the other [...] He climbs in the trees. He is dark. He changes shape like a bear in a cave."'[37] This animistic description of the man as an animal mirrors the Neanderthals' spiritual system, which Golding presents as centring around a female principle of generation, an Earth Goddess, named Oa.

Having seen the *sapiens* climb a tree, Lok also climbs into a tree and, once again, cries out to the men and women, daring to perform some acrobatics in the thin crown of the beech tree, which drives the humans away. In a simian fashion, he swings himself from tree to tree, trying to pursue his quarry, but they have doused their fire and fled. In moments such as these it becomes clear the humans are as scared of the Neanderthals as vice versa, and that some primitive 'fear of the other' (that still plays out irredeemably in racial discourses today) lies behind the distrust. In the novel's final chapter, the reader learns that the humans refer to the Neanderthals as 'devils' and that their violence towards them is motivated by fear; fear of 'the devil haunted mountains' where the Neanderthals live;[38] fear of being pursued by the Neanderthals, as they depart from the island in a dug-out boat saying '"They cannot follow us, I tell you. They cannot pass over water"'.[39] And yet, in their mutual ability to climb trees, itself a symbol surely of some shared ancestry (of which they are, of course, unaware), the reader sees but one of their similarities.

The more substantial tree-climbing scene comes in the novel's second half, commencing when Fa and Lok climb a tree to hide themselves but, equally, to gain high vantage over the human encampment. It is from here that they wait for their moment to steal into the human camp and take back Liku from her captors. 'The top of the tree was empty like a great acorn cup,' we read, once they have climbed into the branches, although those branches are, conveniently, 'full of food'.[40] While up in the branches, Fa and Lok witness many different things about the new 'others': the tribal decorations on their long, thin faces, so different from those of the Neanderthals themselves, and their slender, upright bodies, equally different. They watch the humans' tribal interactions and social structure. Golding also depicts the humans' sexual habits, described in an aggressive mating scene. Yet beside these more animalistic urges, Fa and Lok also see the humans' skill in problem-solving and their use of tools: the humans move their dug-out boat around on log rollers and are adept in the use of bows and arrows. The secrecy and vantage

of the treetop also affords Lok and Fa an insight into the way the humans handle their own children, as they watch the interactions of a human girl, Tanakil, with their own stolen child, Liku. The Neanderthals' patience in these scenes, waiting for the right moment to descend and take Liku back, is notable: Golding places Fa and Lok in the treetop for a chapter-and-a-half, a passage that lasts well into the night. During this time, they witness the humans' ceremonial rites, in which a *sapiens*, dressed in a stag's pelt and antlers, dances and hollers. There is also a drunken ceremony in which the humans drink some fermented honey-based alcohol – an early, naturally fermented form of mead? – putting themselves into a state of utter intoxication and subsequent sickness. It is this drunken disorientation that allows Fa and Lok to steal into the encampment to take back Liku; a mission that is ultimately thwarted and ends with the Neanderthal infant being taken away for good in the *sapiens*' boat.

In effect then, the tree climbing episode becomes a symbol of refuge and secrecy in Golding's novel. In his work *The Experience of Landscape*, Jay Appleton identifies that a 'universal characteristic of primitive man, transmitted innately to his modern descendants, is the desire to see without being seen'.[41] The treetop is at once a refuge from physical harm and a place from which to observe 'the other', as much as it is symbolic of an atavistic throwback – as the 'inheritors' ourselves, all human ancestors were, after all, originally tree dwellers. As Roger Deakin writes, 'we are not so far away as we like to think from our cousins the gibbons, who swing like angels through the forest canopy.'[42] Perhaps this sense of kinship is why, at the end of Golding's novel, the humans make their get-away observing how the Neanderthals '"keep to the mountains or the darkness under the trees. We will keep to the water and the plains. We shall be safe from the tree-darkness."'[43] Some deep-seated human fear of the forest is enacted here, but at least the ability to climb trees is suggestive of a movement out of the darkness and into some kind of light. In this, Golding evokes the common metaphor of getting 'out of the woods', which is both literal and symbolically psychological at the same time. It also suggests a progressive sense of enlightenment and evolution.

In tree climbing episodes like this, then, the climbed tree is an emblematic space in which more enlightened decisions can be made. In Lok and Fa's case, decisions about when and how to best take Liku back: Fa reminds Lok that they will make their raid when it is dark. She knows the power of darkness in their cause, and yet expresses this while in the enlightened space of the treetop. The canopy is, paradoxically, a darkened space of enlightenment, for this is where they can be concealed and yet also the space where knowledge is gained. The liminal space of the treetop symbolizes that space of the human mind, which is itself rooted to the ground by the human trunk yet held aloft in the head; the simple mirroring of human body/tree trunk, and human head/canopy symbolizes the 'mind like' space of the tree's canopy. As such, knowledge about 'the other's' habits and behaviour; their

rites and ceremonies; their family and social structures and hierarchies; their beliefs and their child-rearing are all gained while up in the canopy/mind of the climbed tree. It is this emblematic mental space of the climbed tree that is of central importance in a great many tree climbing episodes, whether those be real, literary or artistic.

A story told of the conflicts between Neanderthals and *Homo sapiens* places these tree climbing concerns early on in the 'tree of life', a potent scientific metaphor, model and research tool since the days of Charles Darwin. Used to describe and represent the evolutionary development of species and the relationships between them, Darwin posits the metaphor in his canonical *On the Origin of Species*: 'The affinities of all the beings of the same class have sometimes been represented by a great tree. I believe this simile largely speaks the truth.'[44] If Darwin's metaphor of the 'evolutionary tree' largely speaks the truth for the evolutionary relationships of species, then that genetic idea has also spoken truth in the form of the 'family tree', or genealogical representation of descent and inter-relationships within individual human families.

A poetic embodiment of the idea of the family tree can be found in Thom Gunn's poem 'The Cherry Tree'. The Anglo-American poet, Gunn, offers an extended metaphor about a tree 'giving birth' to her leaves and blossom: 'there's something going on / in these twisted brown limbs, / it starts as a need / and it takes over', until 'tiny bumps / appeared at the ends of twigs.' This is the family tree personified. 'She wears them like a coat / a coat of babies'. When those babies (the cherries) fatten up, 'she can repose a bit', her work is done. She gives them away to the world; to birds, to men, to human children.[45] The idea of 'mother trees' is standard in both forestry science and scientific research in tree communication. Mythology, science, beliefs and symbols are, it would seem, deeply intertwined, like the roots and mycorrhizal networks of forests themselves. Life, death, regeneration. The tree is emblematic of it all.

The following chapter turns its attention to those 'fruits' of family – children – to explore the time-honoured and oftentimes cherished relationships between tree climbing and childhood. If there are prevalent attitudes against adults climbing trees, because of 'madness' or some other derangement, then surely the image of a child in a tree is a trusted and nostalgic one?

Notes

1 Michael Fish. https://www.bbc.co.uk/news/av/world-24713504
2 Ibid, p.*x*.
3 https://www.studiointernational.com/index.php/hurvin-anderson-interview-i-am-looking-at-where-things-collide-britain-jamaica-arts-club-chicago
4 Stephanie Kaza. *The Attentive Heart*, p.21.

5 Suzanne Simard. https://www.ted.com/talks/suzanne_simard_how_trees_talk_
 to_each_other
6 John Fowles. *The Tree*, p.78.
7 Ibid, p.31.
8 Peter Wohlleben. *The Hidden Life of Trees*, p.10.
9 Ibid, p.51.
10 Ibid, p.16.
11 Ibid, p.17.
12 Colin Tudge. *The Secret Life of Trees*, p.7.
13 Michael Cadnum. 'Climbing a Tree', p.39.
14 John Fowles. *The Tree*, p.11.
15 In Gary Andrew Poole. *Up a Tree, for the Fun of It*. https://www.nytimes.
 com/2005/01/07/travel/escapes/up-a-tree-for-the-fun-of-it.html
16 Stephanie Kaza. *The Attentive Heart*, p.89.
17 Victoria Bladen. *The Tree of Life and Arboreal Aesthetics in Early Modern
 Literature*, p.229.
18 John Muir. *The Mountains of California*. Ch. 8. 'The Forests'.
19 Samantha Walton. *Everybody Needs Beauty…*, p.93.
20 Lucy Jones. *Losing Eden*, p.109.
21 Philip Larkin. From 'The Trees'. *Collected Poems*, p.166.
22 Ibid, from 'This be the Verse', p.180.
23 John Fowles. *The Tree*, p.91.
24 Ibid, p.11.
25 Colin Tudge. *The Secret Life of Trees*, p.267.
26 James Aldred. *The Man Who Climbs Trees*, p.14.
27 Laura Beatty. *Pollard*, p.261.
28 Richard Mabey. *Beechcombings*, p.30.
29 Colin Tudge. *The Secret Life of Trees*, p.5.
30 Jack Cooke. *The Tree Climber's Guide: Adventures in the Urban Canopy*, p.11.
31 Richard Preston. 'Rumors of a Lost Continent'. In *The Wild Trees*.
32 Thomas S. Kraft, Vivek V. Venkataraman, and Nathaniel J. Dominy. 'A Natural
 History of Human Tree Climbing', pp.105–18. http://dx.doi.org/10.1016/j.
 jhevol.2014.02.002
33 All quotes from this tree climbing episode from Stephanie Kaza. *The Attentive
 Heart*, pp.178–82.
34 David Wagoner. 'Climbing a Tree'. In *Good Morning and Good Night*, p.34.
35 David Wagoner. 'Tree House'. In *Good Morning and Good Night*, p.33.
36 William Golding. *The Inheritors*, p.79.
37 Ibid, p.95.
38 Ibid, p.231.
39 Ibid, p.229.
40 Ibid, p.137.
41 Jay Appleton, cited in Sue Stuart-Smith. *The Well Gardened Mind*, p.76.
42 Roger Deakin. *Wildwood*, p.x.
43 William Golding. *The Inheritors*, p.231.
44 Charles Darwin. *On the Origin of Species*, p.129.
45 Thom Gunn. 'The Cherry Tree'. *Collected Poems*, pp.294–6.

6

The child in the tree

Tree climbing begins in childhood and, metaphorically, carries a person into adulthood through a process of 'individuation' (Jung).[1] Paul Batchelor's poem 'Tree Climbing' (2006) captures something of the childhood call to climb a tree despite the minor inconveniences of 'the rasp / of bark to palm', or that moment when you have to 'come down when they call'. Tree climbing, Batchelor asserts, 'is second nature'; there are 'no experts'. All you have to do is

> throw
> yourself off balance, wrap
> your feet around the branch you hold
> & from that new perspective see
> how the world hangs: head over heels.[2]

If watching children play on trees and climbing frames is evidence enough, Batchelor's feelings would appear to be commonplace among children. Climbing a tree and hanging upside down from a branch is the child's special preserve. Or, at least, tree climbing *used to be* so. Being part of what psychologists call 'risky play', tree climbing has recently come under fire from worried parents and teachers who, living in an increasingly litigious society concerned with Health & Safety, and worrying about their children sustaining injuries, have cracked down on the activity. It seems that children simply do not climb trees as much as they used to.

This chapter begins with a discussion of the benefits of such 'risky play' and finds parallels in literary representations, as in Andrew Miller's historical novel, *Ingenious Pain*. It examines some adult strictures about climbing – sometimes stemming from the childhood practice of 'scrumping' fruit from orchard trees – locating the imaginative thrills of childhood

climbing in mildly transgressive activities such as this. A childhood tree climbing essay by novelist William Golding explores ideas of authority and childhood transgression, while research in child psychology is shown to highlight significant benefits from climbing activities in children's emotional and social development, as well as their physical development. Children with ADHD and behavioural problems are particularly shown to benefit. Through a discussion of two Spanish paintings by Francisco de Goya, and Jose Maria Sert y Badia, the chapter develops ideas about individual and social benefits of childhood climbing, and discusses selected poems of childhood tree climbing which explore the child's discovery of freedom from adult responsibilities of politics and rule. Further psychological research into 'decision trees' (path choice), the well-known psychological 'Blob Tree' test, and therapeutic resources such as the 'Narrative Tree of Life Therapy', are discussed in relation to the process of individuation, by which children develop into whole, integrated and independent individuals. These matters are discussed with Cognitive Behaviour Therapy specialists, going on to examine questions of individuation and trauma recovery in two novels: one young adult novel, *Tree Girl*, by Ben Mikaelson, which explores tree climbing in the context of the Guatemalan civil war, and secondly Ian McEwan's 1992 novel, *The Child in Time*. In both examples, post-traumatic recovery and processes of individuation are shown to be essential results of their protagonists' tree climbing habits, developing the overall argument about the benefits of the 'Climbing Cure' posited in Chapter 4.

*

In 2014, Bristol City Council, UK, had planned to ban tree climbing in parks, but those plans were shelved after public complaint. In 2018, Wandsworth Borough Council, London, UK, planned fines of up to £500 for children climbing trees, since the activity was deemed unsafe and antisocial, annoying others who were also enjoying a day out in the park. After public and media outcry, the Council's plans were dropped. After all, what's the worst that can happen? Scraped shins, some minor cuts and bruises? A fall and a broken arm? Head injury? In reality, more children injure themselves badly by falling out of bed than they do by falling from a tree. In the UK, Accident & Emergency admission figures show a marked reduction in annual tree-falling accidents between 2000 and 2007, from 1,823 down to 1,067 cases. Children are more likely to injure themselves falling from bed – 2,531 cases in 2007, up from 2,226 in 2000.[3] The irony is that, in bringing children indoors and giving them free-rein on their computer and phone screens, the Health & Safety obsessed state might be doing its children a great disservice, adding to eyesight problems, repetitive strain injury in hands and arms, back

problems, and potentially adding to their mental health problems through lack of social contact and contact with the real world. Samantha Walton anecdotally confirms the feeling, describing how 'doing almost anything on my phone is bad for my anxiety and insomnia' since it 'sends me spiralling off on ludic loops and craving dopamine highs. The truth is, I'm better off when I'm using my phone less.'[4] If the same is true for children, then perhaps time outdoors doing such things as tree climbing, where possible, would be a more desirable alternative?

In an article for *The Conversation*, 'Should I Let My Kid Climb Trees?' Sasha Petrova interviews five experts – a teacher, an environmental educationalist, a PE lecturer, an injury epidemiologist and a paediatric surgeon who operates on children who have fallen out of trees – if they think it is still okay to let children climb. The answers from all five are a resounding 'Yes!' with one or two obvious caveats about common-sense safety precautions.[5] From these adults' points of view, climbing trees is good for children for many reasons. It helps with developing a sense of balance and muscular control (both fine motor control and whole-body coordination), and has overall beneficial effects on children's physical development. It improves hand-eye coordination, flexibility and spatial awareness, and it enhances a child's problem-solving abilities, along with their creativity. Children gain stronger muscles, better balance and confidence in movement. Researchers working with young children conclude 'Climbing is a central motor achievement for the developing child'.[6] And if they climb with other children, they are improving their social and cooperative skills as well. Climbing a tree gives children a sense of enjoyment, of confidence in overcoming risks and challenges and it connects them with nature, bringing all the potential benefits that the scientific research describes. Climbing teaches children to cope with the unexpected, as well as with failure. Outdoor play is spontaneous, imaginative, surprising and detaches children from their digital technologies, for a while at least, which has marked effects on their emotional and social development, self-awareness, personal sense of freedom and resilience.

Studies from the University of Illinois show that nature-based activities such as tree climbing can help children with ADHD – 'children with ADHD who play regularly in green play settings have milder symptoms than children who play in built outdoor and indoor settings. This is true for all income groups and for both boys and girls.'[7] Nature-based risk-taking activities such as tree climbing have also been shown to have an effect on children's near-sightedness.[8] Other studies from Norway confirm that 'risky play' reduces anxiety disorders and phobias in young children, through learning about fear in activities, particularly play where children can 'disappear', 'get lost' and 'play near dangerous elements' such as tall trees. Such studies from evolutionary psychologists and child development psychologists conclude that 'children will benefit psychologically from

natural adaptive fear alleviation and the anti-phobic effect of risky play.'[9] A study from the University of Phoenix concludes that 'children afforded the opportunity to be involved in risky play such as tree climbing have the potential to grow socially, emotionally, physically, cognitively, and creatively, and have increased resiliency'.[10] All the studies show what used to be basic common sense, but is now under threat from Health & Safety initiatives: safe tree climbing is good for children. Accordingly, the animator and entrepreneur, Leo Murray, recognized this and set up *Monkey-Do*, a risky-play organization, which fused his early work as a tree surgeon with his experience as a youth leader in an outdoor education charity. Murray brought children into close contact with trees and made innovations in designing woodland adventure playgrounds. Such projects allow children to climb and experience the risk, without any real danger of injury.

The dangers of childhood tree climbing are also present in literature. English novelist Andrew Miller's debut historical novel, *Ingenious Pain*, presents its readers with a mid-eighteenth-century narrative of the life of a surgeon, James Dyer, who suffers a strange affliction: he cannot feel physical pain. This manifests itself in many ways in Dyer's life, but one of them is his complete lack of compassion as an adult. Miller's novel has won appropriate praise for its innovations in historical fiction, but what is of particular interest here is the inciting incident: the reader discovers the young James Dyer's lack of pain sensation *because he falls from a tree*.

Sneaking away from a family summer wedding party, the young boy James comes to an old cherry tree, the tallest in the orchard: 'He climbs, smudging his shirt-front with lichen as he stretches up for the lowest branch, then swinging his legs, rotating his body until he is topside of the branch like a drowsy cat. He sits up, finds another branch within easy reach and sees how he may go from one to another as if ascending a spiral staircase.'[11] There is something fairy-tale like – Jack and the Beanstalk springs to mind – in that spiral staircase to the skies. James watches the birds stealing the cherries and pauses to eat the fruit himself, spitting out the pits to bounce off the lower branches, before continuing his climb, 'more carefully now as he feels the branches bow beneath him. The foliage thins, and then, among a tangle of delicate wood, as though he has hatched from a jade egg, his head is in the sky and he is breathing the tangy breeze and narrowing his eyes against the sun.' Again, the sense of smell is evoked here in the treetop; its power to evoke memories, but also its power to provide physical and mental benefits. James breathes in the 'tangy air' and watches the wedding party back in the yard of the house – the dancers and revellers – taking in the view of his local landscape. Suddenly one of the revellers sees him in the treetop and calls out: 'Down from there, James. Where's your sense, boy!' It is an admonition and a reflection of age-old attitudes towards tree climbers: they are foolish

and sense-less. In light of what is about to befall James, the word is also prophetic – once he has fallen, he will literally be senseless and unable to feel pain at all:

> James leans from the tree. The shouting stops. Even their hands freeze in front of them. He feels as if, stepping out, he will have no difficulty in flying. He stretches out his arms, gazes into the far ends of the afternoon. His weight passes a line, fine as a human hair, and then he is flying, amazingly fast into the green sky, and then nothing, nothing but the memory of flight, faint and fading, and the iron taste of blood in his mouth.

James breaks his leg. 'The foot hangs slack like a loose stocking,' Miller describes with an unerring eye for the queasily estranged image. But James just lies there as the doctor assesses the break: 'He has never seen a break so complete as this.' Miraculously, his leg mends quickly, but James feels nothing. His family are bewildered. James observes it all happening to him, as if from the outside, dispassionate and disconnected in his body's lack of sensation. And so the theme is set for what follows in the remainder of the novel.

So why *do* children themselves love to climb trees? The Florida Professor of child development, Christine Readdick, summarizes how children climb 'to procure some desired object'; 'to heighten their visual field'; 'to escape or overcome a barrier'; 'to lord it over playmates'; 'for the pleasure of practicing their new-found skill'; and 'for increased opportunities for acting "as if" or pretending'.[12] Readdick's list might be extended: because the tree is simply there; for fun; to test themselves; to be alone, and any number of unknown psychological, biological, or evolutionary impulses as previously discussed. But Readdick's first reason, 'to procure some desired object', is surely the most obvious. As James Dyer's fruit eating shows while he is up the cherry tree, scrumping (stealing fruit) is an obvious reason to climb. One gets to go up a tree *and* eat the fruit. Task and reward. It's a simple formula. The boy in Hurvin Anderson's earlier *Rootstock* painting seems to know this innately.

In his watercolour painting, *Scrumpers* (1867), Victorian artist Henry Towneley Green shows three young children gazing up longingly at the fenced-off apple trees.[13] 'Should we; shouldn't we?' they seem to be saying. 'Which one of us is going to do it?' The younger boy in front seems the most interested. In the background hangs the watchful, parental eye of the house; the gaze of patriarchal authority. The tree itself does not seem so tall – it's the forbidding fence that presents more of a difficulty. The climb into the tree will be a pleasure. There are obvious connotations here of forbidden fruit, with all the usual associations of innocence and experience. So it is that scrumping for forbidden apples includes some

of tree climbing's most obvious general pleasures for children: a sense of adventure and curiosity; of testing your own limits and capabilities. Of doing something transgressive that adults might disapprove of; for which one could get into trouble; for which 'your mother could really tell you off', as Andy Goldsworthy commented earlier. These qualities come to the fore for child climbers. Climbing trees is a small transgressive act. That watchful eye of the house's window is always there, overlooking childhood but, being out in nature and up a tree, it is not, which gives a thrilling sense of freedom, of the rules being relaxed.

While the three children in Towneley Green's painting are out playing together, tree climbers, however, often make their ascent alone. Children love to climb trees for that delicious sense of solitude that it offers, getting away from parents, siblings and the demands of friends. Such solitude brings with it a broadening of the imagination. Children start to indulge in fantasy play. This in turn changes their perspective. They forget themselves and imagine themselves as others or as animals. And yet children also get a great sense of self-satisfaction in knowing that they have overcome a set of small risks in getting up the tree. It feels good to concentrate; to look up into the branches and to plan the best route up. And down. They think for themselves and their parents' or guardians' voices fade away in the mind, leaving the child to rely on their own decision-making. This brings a sense of achievement that might not have been felt on the ground. A parent is likely to say nothing more than 'Look at the state of you!' when the child returns from climbing, and that's a risk worth taking. When the risks of the actual climb become too much, it also strengthens the resolve and will, or teaches how to cope with failure. Trying gives children that 'You can do it' feeling that helps them egg themselves on, followed by the 'I did it' rush that completes the climb and descent. 'It's fun,' children will repeatedly report back on their climbing. Nature writers such as Richard Mabey's work abounds with such recollections. These are the reasons children like to climb. There's a perfect symmetry in going up, and coming back down, by yourself. Climbing a tree is one of the simplest forms of pleasure one can take out there in nature as a child.

Considering the three boys in Goya's famous painting 'Boys Climbing A Tree' ('Muchachos Trepando a un Arbol'), it is easy to see just how many of these qualities are present in the scene Goya presents. The background combines the immense mountainous landscape to the left with an impressive castle on the right. The tree is, of course, also much larger than the three boys. The viewer gets a sense of growth and potential from the picture – from such small adventures of childhood, the greater adventures of adulthood (mountaineering, architecture and governance, from the painting's main symbols) will grow. The painting was a cartoon for one of the tapestries in Carlos IV's office at El Escorial. Painted in Goya's later years, there's a sense of nostalgia captured in these active children set against the light background.

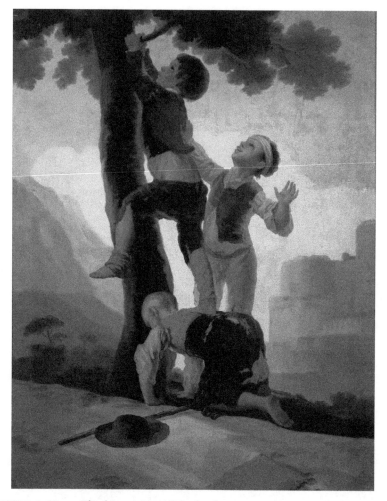

FIGURE 1 'Boys Climbing A Tree'/'Muchachos Trepando a un Arbol' (1790–92). Francisco de Goya y Lucientes. Painting for a tapestry. Oil on canvas. 141 × 111 cm.

In Goya's study, teamwork and social skills are also on display. Cooperation, friendship and support; both literal and metaphoric. From the scientific point of view, the boys are demonstrating all the benefits of tree climbing that the research shows: focus; fine and gross muscle control; hand-eye coordination; balance; flexibility and spatial awareness. They have clearly planned how to do this, who is to play which role in solving the problem of climbing this particular tree. Of the two faces that are visible, the climbing boy looks focused and confident. The other is gazing up and clearly enjoying the game. It all looks fun. There is also a sense of enjoyment and optimism in the bright colours, the airiness of the view and the bushy

welcoming nature of the leafy canopy. There is freedom here – the watchful eyes of the castle, like Towneley Green's watchful house window, are well in the distance. Authority is at arm's length. The boys can be boys for a moment. Preoccupations can be put aside – the boys' clothes are ragged, suggesting rural poverty. They are barefoot and the boy on all fours appears to have alopecia as well as torn britches. But climbing this tree they can concentrate on the small, transgressive pleasures of life, free from those hardships. They can concentrate on the here and now. The whole effect is joyful and liberating.

A similar sense of hopeful liberation can be seen in another Spanish painting of boys climbing a tree, Jose Maria Sert y Badia's 1932 panel *Stealing Apples* ('*Robando Manzanas*'), painted just four years before the Spanish Civil War broke out.

FIGURE 2 *'Stealing Apples'/'Robando Manzanas' (1932). Jose Maria Sert y Badia. Oil on panel. 99 × 149 cm.*

Jose Maria Sert y Badia (1874–1945) was a Catalan artist and muralist, who grew up in the studio of his father, an affluent textile factory owner. Sert y Badia produced tapestry cartoons and other fabric designs, and this interest in fabrics can be seen in his painting. While the boys' clothes are patched and ragged, there is something of the theatrical wardrobe about them, with the younger boy's floppy black rural hat and his almost Harlequin-esque jacket and trousers. His clothes seem to suggest that this is a performance – a performance of childhood itself, perhaps, or a

performance of naughtiness, of transgression. With all its connotations of Eden, the apple points to knowledge and experience that has, until now, been forbidden to the boys. The hint of Harlequin in the smaller boy's clothing suggests a staged mischievousness. The second boy wears some kind of drapery wrapped around his shoulders, as though he were a Roman Emperor, or a figure from a Renaissance fresco, which is unsurprising since Sert y Badia travelled to Italy where he studied Renaissance fresco painting. This influence can also be detected in the painting's well-defined figures, their strong gestural movements and the powdery palette of colours – from the baby blue waistcoat of the smaller boy and the summery sky with its cotton puff clouds, to the soft pinks in the other boy's face, his waistcoat and the draped fabric.

In its imagery, the painting is also bold and iconic. The two boys have climbed into a tree to scrump apples. But the tree is bare; not a leaf in sight, let alone any apples. In fact, the tree looks to be completely dead. If this is some kind of childhood Eden, then the adults have certainly laid the garden to waste. Is this tree symbolic then of the country the boys have inherited in the decades after the First World War? The smaller boy holds one sole apple aloft. Where did it come from; not from this tree, surely? The second boy mimics his friend's gesture, holding his hand up to the clouds. It looks as though he is giving a salute of victory and, in that sense, perhaps these young scrumpers prefigure the revolutionary youth of the Spanish Civil War? In 1931, just the year before the painting was made, Niceto Alcalá Zamora was head of State in Spain, returned to power with a large majority of Republicans and Socialists. America had just entered the Great Depression. The reformist Spanish government was trying to help its own rural workers by giving tenure to farm workers and instituting an eight-hour day. Perhaps these boys represent such rural poverty and the new Republic's optimism for them? But Fascism was also on the rise across Europe, as well as in Spain, threatening to unseat the reformers. In October 1931, Manuel Anzaña became prime minister of a minority government that eventually acceded power to the Right in 1933, following an unsuccessful uprising in August 1932. Eventually Franco's military coup would arrive and start the Spanish Civil War in 1936. Given that the painter had Right-leaning tendencies, perhaps these boys represent the upsurge of nationalist populism of the times? Or maybe the second boy's gesture is simply a painterly reference – there is certainly something of a benediction in his hand gesture; something almost Christ like in the benign curl of his hand.

What do all these contesting interpretations of childhood tree climbing signify in this painting? That youth is able to find life, even in the most barren of places? That nature will regenerate on her own? That the nation is in a dormant state and needs youth to make it fruitful again? Whichever it may be, there is a light and breezy airiness about the image that speaks of hope, adventure and positivity. Climbers can find metaphorical fruit even if they climb the most barren of trees, Sert y Badia seems to suggest.

*

In his short, memoir-come-essay 'The Ladder and the Tree', William Golding writes of the childhood 'enemy within' that plagued him growing up in a shadowy old house, in Marlborough, which stood on the Green next to the graveyard of the fourteenth-century church, St Marys. It was a 'house rooted in the graveyard', Golding writes, and all the more terrifying for that.[14] What bedevilled the young Golding were recurrent night terrors that 'came with the darkness' and reduced him 'to a shuddering terror that was incurable because it was indescribable'. The shadowy old house and the graveyard next door terrified the young boy. He was afraid of dying and of death itself. But he knew of a way of escaping these terrors: 'I climbed away from them.' Standing by the wall of their garden was a chestnut tree. 'I learned to climb that tree with a kind of absent-minded dexterity,' writes Golding. Contrary to the atavistic urges discussed on the previous chapter, Golding asserts that tree climbing appeals to elevated *human* instincts: 'There is something about a tree which appeals not to a vestigial instinct, but to the most human, if you like the highest, in a child.' It is the 'unvisited place, never seen before, never touched by the hand of man'. A tree is a final frontier. The last wilderness, Golding seems to suggest.

The chestnut tree in the corner of the Golding's garden was, then, his escape from the terrors of the graveyard and the shadows of the house. Golding describes how the tree was nothing more than itself – trees possess this kind of *quiddity*, this IS-ness – and it gave him a private place, a latibule, that was 'Safe from skeletons, from Latin and the proper requirements of growing up'. From this secret safe-haven, he listened to young girls wandering the village path beneath him, talking about what older boys would do to you when you grew up – 'They gets you down and pulls off your clothes' the girls speculate – and he watched the secret meetings of a pair of lovers who did, indeed, fumble inside each other's clothes until they realized that there was a boy watching them from above, and ran away in a fluster. He also read books in the tree and found a special kind of reading experience while on high: 'Crouched in the branches, lifted above fear, I had no doubt that if one frowned long enough at the page it would brighten and come alive. Indeed, it did. The words and paper vanished. The picture emerged.' The experience was so vivid to him, in fact, that he thought the tree and the moving pictures generated in his mind were one and the same thing. He associated that imaginative growth with the tree itself and, in literary terms, the tree certainly makes for an excellent metaphoric representation of imaginative growth.

Spending long periods of time in the canopy, the young William Golding became known amongst his friends. 'People were led to the garden, and I was pointed out to them, like a rare bird.' The recurring notion that tree climbers are, at least, 'a little unusual', once again raises its head. Golding's father

made him a ladder (of the essay's title) with which to attain the canopy of the chestnut tree more easily. But he fought with his father about learning Latin, which the young boy eventually knuckled down to. The rules and verb declensions of Latin were 'like a ladder which I knew now I should climb, rung after factual rung,' and the young Golding eventually mastered the disciplines of Latin, and grew up. As with Calvino's *Baron...* and other tree climbing narratives, family tensions are wound-up here with the act of climbing. Many years later, as an adult, Golding writes that 'I cut it down a few years ago with strangely little regret.' It's an extremely dispassionate response to a tree that cured him of his own fears and demons, and which figured strongly in his own processes of individuation.

Literary trees are filled with children like the young Golding. In William Wooten's sonnet-like poem, 'Waves', the reader is presented with a 'day's parade' when children have climbed up into the trees to watch the world go by. It brings to mind a nostalgic photograph, black and white perhaps, of scruffy little children high in the branches of some city street, with 'Lichen at their fingers and scraped knees', while a celebratory pageant rolls by beneath them – perhaps a village fete parade, a local carnival, a military homecoming. 'There are children in the trees,' writes Wooten, 'High above the day's parade.' The children look down on the faces of adults who, similarly, in their own childhoods, would have done the same thing – climbed the trees for a special perspective. The poem introduces ideas of cycles, of life and death, both through the poem's own cyclical form (the lichen line is repeated at the beginning and end) and through the mention of 'churchyard children at the graves / Of commoners and dignitaries / Who played' in the branches of trees as well. William Golding's chestnut tree adjoining the graveyard comes to mind, trying to come to terms with the presence of the dead (and death itself) in his own life. Climbing a tree, Wooten seems to suggest, gives that special, long perspective on 'grave' matters. Again, in a William Blake-like mood of innocence and experience, climbing a tree balances the sense of childhood innocence with that of the foreknowledge of dying. It's okay, the trees seem to say. They have seen it all before and will again. Since the poem is titled 'Waves', perhaps these trees are simply a reminder to balance that innocence and experience and to simply 'go with the flow'?[15]

Wooten's poem also hits upon something practical – people climb trees to get a better vantage – which turns into something more existential: the view from a tree is tied up with notions of mortality. In his book *Wildwood: A Journey through Trees*, Roger Deakin wrote of a visit to Lesbos. 'I have never seen so many people up trees as I did that afternoon on Lesbos,' Deakin writes. 'The entire population of the hill town of Aghia Paraskevi seemed to have climbed them, shinning up to every available perch in the branches of the long-suffering olives and pines along the dusty, crowded street to get a better view of the horse races.'[16] Climbing trees affords that practical ad*vantage*; the canopy yields a higher vantage point. But the

'long-suffering olives and pines' speak of something to do with the nature
of cyclical time and human nature: people have been doing this forever.
Deakin has only seen it the once, but people here have been shinning up the
trees for centuries. His sentence elevates the practicality of climbing to an
existential metaphor about the human relationship to the passing of time
and the fleeting experience of that. The character of Zacchaeus in the Bible
is evoked, who climbs into a sycamore tree to get a better glimpse of Jesus
over the heads of a thronging crowd. (Luke) Rise into a tree, such stories
and poems seem to say, and the climber will metaphorically 'rise above' this
earth-bound mortal lot.

That 'mortal lot' – like the practice of tree climbing itself – begins, of
course, in childhood. The 'better vantage' that climbers seek out from
childhood is implicit in Seamus Heaney's 1984 poem 'In the Beech', a
narrative poem that places the poet, as a boy, up in the branches of a beech
tree, during the Second World War: 'I was a lookout posted and forgotten,'
the poem begins.[17] Looking down he can see 'the concrete road' to one
side and 'the bullocks' covert' to the other. Heaney describes the tree itself
as both 'a strangeness and a comfort', unable to tell whether the trunk of
the tree was 'bark or masonry'. Up in the crown he is both in his element
and out of it; something found in many tree climbing narratives. The child
is simultaneously detached from the human world as he hides in the tree,
hovering somewhere between the human world of 'concrete' and 'masonry'
and a 'red-brick chimney' nearby – so antithetical to the natural image of the
tree itself – and the pastoral world of 'bullocks', 'churned-up mud', 'ivy' and,
of course, the tree in which he sits. The boy narrator also looks out upon the
covert world of military manoeuvres going on in the background: 'I felt the
tanks' advance' – there were British tanks and planes based in Ulster while
Heaney was growing up – and a close up of a fighter pilot in goggles passing
over the tree: 'And the pilot with his goggles back came in / so low I could
see the cockpit rivets.'

But the poem also hints at a more psychological, perhaps even Freudian
undertone, since the tree's crown is also the place where the boy 'discovered
peace to touch himself', an expression of self-pleasured sexual awakening
that is mirrored by the phallic imagery of tree, chimneys, steeplejacks and
military aggression. Woods and trees have erotic connotations and are
sometimes figured as sites of illicit love. The poem ends with the phrase
'tree of knowledge', which represents the carnal knowledge the boy gains
of himself, as well as knowledge of good and evil implicit in the military
manoeuvres. As Heaney himself noted, in a more innocent tone, during a
radio interview in 1984, 'It's one of those universal childhood reveries that
you remember being in a tree and the address and airiness of it, and the
secrecy and the removal from the usual world.'[18]

The same group of poems in Heaney's book *Station Island* also includes
the poem 'Drifting Off' where, again, the reader encounters the idea of

mental escape. The poem recounts a litany of bird species – albatross, gannet, rook, cuckoo and many others:

> In the camaraderie of rookeries,
> in the spiteful vigilance of colonies
> I was at home.[19]

which denotes not only Heaney's new-found childhood understanding of Irish bi-partisanism with its 'spiteful vigilance of colonies', and the uncaring character of the natural world, but also the tree-top paradox that lets the climber feel both 'at home' and simultaneously 'out of place' – lessons that are commonly learned in childhood.

<div align="center">*</div>

Psychologists have long used trees as metaphors for inner states and processes. In her book, *Between Earth and Sky,* Nalini Nadkarni writes about 'decision trees' – those branching flow charts, where each branch leads to a different outcome. Other common metaphors for this include 'the garden of forking paths', where one route is taken in preference over another, or poet Robert Frost's well-known 'The Road Not Taken':

> Two roads diverged in a wood, and I –
> I took the one less traveled by,
> And that has made all the difference.[20]

Taking the less-trodden path is an important decision in the process of creative individuation. But returning to decision trees themselves, Nadkarni goes on, tying the image of the decision tree back to her own tree climbing experiences in childhood as she imagined her future paths to adulthood:

> Each idea would start in my mind as a single point, a specific vision of what I wanted to be – a doctor, a dancer, a veterinarian, a cabin girl on a sailing ship – and then my imagination would branch into the multiple directions I would travel in the future to make that dream happen, branches as complex and ordered, as definite and mysterious, as the twigs at the tops of my tree.[21]

So it is that climbable trees yield metaphors about journeys of becoming, of individuation.

Therapists have also used the metaphoric tree as a model to get young people to open up and talk about their inner lives and experiences. There is, for example, a well-known test used in behavioural psychology – the Blob

Tree test, created by behavioural psychologists Pip Wilson and Ian Long. The test helps young people to recognize and strengthen their emotions in a therapeutic setting. It can also be used to help young people understand their social relationships. The image presented is of a tree being climbed by different 'blob' figures. Each 'blob' is in a different mood and has a different position on the tree. There are two parts to the test. First, the young person identifies the blob that they think most resembles where they are in life at the moment. Secondly, they identify the figure that they would most like to resemble. If they choose figures 1, 3, 6 or 7, for example, this indicates they are a resolute person, unafraid of difficulties or obstacles. Figures 2, 11, 12, 18 or 19 reflect their amiability and dependability with others. This Tree of Life helps therapists to explore where the young person sees themself as they first come into therapy. The metaphor of the Tree of Life has widespread occurrence in mythology, psychology, literature, evolutionary theory and spiritual beliefs. In the therapeutic context, it has narrative connotations concerned with identity and wellbeing. Essentially the Blob Tree is used as an external representation of the young person's internal world.

Dr Sarah Charles is a psychotherapist and Cognitive Behavioural Therapist who studied for her PhD in neuroscience. She works as the Operations Manager of a young persons' Wellbeing Service in Kent, UK. Dr Charles uses an adaptation of the Blob Tree resource with early age adolescents as an open-ended resource. 'It's useful at a time of unsettled transition, like changing schools, when young people's issues become more obvious,' she says. 'I do six sessions with vulnerable children,' Dr Charles reports. 'You're trying to make what's implicit – their feelings – explicit, through the metaphor of the tree. It's a way of showing change and progress. If it's a good therapeutic alliance between you and the young person, they will be able to talk freely about things by session six and make progress.'

Do the young people she works with question why she is using a tree? 'No,' she says. 'They accept it as a Tree of Life and just go with it. It just stimulates a lot of conversation.' For the therapist, there is already a set of 'answers' that the figures symbolize, but the process is not about telling the young person what the 'answer' is; it's about getting them to talk about their feelings, which can be intense and disconnected. 'It allows them to make those feelings explicit in an easy way,' Dr Charles says. How does she know if it's been a success? 'You never *really* know,' she replies, 'but they will tell you that they feel better, or different. It's different for each individual. You use it as a reference point and keep coming back to it, to discuss changes in their feelings and perceptions of themself.'

Not all the blobs on the tree are climbing – some sit, some play, some help others – but the climbing blobs specifically symbolize a young person trying to make progress. One of the climbing figures is climbing alone, another of the climbers is being given a leg up by a friend: 'They need support to get to where they want to go.' What happens, however, if the young person in therapy identifies as a 'positive' blob to begin with but, by the end of the

sessions, identifies as one of the others, perhaps a more negative-seeming one? 'That could be considered a positive outcome too,' Dr Charles explains. 'Some young people might identify first as one of the more positive blobs, because they are "people pleasing"; they are performing a kind of persona to keep their parents or carers happy. After doing some therapy they then say, "actually, this is how I *really* feel," so that's a more honest representation. Which is progress. They are beginning to be more self-aware.'

The symbol of the tree – through all its cultural, spiritual and natural connotations – can help to make a young person feel more self-aware. 'The tree is there a lot in mental health discourse,' Dr Charles says. 'It's an innate metaphor. A universal thing. The tree is a thinking space. A safe space.' As countless examples have already shown, and as tree climbing aficionado Jack Cooke confirms, 'There is nothing better for seeing the world more clearly than removing yourself a little distance from it'[22] up a tree, although some people who climb trees are, as Dr Charles goes on to point out, 'looking down on life, rather than living life. They're the anxious observer.' In this sense, tree climbing 'as escape' might also have fewer positive connotations than is first apparent: the notion that 'Yes, I'm free!' might actually be 'Help, get me out of here!', or another form of self-isolating. Cody Lee Miller in his Seattle sequoia tree would seem to be a good example. Dr Charles describes such climbers as 'Self protecting. Not *in* their life. Not fully present.' Many climbers, perhaps, house both kinds of climber inside them, and vacillate between the two as the climb changes from 'easy' to 'hard' and back again.

Dr Charles also presents a second tree resource that she uses with young people: the 'Narrative Therapy Tree of Life Project'. This resource was designed by *Ncube* (2006) in Zimbabwe, and developed further by the Dulwich Centre Foundation, Australia, an organization that supports individuals and communities facing mental health difficulties. The Tree of Life narrative technique was originally used by therapists to support vulnerable children, but it has since been developed for working with adults. It is, according to academic psychologist Samantha Lock, 'a flexible psychosocial, narrative approach that can be adapted to work with various populations to break barriers to help-seeking and support community connectedness, as well as with children and young people in various settings.'[23] Sarah Charles explains that the technique uses metaphors of the Tree of Life to get participants to explore memories and stories in an attempt to find strength, hope, strong values and connectedness to others. The tree is a metaphor for the body and provides a basis for a process of grounding. A traumatized person will often feel disassociated from their own body, as well as from others. Using the Tree of Life technique, group work allows for a reconstruction of individuals through shared experience and empathetic understanding. Participants draw a large outline picture of a tree with roots, trunk, branches and leaves, and then, with guided questions from the therapist, begin to add words to their drawing. The whole process might span five or six sessions, giving participants time to reflect on their lives.

Around the roots, the therapist asks participants to write words about where they come from, their memories and their family. The ground represents their present life and is the place to write about day-to-day activities. Up and down the trunk the therapist asks them to write words relating to their skills, abilities and values. The branches represent hopes and goals, wishes and aspirations. On the branches participants are encouraged to write 'leaf' words about the people who play important roles in their life, while hanging from the branches are 'fruits' – the things/values they have been given in life, along with what they feel they have given back. Around the tree participants might write words concerning 'storms' – the challenges that life has thrown at them, as well as their coping strategies.

'This kind of narrative technique,' Dr Charles says, 'is a bit of a mnemonic exercise. It helps young people attach specific memories or thoughts to a part of the tree, and that helps them hold them there and remember them. Parts of trees are very familiar to us all, so we don't forget what we've put there.' In doing this exercise, participants are, in some sense, 'climbing the tree' of their own life – climbing up into the branches of their imagination and delving down into the roots of their memories, to make sense of traumas in their lives. 'It's a very visual way of actively linking your internal story with something external. Again, it's about making the implicit become explicit,' Dr Charles explains. 'It creates a whole. Young people who are traumatized often feel very disconnected. The tree helps them start to make links and emotional connections between how they are *thinking, feeling* and *behaving* – the three central tenets of Cognitive Behavioural Therapy.'

In her academic review, 'The Tree of Life: a review of the collective narrative approach', Samantha Lock summarizes some of the many studies which show positive outcomes with the Tree of Life, with vulnerable Zimbabwean children and those affected with HIV; African and Caribbean men in Hackney, London; Vietnamese and Liberian refugees in Australia; and work with Latino communities in the United States. Lock notes that the technique 'is specifically fitting for providing people with opportunities to give a voice to their traumas, evaluate their interpretations, reconsider their identity, draw conclusions and re-author their lives.'[24] Participants create their own preferred narratives of their lives, coming to own them more fully and move forward free from the traumas of the past.

Dr Sarah Charles also affirms the collective benefits of this technique in her own work. 'The Blob Tree is done with individuals,' she says, 'but the Tree of Life Narrative exercise is often done in groups where it works very well.' Most real-life tree climbers, however, are solitary – they climb trees either for pleasure, to get away from it all, to think things through, or because they have mental health problems themselves, or are seeking some spiritual enlightenment, or any of the other reasons discussed in these pages. And, more often than not, they climb trees alone. The Blob Tree test is like that solitary climber in a social context. But the Tree of Life Narrative technique, used in groups, creates a metaphoric 'woodland of climbers'.

'Yes, traumatized individuals use this technique to share their experiences,' Dr Charles concludes, 'but there's something *collective* about the woodland or forest. It's trying to get people to remember, reaffirm and validate their positive qualities and strengths. We feel disconnected from these positives when we feel traumatized. This exercise helps us to reconnect to ourselves and others.'

*

One of the most traumatic narratives relating to tree climbing can be found in Ben Mikaelsen's *Tree Girl*, a novel for young adults. Its heroine is Gabriela, an indigenous Indian teenage girl from Guatemala, who likes to get away from village life by climbing trees. 'For as long as I can remember, trees have coaxed me to their branches in the same way light tempts a moth on a dark night,' Gabriela narrates at the start of the novel.[25] Her mother tells her that climbing trees takes you closer to heaven, encouraging her to climb, although the old women of the village express those safety-conscious opinions about climbing trees that have become increasingly prevalent. Trees can be dangerous, of which Gabriela is well aware, knowing the dangers of a fall. Her mother also tells her that she is a climber because she sees 'beauty the other children are blind to' and asks questions the other children can never think to ask. 'You sing and dream and love poetry,' she tells her daughter.[26] Here, tree climbing is associated with higher aesthetic instincts and inquisitiveness. Gabriela always climbs barefoot, like many tree climbers, to get a better feel for the tree. Because of her ability to climb, she earns the nickname Tree Girl, or *Laj Ali Re Jayub* in her native language, Quiché. During the celebration party of her fifteenth birthday – her *quinceañera* – she outwits a group of taunting boys, by climbing a high tree and pelts them with hard avocados. Thereafter she is known as Tree Girl.

But Gabriela's life changes irremediably when guerrilla warfare comes to her area and her brother, Jorge, is dragged away by fighters after he insults them. The context of the Guatemalan civil war is complex, but the struggle between government forces and communist rebel groups essentially revolved around long-standing issues of unfair land distribution. The United States had long been involved in suppressing communist and leftist forces in the country and supplied arms and money throughout the 1980s that were used against indigenous peoples, such as Gabriela and her family. They go looking for Jorge, but he has vanished. Throughout the novel, Gabriela finds 'sanctuary' in the forest: 'I found trust among the trees. If I sat as still as the air,' she says, 'owls and eagles would fly past, close enough to be touched. I never reached for them, because I knew how that would betray the forest's trust in me, and now, more than ever, I needed a place where I could trust and be trusted.'[27] In the trees, Gabriela finds a sense of balance with the natural world and a relationship of reciprocal trust – something sadly

missing in her war-torn country. Based on the real-life testimony of a young girl much like Gabriela, *Tree Girl* is a brutal and graphic depiction of the excesses of civil war, and men's cruelty to other human beings. Tens of thousands of indigenous people were raped, tortured and murdered during the genocide in Guatemala.

Events in the novel, as they did in the real war, deteriorate rapidly. Guerrillas come to her school, murder her teacher and all the other students. Gabriela saves herself by climbing a tree. Soon after, her whole family is also massacred when soldiers come to their village. She runs into the forest and escapes again, avoiding the soldiers whom she knows are intent on raping and murdering her. Gabriela flees north as a refugee and, during her flight, hides in the canopy of a *machichi* tree set in the middle of a village plaza, from which she is forced to endure watching the scene as a troupe of soldiers rape, torture and murder the inhabitants of the village – men, women and children all. It is a truly shocking passage, recounted by Gabriella in graphic detail. But the transformation that occurs in this instance is within her own consciousness: she feels that she is a prisoner in the tree, since she will be assaulted and murdered herself if she descends. Exhausted, nauseated, hungry and desperately needing to relieve herself, she endures watching the violence and, after the soldiers have razed the pueblo to the ground and gone on their way, she descends from the tree, overcome with survivor's guilt:

> Climbing that tree had not been an act of bravery. It was the act of a desperate coward. Everyone else had faced the soldiers except me. I had hidden while others died. By being a Tree Girl, I had been a coward. There was a time when trees brought me closer to Heaven, but climbing the tree in the plaza had brought me closer to Hell. I made a promise to myself that day [...] Never again would I climb a tree.[28]

It is a promise that she reminds herself of once again when faced with a *machichi* tree on her flight to the north: 'Tree Girl was a coward,' she remonstrates with herself, 'who sat in a tree and let a whole pueblo die. I would never again climb a tree. Tree Girl was gone forever.'[29] The sense of loss she feels at the murder of her family and people is made metaphoric by denying herself the one pleasure she used to know – climbing trees – the very thing that gives her a sense of identity. Tree climbing here, then, is transformed into a symbolic metaphor for post-traumatic stress; a cruel transformation.

Eventually, however, Gabriela arrives at a refugee camp where she is reunited with one of her younger sisters, Alicia, who has also survived the massacres and made her own way north, where they recover from the traumas of their experiences by learning to talk about them. In the end, it is the younger sister, Alicia, who makes the symbolic tree climb, which now symbolizes both girls 'trying to escape the past'.[30] Gabriela lifts her sister into the branches of a *machichi* tree and feels her little sister tug at

her: 'Imperceptibly at first, I reached up, my heart pounding, my body trembling as if from fever. Then I gripped the branch. Deliberately I lifted my feet off the ground and pulled myself up beside Alicia.'[31] Sitting in the branches again, Gabriela cries for her family and for the past and, in that moment, glimpses a possible future with hope that things will be better for both of them, their people and their country. It is in this moment that Gabriela realizes that a Tree Girl cannot

> blame themselves for things they can't control. Tree Girls know that when they climb they might fall. But they know also that climbing lets them visit the birds. They're strong enough to face the bad in life in order to know the good. They're strong enough to face pain so that they can also know hope. They're willing to risk the ugliness of life in return for the beauty they find. Tree Girls find beauty when nobody else dares.[32]

In this passage, tree climbing is restored to its original, beneficial function. Gabriela's identity is restored and her oneness with trees as a metaphoric symbol of balance, recovery and wellbeing, is made manifest once again. It is a literary metaphor that equates with the Tree of Life post-traumatic therapy practices. In his endnote to the novel, the author expresses his opinion that 'climbing a tree is a metaphor for life. We cannot live life to its fullest, breathing the clouds, without risking the climb,' he writes. 'That is why I knew that Gabriela, the Tree Girl in my story, needed to find the strength to climb again.'[33] So it is that, once again in fiction, tree climbing is presented not only as a literal activity of connection with nature, with all the wellbeing it brings, but also a psychological metaphor for individuation and wholeness – it cures shock and stress and, in this case, helps in the recovery from extreme trauma.

*

In Ian McEwan's 1992 novel, *The Child in Time*, the protagonist Stephen Lewis also experiences a traumatic event at the outset of the narrative – the abduction and loss of his three-year-old daughter, Kate. This event has far-reaching effects on his relationship with his wife, Julie, and deeply affects his own mental wellbeing. Stephen is a successful children's writer and has been serving on a governmental Official Commission on Childcare. Following Kate's kidnapping, he experiences several temporal hallucinations, such as seeing the apparitions of his parents through a pub window, some forty years earlier and just days after he himself was conceived. When he tells his mother of this hallucination, she admits to him that, at the time of his conception, she herself remembers being in the same pub and feeling the presence of a child outside the window. This synchronicity is one among a number of temporal devices that McEwan employs: time slows for Stephen in a dramatic car

crash with a lorry; he is haunted by the idea of Kate still living in a parallel quantum life. As such, the plasticity of time becomes a dominant theme of the novel, discussed at the individual experiential level, but also through the lens of particle and quantum physics with his friend, Thelma.

Thelma is a successful physicist, married to Stephen's publisher, Charles Darke. It is Darke's story that provides the tree climbing episode in the novel and a link to the discussion here of children's tree climbing. Darke moves from a busy city publishing company to become an MP, eventually resigning and retiring to the country with Thelma. The motives for Charles's retreat are not revealed until late in the narrative, when the reader discovers that he has, for many years, been visiting prostitutes who dress him as a schoolboy and spank him: 'He wore his short trousers and had his bottom smacked by a prostitute pretending to be a governess,' Thelma tells Stephen.[34] When Charles begins to build a tree house at the top of a tall beech tree in the grounds of his and Thelma's house, both Thelma and Stephen (and the reader) are unsure as to 'Whether Charles had taken a courageous journey into his past, or had simply gone mad in a sweet harmless way'.[35] The truth is soon revealed – '"It's alright, you can say it. He's completely mad,"' Thelma says – and, indeed, by the novel's end, Charles has committed suicide, walking out into a snowstorm to sit down at the base of his beech tree where he slowly freezes to death.[36] Here then is the mental health context for the tree climbing scene of the novel: Charles's inner psychosexual turmoil and Stephen's grieving hallucinations about time following the loss of his daughter.

When Stephen is called out to Thelma and Charles's house on a visit, Thelma sends him out to the woods to find her husband. Stephen sets out to look for Charles and, in doing so, experiences one of his temporal hallucinations. Beside a dead oak tree, 'a pillar of rotten wood' (that is surely a metaphor for Charles' corrupt and decaying adulthood), Stephen sees a boy step out from behind it. The boy stops and stares:

> 'Hullo,' Stephen said in a friendly way as he went forward. 'What are
> you up to?'
> The boy steadied himself against the tree while he lifted a leg and
> scratched above his ankle with the tip of his scuffed shoe. 'I dunno.
> Jus' waiting.'
> 'What for?'
> 'For you, idiot.'
> 'Charles!' As Stephen closed the gap and extended his hand he was not
> certain whether it was going to be taken. It was then Charles put his
> arms around Stephen's neck and embraced him.[37]

The 'apparition boy' initially appears from nowhere as a shock, and the reader is as disoriented as Stephen by his appearance. As the boy is further described in his nostalgic, English public schoolboy way, it becomes clear

that he has been climbing trees and getting into scrapes with his 'blood-streaked knees'. The handle in his pocket conjures a catapult. Time then collapses on itself and it becomes clear that the boy is, in fact, Charles, dressed up as a schoolboy. Stephen has seen him in his regressed state: 'Once a businessman and politician, now he was a successful pre-pubescent.' Charles whisks Stephen further into the woods to go and find the tree house that he has been building all summer. The shock of seeing his old friend in such altered light begs Stephen to ask questions of Charles's mental health: 'Perhaps Charles was in an advanced state of psychosis and had to be handled with care.'[38]

Charles takes them to the beech tree and points up to the tree house in the canopy. He starts to climb up, using a set of nails that he has banged in with a stone, in the fashion of a makeshift ladder. Charles proves himself an excellent climber, but Stephen is inexperienced and afraid, 'alarmed to find that he was already rather high up.' He dares not look up or down and keeps his eyes fixed on a woodlouse crawling along a branch in front of him. '"I think I'll take it bit by bit," was all he could say.' The climb is, then, a tense and anxiety-inducing affair, with several stops on the ascent to take in the view, to calm himself. 'He strained to hear a comforting sound from the ground. Even birdsong would have done. But up here there was nothing, not even the wind. It occurred to him fleetingly that he was engrossed, fully in the moment.' This Zen-like focus on the present moment is balanced with a longer view, 'One day I'll be doing something else. But he wasn't entirely sure. He knew that for now all he had to do was climb and let circumstances look after themselves', which is, perhaps, an equally Zen-like fatalism. 'I don't want to be doing this any more,' Stephen thinks. 'I want to do something else. Take me out, make this stop.'

Eventually the climb does end when he reaches Charles's tree house platform, where Stephen lies face down trying to suppress 'the sob rising in his throat' – the climb has reduced him to the vulnerable regressed position of a sobbing child. When he recovers his composure, he directly confronts Charles: '"Tell me," he said quickly, his words pitched higher by nausea and fear, "why are you behaving like a kid? What are we doing up here?"' Charles's response is to show Stephen his toy catapult and, after a brief demonstration, Charles simply says '"It's just' ... well, it's a matter of letting go ... "' Stephen is unsure whether his friend is talking about catapult technique or real life. For the reader, the (again Zen-like) insistence that happiness is simply 'a matter of letting things go' hangs heavily between the two friends. Stephen, of course, has his own things to let go of, not least his grief at the loss of his daughter. Charles's regression to his schoolboy incarnation is, in fact, a liberation for both Thelma and Stephen: 'Thelma no longer had to live with the secret all by herself' and, if only Stephen knew 'what he himself wanted, what he wanted to be, he could be free to carry it through'.

This episode brings together many of the fictional tree climber's key concerns. Tree climbing here is seen as an active motif in the process of

individuation, following one's desires and 'letting go'. It is intrinsically wound up with questions of time. There are sexual/Freudian undertones, and family conflicts. The climb also comes at a time of internal psychological conflict. This tree climbing episode places positive childhood representations of tree climbing against regressive, infantile ones. Time and again it seems, in real life and in literature, tree climbing episodes such as this imitate each other in remarkably similar ways. It is by climbing the tree and accepting Charles's regression that Stephen comes to understand something of his own relationship to time and to grief.

Notes

1 Paul Batchelor. 'Tree Climbing', p.8.
2 The psychological development of the individual into an integrated whole, as distinct from collective familial, or cultural, identity.
3 All figures from Claire Heald. 'What Can We Learn from Climbing Trees'. http://news.bbc.co.uk/1/hi/magazine/7358717.stm
4 Samantha Walton. *Everybody Needs Beauty …*, p.251.
5 Sasha Petrova. 'Should I Let My Kid Climb Trees?'. https://theconversation.com/should-i-let-my-kid-climb-trees-we-asked-five-experts-125871
6 Christine A. Readdick and Jennifer J. Park. 'Achieving Great Heights: The Climbing Child'. p.14.
7 Andrea Faber Taylor and Frances E. (Ming) Kuo. 'Could Exposure to Everyday Green Spaces Help Treat ADHD? Evidence from Children's Play Settings', pp.281–303. https://www.gwern.net/docs/nature/2011-taylor.pdf
8 Kathryn A. Rose, *et al.* 'Outdoor Activity Reduces the Prevalence of Myopia in Children', pp.1279–85. https://pubmed.ncbi.nlm.nih.gov/18294691/
9 Ellen Sandseter, Beate Hansen and Leif Edward Ottesen Kennair. 'Children's Risky Play from an Evolutionary Perspective'. https://journals.sagepub.com/doi/full/10.1177/147470491100900212
10 Carla Gull, Suzanne Levenson Goldstein and Tricia Rosengarten. 'Benefits and Risks of Tree Climbing on Child Development and Resiliency', pp.10–29.
11 All quotes here from Andrew Miller. *Ingenious Pain*, pp.80–3.
12 Christine A. Readdick and Jennifer J. Park. 'Achieving Great Heights', p.15.
13 https://en.wikipedia.org/wiki/Henry_Towneley_Green
14 All quotes taken from William Golding, 'The Ladder and the Tree', pp.167–72.
15 William Wooten. In Michael Mckimm, *The Tree Line*, p.62.
16 Roger Deakin. *Wildwood*, p.208.
17 All quotes from the poem here, Seamus Heaney. From 'In the Beech'. *Station Island*, p.100.
18 Irene de Angelis. 'Seamus Heaney's Arboreal Poetry'. In Carmen Consilio and Daniela Fargione. *Trees in Literatures and the Arts*, p.116.
19 Ibid, p.104.
20 Robert Frost. 'The Road Not Taken', p.1232.
21 Nalini Nadkarni. *Between Earth and Sky*, p.58.
22 Jack Cooke. *The Tree Climber's Guide*, p.8.
23 Samantha Lock. 'The Tree of Life', pp.2–20.

24 Ibid.
25 Ben Mikaelsen. *Tree Girl*, p.1.
26 Ibid, p.12.
27 Ibid, p.46.
28 Ibid, pp.137–8.
29 Ibid, pp.167–8.
30 Ibid, p.219.
31 Ibid, pp.220–1.
32 Ibid, pp.221–2.
33 Ibid, pp.225–6.
34 Ian McEwan. *The Child in Time*, p.200.
35 Ibid, p.182.
36 Ibid, p.121.
37 Ibid, p.107.
38 All remaining quotes here from ibid, pp.109–15.

7

The archetypal tree

As the American poet and Buddhist, Chase Twichell, writes in her poem 'White Pine', trees have always been emblematic; a 'witness / to my life'.[1] The speaker in the poem has found solace for their 'griefs' by pressing a cheek against 'a cone's rough open scales' and crying. The 'climb' here is metaphoric: she has wept her griefs into the 'high darkness / of their arms'. This emotional openness and the solace provided by trees echoes that found by many tree climbers. But it is the emblematic symbolism of the tree in the poem that reaches back to humanity's ancestral roots; to Lok and Fa in their canopy in Golding's *The Inheritors*, and to their Earth Goddess, Oa. It is to this emblematic ancestry that we now turn.

From summaries of sacred trees in religion and myth, to questions of bioengineering in contemporary novels, this chapter discusses some of the ingrained tree myths of Western literature and art, particularly looking at characters who are *transformed into* trees, or the spirits that *inhere* to trees. From Ovid's *Metamorphoses*, sacred oaks, spirits of *genius loci* and the inspirited trees of Osiris, Attis, Christ, Dionysus, to the pagan 'green cathedrals', medieval Green Men and the appearance of a tree-related Earth Mother in the 2009 film, *Avatar*, this chapter unpicks the narrative roots of Western literature and art's fascination with tree symbolism. It also discusses the idea of 'becoming tree' in myths of tree climbing, represented by Bernini's Baroque sculpture of the pursuit of Daphne by Apollo, and engages with such metamorphoses in poetry by Ezra Pound, to the commonplace tree transformations of fairy tales. Such transformation of human into tree, and the interpenetration of flesh and wood, is discussed in relation to D.H. Lawrence's appreciation of his favourite tree, beneath which he frequently wrote, and finds echoes in more recent ecocritical concepts, such as Jane Bennett's 'vibrant materialism' and the 'transcorporeality' proposed by ecocritic Stacy Alaimo, both of whom propose a two-way porosity between human subjects and their environments.

If there is anywhere, real or fictionalized, where trees most get beneath the human skin, it is surely in the transformational and symbolic world of the forest. In Jungian analysis, forests are symbols of the hidden, the unconscious and, in Freudian terms, the *unheimlich*. Through a discussion of some of Grimms' fairy tales, Sara Maitland's modern study of fairy tales, and paintings by contemporary artist Peter Doig, this chapter moves away from the 'dark', 'uncanny' connotations of the woods and argues in favour of the healing, aligning energies of forests experienced in tree climbing. An interview with the eco-psychologist and counsellor, Roselle Angwin, explores creative and therapeutic uses of the Celtic Tree-Moon Calendar, before bringing myth and biology back together in a discussion of tree climbing and bioengineering in Margaret Atwood's 2009 novel, *Oryx and Crake*. Each example helps to further the argument that in climbing trees, climbers are (in mythic terms at least) trying to 'become tree', playing out their 'inner green man or woman' through a process of ascent and metamorphosis, if only for the short duration of the climb.

<div align="center">✻</div>

The worship of trees has been significant throughout human history. J.H. Philpot made an early compendium of some of the mythology in her popular 1897 publication *The Sacred Tree; or The Tree in Religion and Myth*, covering tree religions and myths from across the globe since the birth of civilization. In Western culture the material is extensive and too varied to summarize here, but images of the Christ Child in a tree, for example, recur in the thirteenth-century 'wood-of-the-cross' and 'rood tree' legends, which trace the origins of the wood in Christ's cross back to the Old Testament, and sometimes to Paradise itself (being the tree from which Adam and Eve disobediently ate), as well as in the Grail Romances of Arthurian legend.[2] In his contested and problematic study of folkloric traditions and vegetation myths, *The Golden Bough*, Sir James Frazer documented examples of the worship of trees in the religious history of Europe, including rites involving May trees, Maypoles and Whitsuntide ceremonies, for example, as well as summarizing the relics of tree-worship in Europe, North America, the Indian subcontinent and East Africa. Frazer's text received wide academic criticism for its speculations, its *a priori* assumptions and its totalizing narrative: Ludwig Wittgenstein described it as crude, while other critics have dubbed it 'an embarrassment'.[3] And yet, *The Golden Bough* retains some popular appeal with influence upon numerous modernist writers: Robert Graves, T.S. Eliot, W.B. Yeats, James Joyce, Carl Jung and D.H. Lawrence, among others.

Writers on trees often talk about the 'green cathedral' effect of trees; building on the ancient idea of the 'sacred grove' inhabited by a *genius loci*, or spirit of place, where the sacred rites – the sacrifices (from Latin, '*sacra*

facio', 'I make sacred') – can be conducted. John Fowles writes: 'I am certain all sacred buildings, from the greatest cathedral to the smallest chapel, and in all religions, derive from the natural aura of certain woodland or forest settings. In them we stand among older, larger and infinitely other beings.'[4] This sense of the ancient is inherent to Western myths and spiritual beliefs around trees. In the *Metamorphoses*, Ovid writes of Ceres's sacred oak standing in such a grove, beneath which the Dryads held their festive dances. The move from 'sacred grove' to 'cathedral' is both a visual parallel and a political supplanting: the towering stone columns of medieval cathedrals mimic the massive trunks of trees; the stone vaults with their decorated corbels echo the branches of the canopy; the diffused patterns of stained glass find their predecessors in the light filtering through forest leaves. The sacred grove is a pagan space to enact natural rites and to commune with the nature gods, but it has been supplanted by the stone edifice of the official church. Official religion has suppressed and replaced its earlier, perhaps more transgressive, versions of human spirituality.

Tree spirits are prevalent in many cultures, from the dryads of ancient Greece, the Green Man of medieval Europe, the *kami* spirits of Japanese Shinto, which inhabit everything in nature, and the *kodama* of Japanese folk stories that inhabit trees. In the West, such 'inspirited' trees hark back to classical notions of trees as the abodes of gods and spirits, spirits of vegetation and other vernal spirits – the Greek god Pan, dryads (tree nymphs), Silenus (the Dionysian man of the forest), Silvanus (the Roman deity of the woods), Fauns, Satyrs and others. These inspirited trees connect the underworld of roots (where the dark deities of death and regeneration abide) with the heavenly world of the skies (where the sun and moon deities live). And one doesn't have to believe any of these myths to climb a tree and appreciate their legacy – they are culturally embedded, recurring in stories, films and, of course, capitalized upon in advertising. In the past, gospels were read out beneath the boundary trees as villagers 'beat the bounds' of the parish in the medieval ceremony of Perambulation. Along with such practices, trees have been decorated and hung with ribbons and other keepsakes at holy wells for millennia. Sacrificial skins and straw figures have been hung in the branches of trees and effigies affixed to the top of trees, left there throughout the year to symbolize wood spirits.

In Greco-Roman mythology, the water spirit, or naiad, Daphne, is chased by the god Apollo. Apollo has angered Eros (Cupid), who punishes him by striking him with a golden arrow and making him fall in love with Daphne. To spite Apollo further, Eros strikes Daphne with a leaden arrow, which repulses her from Apollo's advances. What is more, Daphne has already promised herself to a life of chasteness. Things have been set up to end in nothing but disaster. Blinded by his love, and refusing to take no for an answer, Apollo pursues Daphne and, at the moment he grasps her to kiss her, she is turned into a laurel tree. In his *Metamorphoses*, the Roman poet Ovid describes the moment: 'a heavy numbness seized her limbs, thin bark

closed over her breast, her hair turned into leaves, her arms into branches, her feet so swift a moment ago stuck fast in slow-growing roots, her face was lost in the canopy. Only her shining beauty was left.'[5] Apollo then embraces the nymph-turned-tree. 'My bride,' he cries, 'since you can never be, at least, sweet laurel, you shall be my tree. My lure, my locks, my quiver you shall wreathe.'

Gian Lorenzo Bernini's life-size marble statue, sculpted between 1622 and 1625, depicts the climax of the story, capturing in marble the transformative moment of Daphne 'becoming tree'; the nymph's fingers are turning into leaves, her feet into roots, her hair becomes the foliage of the canopy.

FIGURE 3 *'Apollo and Daphne' (1622–25). Gian Lorenzo Bernini. Life-size marble.*

There is an enormous amount of Baroque energy at play in the sculpture. The sweeping, upward arc formed by the arms and legs of both figures moves the viewer's eye dynamically up from earth to air. The hanging cloth around Apollo's waist seems to flow in the wind, beginning at his hips and curving around his back and shoulders in a wide, sweeping arc of cloth that brings the energy around to Daphne's midriff, where her skin changes into bark, almost as though she were inside a hollow trunk.

Delicate leaves sprout from Daphne's leg, pointing towards her pursuer's groin. Apollo's left hand is placed around her torso, giving the impression of a charged, erotic dance. His right hand trails behind, its wrist cocked, fingers tentatively splayed, to suggest his moment of recognition that something is going wrong. Both figures' legs are in fluid motion, although Daphne is becoming rooted. The emotion is palpable: Daphne's face contorts in shock as she realizes what is happening; as she realizes that escape from Apollo's advances comes at the cost of being turned into inhuman, earthy matter. There is also a tangible sense of loss on Apollo's love-struck face: Bernini seems to have captured him in that moment when passion turns to bewilderment, to recognition and, finally, to regret. Visitor reports from the gallery claim that the looks on the figures' faces seem to change depending on where you view the sculpture from. Bernini planned for the sculpture to be placed against a wall and for his viewers to see it from the side, so that the whole effect could be grasped in an instant, with the reactions of both figures visible at once. But the sculpture is now placed 'in the round', so viewers can circle it. Standing in front of the sculpture, the shadows in the marble seem to change the emotion. As the Borghese Gallery describes: 'Daphne is not so worried anymore, but Apollo is terrified and desperate. Bernini combined in his work the contradictory principles of images.'⁶ The technical facility on display in the sculpture is remarkable – marble is an unforgiving medium, and yet Bernini manages to convey delicacy, yearning, energy, sexual appetite, dynamic movement and contradictory opposites, with complete mastery.

Everything about this sculpture and the myth on which it is based is about transformation. In Ovid's work, ideas become stories and stories become words – first in orality and, later, in written text. The written word becomes myth and those myths become metaphors for the way people live their lives. This particular mythic metaphor is still highly prescient – in this 'Me Too' age, Bernini's sculpture and Ovid's cautionary tale both speak powerfully about the relentless sexual pursuit of a woman by a man who cannot accept no for an answer. The transformation also happens on other material levels too: human flesh becomes wood in the myth and, in Bernini's sculpture, everything becomes marble that mimics human flesh and drapery and wood. The materials – and the concepts – shift back and forth in imagination. Everything is in flux. Nothing is static. And yet still it seems to be so. To relate this back to the central image of climbing trees, being in a tree – being human flesh and blood and mind, in an organic,

non-human tree – conveys some of these paradoxical qualities of flux and transformation. Climbing confers a sense of change, of metamorphosis, of becoming – if only for a while, or in the imagination, before the climber has to come back down to earth again.

After Apollo declared that hereon after 'my locks, my quiver you shall wreathe', the laurel wreath became symbolic as a crown to designate victorious athletes in games associated with Apollo and, for a long time after that, for leaders, poets and musicians. The title 'Poet Laureate' preserves the tradition – a poet decked in a crown of laurels. Thus, the emblematic figure crowned with leaves finds their way from myth, into folkloric practice and into literature. He abounds in different manifestations across time and place: the Green Man of medieval England, whose open mouth spills forth abundant foliage and greenery. 'The leaves flow from him like poems or songs,' Roger Deakin writes.[7] He is present in the figures of the Green Knight of the Sir Gawain legend; Green George; Jack-in-the-Green; the Little Leaf Man and others. His female counterpart is the Green Woman, or Sheela-Na-Gig, usually depicted in stone carvings as a primitive female form holding open her own vulva to give birth to foliage and vegetation. Or Mother Earth. In Golding's novel, she is the fictional earth Goddess, Oa. In James Cameron's 2009 film *Avatar*, the blue Na'vi creatures of the planet, Pandora, live in harmony with nature and worship a mother goddess called Eywa and a symbolic Tree of Souls. These powerful symbols have persisted into the age of the virtual reality avatar. As John Fowles writes, 'One of the oldest and most diffused bodies of myth and folklore has accreted round the idea of the man in the trees. He possesses the characteristics of elusiveness, a power of "melting" into the trees, and I am certain the myth is so profound and universal because it is constantly "played" inside every individual consciousness.'[8] If Fowles is right, then perhaps all tree climbers, both factual and fictional, are playing out their own 'inner green man or woman' by climbing up into the branches and 'melting into the trees'?

Returning to the roots of these symbols, Ovid's *Metamorphoses* tells of other tree transformations. Erysichthon cuts down the goddess Ceres's sacred oak tree and is punished by a visitation of Famine. In Book Ten of the *Metamorphoses*, Myrrha, the mother of Adonis, is transformed into a myrrh tree while praying: 'the earth closed over her legs; roots grew out and, stretching forth obliquely from her nails, gave strong support to her up-growing trunk.'[9] While in this transformed shape of the myrrh tree, Myrrha gives birth to Adonis, the fruit of her incestuous congress with her father, Cinyras. The aromatic resin that exudes from the tree has been used as a perfume, incense and medicine since time immemorial. It has antiseptic properties and has been used as an analgesic for toothache, as well as in ointments for bruises, sprains and aches. It is used in Ayurvedic and traditional Chinese medicine and has purported benefits in treating indigestion, ulcers, coughs and colds, asthma, lung congestion, arthritis and even certain cancers. Legend has it that the resin is formed from

Myrrah's tears. As Peter Fiennes writes, in Ovid's world 'The boundaries are permeable'[10]; the mythic transformations make sense of the transformational powers of the tree's products. Myths, like medicinal compounds such as myrrh, or the healing phytoncides of forest bathing trips, are seen to be remarkably powerful things.

Tree transformations crop up repeatedly in Ovid's world, and in other works based upon Ovid. In his early-twentieth-century poem, 'The Tree', American poet Ezra Pound makes allusions to two of Ovid's myths: those of Daphne and Apollo, and then the story of Baucis and Philemon. Pound conjoins the two with a moment of modernist epiphany, in which the speaker visits a wood and, like Daphne, becomes a tree: 'I stood still and was a tree amid the wood, / Knowing the truth of things unseen before.'[11] In their tree-like rootedness and silence they imagine the transformation of Daphne and ponder, briefly, on that bitter love story. Being amongst the trees and in nature lets the narrator see both nature and their own love in new ways – they come to understand 'many a new thing' about nature and love that had previously seemed foolish to them. Perhaps the narrator had, at first, loved too ardently and blindly as Apollo had done, and lost his love as a result? The parallelism of the myth and poem would suggest something of this kind.

The second myth alluded to in Pound's poem, through the introduction of a 'god-feasting couple', is that of Baucis and Philemon. The myth describes how, when the gods Zeus and Hermes come to earth and take the form of wandering travellers, they are rejected by everyone they encounter in the village, save for the poor old couple Baucis and Philemon. The couple are symbolic of an ideal love – Philemon means 'one who loves'. The old couple give all they have to Zeus and Hermes who go on to enact the wrathful morality of the tale – in the consistently vengeful manner of the old gods, they destroy the village in a great flood and reveal their true identity to Baucis and Philemon. The old couple then dedicate a temple to the gods and, when asked what they would like as reward, simply ask that they might die together so neither should experience grief and loneliness. Instead of dying, the two are transformed into two trees at the time of death – an oak and a linden (lime) tree – that grow entwined as a symbol of undying love. Pound changes the linden tree to an elm in the poem and, like the characters in the myths he evokes, the observer of his poem is transformed by nature, as well as by love. Becoming a tree allows him this revelation:

Nathless I have been a tree amid the wood
And many a new thing understood
That was rank folly to my head before.

The poem reifies these transformative physical, emotional and psychological effects of 'becoming tree'.

If the interpenetration of the human with the tree has classical antecedents, then the impulse has found reiteration through Romantic poetry, into the

twentieth century and also into present day ecocritical thinking. In his epic poem, 'Childe Harold's Pilgrimage' (1812–18), Lord Byron writes how: 'I live not in myself, but I become / Portion of that around me,' going on to venerate the interconnectedness of nature in the lines

> I can see
> Nothing to loathe in nature, save to be
> A link reluctant in a fleshy chain,
> Class'd among creatures, when the soul can flee,
> And with the sky, the peak, the heaving plain
> Of ocean, or the stars, mingle, and not in vain.[12]

The intermingling of self with wider nature here – with mountains, with 'a fleshy chain' of creatures (a proto-evolutionary image) – and with the vast elemental forces of the ocean and the cosmos, is echoed by the same 'mingling' and sense of interconnectedness found in Percy Bysshe Shelley's poem of just one year later, 'Love's Philosophy' (1819), the first stanza of which begins: 'The Fountains mingle with the River / And the Rivers with the Ocean,' proceeding to comment upon how:

> Nothing in the world is single;
> All things by a law divine
> In one spirit meet and mingle.[13]

In addressing such 'mingling' to the recipient of this love poem, Shelley captures in lyric form his notion of a universal erotic impulse in nature. The impulse is developed further still in the neo-Romantic eroticism of D.H. Lawrence. In his book on psychoanalysis and the unconscious, *Fantasia of the Unconscious*, Lawrence comments, 'It's no good looking at a tree, to know it. The only thing is to sit among the roots and nestle against its strong trunk.'[14] Accordingly, Lawrence often wrote leaning up against a tree; a big pine-tree that rose 'like a guardian spirit in front of the cabin where we live' on a ranch in the Rocky Mountains.[15] Much of the time Lawrence describes how he simply lives 'beneath it, without noticing', but every once in a while is drawn to upgazing and realizing 'that the tree is asserting itself as much as I am. It gives out life, as I give out life. Our two lives meet and cross one another, unknowingly: the tree's life penetrates my life, and my life, the tree's. We cannot live near one another, as we do, without affecting one another.'[16] Both Byron and Shelley's 'mingling' feel implicit to Lawrence's sense of inter-penetration. He goes on: 'I have become conscious of the tree, and of its interpenetration into my life,'[17] concluding that 'what does life consist in, save a vivid relatedness between the man and the living universe that surrounds him.'[18]

Lawrence's ideas find echoes in the ecocritical writings of Jane Bennett, some ninety years later, who discusses in her neo-materialist book, *Vibrant*

Matter, how material entities (such as trees) are not 'passive objects or stable entities (though neither are they intentional subjects)', being instead what she calls 'vibrant materials', echoing Lawrence's 'vivid relatedness'. Bennett explains how she is 'looking for a materialism in which matter is figured as a vitality at work both inside and outside of selves',[19] hinting at the porosity of the human subject, who both affects and is affected by the environment in which they live. Citing the American philosopher, psychologist and educational reformer, John Dewey, from his work *Art as Experience*, Bennett discusses the 'porosity of the border between a human body and its out-side', reiterating Dewey's opinion that 'The epidermis is only in the most superficial way an indication of where an organism ends and its environment begins' and acknowledging the 'dependence of the self for wholeness upon its surroundings'.[20] Such thinking leads Bennett to the conclusion that if human culture is indistinguishable from the 'vibrant, non-human agencies' which are within and without it, then our environmental ethics must go beyond the human individual and human collective towards 'the (ontologically heterogeneous) "public" coalescing around a problem.'[21] In other words, 'we cannot live near one another, as we do, without affecting one another', as Lawrence has it, which would include such non-human entities as trees. Trees are themselves a part of a 'public' that coalesces around an environmental concern, as Bennett describes it.

This enmeshed notion of 'porosity' finds further echoes in other recent ecocriticism, such as Stacy Alaimo's work on 'transcorporeality': 'transcorporeality means that all creatures, as embodied beings, are intermeshed with the dynamic, material world, which crosses through them, transforms them, and is transformed by them.'[22] Like Jane Bennett, Alaimo suggests an entangled, post-human world of agencies (and ethics) that goes beyond simple ideas of ecological interconnectedness. It is this porous, entangled world that the tree climber participates in as they 'get to know' the tree (Lawrence), rather than simply looking at it, a feeling so profound in Lawrence's own experience of his porousness that he wrote: 'I would like to be a tree for a while [...] I lose myself among the trees. I am so glad to be with them in the silent, intent passion, and their great lust. They feed my soul.'[23]

Writing of her childhood in the Southern United States at the end of the twentieth century, writer and naturalist Janisse Ray describes how 'Something happens to you in an old-growth forest' – you slow down until you feel that the blood in your veins 'has turned to sap'. The metaphor is, again, one of 'becoming tree'. Ray goes on: 'You hanker to touch the trees and embrace them and lean your face against their bark, and you do. You smell them.' This sensory-based immersion in trees (this 'forest-bathing') leads to further transformation, to *transcorporeality*: 'The trunk is your spine, the nerve centres reaching into other worlds, below ground and above,' writes Ray.[24] Buddhist teaching also collocates such ecological thinking with spiritual awareness and the Lawrentian nourishment of the 'soul', in the

Lotus Sutra which, among other matters, speaks of the unity of the universe, as well as in Mahayana Buddhist thinking about 'interbeing' as encapsulated by the metaphor of Indra's Jewel Net, which describes the interpenetration and interdependence of everything in the cosmos,[25] or what contemporary ecocritic Samantha Walton describes as the 'complex, entangled ecosystems that we're a part of, and that invite us in'.[26]

*

Mingling, entangled, 'transcorporeal' bodies abound in Greek myth, often in association with trees. The Greek god Dionysus, also sometimes referred to as 'Dionysus of the trees', comes from the tradition of inspirited trees – in his case, almost literally 'inspirited' with the spirits of alcohol. As a god of the vine harvest, religious fervour and ecstasy, Dionysus was the patron of grapes and cultivated fruit trees, and rituals were performed in his honour to make trees bear fruit. The reader recalls William Golding's band of *Homo sapiens* intoxicating themselves in *The Inheritors* on their alcoholic fermented honey – a primitive precursor to the honey wine, Mead – unaware that they are being watched from the trees by Lok and Fa. The Dionysian parallel is also echoed in Thomas Hardy's 1887 novel, *The Woodlanders*, in which the young Grace Fitzpiers (nee Melbury) imagines her true love, Giles Winterborne, 'as the fruit-god and the wood-god in alternation: sometimes leafy and smeared with green lichen, as she had seen him amongst the sappy boughs of the plantations: sometimes cider-stained and starred with apple-pips, as she had met him on his return from cider-making'.[27] In Grace's imagination, Winterborne might be the Green Man and Dionysus rolled into one attractive, god-like, intoxicating man. Winterborne fuses Greek myth and medieval lore in a paradoxical figure. As Roger Deakin writes, 'Like the two masks of Dionysus that still represent the modern theatre, the Green Man is both playful and terrible [...] paradox is his very nature.'[28] For Grace, in Hardy's novel, Giles Winterborne certainly embodies that sense.

If the myth of the Green Man seems ubiquitous, then so is the symbol of the Tree of Life. According to Jewish mythology, in the Garden of Eden there is a tree of life, or tree of souls, that blossoms and produces new souls, which fall into the 'Treasury of Souls'. The Angel Gabriel reaches into this treasury and takes out the first soul that comes into his hand, before conferring it upon a human body at birth. The tree is emblematic of a fresh start, positive energy, good health and a hopeful future. The tree also suggests immortality. It ages and yet it brings forth seeds that replicate it. Trees endure. As do their symbolic meanings. Hazel twigs have long been used for divining water and the hazel tree itself, like the apple tree of the Bible, used to be thought of as a tree of wisdom; its nuts were thought to be the food of knowledge. In her 2021 book, *The Tree of Life and Arboreal Aesthetics in Early Modern*

Literature, ecocritic and early modern scholar Victoria Bladen examines the motif of the Tree of Life and what it meant to early modern writers. Tracing its biblical, classical and folkloric antecedents, Bladen shows how the Tree of Life related to representations of Christ, the cross and of Paradise; ideas of death and resurrection; conceptions of the self, and even the condition of the political state and royal lineages. 'Expressing immortality, conceived as an endless source of life and rejuvenation, it has traditionally evoked the idea of paradise. Imagined as a cosmological structure, the tree of life as world tree constituted an axis linking heaven, earth and the underworld.'[29] Bladen shows how early modern writers imagined 'the self in arboreal terms', using 'the tree of life to imagine the life of the soul and their relationship with God, thus figuring their poetry as sacred fruit.'[30] Early Modern writers, Bladen argues, saw the Tree of Life as 'A key motif for understanding the human condition as suspended between the divine and the material'. Trees, in this sense, may be seen as the ladder between 'those distinct yet interlinked spheres'[31] and, in climbing them, the climber enacts the symbolic ascension of the material self to the heavenly or spiritual one.

The Celts believed that trees were actually their ancestors re-embodied and were gatekeepers to the Otherworld. As such, the Tree of Life in Celtic mythology was sacred. The Celtic formation of *idir eathara* – that in-between-ness that is neither boundary, nor inside or outside – finds embodiment in the trees that stood as gateways to the Otherworld. The Celtic Tree of Life becomes an emblem of *idir eathara* itself, representing the afterlife, and connecting Earth with heaven. The Celts may well have adapted their tree of life symbol from the Norse Legend of the World Tree – Yggdrasil, the source of all life on Earth in Norse myth, which represented the cycle of birth, life, death and rebirth. As the anonymous thirteenth-century *Poetic Edda* describes:

The ash tree Yggdrasil
Endures more pain
Than men perceive,
The hart devours it from above
And the side of it decays,
Nidhogg is gnawing from below[32]

showing just how this Norse version of the Tree of Life existed in a perpetual cycle of rebirth, growth, decay and being eaten. In ancient Egypt too, the tree of life symbolized both death and abundance, with the branches representing the heavens, the tree symbolizing the centre of the universe and the roots reaching down into the underworld. The tree of life is also related to the biblical 'tree of knowledge', of which Adam and Eve ate and precipitated their expulsion from Eden. And all of these mythical trees are part of a worldwide symbol, 'the world tree' that is portrayed in various Indo-European, Siberian and Native American mythologies and religions.

What these myths, legends and beliefs point to is that woods are powerful, revelatory places, deeply embedded in diverse cultures, providing persistent metaphors, symbols and myths for external and internal natural processes. Tree climbing aficionado Jack Cooke writes that 'trees offer escape for mind and body, and we come closer to legend every time we step into them.'[33] Woods and forests are traditionally home to the unfamiliar, the weird and to unknown threats. Peculiar things happen in the woods, as Alice found out when she landed in *Wonderland* on the other side of the eponymous looking glass. Such tree-framed peculiarities range from the fairly benign weirdness of the teddy bears having their picnic, to the horror movie terrors of *The Blair Witch Project*. What one knows and understands in everyday life often does not seem to apply in the woods. As well as being slightly on guard amongst the trees, it is also possible to relax everyday rules and let the body and mind wander. That duality is ever-present: how wondrous and soothing to see a deer fawn in the woods; how weird and unsettling to 'see' it turn into a Faun, half human, half animal. The enclosed embrace of trees seems to permit both. As Peter Fiennes writes, 'It is safer, but weirder, in the woods.'[34] The woods are, to rally Freud's concept, *unheimlich* – they are *uncanny*: strangely familiar, unfamiliar, eerie and taboo all at the same time. They cover up hidden things that may either remain hidden or be brought to light.

Woods are, accordingly, the realm of fairy tales, of lost children, witches in gingerbread houses, talking trees, hungry wolves and lost little girls in red bonnets. Wild green men live there with foliage spewing out of their open mouths. Outlaws. Rumpelstiltskin. Folk are afraid of the woods and yet strangely drawn to them. Oberon and Titania live there casting mischievous spells on each other and upon unwitting village folk who blunder into their terrain. The impish Puck can drop a liquid into a sleeper's eye and, before they know it, their head has been turned into that of an ass. Dark and dangerous things happen in the woods.

The Swiss psychiatrist, Carl Jung, likened the forest to the unconscious mind, examining the archetypal nature of the fairy tale characters who inhabit it. The unconscious forest is, thus, enchanted. In Jungian terms, the forest is both outside of the mind *and* inside it. The trees give cover, but the trees of the mind cover things up too. As arboreal botanist Nalini Nadkarni writes, 'Trees symbolically manifest the importance of that which is hidden,' echoing the psychoanalytic tradition. 'Tree roots can also symbolize that which we keep hidden from ourselves and others,' she goes on, 'our troubles, our failings, our addictions, our ill health, and our fears. We know that revealing these hidden roots to our spouses, our friends, our pastor – and most of all to ourselves – is the first step toward finding the strength to overcome them.'[35] These tensions between the visible and the hidden have meant that forests have always yielded rich metaphors for the psychological life. As Victoria Bladen writes of the English poet Andrew Marvell, 'For Marvell, the forest is a space of the mind,'[36] acknowledging that forests

are psychological spaces that hold their secrets, revealing them only slowly. Returning to the memoir of American naturalist, Janisse Ray, Ray captures this notion concisely in writing of her childhood experiences of old-growth pine forests in Southern Georgia, 'A forest never tells its secrets but reveals them slowly over time,' she writes.[37] Each of these writers knows that forests yield, but that they yield slowly. As Sara Maitland concludes in her book, *Gossip from the Forest* (2012): 'The forest hides things; it does not open them out but closes them off. Trees hide the sunshine; and life goes on under the trees, in the thickets and tanglewood. Forests are full of secrets and silences.'[38] Druids meet in sacred groves, climbing oak trees to cut the mistletoe, as the Roman philosopher Pliny records it in his *Naturalis Historia*. Naked acolytes parade past their tree-stump altars. Mystical rites are conducted. And grisly discoveries can be made. Bodies are discovered buried there in shallow graves of recently overturned soil. In his comprehensive work, *Landscape and Memory*, Simon Schama notes how classical civilization defined itself in contrast to the primeval savagery of the forest.[39] Primal urges are played out under the cover of trees. 'The woods are lovely, dark and deep,' wrote American poet Robert Frost, acknowledging their uncanny duality.[40] It is light outside the woods, above the canopy at the forest's edge; but inside it is dark. Is climbing a tree, therefore, a symbolic attempt to raise an internalized 'darkness' into the literal and the metaphoric light, or to leave that dark part of the self there, at the top of the tree, like a confession, where it can be seen, acknowledged and then climbed down and moved on from?

In *Gossip from the Forest*, Sara Maitland explores the interwoven intricacies of forests and fairy tales, blending her analysis with re-writings of some of the classic tales. 'Right from the very beginning,' Maitland writes, 'the relationship between people and forest was not primarily antagonistic and competitive, but symbiotic. Until recently, people could not survive without woodland.'[41] Forests were traditionally places of labour and of survival; they were not places for the 'worried well' to go forest bathing. Maitland discusses how the landscapes people inhabit shape the ways in which they think and tell stories. In fairy tales, she contends, the forest is a dangerous and exciting place that sets tests and trials: 'coming to terms with the forest, surviving its terrors, utilising its gifts and gaining its help is the way to "happy ever after",' Maitland writes.[42] The harsh realities of the actual forest shape the ways people think and, therefore, the way they tell stories. For Maitland, forests are chaotic, enchanted spaces, as are the fairy tales that are set in them.

Fairy tales can be cruel, dangerous and abusive. Maitland notes that fairy tales about children 'are very often much darker and less playful than the ones about adults. Truly horrendous things happen to these children. They are the victims of abusive households. They sensibly run away or are deliberately abandoned in the forest. Here appalling things occur.'[43] But they can also be playful and funny: 'A surprising number of them are very

silly indeed – they are jokes, elaborate teases, for fun.'[44] If running away
to the forest, then, is the fairy tale child's way of escaping the tribulations
of conflicted domestic spheres, then tree climbing more generally might
be seen as the fictional character's way to escape such conflicts too. Both
Cosimo, in Calvino's novel, and Anne, in Laura Beatty's *Pollard*, with their
dysfunctional home relationships, as well as the real life *#manintree* case,
each attest to the folkloric theme. Climbing a tree is another version of the
'running away' of fairy tales, or of the 'running away to sea' found in more
swashbuckling adventures.

'Many fairy stories begin with the protagonist spending a night up a tree
in a forest,' Maitland writes, 'and seeing from that height a "small light" far
off through the woods which they then follow to find their adventure and
destiny.'[45] A search through *The Complete Fairy Tales* (1857) of the Brothers
Grimm (which alone contains some 210 stories from a vast oral tradition
that is much larger) confirms Maitland's comments: Grimm's Fairy Tales is
replete with tree climbers. The 'Little Taylor' climbs a tree and throws down
stones on the heads of two sleeping giants to outwit them. In the 'original'
story of Cinderella, the heroine's mother is buried beneath a hazel-tree, to
which Cinderella goes to commune with her mother's spirit in the form
of a little bird. The bird grants Cinderella's wishes, which come as gowns
and slippers. Dressed in these, she is able to entrance the prince. Cinderella
also climbs into the branches of a magnificent pear tree at the palace. The
King, not wishing his son to fall for one so low as Cinderella, has the pear
tree chopped down. In '*Fundevogel*' ('The Foundling Bird'), the story begins
when a forester finds a child crying in the top of a tree, after it has been
snatched away and deposited there by a bird of prey. There is repeated
tree climbing in 'The Knapsack, the Hat and the Horn', and the characters
Frederick and Catherine in their eponymous tale outwit a bunch of robbers
when they are caught hiding in the branches of a tree. Other common tree
themes are explored in tales such as 'The King's Son Who Feared Nothing',
in which the son steals apples from the Tree of Life in his struggle of wits
with a giant, and in 'The Four Skilful Brothers' – who learn trades as a
huntsman, an astronomer, a tailor and a thief – before they are set a trial to
find out how many eggs there are in a nest at the top of a tall tree.

In one of the strangest tales, 'One Eye, Two Eyes, Three Eyes', about
three sisters with one, two and three eyes respectively, a beautiful tree with
golden fruit grows from the buried heart of a goat. They climb the tree
to take the fruit, with Two-Eyes prevailing against her sisters' cruelty and
where her sisters have previously failed. In the tale 'Simeli Mountain', an
archetypal poor man climbs a tree to spy on some robbers who know the
secret words to gain access to the jewel-filled mountain. Here, the tree
becomes a secret vantage point once again. A tailor's apprentice gets a good
night's sleep at the top of a tree at the start of 'The Glass Coffin', and thieves
steal a fake moon lantern by climbing an oak tree in 'The Moon', among
others.[46] In all of these archetypal fairy tales, tree climbing enacts themes of

secrecy, cunning, knowledge, trial and skill, prohibition and transgression, cruelty and overcoming circumstances, familial conflict, and desire and sexuality – themes that recur in a great many tree climbing poems and novels.

The tale 'All Fur' (also known as 'The Six Swans') is 'explicitly about father-daughter sexual abuse,'[47] writes Sara Maitland. Horrified by her father's suggestions, the daughter in this story runs away to the forest and falls asleep in a hollow tree, inhabiting the safety of her chosen latibule, where she is found by the King who is out hunting. Maitland retells this fairy tale as 'The Seven Swans' Sister', beginning with the young woman sitting 'all day on the wide branch of an ancient oak tree,'[48] which she has worn smooth with her sitting. Here she sews clothes for her seven lost brothers, who have been maliciously turned into swans. These shirts have to be sewn from starwort, a tiny, fragile, white flower that must be impossible to work with (another common thread in fairy tales is the inconceivable task). It is a labour of love. And yet this traumatized young woman has 'aligned herself to the silence of the forest, the deep energetic silence of growing things, of seasons turning and of the soundless music of the stars'. Through her task of sewing, she will ultimately release her brothers from their curse. Her exile in the trees is penance for them. 'Some would have called it clinical depression or "survivor's guilt" or even "autism". She called it love,' Maitland writes. The tale continues with the young woman being accused of witchcraft, condemned to burn, but being saved from this horrific fate by the arrival of her swan brothers at the story's end, who are finally released from their enchantment.

All weirdness and uncanny-ness aside, it is the language Maitland uses to describe the general reaction to the young woman in the tree that is pertinent here: she must be either 'clinically depressed', suffering 'survivor's guilt' from the abuse she and her brothers have suffered at the hands of their father, or even 'autistic'. Such 'survivor's guilt' linked to tree climbing, echoes the traumas of the young adult novel, *Tree Girl*, and the general consensus that it is only disturbed or 'mad' people who climb trees. But the young woman actually seems far from that – the trees have certainly bathed her in serenity, following the traumatic, abusive events that have led to her running away in the first place. Rather than the tree being a symbol of madness, then, as is commonly conceived, the forest is, to the contrary, the place of healing; of 'alignment'; of 'deep energy' and 'silence', which confers some kind of inner peace. As Maitland concludes her book, the forest 'rewards human beings who go into it and get to know it. This is what the fairy stories tell us and it happens to be true.'[49]

*

In keeping with these questions of light, darkness and the uncanniness of woodlands, contemporary British artist Peter Doig has painted a series of canvases. Born in Edinburgh in 1959, Doig moved to Trinidad when he was

a baby. He grew up mostly in Canada, but also studied in London, where he lived for years, before returning to the Caribbean in 2002. He now lives between Trinidad, London, New York and Düsseldorf, where he teaches. Doig has made a group of works all of which cohere around the image of his daughter climbing through a thicket of trees.

'Girl in White With Trees', housed in the Bonnefanten Museum, Maastricht, is based upon a family photograph of Doig's daughter, taken by her sister, at their house in London.[50] The artist's images are often painted from a mix of memory and photographic stills, and 'Girl in White With Trees' is one such painting, presenting the viewer with a magical realist image, almost as though it were taken straight out of a children's fairy tale, or piece of folklore: a 'child in the woods', lost in the shadowy, entangling forest. This painting speaks of the figure of the 'Wild Child' of myth and lore: *Little Red Riding Hood*, *Thumbelina* or the young girls in trees in Grimms' tales. As well as capturing the magical innocence of a child's dream, Doig's painting also hints at the darker undertones of the fairy tales, with its sombre colours and dark shapes, the palette of blues, greens, greys and browns. And yet this particular painting of Doig's is also, paradoxically, bright. The girl herself is white and the night sky shines through the branches, bringing light, hope and depth to the canvas. As if to heighten her smallness, the Milky Way hangs high above her, shining through the trees with romantic splendour. This show of the heavens is *sublime* in the sense suggested by the English philosopher Edmund Burke in his *Philosophical Inquiry Into the Origin of Our Ideas of the Sublime and Beautiful* (1757): that natural show of majesty, greatness and awe that is beyond measurement or imagining, and which contains not a little bit of folkloric terror. Doig's painting captures both her innocence and childlike wonder, and a potentially terrifying meeting with nature and the stars. The co-placement of trees and Milky Way in Doig's image echoes the words of the American naturalist, writer and activist, John Muir, who wrote of his experience of tree climbing during a storm: 'We all travel the milky way together, trees and men; but it never occurred to me until this storm-day, while swinging in the wind, that trees are travelers, in the ordinary sense.' Muir's comments move on to a reflection on the relative *smallness* of human actions as compared to the vastness of the heavens, or even the relative largeness of trees: 'our own little journeys, away and back again, are only little more than tree-wavings – many of them not so much.'[51] Such a sense of smallness – that human acts are little more than the waving of a few branches under the vastness of the Milky Way – seems intrinsic to Doig's frail image.

But what of the trees themselves? Climbing in this thicket of branches, the girl is tentative in her waking dream. There is something almost 'neural' and brain-like about the twisted clump of bare branches in which she stands. With the sparks of starlight flickering between the branches, like synapses firing their electric charges in the human brain, the painting evokes the human mind with all its dreams and fantasies, its thoughts of

adventure and escape. Climbing trees often fulfils these desires. But like the covert through which she climbs, the girl's thoughts are impenetrable – the viewer has to project themself into the girl's mind, finding some empathy with her, through memory and imagination. She looks like a figure in a dream walking tentatively towards some mysterious light. Often depicted in tunnels or walking through the overhanging tunnel-branches of trees, such figures symbolize near-death experiences. The allusion to morbidity is not coincidental. In an interview with Robert Enright of *Border Crossings* magazine, Doig develops the theme in a double-edged comment on parenting, which

> makes you think about all sorts of things that you don't necessarily want to think about. Sometimes you see your child in a very different way. I look at one of my daughters when they're all asleep and you can say there's a beautiful, sleeping child, but you can also have morbid thoughts because she's sleeping in a strange position and she looks like she may be dead. If you have a child, you're always thinking about things like mortality.[52]

Parents may be familiar with these sentiments – the heightened sense of mortality that comes with the paradoxical view of watching one's own children bursting with life, yet aware of questions of mortality. In fact, so far as 'walking towards the light' goes, scientific research points to findings that the hallucination of light at the end of a tunnel is caused by a surfeit of carbon dioxide in the blood, caused by physiological stress at the time of dying, rather than any spiritual or supernatural phenomenon – there is no scientific basis for such glimpses of 'the afterlife'.[53]

Before Doig settled on the final version of his painting, he made several studies for it. A gouache and watercolour work on paper, 'Girl in Tree' (2001), shows the same subject, but in this work there are just grey and black trees with the girl painted in as a black silhouette. In another of the same period, the background is blue-black, the girl is sketched in white again, but this time the thicket of branches is bright red, conjuring up arteries and veins – it is as though the girl were microscopic and trapped inside the blood-red recesses of the human body. In a third, 'Study for Girl in White With Trees', the background is conveyed in a palette of bluey-greens; the branches are grey and white; there are no stars; the girl peers out of the painting while holding a branch. Each one of these images conveys a different mood, a different relationship between internality and externality.

In Doig's finished painting, the girl looks tentative. She is literally 'holding on' with one hand, fragile in her whiteness. She comes across as a little ghostly, unformed, compared to her setting, like an angel, or a tree nymph. A dryad. A being that might be encountered momentarily in dream, myth, or fairy tale, and who vanishes suddenly. Her face is sketched in a childish, rudimentary fashion, as if to heighten her childishness, being not

yet fully formed. She stands with that awkward, toes-turned-in stance that shy children can often show. The tree climber in this painting has none of the child-like vigour found in other paintings of children climbing trees – she has a brooding, romantic fatalism about her.

<p style="text-align:center">*</p>

The Cornish author, painter, ecopsychologist and counsellor, Roselle Angwin, lives part of the year in Devon and part in Brittany. Roselle leads the 'Fire in the Head' creative and reflective writing programme and other ecopsychology courses under the banner of 'The Wild Ways'. One of her courses, 'Tongues in Trees', is a year-long distance learning creative course based on tree lore, tree botany and the Celtic Tree-Moon Calendar. Her recent book, *A Spell in the Forest,* explores tree lore, myth, individual tree species, the Celtic Ogham alphabet and the author's own relationship with trees, including tree climbing.

The Celtic Tree Calendar is a calendar with thirteen lunar divisions that don't quite follow the waxing and waning lunar cycle. It is based on the idea that each of the letters in the Celtic Ogham alphabet corresponds to a specific species of native tree. There are many versions of the tree calendar – some have twenty or twenty-two trees – and there is some controversy as to whether the version of the calendar Roselle uses actually originated with early Celtic peoples, whether it predates the time of the Druids, or whether it is a modern invention of the poet, novelist and classicist Robert Graves (1895–1985) from his study of the nature of poetic myth-making, *The White Goddess* (1948). Graves's version of the calendar has just thirteen trees. Angwin's use of it has brought her in to conflict with some academics who dispute Graves's system. But it works for Roselle. Such religious or spiritual frameworks are not doctrinal; they don't need to be literal, historical facts. Rather they augment a follower's inner life and help them live in a particular way.

Eleven of the months in the modern Tree-Moon calendar are named after native British trees; three – vine, ivy and reed – are not trees at all. Each Tree-Moon month is associated with certain archetypal qualities. For example, the Birch Moon (December 24–January 20, *Beth,* pronounced *beh*) signifies rebirth and regeneration at the year's turn, while the Ash Moon (February 18–March 17, *Nion,* pronounced *knee-un),* signifies knowledge, prophetic dreams and spiritual journeys. In Norse mythology, Yggdrasil, the world tree, was an ash tree. The god Odin hung from Yggdrasil for nine days and nights so that he might be granted wisdom. Thereafter the ash tree has often been associated with divination and knowledge. The Willow Moon (April 15–May 12, *Saille,* pronounced *sahl-yeh*) is associated with healing, cleansing and growth which, of course, is a mythical response to the apparent fecundity of willows along watercourses, and to something

that science has since described: willow bark contains salicylic acid, with its antibacterial and analgesic properties. A constituent of aspirin. Other native British trees celebrated in the tree-moon calendar include Hawthorn, Oak (*Duir*, meaning 'door' and the root of the word 'Druid'), Holly, Hazel and the Elder. The latter Elder Moon (24 November–23 December, *Ruish*, pronounced *roo-esh*), is unsurprisingly a time of endings and new beginnings, of birth, death and rejuvenation.

Roselle has long been a tree climber herself. 'I climbed the other day,' she says when we meet. 'I climb better in bare feet, like all tree climbers. But it was wet and muddy where I was, so I didn't take my boots off and I didn't get very high. It's a fallen alder over the stream where I live.' Her poem, 'Tongues in Trees', is the first thing that readers encounter in *A Spell in the Forest*. The phrase 'tongues in trees' comes from Shakespeare. In Act II scene I of *As You Like It*, the old Duke talks of being free from the politics of court while out in the Forest of Arden:

And this our life, exempt from public haunt,
Finds tongues in trees, books in the running brooks,
Sermons in stones, and good in everything.
I would not change it.[54]

The speech recalls the myth of the inspirited tree and the restorative powers of nature, far from the contrivances of the world of politics and governance. It also prefigures Goya's boys climbing trees far from the adult world of the castle. The idea of 'good in everything' perhaps derives from the book of *Genesis*, after God has created everything and seen 'that it was good'. The book of *Proverbs* also provides: 'The soothing tongue is a tree of life, but a perverse tongue crushes the spirit.'[55] There is something of the values inherent in each of these quotes in Roselle's poem, which catalogues a personal list of trees she has climbed: a 'big old fir in the orphaned lambs' field' where she 'learned to hear the whisperings of cedar'; two cherry trees where 'no one could find me for blossom', and then as a 'solitary adolescent with an old red bike / and a penchant for melancholia,' she discovers 'the greenwood, and the ruins / of the hermit's cell with its well and thorn tree.'[56] Here again, tree climbing is associated with solitude, a cure for melancholy and a meditative retreat. From such youthful climbing adventures, the poet grows up through university years in the city, where she is 'uprooted', and takes to filling the bath with sprouting willow stems: 'willow was my green company,' she writes. The poem ends on an affirming note: in a 'startling green blizzard / of chlorophyll', and 'every tree shouting / its jubilation of leaves'. The list-like, naming properties of the poem work on the reader in the manner of a prayer or incantation. Roselle describes how

naming gives us an intimacy, but also separates the tree as well. We think we do all this stuff to trees, name them, use them, but what if we turn it around and listen to them instead? We need to shift attention from

the anthropocentric to the ecocentric. The poem names, but also wants things to remain nameless so that they are not just co-opted as another kind of mental resource for us.

In this, Roselle acknowledges the restorative value of trees, and the dangers of co-opting the 'nature cure' as just another resource.

What is it about climbing trees that so interests Roselle in both her own writing and ecopsychological work? 'Ascent and descent', she says. 'In a Jungian sense, the shaman climbs the tree towards the heavens, but often has to go downwards first, through the roots to the underworld. There's something archetypal about that, escaping the human eye and being closer to whatever it is we may understand by "spirit", while being close to a material being like a tree?' Her analysis agrees with the practices of tree climbers, real and fictional, who express that need to 'escape the human eye' and gain a sense of strengthened spirit through nature.

Tongues in Trees is also the name of the annual course Roselle runs with writers, photographers and visual artists. Each month, her students work from a course pack based on the ecology, folklore and history of one of the Celtic Tree Calendar species. 'The students have a specific practice with each monthly tree. Drawn towards a particular tree of the species, they reflect and respond to it.' The brief allows her students a close relationship with their chosen species. 'They relate more intimately to each species, learning the characteristics of trees and how those characteristics can mirror aspects of their own inner lives. They discover how to bring together their inner and outer lives.' This bringing together of outer and inner lives is the central focus of her work, just as it has been central to inner and outer metaphors concerning tree hollows and canopies.

Roselle is knowledgeable of the scientific research behind the benefits of forest bathing and other nature-based therapies and prescribing schemes. She also trained as a therapist in transpersonal psychology, rooted in Jungian psychoanalysis, with its central image of the Tree of Life, and the process of individuation. 'In order to transform yourself,' Roselle explains, 'you first have to differentiate. Not only from your familial and societal background, but from all the different blurred aspects of yourself, before you can bring them back together in a synthetic whole. The tree, in Jungian analysis, is a metaphor of that. Its branches are in the celestial realm and its roots in the underworld. Bringing matter and spirit together.' Her practice with the Celtic Tree Calendar is, she says, a way of taking herself out of herself, 'and into the larger web of life, the Celtic otherworld, the more than human.' Again, this work with trees echoes the actions and motivations of many fictionalized tree climbing characters, for whom inside and outside become one, and for whom the 'ultrahuman' provides both a reassuring sense of interconnectivity and a perspective-yielding distance on inner problems and concerns.

*

The Jungian archetypes explored in Roselle Angwin's ecopsychology courses and writings are part of the recurring archetype in tree myth and lore of the goddesses, gods and other spirits that inspirit trees. If Angwin's work looks back to Jungian psychology, and other older archetypes, then Margaret Atwood's 2009 novel, *Oryx and Crake*, projects these archetypes into a dystopian, post-human future. At the start, the protagonist, Snowman (also known as Jimmy), is found sleeping in the branches of his tree house. The world around him has been brought low by disasters in gross genetic engineering and massive environmental collapse, dominated by big bio-corporations. Bizarre hybrid animals – 'pigoons', 'rakunks', 'woolvogs' and glow-in-the-dark rabbits – roam the land. It is to avoid these beasts that Snowman/Jimmy has moved up into the trees. His ascent is not, therefore psychological, like many other fictional climbers; it is borne out of necessity and safety. But his climbing does relate to the mythic, archetypal and religious tendencies discussed here.

Atwood's plot is complex and speculative, with flashbacks to Snowman/Jimmy's friend Crake, who has genetically engineered a race of people – the Children of Crake, or Crakers, with luminescent green eyes and blue penises – who live in a biodome called *Paradice*, run by Crake, his team of programmers, and Crake's female companion, Oryx, a young woman who has escaped from a traumatic past. The biodome is eventually breached and Snowman leads the Crakers out into the wider world. Snowman climbs up into his tree, not far from the Children of Crake who live on the ground. The Crakers are able to avoid the attacks of pigoons and woolvogs by urinating in a circle around their camp – their genetically-manipulated urine serves as a sufficient deterrent to the biologically engineered predators. For all its extensive critique of human biological engineering, that is not the main concern here, rather, the early scenes in which Snowman lies drinking alcohol in his tree and the Children of Crake come to him for symbolic and mythical sustenance. They come to hear Snowman tell them tales of their 'god', Crake, in a scene that is twistedly reminiscent of the Buddha's disciples coming to hear his lessons of enlightenment underneath the Bodhi tree (echoing Kiran Desai's parodic character, Sampath Chawla, with his fake sermons from the guava tree in that novel): '"Snowman, tell us please about the deeds of Crake,"' the acolytes call in *Oryx and Crake*. 'A story is what they want, in exchange for every slaughtered fish. Well, I owe them, Snowman thinks. God of Bullshit, fail me not.'[57]

What Snowman tells them is a twisted creation myth of their own beginnings and a fable-like explanation of the chaos and destruction that has befallen the earth. The Children of Crake themselves only want to hear of their 'god', Crake, and his consort, Oryx, who also assumes deity-like proportions in their minds. Snowman knows that he is making up

lies to keep the Children of Crake happy and docile, and Crake himself 'was against the notion of god, or of gods of any kind and would surely be disgusted by the spectacle of his own gradual deification.'[58] Atwood's parody of creation myths, religious narratives and far-fetched spiritual storytelling is here set in what would have been seen, at one time, as the most religious of settings: a sacred grove beneath a tree under which the 'master' reveals his wisdom.

Towards the end of Atwood's novel, Snowman climbs another tree for safety and, while in the branches, tends to one of his feet, which he has wounded in his escape from *Paradice*. While in the branches he muses on human ancestry. '*Arboreal, a fine word. Our arboreal ancestors*, Crake used to say. *Used to shit on their enemies from above while perched in trees. All planes and rockets and bombs are simply elaborations on that primate instinct.*'[59] This scatological moment, which parodies modern warfare, speaks back to William Golding's Neanderthals watching the *Homo sapiens* from the safety of their tree-top hideout, and that more general atavistic urge inherent in tree climbing. Like the global myths and stories of inspirited trees, green men and women, and the extraordinary metamorphoses of humans into trees in Ovid, the urge to climb into the branches may simply inhere in human DNA. Atwood's genetic manipulations in *Oryx and Crake* seem to come full circle here – after all the human manipulation of genetic material, the human protagonist in this novel returns to the trees. If mythology and biology come together, then, in Atwood's novel, the next chapter examines how the myths associated with trees come together with visionary experience, to make tree climbing a metaphor of quest and enlightenment.

Notes

1 Chase Twichell. From 'White Pine'. *The Snow Watcher*, p.106.
2 See Nicole Fallon. 'The Christ Child in the Tree: The Motif in the Thirteenth-Century Wood-of-the-Cross Legends and Arthurian Romances'.
3 Robert Ackerman. *The Myth and Ritual School: J. G. Frazer and the Cambridge Ritualists*, 1991.
4 John Fowles. *The Tree*, p.62.
5 Ovid. *Metamorphoses*, Book 1.
6 Borghese Gallery. (2020). 'Apollo and Daphne'. https://borghese.gallery/collection/sculpture/apollo-and-daphne.html
7 Roger Deakin. *Wildwood*, p.110.
8 John Fowles. *The Tree*, p.42.
9 Ovid. *Metamorphoses*, book 10.
10 Peter Fiennes. *Oak and Ash and Thorn*, p.107.
11 All lines cited here from Ezra Pound. 'The Tree'. In *Collected Shorter Poems*, p.3
12 Lord Byron. *Childe Harold's Pilgrimage*. http://knarf.english.upenn.edu/Byron/charold3.html
13 Percy Bysshe Shelley. *The Poems of Shelley*, p.226.

14 D.H. Lawrence. *Fantasia of the Unconscious,* p.28.
15 D.H. Lawrence. *Pan in America,* p.105.
16 Ibid, p.106.
17 Ibid, p.107.
18 Ibid.
19 Jane Bennett. *Vibrant Matter,* pp.62–81.
20 Ibid, p.102.
21 Ibid, p.108.
22 Stacy Alaimo. In Braidotti and Hlavajova. Source: https://www.academia.edu/32205792/Alaimo_Trans_corporeality_for_The_Posthuman_Glossary
23 Ibid, p.29.
24 Janisse Ray. *Ecology of a Cracker Childhood,* p.68.
25 https://www.learnreligions.com/indras-jewel-net-449827
26 Samantha Walton. *Everybody Needs Beauty …* , p.65.
27 Thomas Hardy. *The Woodlanders,* p.278.
28 Roger Deakin. *Wildwood,* p.114.
29 Victoria Bladen. *The Tree of Life and Arboreal Aesthetics in Early Modern Literature,* p.1.
30 Ibid, p.74.
31 Ibid, p.222.
32 From the *Poetic Edda,* translated by Henry Adams Bellows (1936) https://www.sacred-texts.com/neu/poe/index.htm
33 Jack Cooke. *The Tree Climber's Guide,* p.23.
34 Peter Fiennes. *Oak and Ash and Thorn,* p.90.
35 Nalini M. Nadkarni. 'What Is a Tree?'. In *Between Earth and Sky,* pp.19–58.
36 Victoria Bladen. *The Tree of Life and Arboreal Aesthetics in Early Modern Literature,* p.178.
37 Janisse Ray. *Ecology of a Cracker Childhood,* p.65.
38 Sara Maitland. *Gossip from the Forest,* p.135.
39 Simon Schama. *Landscape and Memory,* p.82.
40 Robert Frost, from 'Stopping by Woods on a Snowy Evening', p.1237.
41 Sara Maitland. *Gossip from the Forest,* p.5.
42 Ibid, p.8.
43 Ibid, p.102.
44 Ibid, p.293.
45 Ibid, p.123.
46 The Brothers Grimm. *The Complete Fairy Tales.*
47 Sara Maitland. *Gossip from the Forest,* p.131.
48 All quotes here from this fairytale, ibid, pp.163–9.
49 Ibid, p.317.
50 https://www.bonnefanten.nl/en/collection/1005433-girl-in-white-with-trees
51 John Muir. *The Mountains of California.* Ch. 10. 'A Wind-storm in the Forests'.
52 Robert Enright. 'The Eye of the Painting'. https://bordercrossingsmag.com/article/the-eye-of-the-painting-an-interview-with-peter-doig
53 Jeff Wise. '"Go toward the Light"'. https://www.psychologytoday.com/us/blog/extreme-fear/201004/go-toward-the-light-the-science-near-death-experiences
54 William Shakespeare. *As You Like It,* p.2, i.
55 *Proverbs* 15:4.

56 All quotes from the poem used with permission of the author, Roselle Angwin. From 'Tongues in Trees', in *A Spell in the Forest*.
57 Ibid, p.117.
58 Ibid, pp.119–20.
59 Ibid, pp.416–17.

8

The visionary tree

In the 1760s, years before he found his vocation as a poet and artist, the young William Blake walked across Peckham Rye near to where he lived, and had one of the many visions that would come to him throughout his life. Blake would, of course, grow into the man who, after his death, would be seen as one of the great visionary poets and illustrators of the age. That visionary element of his work found its root, perhaps, in the experience he had on Peckham Rye – for what the young Blake saw was a tree filled with angels.

The image of a spangled tree, filled with angels, or simply lights is common enough in the West: symbolic trees from the time of pre-Christian pagan belief are still brought into houses in Winter to recreate the glint of ice and snow on branches, and to inspirit the home. In her 1974 non-fiction book, *Pilgrim at Tinker Creek*, American author Annie Dillard places such a glittering tree at the narrative heart of her work. *Tinker Creek* was awarded the Pulitzer Prize for non-fiction – written over a year, Dillard's narrative documents the flora and fauna of Tinker Creek, Roanoak, in Virginia's Blue Ridge Mountains. Using the form of personal journals, Dillard offers reflections on solitude, writing, spirituality, religion and natural history. At times visceral and unforgiving in its depictions of nature's indifference (its ultra-humanity), the book is more of a spiritual pilgrimage, since the narrator never leaves the locale. The journey is an inward one, in the Transcendental tradition of Thoreau and Emerson. This chapter builds on the idea of the tree climb as such an inward journey, as much as it is an outward journey into the canopy.

Early in the work, Dillard tells of a blind girl who has had her sight restored. On seeing a tree for the first time, the girl simply calls it 'The tree with lights', overawed as she is by her first experience of the natural beauty that comes with sunshine through the branches. Dillard tells how she herself then 'searched through the peach orchards of summer, in the forests of fall

and down winter and spring for years', to find the tree with lights. Eventually she finds the tree 'in the backyard cedar where the mourning doves roost charged and transfigured, each cell buzzing with flame'. She likens herself in this moment to a bell that has been struck. 'I have since only very rarely seen the tree with lights in it [...] but I live for it.'[1] Throughout the book, the tree with lights acts as metaphor for 'the steady, inward flames of eternity' or, in plainer terms, for what happens inside when someone experiences the present moment in all its totality; when the world becomes seen as if new and whole again. It was in this moment that 'some undeniably new spirit roared down the air, bowled me over, and turned on the lights'.[2] In the stories, poems and art discussed in this chapter, these visionary experiences with trees and tree climbing are brought to the fore.

Climbing a tree begins with 'upgazing' – looking up into the light of the canopy and considering something higher; something bigger than the self. It is easy to see how this physical activity translates quickly into a more inward quest for something 'higher' within. Metaphors of 'rising into the light' recur in tree climbing literature and art, and this chapter explores that symbolism. Sometimes, however, it is not just the physical prowess of climbing itself that 'takes us higher'; it may equally be the 'road of excess' that leads to these heights. From Piero Di Cosimo's 1499 painting, 'The Discovery of Honey by Bacchus', to poet Thom Gunn's experimentation with LSD, tree climbing has been associated with ideas of religious fervour, ritual, intoxication and ecstasy. Such spiritual elevation also finds expression in some simpler stories of visionary hope: Jean Giono's depiction of the physical and spiritual regeneration of a post-war French valley, in *The Man Who Planted Trees*, provides a narrative of the healing qualities of trees and is, itself, related to other traditions of 'planting' narratives, such as the Johnny Appleseed story. Trees, and their seeds, become metaphors for the regeneration of something within.

Given the existence of pervasive 'Tree of Life' symbols in Western cultures, it is unsurprising that such images of 'seeding' and birth, should be mirrored by images of dying and life cycles. Poems such as Thomas Hardy's 'Transformations' speak of the human body 'becoming tree' after burial. When bodies are laid to rest in groves or wooded graveyards, their constituent parts are taken up by the tree in a final, slower, symbolic 'climb'. This may be one reason why lying back and upgazing through the 'stained glass' greens of the 'cathedral' canopy, into the mesmerizing 'tree of lights', carries strong spiritual connotations. These spiritual urges to 'upgaze' are discussed in poems by Polish Nobel Laureate Wislawa Szymborska, and Anglo-American poet Denise Levertov, examining questions of scale, transcendence and the 'ultrahuman'. Things often seem to fall into place when people gaze up – in gazing up, people pay attention 'in the moment', using forms of 'rapt attention' and 'soft fascination' that scientific researchers have identified as commonplace in an immersive experience of nature. Such attention is also common in the work of nature writers, from John

Clare to his modern counterparts, Annie Dillard and Miriam Darlington. The chapter discusses their orientations to upgazing, paying attention and 'ecoseismic' sensitivity – tuning in to the resonances of the natural moment as a way of initiating change and transformation. Such calls to change are also found in art, and the chapter concludes with a discussion of a painting by Polish artist, Hubert Bujak, which presents the tree climb as 'answering a call' that seems to come, simultaneously, from without *and* within. Bujak's work is seen to be a visual representation of Jungian ideas of individuation, once more; of 'becoming animal'; of reintegrating humanity with nature. The tree climb, this painting suggests, is a quest not only for something 'up there', but also for something 'in here'. The tree climb answers the joyful call of the upgazer and sets the climber on an internal journey of change. At its simplest, it fulfils a simple and natural sense of hopeful inquisitiveness.

✳

Exhibited at the Saatchi Gallery, Gavin Banns's painting 'Seeking to rise into the light, man climbing tree', takes its inspiration from a quote of the German existential philosopher, Friedrich Nietzsche in *Thus Spoke Zarathustra*: 'But it is the same with man as with the tree. The more he seeks to rise into

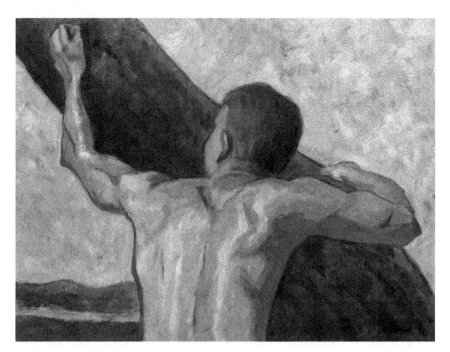

FIGURE 4 *'Seeking to rise in to the light, man climbing tree' (2016). Gavin Banns, Oil on wood, 40 × 30 cm.*

the light, the more vigorously do his roots struggle earthward, downward, into the dark, the deep – into evil.'[3] Nietzsche's metaphor begins reasonably enough: trees grow upwards towards the literal light of the sun, placing their leaves in the optimal position for photosynthesis and, as a parallel, people strive to better themselves, growing towards the metaphoric light of self-improvement, enlightenment and goodness. People, on the whole, tend to be 'upwardly mobile' in their material, as well as their spiritual, ambitions. But to make that upward growth possible, trees – and by extension people – need to be firmly rooted and so their roots struggle 'earthward, downward'. The idea seems fair enough; solid foundations are required from which to grow. But metaphorically equating this downward growth into a nourishing soil with 'evil' seems something of a stretch. Furthermore, biologists have been discovering that the root systems of trees are nowhere near as deep as once thought – as Britain's pre-eminent expert on woodlands, Oliver Rackham, writes, 'most trees in England are shallow rooted.'[4] Like a storm-blown tree, Nietzsche's hyperbolic metaphor begins to topple. Nonetheless, a seed of truth remains in it: human beings certainly do seem to have an urge to 'rise into the light', to strive, to live purposefully. 'Rise', with its positive connotations of upward movement and betterment, and 'light' with all its connotations of goodness, enlightened knowledge, the spiritual/divine and so forth, are combined together to convey a powerful human urge. Bringing themselves, or their inner thoughts and feelings, up into the light, appears to be a critical factor for tree climbers of many stripes. As Victoria Bladen writes in her study of various Early Modern English poets, 'the tree facilitates a transformative experience whereby the protagonist seeks to approach the divine.'[5]

Gavin Banns's painting certainly seems to capture this noble urge. The young man's body is taut and muscular. He seems to shine with the sunlight or perhaps with the sweat of his exertion. The sky is bright and full of light – brushstrokes of white, blue and yellow combine to suggest a hot summer's day. The tree's trunk is huge and points upwards at a steep angle. The man's right arm clasps the trunk securely. His left reaches up to find its hold and to reach towards the light. His gaze is fixed and purposefully directed towards that raised hand. This is a climber on a mission. There is also something Christ-like about him – there is something of the redemptive metaphors of the Stations of the Cross in the way that the man appears to be holding the timber as though it were a crucifix, fixing his steadfast gaze upon the heavens.

In his artist's statement for the Saatchi Gallery, Banns writes of his sketching and drawing practice as an emulation of old masters. 'Submersing oneself into art,' he writes, 'silences the constant chatter of the mind, it allows you to enter a state of flow and being without any of the trappings or disturbances of modernity. As such, it is a necessity for myself personally, to make a meaningful connection with the physical world as perceived by the senses, as well as the internal.'[6] Banns expresses something meditative here

when he comments on art's ability to 'silence the mind' and bring it into the zone of 'flow and being'. The modern world falls away. He could equally be talking about climbing a tree itself, which has the same 'zone like' qualities of concentration and 'rapt attention'. Like painting, climbing a tree makes 'a meaningful connection with the physical world' and, like painting, climbing a tree also makes a connection with the 'internal' world too. Banns's image of the man readying himself to climb 'into the light' captures something essential about the beneficial feelings tree climbers experience when making their ascent.

Of course, the visionary experiences that people have of 'climbing into the light' do not only come about because people are *naturally* 'in the zone'. Sometimes (and not uncommonly for artists and writers) they *take something* or *drink something* to get themselves into the zone. Climbing a tree certainly gets you high, both literally and metaphorically, but some heights and visionary experiences are induced, for example, through Bacchanalian revelry, or practices such as the drunken ceremony in Golding's *The Inheritors*. Such literary scenes find parallels in Piero Di Cosimo's (1462–1522) painting of the Italian Renaissance, 'The Discovery of Honey by Bacchus' (1499), that is typical of his mythological and allegorical subjects.

Di Cosimo's painting is based on the ancient Roman poem 'Fasti' by Ovid, which had been published in Venice just two years before, in 1497. In the focal centre of the painting stands a dead, hollow tree, towards which a procession of satyrs and bacchantes (followers of Bacchus) are heading, clutching a host of household implements and instruments to make a din

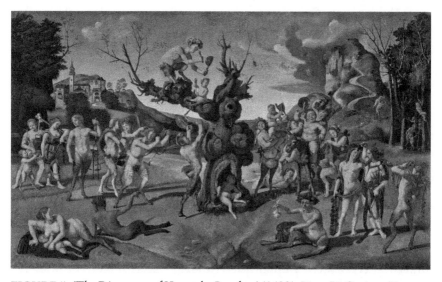

FIGURE 5 *'The Discovery of Honey by Bacchus' (1499). Piero Di Cosimo. Tempera with oil glazes on panel. 79.2 × 128.5 cm.*

that will attract the bees. From stage right enters Silenus, seated on an ass. Silenus was a companion of Bacchus/Dionysus and leader of the satyrs. These satyr followers, the 'Sileni', are clearly drunk, as they always were in the mythology. An old satyr has climbed up into the branches of the tree and is banging a percussive instrument to attract a swarm of bees to settle in the hollow. Age and youth are held high in the branches of this symbolic specimen – the old satyr is accompanied by a youth seated astride a branch stump. In the hollow at the base sits another young satyr. Given his baby-like flesh and features, perhaps this cherub is symbolic of pregnancy and childbirth, the protective space of the hollow tree symbolizing the womb? As discussed earlier, trees are often associated with feminine principles and motherhood. To the right, a naked man climbs a tree at the edge of the forest, whether in fear or admiration is unclear but, coming out of the forest and the 'wilderness' side of the painting, his ascent might be seen as a 'civilising move' to join the cult of Bacchus; to climb into the light out of the forest and to become enlightened.

Bacchus, or 'Dionysus of the trees', was a god of the vine harvest and religious fervour, ritual madness and ecstasy. Bacchus deranged the senses. He was the patron of grapes and cultivated fruit trees and orchards, of winemaking and wine. The Romans worshipped his frenzy or *bakkheia*, that liberated his followers from self-consciousness, fear and cares, turning the world order upside down. If only for a little while. Like the supreme god Zeus, Bacchus/Dionysus was raised in a cave and fed on honey. His worship therefore is based upon the time when mead – the alcoholic liquor made from honey – was the more prevalent drink than wine. Honey remained sacred to the god and his followers. Bacchus has also been credited as the creator of beekeeping. The painting captures this pivotal moment in the growth of the cult of Bacchus, and a significant step in the history of civilization, symbolized by the ordered town painted in the upper left-hand side of the painting and the more disordered wilderness to the right – the forest, a mountainous path and an edifice of cliffs beset by threatening clouds that are surely symbolic of the wildness of nature – as well as by the naked man climbing out of the dark of the forest into the light of day.

Bacchus himself is in the foreground of the painting, to the right, his modesty protected by a drape of red cloth, his face curiously twisted in an ecstatically drunken smile. He leans on a *thyrsus* – a symbolic staff topped with a cone, or vine leaves and grapes, symbolic of himself and his cult. The *thyrsus* is a symbol of prosperity, fecundity and hedonism and was often dripping with honey. It was both a magical wand and a weapon used to drive off those who opposed his hedonism – 'the weapon wreathed in ivy shoots', as Euripides writes in his tragedy, *The Bacchae* (405 BCE). In this canvas, Bacchus talks to the goddess Ariadne, his arm draped affectionately around her, as though the two were in love. The Romans identified Ariadne as Libera (or Proserpina) – Libera meaning 'the bride of Liber', and 'Liber' being the Latin name of Dionysus. Both 'Libera'

and 'Liber' point to 'liberty' and its derivatives; liberty being exactly what the followers of Dionysus were pursuing in their hedonistic excess. The etymology and the symbolism run deeply together.

In the painting, Ariadne is pointing to the crown of ivy leaves on Bacchus's head. In an analysis of the painting, art critic Thomas F. Mathews argues that 'ivy was known to the Bacchantes as another intoxicant; it also produced a red dye consonant with the colour of wine',[7] bringing to mind Bacchus's modest cloak in the painting. Academics cannot agree on the symbolism of the painting and Mathews points out some interesting divergences in the opinions of other major art critics: is it about 'Epicurean evolution', about 'civilising effects', or about Mathew's own interpretation of the symbolism: 'love'? Possibly all of these, and other meanings too. In ancient poetry, the Muses – the goddesses of art, poetry and science – were also associated with bees: 'the birds of the Muses' as they were known. The Muses could make mortals eloquent by placing honey on their lips, making their voices sweet, a notion that persists today in language as the 'honeyed voice' – someone with a sweet voice, or whose voice is insincere. Honey was also a favoured food of the gods. Ambrosia and nectar, which both grant immortality, were considered to be similar to honey and the mead made from it. As such, honey was a popular offering to make to the gods as well as to the dead. In this painting then, tree climbing – the man to the right and the satyrs at centre – are significant elements in the symbolism of hedonistic reverie, of a derangement of the senses, as well as of religious ecstasy or enlightenment.

Bringing these ideas more up to date, the Anglo-American poet Thom Gunn's poem, 'The Fair in the Woods' (1971), recounts an episode when he undertook some significant outdoor hedonism, accompanied by some tree climbing. 'The Fair in the Woods' recounts an episode when Gunn took LSD at a 'Renaissance Fair' in San Rafael Woods, just outside San Francisco where the poet lived. This poem creates a 'landscape of acid' in which the poet is, to use the common parlance, 'out of his tree' on hallucinogenic drugs.[8] For all its derangement of the senses, the poem is highly ordered: there are six stanzas each of five lines, with regular line length, a pulsing meter and a rhyme scheme. And for all the bacchanalia that the poem recounts, there is a great sense of ordered calm. Some of the revellers present are:

> clustered in the upper boughs, from where
> They watched the groups beneath them make their way,
> Children of light, all different, through the fair,
> Pulsing among the pulsing trunks. And they,
> The danglers, ripened in the brilliant air.

The 'switched on' acid takers – these 'Children of light' – sit ranged in the branches like fruit, ripening their minds with the experience. They are not just seeing 'the tree with lights', to recall Annie Dillard; they *are* the tree with lights, its substance and its fruit. Drugs aside, this tree climb, the

poem suggests, was a mind-expanding experience. In Gunn's experience, tree climbing takes the climber from 'child' to the implied 'maturity' of the fruit image.

The growth of such fruit begins, of course, with the planting of rootstock saplings. In modern English poetry, the poet, publisher and maverick millionaire, Felix Dennis, established a charity that planted the native broadleaf Heart of England Forest in Warwickshire and Worcestershire, covering over 3,000 acres and comprising over 1.3 million trees. Concerning his tree planting activities, Dennis wrote the memorable couplet: 'Whosoever plants a tree / Winks at immortality', which in itself sounds not dissimilar from the aphoristic couplets of that visionary poet William Blake with whom this chapter began. Planting trees is, Dennis suggests, a small visionary engagement with time itself – an acknowledgement that people are only passing through, outlived by the trees that they leave as a legacy to future generations.

The most well-known tree planter in literary terms is the figure of Johnny Appleseed – the man who wanders and plants up the land by scattering seeds as he passes through. In fact, Johnny Appleseed was a real man, John Chapman (1774–1845), who famously planted apple nurseries across large parts of Pennsylvania, Ontario, Ohio, Indiana, Illinois and West Virginia. Chapman was a leader in conservation and a missionary for the New Swedenborgian (Lutheran) Church. To this day there are museums and historical sites preserving his legacy, such as the Johnny Appleseed Museum in Urbana, Ohio, and the Johnny Appleseed Heritage Centre in Ashland County, Ohio. The Scottish poet and novelist John Burnside writes about the Johnny Appleseed legend in the poem 'Appleseed', describing 'the barefoot man / walking a hundred miles to plant a tree.'[9] The poem addresses the nature of the human soul:

> the wider rootedness that, as a kind
> of shorthand, we will sometimes call the soul
> and sometimes spirit.

For Burnside that soul is 'rooted', like a plant, growing 'wild and single'. The Johnny Appleseed legend is a form of 'code' and 'shorthand'. It is:

> One of those stories gathered from the wild
> that everyone repeats, as if we'd learned
> that what, in code, we sometimes call the soul
> is out there, growing, rooted in the stars.

This is a poem beginning in legend and moving towards a pantheistic form of spirituality that sees the natural world, 'the stars' and 'growing, rooted' things such as apple trees (and, indeed, human beings), inspirited with 'soul' or 'spirit'. It is a poem about aspiration, individuality and community, about rootedness and ascent.

The Johnny Appleseed story is echoed in a French short story of 1953 – *The Man Who Planted Trees*, by Jean Giono (*L'homme Qui Plantait Des Arbres* in the original French, though first published in English). Giono's story is an allegorical tale about a shepherd, Elzéard Bouffier, who single-handedly replants a forest of oak, beech and birch in a desolate valley in the foothills of the Alps in Provence. When he first visits, just before the outbreak of the First World War, the valley is a forsaken place: 'There were epidemics of suicide and frequent cases of insanity, usually homicidal.'[10] The allegorical rescue of the valley through tree planting therefore echoes closely the mental health debates discussed so far concerning tree climbers, perceptions about their 'madness' and the 'climbing cure'. The tree planting is also a visionary transformation. Trees take the characters from 'insanity' to 'health'; from homicide to giving life. Set in the four decades between the two world wars, the story tells of the re-foresting and re-wilding of the Alpine valley where more than 10,000 people eventually come to live. This re-inhabitation of the natural world in the inter-war years is poignantly allegorical. It is a land of Canaan sprung from the wasteland and 'it was impossible not to be captivated by the beauty of those young trees in the fullness of health'.[11] There is something intrinsically healing about trees and forests the book quietly, and ever-so-charmingly, insists, as if predicting the scientific evidence about forest bathing and other tree-related health benefits, that would come over fifty years after the book's publication. The narrator revisits the valley time and again over the forty years of the story, to see how the re-forested valley is coming on. On his final visit he comments on how the whole countryside 'glow[ed] with health and prosperity [...] people from the plains, where land is costly, have settled here, bringing youth, motion, the spirit of adventure. Along the roads you meet hearty men and women, boys and girls who understand laughter and have recovered a taste for picnics.'[12] The allegory of hope, carried in the branches of all those trees, has travelled a long way from the insanity, homicide and suicide with which the narrative begins.

Such a visionary sense of hope might also be intrinsic to an understanding of the great cycles of life and death of which everyone is a part, and to which everyone is subject. Of the trees that grow in the cemeteries of cities, towns and villages, Jack Cooke writes that 'what becomes of London's dead is not tied to headstones but living in the trees'.[13] The constituent parts of people's bodies become 'exposed to wind and rain [as] roots carve channels through their graves. In this way, the city's dear departed have not left us, but are mingled instead with the stems of our trees.' Such a commingling of the dead human body through the roots of trees is, perhaps, the last great metaphoric 'climb'. The tree takes the body's resources, one more time, up into its branches and leaves and holds them there, proud to the heavens. And to climb these trees while still alive, Cooke argues 'is its own form of eulogy. By climbing we observe the cycle of matter between the animal and vegetable worlds, the conversion of the dead man or woman to the living plant. What better way to honour the dead than to sit among them?'

The idea is not a new one – it takes Felix Dennis's idea of 'planting a tree' and 'winking at immortality' and considers the metamorphosis of the human body in death. The idea was expressed earlier last century in Thomas Hardy's poem 'Transformations', written about a visit to Stinsford churchyard, Dorset, where Hardy's heart now lies buried. Hardy's poem begins with the idea that 'Portion of this yew / Is a man my grandsire knew' and, in the second stanza, 'These grasses must be made / Of her who often prayed'. The poem ends:

So they are not underground,
But as the nerves and veins abound
In the growth of upper air,
And they feel the sun and rain,
And the energy again
That made them what they were.[14]

Hardy's poem leans heavily on T.H. Huxley's 1868 essay 'On The Physical Basis for Life', in which Huxley wrote, 'There is a sort of continuance of life after death in the change of the vital animal principle, where the body feeds the tree or the flower that grows from the mound.'[15] It presents a rationalist view of what 'life after death' might be. Hardy was himself an agnostic and a naturalist. He was also a realist, as his poems and novels attest. While Hardy did not believe in a Christian afterlife, there is in his poem something of the ineffable human hope that 'life goes on' and that 'visionary' experiences (including those of climbing trees in life, or 'climbing' them symbolically through death) might be a part of that.

When burial under a tree does finally come, the body will be laid out lying on its back. Until such time, people will continue to take pleasure in life lying on their backs under a tree and 'upgazing'. As the American author Stephanie Kaza writes: 'Sometimes you have to look at a tree from the ground. On your back. Nothing between you and the sky except the arms of a tree. Just lying on the earth, looking up.'[16] From that position, the climber decides to make a climb and plans a route up. Once the climber has reached the lowest branch it's all about looking up and trusting to balance and foothold. The crown beckons, seemingly calling the climber upwards. The climber knows that the voice is their own, inside their own head, but the 'call' seems to stand for that fusing of inside-outside again; the way that a tree's canopy is both inside and outside; an open enclosed space. It makes the climber feel like the welcoming voice is not their own, but coming from the tree itself. 'Climb!' it seems to say. 'You can do it,' lending that reassuring feeling that there's something else going on in the world that is as equally important, if not more so, than one's own momentary cares and concerns; that there is something secret about to be revealed in the lives of nesting birds, or the struggles of insects, or the simple seasonal struggle of the tree to blossom in time for pollination and fruit production. Feeling the curve of

a branch beneath the feet, or rough bark against the back, the climber looks up through the leaves and imagines an answer to their questions coming in the form of a nesting bird, or in the form of a trail of ants, cutting leaves and carrying them all the way back down the trunk to their nest. The secrets of the tree and its embodied history pick the climber up, hold them and swathe them in something bigger than the self. 'Being in a tree is not the same as sitting beside a tree or underneath one,' writes Stephanie Kaza. 'I fit my body to the tree's body. I enter the web of tree relationships and slow down into tree time. No thoughts, no ideas, no direction, no anticipation [...] minute-by-minute cleansing the ragged mind.'[17] The ground seems to recede. The air seems more open. The climber feels they could spend the rest of the day up there, watching it all go by. A climber has to hold themselves differently than on the ground; think about balance; be more 'in the moment' to place a foot exactly where it needs to be, and to feel the steadiness and poise of the body with the limbs of the tree. The climber wriggles their body to fit between the branches and find a comfortable way to rest the legs, leaning back against the wood, blurring the boundary between human and non-human. For a moment, the climber 'thinks tree', becomes tree.

In her poem 'Apple Tree', from the 1976 collection *A Large Number*, Polish Nobel Laureate Wislawa Szymborska presents her readers with a vision of an apple tree from below. Szymborska was born in Poland. A columnist, translator, editor and celebrated poet, Szymborska won the Nobel Prize for literature in 1996. In the poem, Szymborska imagines sitting 'under an apple tree, lovely / and bursting with blossoms like peals of laughter' in May.[18] The trees are personified with the ability to 'laugh' their blossom into being. The poem ends with the lines: 'to linger longer, not to go home again. / Since only prisoners want to go home,' alluding here to dissident prisoners perhaps, or maybe those many prisoners of war of whom she would have been aware as a young woman living through the tribulations of the Second World War in Eastern Europe. Szymborska's political leanings were complicated: she joined the Polish Communist Party in 1952, but later renounced her early Stalin-era poetry and broke with communism in 1966.[19] The idea of the prisoner might remind the reader, tangentially, of Cody Lee Miller in the *#manintree* case, imprisoned repeatedly as he was while suffering from paranoid schizophrenia. Whichever 'prisoners' Szymborska literally intends here, the poem invites the reader to see the word 'prisoners' symbolically. People are 'imprisoned' by the very things that the apple tree liberates them from: the tree is 'unruffled by both good and evil'; it does not care 'which year and what country', or 'what kind of planet and where it is rolling'; it is 'untroubled by whatever happens'. Here again, as with other nature writers who allude to nature's indifference, the paradoxical disinterest of the natural world that is so liberating to climbers in times of difficulty, raises its head. The apple tree's 'every leaf trembles with patience', Szymborska writes; 'it rustles its branches regardless'; regardless of the narrator's own cares and worries. Sitting under the tree, the speaker realizes that 'it neither

heartens nor horrifies me'. The space beneath the apple tree is a transitional space – an *idir eathara* – where nature teaches how to let go, how to be like it; to be 'untroubled by whatever happens.'

The theme of 'upgazing' is also found in the last book of the Anglo-American poet, Denise Levertov. Published posthumously in 1999, two years after Levertov died, *This Great Unknowing* was first published in the United States and then republished in the United Kingdom two years later. The first poem in the book is titled 'From Below' and presents a humble lesson in shifting childhood and adult perspectives. There is a 'partner poem' later in the book, 'Descending Sequence', that paints a fear-laden apprehension of dying, but in 'From Below' the reader is engaged with what Levertov calls 'upgazing'. It begins with personified trees and an adult reflection on being in the forest, working through a simple pun:

> I move among the ankles
> of forest Elders, tread
> their moist rugs of moss,
> duff of their soft brown carpets.
> Far above, their arms are held
> open wide to each other, or waving.[20]

Everything here is personified: the forest trees (some of which might well be elder trees) are 'Elders'; the wise, sturdy reliable forebears of the family. They have 'ankles'. The forest floor is 'rugs' and 'carpets', which prefigures a move indoors in the poem. The boughs are 'arms' held wide for an embrace, or greeting, or simply waving hello, goodbye, or just in friendship and recognition. The poem does then, indeed, move indoors and fuses inside and outside again, creating that magical 'third space' between them, that *idir eathara*, which allows for revelation. Levertov continues her analogy, wondering what it is that the trees might be thinking – something that must remain forever unknown and unknowable, just as were the thoughts of adults:

> when in infancy I wandered
> into a roofed clearing amidst
> human feet and legs and the massive
> carved legs of the table.

The sense of childhood perspective is charming, recalling the 'massive' table of the family home. The lines also recall notions of the 'sacred grove', or the 'green cathedrals' of woodland spaces that provided a locus for pre-Christian religious rites. The disorienting questions of childhood scale – looking up to the remote world of adults and wondering what they are so concerned with – are opened up for the reader. Levertov's conclusion is that 'the minds of people, the minds of trees' are 'equally remote', unknowable things. In

Levertov's poem the trees are personified and *mindful*, inside and outside become one, and the childhood past and adult present are drawn together in the same action of 'upgazing'. In her final stanza, the poet draws a simple parallel between looking up at one's 'elders' and wondering what it is that they might be talking about, and her own sense of wonderment at nature, just gazing up through the trees: 'drawn to upgazing – up and up: to wonder / about what rises so far above me into the light.' In her ending, Levertov draws attention to 'sensations', as well as to thoughts. Looking up through the trees also does this: gazing far above into the light, looking up provides a sense of scale and transcendence. People are small, nature is big; people may have problems, but they are probably, in the grand scale of things, ultimately tiny. The hugeness of trees helps people gain that simple perspective. Things fall into place. Looking up through the trees is an aid to rising above things. It is a literary equivalent to Gavin Banns's painting which works as a visual representation of the themes.

Paying attention to the world around, in the way that Levertov suggests, is essential not only to a sense of wellbeing, but also to the work of the naturalist and the writer. The Romantic poet John Clare held the notion of 'dropping down' into nature when he wanted to pay attention and make notes in the field. It was a kind of subsuming himself in nature, becoming unobtrusive, as in the image of a nature photographer hidden in a camouflaged hide. The contemporary nature writer, Miriam Darlington, developed a similar theory of immersion when she was out watching otters for her popular nature book *Otter Country*. Darlington comments on the 'sensory immersion' she developed while writing the book:

> Since hearing is personally my primary sense and we often hear wildlife before we see it, particularly birds – but many other things like crickets, the water, grass, leaves – I developed my thinking around 'deep listening'. It's a state of flow, variously called 'the naturalist's trance' and other such expressions. Its 'ecoseismic' writing, where the reverberation causes resonances and moves one to change.[21]

With such a mode of looking and paying attention, the reader is back in the territory of the 'soft fascination' which research shows to be a form of involuntary attention, requiring no mental effort. It is a commonly used mode of paying attention in the natural world. In *Pilgrim at Tinker Creek*, Annie Dillard also describes the similar way in which she too would immerse herself in nature, dropping down to the frog's eye level, for example, to really *be in it* and, perhaps more importantly, to be *of it*. Dillard distinguishes between two types of seeing: one that is active and verbalized; the other that is more passive and a 'letting go'. The first is analytical, logical and prying, while the second is a form of rapt attention. 'There is another kind of seeing,' Dillard writes, 'that involves a letting go. When I see this way I sway transfixed and emptied. The difference between the two ways

of seeing is the difference between walking with and without a camera.' Dillard goes on to describe how walking with a camera is mediated and pre-calibrated; the act of carrying a camera changes the way in which one looks and *sees*: 'I walk from shot to shot, reading the light on a calibrated meter.' But walking without a camera is liberating and 'emptying'. This kind of attention allows 'my own shutter' to open, Dillard writes; 'the moment's light prints on my own silver gut. When I see this second way I am above all an unscrupulous observer.'[22]

As the poems discussed here suggest, 'upgazers' also use this form of attention, and tree climbers most definitely do. Rather than 'dropping down', the tree climber 'rises up' into nature, giving one what Richard Mabey calls a 'simultaneous, present-moment, panoramic sweep.'[23] It's that kind of view that is needed from time to time: to get perspective; to see the bigger picture; to 'rise up' into a new kind of attentive mode of awareness. As Peter Fiennes wittily says in is tree study, *Oak, Ash and Thorn*: 'Can I have my life again please? I'd like to pay attention this time.'[24]

<div align="center">*</div>

The Polish painter and sculptor, Hubert Bujak, was born in 1980. He studied at the Faculty of Painting and Sculpture in the Academy of Fine Arts, Wrocław, Poland. Among his many works that explore the cultural symbolism of nature and humanity's place in it, Bujak has painted many canvases depicting trees and dismembered tree trunks, along with several canvases of people in trees – or even people *as* trees – and one of a tree climber.

Like so many tree climber's, Bujak's climber is barefoot. Dressed in a simple, short-sleeved white shirt and blue jeans, the man is a nondescript character, who looks as though he might have just been taking a walk one day in a city park or field, and suddenly found himself upgazing, giving him the inkling to take off his shoes and climb. What is it that has called to him? What has he seen up there in the canopy or felt inside himself? His response suggests something simple and unpremeditated; a notion supported by the simple shapes, colours and lines of the painting. Something unconscious has caught him.

Or perhaps there is something more furtive in his actions? Has he lost his shoes while running away from something? Is he climbing up into the branches to escape from something, or someone pursuing him, or even from himself? Given the painting's stark, muscular forms, is there some kind of implied violence and fear at play here? Take the figure out of the tree and recontextualize him in this pose, and he might be a 'political thug' with shaved head, raised muscly arms and outstretched foot. There is even something potentially threatening about him out of context.

Symbols and archetypes such as the tree climber draw upon collective memory, and Bujak's image feels drawn from such a pool. It makes a strong

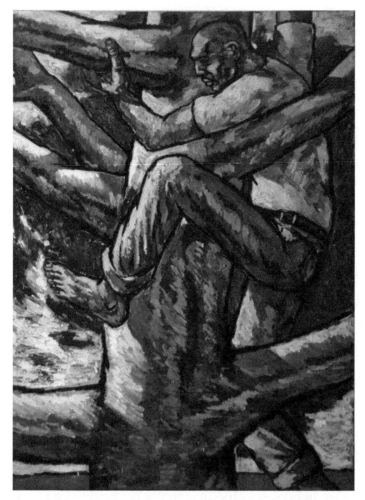

FIGURE 6 *'Climbing a Tree' (2016). Hubert Bujak. Oil on canvas. 59.1 × 78.7".*
© *Hubert Bujak.*

visual impact with the monolithic character of both tree and man – they
seem to be almost equals, caught in an embrace, or perhaps even a struggle.
Both look as though they are holding each other up. Or resisting each
other. But the climber is nothing if not purposeful – an agile and muscular
man able to pull himself up by his arms alone, while his left leg reaches
high to find a new foothold. Bujak's painting recalls the simplified shapes,
bright colours and gestural marks of Expressionist paintings, and the dark
outlined forms and bright colours found in Van Gogh's works. As such,
Bujak's image also accentuates the qualities of inner feeling associated with
the Expressionists and with Van Gogh – there is something deeply wrought
and expressive at play here.

In a statement on his artist's web pages, Bujak writes: 'My entire creative activity is subordinated to the idea of direct expression. I strive to illustrate thoughts, which cannot be expressed other than through a phenomenon, image or object. I achieve it through the use of simple forms, symbols, archetypes.'[25] What might the thoughts and feelings of this climber be, the painting asks? As with Denise Levertov's poem, the 'minds of people' (like the minds of trees) are remote, and the viewer must project themselves into the expressive space to respond to the painting's question through memory and imagination. In discussing some of the painter's other works, Anna Bujak writes:

> The predominating motifs in Hubert's work are the images of a man who 'survived his world' and nature, which is not the background of a painting but is equally important as other objects. The man who faced his own brutality, evil, aggression, animal-like behaviour is a creature out of history, independent from social laws and disciplines, confronting himself, embodying Jung's shadow archetype.[26]

Bujak's painting of the climber, then, displays this kind of primitive energy and survival. The climber is facing – and surviving – himself as he makes his ascent. He has 'become animal' – a term that has been popularized in animal studies and in critical theory since Gilles Deleuze and Félix Guattari published their 2007 essay 'Becoming Animal'. Deleuze and Guattari identify, among other types of animal, the Jungian or archetypal animal with symbolic presence in myth, ritual and spiritual belief in diverse cultures. Anna Bujak also nods to another aspect of Jungian theory here in referencing 'Jung's shadow archetype': the 'shadow' being that part of the unconscious mind that is composed of repressed ideas, desires and instincts, often of a sexual or animalistic kind. This repressed shadow is formed from attempts to conform to cultural norms and expectations; to 'social laws and disciplines' as Anna Bujak writes. In Jungian analysis, it is only by re-integrating the shadow into the whole being that a person becomes fully individuated. Anna Bujak seems to be suggesting that the figures in Bujak's paintings – such as this climber scaling this bold, iconic tree – are confronting the darker 'shadow' side of their psyches, surviving it and attempting to reintegrate themselves, as well as reintegrating humanity with nature. The painting's depiction of the tree as a solid scaffolding certainly seems to elicit the idea of humanity needing to reconnect with nature, and to regain a sense of balance in face of its more destructive tendencies; a balance that is echoed by the strong sense of order and harmony in the painting. This simplicity and balance suggests that this archetypal climber is in search of something positive as he hauls himself up into the branches. It could be something he expects to find in the tree itself, in nature, or – Jungian analysis aside – something simple he is looking for in his own inner life and character. Perhaps there is just something innocently

nostalgic about the climber's ascent? He has deliberately taken off his shoes and left them at the tree's base. It's an impulse. He wants to reconnect. This seemingly urban man is doing something he hasn't done since he was a child. He is rediscovering himself, reconnecting with his own sense of play and adventure and closeness to the natural world.

As well as there being, then, something archetypal, shadowy and animalistic about climbing a tree, there is also something joyful, liberating and childlike. Lest one succumbs to the pitfalls of psychological fatalism – everything happens for a reason and every climber is only doing it because of some unconscious trauma or repressed 'shadow work' that they need to see through – it should be remembered that, sometimes when a climber makes their ascent, they have just been upgazing and heard the joyful call of the wild.

Notes

1 All quotes here from Annie Dillard. *Pilgrim at Tinker Creek*, chapter 2.
2 Ibid, chapter 13.
3 Friedrich Nietzsche, from *Thus Spoke Zarathustra,* quoted in Saatchi Gallery. https://www.saatchiart.com/print/Painting-Seeking-to-rise-into-the-light-man-climbing-tree/733824/4176641/view
4 Oliver Rackham. *Woodlands*, p.33.
5 Victoria Bladen. *The Tree of Life and Arboreal Aesthetics in Early Modern Literature,* p.165.
6 Gavin Banns. 'Artist's Statement'. Saatchi Gallery. https://www.saatchiart.com/banns
7 Thomas F. Mathews. 'Piero Di Cosimo's Discovery of Honey', pp.357–60, p.359. www.jstor.org/stable/3048117
8 All quotes from the poem here, Thom Gunn. From 'The Fair in the Woods'. *Collected Poems*, p.210.
9 All quotes here from John Burnside. 'Appleseed', p.32.
10 Jean Giono. *The Man Who Planted Trees*, p.6.
11 Ibid, p.15.
12 Ibid, pp.22–3.
13 All quotes here from Jack Cooke. *The Tree Climber's Guide*, pp.146–7.
14 Thomas Hardy, 'Transformations', in *Moments of Vision* (1917).
15 T.H. Huxley. 'On The Physical Basis For Life'. https://mathcs.clarku.edu/huxley/CE1/PhysB.html
16 Stephanie Kaza. *The Attentive Heart,* p.19
17 Ibid, p.182.
18 All citations from this poem, from Wislawa Szymborska. *MAP: Collected and Last Poems,* p.226.
19 France24. 'Nobel Prize-winning Author Szymborska Dies Aged 88'. https://www.france24.com/en/20120201-nobel-prize-polish-poet-wislawa-szymborska-dead
20 All quotes here from Denise Levertov. 'From Below'. *This Great Unknowing*, p.9.

21 Miriam Darlington. Private conversation with Andy Brown. 2021.
22 Annie Dillard. *Pilgrim at Tinker Creek*, chapter 2.
23 Richard Mabey. *Nature Cure,* p.37.
24 Peter Fiennes. *Oak and Ash and Thorn*, p.194.
25 Hubert Bujak. 'Artist's Statement'. https://www.hubertbujak.com/hubert-bujak-artist-statement.html
26 Anna Bujak. 'Hubert Bujak's Restored Images'. https://www.hubertbujak.com/articlesartyku322y.html

9

#womanintree

In exploring the Western literature and art of tree climbing, it is no easy task to discover positive representations of women climbing trees. Where they *do* exist – for example, in Golding's character, Fa, climbing a tree to take back her abducted child; Roselle Angwin's engagements with myth and tree climbing; Dr Sarah Charles's therapeutic work with 'Tree of Life' narratives; in poems by Denise Levertov and Wislawa Szymborska, Carolyn Oulton, Sally Flint, Kathleen Jamie and in the images of Paula Rego, to name a sample – the positive and redemptive qualities of women's tree climbing come to the fore. But images of women in trees remain a rarity, for reasons that this chapter presents, and seeks to overturn. There have been strong biblical interdictions about women climbing trees, and many of the representations that do exist are heavily influenced by sexualized, or romanticized male gazes. This chapter argues with such representations, and examines artworks, poems and stories that attempt to reclaim women's tree climbing in positive terms.

To make that recovery of women's tree climbing, Polish artist Cecylia Malik undertook a 365-day project to climb a tree every day for a year. Malik's photographs prompted ecofeminist reclamations of what has been a traditionally male activity. Malik's estranged and rebellious images also find their counterparts in a series of mid-twentieth-century photographs collected by Jochen Raiß, *Women in Trees*, which also raises questions of biblical prohibitions against women climbing trees, and the problematic question of women's clothing. Discussing Roland Barthes's *studium* and *punctum* – two key elements in Barthes's analysis of photography – this chapter questions the shame, guilt and embarrassment that is often attached to the image of a woman in a tree. In particular, the chapter discusses the infamous tree climbing scene in William Faulkner's 1929 novel, *The Sound and the Fury*, in which the character of the young girl, Caddy Compson, is forced to live out her life through the shame of her three brothers, each of

whom viewed her 'muddy drawers' as she climbed a pear tree to peek in on the funeral arrangements of her grandmother. Faulkner attached attitudes of sexual voyeurism and Freudian phallocentrism to the simple image of Caddy climbing a pear tree. Similar psycho-sexual tensions can also be found in poetry of the era, such as American poet Hart Crane's 1932 poem 'Garden Abstract'. Women's relationships with nature and tree climbing are by no means solely determined by a sexualized male gaze, but these mostly male authors seem to present women and girls climbing in this problematic way.

If the roots of questionable gendered attitudes about women climbing trees may be traced back to biblical transgression in the Garden of Eden, then the trope of tree canopies as sites of sexual transgression was still strong when Chaucer wrote *The Merchant's Tale*, which contains one of the best-known cuckoldings in literature, taking place in the canopy of an orchard tree. The irrepressible female character, May, combines her tree climb with sexual transgression that overturns patriarchal authority in the poem. The scene has also been illustrated in different editions of Chaucer across the years, and the discussion here engages with both the poem and the illustrations, to examine changing attitudes to the sexual morality of the tale.

Women's clothing also plays a key role in Angela Carter's 1967 novel, *The Magic Toyshop*, a story of sexual awakening in a young girl protagonist, and in which common ideas about apple trees as symbols of sexual transgression meet recurring debates about women's clothing and the role of family conflict in tree climbing narratives. Such questions of 'the wrong clothing' also find detailed discussion in Dante Gabriel Rossetti's Pre-Raphaelite painting of Jane Morris, 'The Day Dream', in which Rossetti depicts his beloved high in the bower of a sycamore tree. In such images, stories and poems, transgressive images of women in trees are transformed into images of women's transcendental communion with nature. It is a transformation that finds its culmination in a discussion of Idra Novey's novel, *Ways to Disappear*, in which the (by-now familiar) tropes of tree climbing and family conflict, atavistic urges, adult responsibility and Jungian individuation, sees the female protagonist climbing away from patriarchal rule towards an individuated self, reclaiming the act of tree climbing for women in positive terms.

<p style="text-align:center">*</p>

In her 2004 poem 'The Tree House', Scots poet and nature writer, Kathleen Jamie, describes climbing up into a tree at night: 'Hands on a low limb, I braced, / swung my feet loose, hoisted higher, / heard the town clock toll.'[1] Here, the reader discovers, 'I was unseeable.' The poem, therefore, sets up a mood of escape, or retreat, of needing privacy. The female speaker lies

down to sleep while, in the distant streets around her, the nightclub revellers make their rowdy way home in the early hours. She pulls 'a lichened branch' close to her in an act of complicity,

> like our own, when arm in arm
> on the city street, we bemoan
> our families, our difficult
> chthonic anchorage
> in the apple-sweetened earth.

There is a sense of intimacy and belonging then at the tree climbing start of this poem, but also a foreboding sense of the *underworld* in that word 'chthonic'. The narrator is rooted to her dwelling places and to the rooted underworld she will return. The apples have already fallen and are sweetening the earth around the tree. Biblical connotations of fallen apples are not far away. The poem then goes on to imagine what other kinds of life the speaker and her husband might have lived 'alone in sheds and attic rooms', had they not chosen the path they actually took in life. Where would they have ended up? What other kind of dwellings would they have made, other than this tree house that:

> we've knocked together
> of planks and packing chests
> a dwelling of sorts; a gall
> we've asked the tree to carry
> of its own dead, and every spring
> to drape in leaf and blossom, like a pall.

Here the tree house becomes a dwelling place, a metaphor for how best to live in relation to the natural world. It is a makeshift and temporary sort of home that is made on this earth, the poem suggests; one that is 'knocked together', much as the speaker and husband seem to be knocked together by the chance meetings of life. This suggests a fragile kind of existence, heightened by the image of the 'gall' – the swelling growths found on trees – that is neither pleasant nor positive: gall has meanings of 'audacity', 'bitter feelings', 'bile', 'anger' and 'friction', as well as the parasitic swellings caused on trees by viruses, fungi and bacteria, insects and mites. There is also that word 'dead', which speaks of the finality of life's journey and echoes the 'chthonic' underworld alluded to at the beginning. Yet these feelings are held in balance with the regenerative powers of the tree breaking into leaf and blossom each spring. Such is the human lot, this female tree climber seems to say: a balancing act between 'gall' and 'blossom'; between death and being 'hoisted higher'. This female climber, then, fulfils a number of the qualities of tree climbers as previously discussed, not least the urge 'to climb towards

the light' and to find that calming 'in between' place of balance and healing that tree canopies have been shown to provide, but also echoing Hardy's graveyard poem of life, death and the cycle between them that the tree climb may represent.

Taking this restorative female climbing to more rebellious ends, Polish artist Cecylia Malik climbed a different tree every day for a year, beginning her project in September 2009. Malik lives in Krakow and most of the trees she climbed come from that area of Poland. She posted photos of the day's climb on Facebook, commented on and 'liked' by viewers, eventually collating all of the pictures together with an introduction and some short reflections from other writers, in her book *365 Trees*. In her introduction to the book, Malik writes that she was 'inspired by my favourite book, Italo Calvino's *The Baron in the Trees*', that seminal tree climbing narrative, which Malik calls 'a fairy tale about rebellion, love and being oneself'.[2] It is this rebelliousness that also seems to really count in Malik's project. 'It is my diary,' she writes, 'but also a private rebellion, a small rebellion,' freeing her from 'the city, from my duties, from my everyday life.' In the end papers of Malik's book, the prominent Polish eco-activist, journalist and writer, Adam Wajrak, comments on how Cecylia 'restores trees to us'. Children climb, he writes, but for adults, 'climbing trees becomes inappropriate'; it is 'not important'.[3] What he means, of course, is that society has deemed it unimportant and inappropriate for adults. Cecylia Malik reclaims the

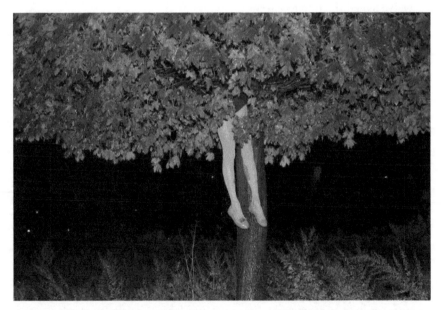

FIGURE 7 *'Tree 342' (2010). Cecylia Malik. from 365 Drzew (365 Trees).* Photograph taken at Klon, 01 September 2010. © Cecylia Malik.

right to climb and turns the act into art, capturing that 'rebellion' in a series of quirky and enigmatic photographs. What is more, she reclaims the climb *for women*.

One key issue for women climbing trees – and society's attitudes towards them – is the question of clothing. Malik writes how 'Every morning I dressed "tree": cheap colourful clothes, thin-soled shoes and red lipstick so that you could see my face from a distance.' Many of her clothes are also red, or other bright primary colours, making stark contrasts against the (often snowy) backgrounds of Krakow. As with Calvino's novel, Malik's performative project has a distinct air of the fairy tale, or of the surreal, about it. These photographs are rebellious acts of estrangement – they redefine women's everyday relationships with trees and urban environments in the most unusual ways. They also disrupt normative standards about women climbing, opening up feminist and ecological discussions as the Facebook threads to her project attest, for example, when she photographed herself in a tree set against the backdrop of the flooding Vistula river in the centre of Krakow to raise awareness about issues of global warming and rising sea levels.

If Malik's photographs are notable for their use of bright primary colour, then Jochen Raiß's collections of photographs of *Women in Trees* are notably black and white. Raiß is an enthusiastic collector of postcards from the *Flohmärkte* of German towns and cities – their flea markets. Over twenty-five years ago he discovered a black and white postcard of a woman climbing a tree, at a stall of one such market: an historical amateur photograph of a woman posing in the branches. The photograph so intrigued him that he continued to search for other such images. By 2016 he had collected over one hundred. Each was taken some time between the 1920s and 1950s, judging from the types of cameras that he has been able to deduce were being used, and the details of fashion in the images. These black-and-white photos now form the content of two best-selling books, *Women in Trees* and *More Women in Trees*. Each features an image of a young woman, or sometimes several women – friends, mothers, daughters, grandmothers – who have climbed into a tree, or been placed there to pose. The women often smile into the camera, clasp the trunk, swing from a branch in elation, lounge back in a semblance of relaxation or seduction, or simply look plain awkward. Some swing their legs. Others drink from a bottle of beer. One holds a rake. Some are athletic or fashionable. Others are nervously embarrassed. All the images are nostalgic.

Raiß's introduction to *Women in Trees* sets the contexts for his finds and says a little about the nature of the photos: 'the high jinks of the spontaneous climbing action, the uncertainty [...] the intimacy of the moment.'[4] Raiß also quotes the Swedish writer Astrid Lindgren, who famously wrote: 'There's no prohibition for old women to climb trees,' a noble sentiment that is to be supported – women, girls and older women should *all* climb trees, if the beneficial findings of the scientific research hold water. Except, of

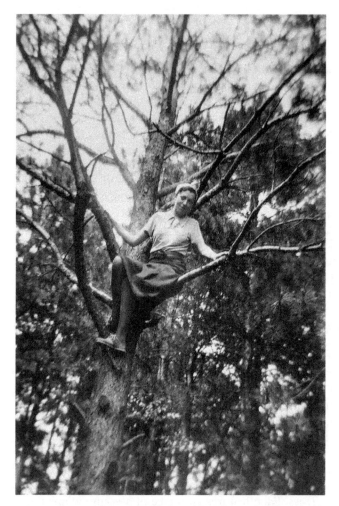

FIGURE 8 From *Women in Trees* (c.1940s). © 'Collection Jochen Raiß'.

course, there *has* always been a strong prohibition against women and girls
climbing. Like many of those tree climbers and writers discussed already
in this book, American writer and naturalist Janisse Ray describes her
sensory pleasures of climbing trees as a child. 'I would rather be sitting in
this certain pine tree I loved. It was within hollering distance of the house
and eyeshot of the shop, and I was allowed to go to it when we weren't
working, before homework, and even if I hadn't been allowed, I would
have sneaked there anyway.' But Ray's mother policed her daughter's tree
climbing activities, not only granting or denying permission to climb but
yelling 'from the doorway to get down out of that tree and lecture later
that it wasn't ladylike, me climbing trees with a skirt on, skinning up my

legs, and that I would tear my clothes or, even worse, fall'.[5] Such a sense of female prohibition is, perhaps, one of the things that makes *Women in Trees* such a compelling collection of photos. Getting behind that prohibition, American novelist, poet and translator, Idra Novey, writes about *Women in Trees* in a 2018 article for *The Paris Review*. In her review, Novey claims that 'The tension between trees and female disobedience is biblical.' Eve's transgression in the Garden has provided Western culture with the symbolic stricture that a woman or girl 'is not meant to reach into trees or climb them; she should quietly remain on the ground and bear new life. Get down, history has said to the grown woman brazen enough to take even a brief arboreal leave from her earthly duties. Once a woman is off the ground, it may occur to her to keep on climbing.'[6] So, 'only tomboys climb' has been the stated rule for generations of girls, and tomboys have been frowned upon. They are not feminine, which is what girls have traditionally been expected to be. For boys and men, it has always been quite different – boys are expected to climb trees – but women have been expected to remain grounded. Prudish logic dictates that, if a man were to look up and see a woman's bottom, or catch a furtive glimpse up her skirt, who knows what demons she might unleash. The American politician Frances Perkins, who served under Roosevelt's administration, famously said, 'Being a woman has only bothered me in climbing trees.' Politics for women? That's fine. But climbing trees? Not so much. Perkins's quiet and witty observation protests against the prohibition on women climbing trees.

In his preface to *Women in Trees*, Raiß goes on to say, 'These photos are fascinating because of their seemingly incongruous components. What was this woman in the tree's life like? Who did she go for walks with? Whose idea was it for her to climb a tree and sit on a branch? This is something I'll never know.' As with the concealed motivations of the climber in Hubert Bujak's painting, or Denise Levertov's trees/adults, in the last chapter, the unknowable problem of other minds comes to the fore in the context of tree climbing. But one of the other notable elements in these photos is just how many of the photographs are posed. Many of them seem particularly artificial. Many of the women are just a foot or two off the ground, sitting in the crook of a branch, or standing on a stump. They highlight the incongruity of seeing a woman in a tree. The sight of children climbing a tree may be nostalgic and charming, but one does not ordinarily expect to see a grown man in a tree unless he is working, and certainly not a woman. As such, these photos are not so much 'tree climbing' photos, as 'perched' photographs.

There are two particular elements of these photographs that are worth noting. The first is the clothing and the second is the actual climbing. In his short 1980 book on photography, *Camera Lucida*, French philosopher Roland Barthes puts forward the simple notion that a photograph is comprised of two essential elements – what he calls the *studium* and the *punctum*. The *studium* is the cultural, linguistic, historical and political knowledge that a viewer brings to a photograph – the photograph's background 'context'.

Barthes says that the *studium* is the way that viewers 'culturally participate in the figures, the faces, the gestures, the settings, the actions.' The *punctum*, on the other hand, is the puncturing, wounding, personally moving detail that is picked up on in a photograph when the viewer connects with the photo on a personal level. It is the spark; the significant detail that tears through the sense of *studium* and sets the picture alive. It is, for Barthes, 'that accident which pricks me (but also bruises me, is poignant to me).'[7] Barthes's twin concepts are useful in looking at any work of art, but he makes a persuasive case for their application to photography. In the *Women in Trees* photos, the *studium* is elicited through understanding the women's clothing and haircuts; the fashions of the day and, where they can be seen, the detail of cars and buildings around the women. The viewer can begin to locate the photos in time and space and bring their knowledge of the *studium* to help interpret the pictures. But the thing that yields an emotional and intellectual response to the images is the *punctum*. The *punctum* of these photos is subjective and they often have more than one, but the over-riding *punctum* for all of these photographs is the same – it is *the woman* herself, and the very fact that *she is in a tree*.

There are other small *punctums* at play in the images too: the bottle of beer in one; the rake one woman holds; a cushion. And then there are other *punctums* elicited by the sheer incongruity of the women's clothing. In one photograph a woman wears a leopard print coat. In others the women are dressed in long, restrictive skirts. One woman wears a skirt-suit and a neat hat. Some are in their Sunday best. A few wear trousers. One is wearing a fashionable trouser suit, jacket and tie. Perhaps this has something to do with what Frances Perkins said when she complained that 'Being a woman has only bothered me in climbing trees.' It's extremely difficult to climb in long skirts and dresses, to remain 'decorous' and observe strict rules of gender 'propriety'. Society has deliberately made it difficult for women to climb trees. Perhaps this is also why so many of the women are perched.

In some of the photos, however, it does look as though the woman has climbed the tree herself, rather than being posed there by a helpful husband or chaperone (who presumably then went on to take the photo). It is these climbing women who seem to demonstrate what Lulah Ellender writes about Raiß's *Women in Trees,* in her article for *Caught by the River* magazine: 'At a time when the space women took up was tightly controlled,' Ellender writes, 'perhaps they wanted to perch in another dimension for a moment.'[8] It is this 'tight control of women' that the activity of women's tree climbing fights against and attempts to reclaim.

Such 'tight control' of girls and women climbing is central to William Faulkner's novel, *The Sound and the Fury*, published in 1929. Faulkner's novel circles around one key incident of tree climbing, when the young girl, Caddy Compson, climbs a pear tree to look in the window at her grandmother, Damuddy's, funeral, while her three brothers – Quentin, Benjy and Jason – and a group of young black boys look up at her, only to see

the muddy seat of her underwear. In the novel, this moment plays out as a symbol of shame and incestuous desire. Caddy is being a brave little girl, trying to find out what is going on in the secret adult room above the pear tree. It is a courage that she will need later in the book, as she faces the shame of bearing an illegitimate child. A shame that her brothers will not be able to bear: Quentin commits suicide and Jason retreats into anger and vindictiveness, robbing his illegitimate niece of the meagre money that her mother, Caddy, is able to send her. In an interview with Jean Stein Vanden Heuvel, Faulkner once commented:

> It began with a mental picture. I didn't realize at the time it was symbolical. The picture was of the muddy seat of a little girl's drawers in a pear tree where she could see through a window where her grandmother's funeral was taking place and report what was happening to her brothers on the ground below. By the time I explained who they were and what they were doing and how her pants got muddy, I realized it would be impossible to get it all into a short story and that it would have to be a book. And then I realized the symbolism of the soiled pants.'[9]

Told four times from the points of view of the three Compson brothers – Benjy, the mentally disabled brother; Quentin, the later suicide, and Jason the vindictive, down-beaten brother – and Dilsey, the black maid to the Compson parents, *The Sound and the Fury* is centred on Faulkner's image of Caddy's bottom. It is first narrated in Benjy's opening to the novel: 'He went and pushed Caddy up into the tree to the first limb. We watched the muddy bottom of her drawers. Then we couldn't see her. We could hear the tree thrashing.'[10] The same scene is retold and picked-up on a couple of pages later, in Benjy's nonlinear narration: '"Who in what tree." Dilsey said. She came and looked up into the tree. "Caddy." Dilsey said. The branches began to shake again. "You, Satan." Dilsey said. "Come down from there."'[11] Faulkner's choice of word here – Satan – suggests that Caddy's shame is on a par with Eve's guilt in the Garden of Eden, and that the moral strictures about girls and women climbing trees run religiously deep. Again, the reader is reminded of Idra Novey's earlier contention that 'The tension between trees and female disobedience is biblical'. Once she has climbed down, Dilsey takes the children in and gets them undressed. '"Just look at your drawers." Dilsey said. "You better be glad your maw aint seen you."'[12] Much later in the book, Quentin remembers the scene from his own perspective in his section of the narrative: 'Caddy do you remember how Dilsey fussed at you because your drawers were muddy.'[13] The sight of his sister's soiled underwear is, eventually, too much for the tortured Quentin to bear.

In the essay 'The Quest for Eurydice', André Bleikasten casts the pear tree scene and Caddy's ascent, in psychoanalytic terms: 'an image of childhood caught on the brink of forbidden knowledge – evil, sex, death.' The brothers' view of Caddy's dirty drawers comes, for Bleikasten, 'close to

sexual voyeurism', while 'their sister is fascinated by the mystery of death.'[14]
Sex, death and voyeurism (both the voyeurism of the brothers and of Caddy
herself as she peers in through the forbidden window at the funeral) are
remarkably close in the pear tree scene, just as they seem to be in some of
the photos from the *Women in Trees* collections, where the climbers are
caught lying across the branch of a tree in a way that is eerily reminiscent
of Faulkner's scene.

Ut pictura poesis – the Latin poet Horace's analogy between painting and
poetry – seems to hold here for the relationship between the novel and the
photograph: the connotations of sex, death and voyeurism found by André
Bleikasten in Faulkner's scene are plainly visible in the *punctum* image of

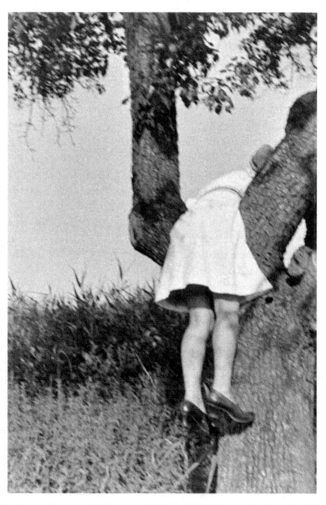

FIGURE 9 From *Women in Trees* (c.1940s). © 'Collection Jochen Raiß'.

the woman's bottom being out of place, but fully visible and, preserved for posterity, in the tree. It is these kinds of overtly sexualized male gazes that projects such as Cecylia Malik's *365 Trees* project, and women's tree climbing in more generalized terms, so successfully overturn.

Faulkner published *The Sound and the Fury* in 1929, the same year that Sigmund Freud published *Civilisation and Its Discontents*, which explored the conflict between the desire for individuality and society's expectations of us. For many years Freud had been well known for interpreting dreams and uncovering their repressed sexual content. It's a commonly understood image that, in Freudian terms, any hard, upright object represents the male phallus. So it is unsurprising that the tree, with its hard, elongated and upright trunk, is also a Freudian phallic symbol. If one agrees with such things, trees – especially in dreams – can represent the penis. A little before Faulkner's novel, the American poet, Hart Crane (1899–1932), wrote a short poem called 'Garden Abstract', which was first published in 1920 in *The Little Review* and then appeared in Crane's book *White Buildings* of 1926. The poem creates a dreamscape in which the Freudian conception of the tree is inescapably phallic. It also leans heavily on the Daphne–Apollo story, by placing it in a modern garden to frame a young woman's sensual desires within the context of climbing (and becoming, again) a tree. At the start of the poem, however, the reader thinks of Eve in the Garden of Eden, contemplating the apple:

> The apple on its bough is her desire –
> Shining suspension, mimic of the sun.
> The bough has caught her breath up, and her voice,
> Dumbly articulate in the slant and rise
> Of branch on branch above her, blurs her eyes,
> She is prisoner of the tree and its green fingers.[15]

Here, the sinful 'apple' of Eve quickly metamorphoses from biblical fruit of temptation into Apollo – the god of the sun. The chime of 'apple' and the suggested 'Apollo' are irresistible so that, by line two, the reader is perhaps already thinking of Apollo's pursuit of the young nymph Daphne in Ovid's tale. Eve's 'desire' for the fruit, for knowledge, becomes the sexualized desire of the Apollo–Daphne story, only this time it is the young woman who is doing all the desiring. Her climb into the tree quickly becomes physical – the young woman is now 'dumbly articulate', with no need for words, but still somehow fluent in another kind of language; the language of 'slant and rise', with all its phallic euphemism. As she climbs the tree to reach the 'shining' apple, her gaze is caught up, her breath is brought short and she becomes, like Daphne, 'prisoner of the tree and its green fingers'. There is a feeling of sensual entrapment at play here. It is at this point in her climb that an Ovid-like metamorphosis begins to fully take place – the young woman starts to *become the tree*, in a dream-like manner: 'And so she comes to dream

herself the tree.' In her reverie, with all its Apollonian sexual connotations
in the vocabulary – the wind 'possesses' her, her hands are 'fevered' – her
breathlessness, the phallic Freudian tree, and the fruit of desire, the woman
completely loses herself in nature, so much so that, at the poem's climax,
she 'has no memory, nor fear, nor hope'. If sexual union has earned itself
the idiomatic expression '*la petite mort*' (the little death), then what faces
the woman here in the poem's final line is a transcendental consummation
with the natural world that mimics the ecstasy of climax: the biblical notion
that 'all flesh is grass',[16] echoes the death-like 'shadows' in the grass, which
add to the connotations of '*la petite mort*'. In her climb, the young girl has
become erotically subsumed by nature.

So it is that trees have strong sexual connotations and have long been places
under which, or against which, lovers have taken their pleasures. Hatsue and
Ishmael in Guterson's *Snow Falling on Cedars* make a prime modern example.
An older tale, one of satirical cuckolding, takes place in the Jacobean play of
John Marston, *The Fawn* (1604–6), when the lead character Tiberio climbs a
plane tree into the bedroom of his lover, Dulcimel. But the image of the tree
as the symbolic ladder to a secret and illicit assignation goes back further
than that. In Chaucer's *The Merchant's Tale* the reader encounters one of
the most infamous tales of sexual misconduct around trees. It's a funny tale
of adultery told in Chaucer's ribald style. Nevill Coghill's 1951 translation
captures the playfulness of Chaucer's original, in lively, modern rhyming
couplets. In the tale, the old knight, January, wishes to take a wife – mainly
for sexual pleasure, but also to sire an heir. He marries the beautiful May, still
in her teens, who presumably accepts the old man because of his wealth. But
a young squire in January's court, Damian, also falls in love with May. After
much toing and froing, May reciprocates his love and promises to make love
with Damian in a tree in the garden. But before this, January himself makes
love to May in the garden and is immediately struck blind for his lustfulness.
Some time later, May and Damian get to fulfil their plan. Damian gains access
to the garden using a forged key, provided by May, and hides in a pear tree.
Did Faulkner take inspiration for the pear tree in *The Sound and the Fury*
from Chaucer's tale? Or perhaps from the original version of 'Cinderella' in
the Brothers Grimm *Complete Fairy Tales*? Or maybe all of these pear trees
are just an oblique reference to Eve and the Garden, without having to be
so obvious as to say 'apple'? Whichever it is, there sits Damian, ready and
waiting in the pear tree. 'Look, there he sits, that lecher in the tree!' the reader
is told, after his secret, hasty climb into the branches.[17] While May is out
walking with January, they reach 'the very tree / Where Damian sat in waiting
merrily, / High in his leafy bower of fresh green.' May suddenly tells January
that she craves a pear hanging from the branches above them – implying that
she is pregnant already with January's heir:

Oh! I have a pain!
Oh Sir! Whatever happens let me gain

One of those pears up there that I can see,
Or I shall die! I long so terribly
To eat a little pear it looks so green.

With its Edenic connotations and May's feigned pregnancy pangs – 'I warn you that a woman in my plight / May often feel so great an appetite' – January gives in to her wish, bending over so that May might more easily reach into the tree. She climbs up by standing on his back: while her old husband is stooped, May hops into the canopy and promptly has unceremonious sex with Damian, right above the old man's head:

Catching a branch, and with a spring she thence –
Ladies, I beg you not to take offence,
I can't embellish, I'm a simple man –
Went up into the tree, and Damian
Pulled up her smock at once and in he thrust.

But there are also two Gods in the garden, watching the adultery unfold: Pluto and Proserpina. Pluto says he will grant January back his sight because of May's infidelity. Proserpina says that she will grant May the ability to talk her way out of the problem. So it is that, once Damian and May are having sex, January suddenly regains his sight and looks up, 'Only to see that Damian had addressed / His wife in ways that cannot be expressed / Unless I use a most discourteous word.' Chaucer's feigned coyness is deeply amusing here. Despite January's protestations, May manages to convince her husband that his new sight is deceiving him: she was only 'struggling with a man', after all, because she had been told that this would restore January's eyes: 'Nothing could cure them better than for me / To struggle with a fellow in a tree.'

Chaucer's is a tale of an old man's lust, a young squire's love and a young wife's desire for the younger man when faced with her unappealing old husband. Its climax (literally) takes place in a tree. As such it brings together many of the psycho-sexual concerns discussed: the biblical 'mistrustfulness' of women who climb trees, that has been used to keep women in their place (on the ground, providing heirs) ever since. Warwick Goble's 1912 illustration that accompanied an edition of Chaucer's works, also heightens the absurdity of women's clothes for climbing trees. In Goble's image, May awkwardly clambers into the pear tree's branches from the old knight's back, dressed in heavy courtly attire – a long dress, train and hanging veils.[18] That said, Damian's clothing doesn't exactly look suited for the climb either. Contrast Goble's image, however, with Dame Elizabeth Frink's 1972 illustration for *The Merchant's Tale*. Frink's etching shows the sexual gymnastics of the tale taking place in complete nudity.[19] While Goble's image captures Chaucer's parody of courtly love, Frink's image is erotically charged: the tree is undeniably phallic here, January's

cuckolding is literally 'exposed' in his nudity, as May and Damian are discovered *in flagrante delicto*, the young man determinedly thrusting between May's raised and parted legs. Frink's is an image from an age of sexual liberation (the 1970s); Goble's from an age of sexual repression (the 1910s). Chaucer's original tale, however, turns May's transgressive tree climb into one of sexual agency: in climbing the tree and pairing with Damian, May overturns January's patriarchal, sexual authority. She reclaims the tree climb for herself, rather than being controlled by the sexualized male gaze and desires of her older husband and is, instead, in control of her own sexual choices.

*

The Magic Toyshop is a 1967 novel by the British novelist Angela Carter. Carter adapted it for the screen in 1987, when it was filmed and produced by Steve Morrison. The novel recounts the coming of age of fifteen-year-old Melanie, who is just becoming aware of herself, her independence, and her sexuality. While her parents are away from the family home on one of her father's lecture tours in America, Melanie steals her mother's wedding dress and wears it into the garden at night. However, when she tries to get back inside, the door is locked and she doesn't have the key, meaning she has to climb the apple tree beneath her window and, in doing so, destroys the dress. The next day Melanie learns that her parents have been killed in a plane crash over the Grand Canyon – Melanie's trauma in the biblically symbolic apple tree is echoed by the literal fall of her parents.

The apple tree grows below Melanie's window with 'twiggy fingers'.[20] On the night in question, unable to sleep, she goes into her parents' bedroom and looks at their wedding photo, wondering about their love, their sex life and her own sexual coming of age. She puts on her mother's wedding dress and goes down to the garden. 'The stillness was like the end of the world. She was alone. In her carapace of white satin, she was the last, the only woman.'[21] But, in her childish mind – for she is still a child in many ways, clutching at her favourite 'Edward Bear' – Melanie begins to imagine monsters lurking in the bushes and, in her panic, turns back to the door, which has swung shut and locked itself: 'it was the apple tree or nothing', she decides.[22] But the tree seems sinister and its laden fruit poisoned. 'In her tree climbing days, the ascent would have taken only a few minutes,' Carter writes. 'But she had given up climbing when she started to grow her hair and stopped wearing shorts every day during the summer holidays.'[23] For Melanie, tree climbing was a childish pursuit only, not to be pursued into her maturing teenage years. But now her periods have begun, and she has started having sexual fantasies. 'How can I climb the tree in this dress, though?' she thinks. 'Hobbled in yards of satin which would rip and tear

irreparably as she struggled for hand and foothold. She would mesh in the branches unable to move up or down.'[24] Here again, the preposterous, dressy clothing is totally inappropriate for tree climbing, and perhaps even a symbol of her mother's marriage – propriety says that women must be on the ground, doing wifely things, bearing children, not out in the garden climbing trees, it suggests. Melanie undresses, as if to shake off the symbol of her mother's marriage. Like a young 'Eve', she becomes 'horribly conscious of her own exposed nakedness'[25] and, as such, her climb is fraught: she scrapes her shins, her thighs and stomach. She scrabbles up painfully. Branches break. She hangs 'in agony by her hands, strung up between earth and heaven, kicking blindly for a safe, solid thing in a world all shifting leaves and shadows'.[26] Carter's language becomes threatening and violent: leaves 'thrust leathery hands spitefully into her eyes'; it is 'an alien element'; twigs tear 'her cheeks and soft breasts. She seemed to be wrestling with the tree.' There is a fraught sexual energy in the symbolism of the climb. The whole thing is a 'struggle' – just as May, in Chaucer's tale was 'struggling with a man' – from which Melanie emerges 'bruised and filthy' and 'bleeding from a hundred little cuts'.[27] The dress is destroyed. The bridal wreath she was wearing gets forgotten in the branches. As a phallic metaphor for her first sexual encounter, Carter's tree creates great discomfort for character and reader.

Climbing in at her bedroom window, Melanie is now out of place. Rather than feeling out of place in the branches, the climb has now made her feel out of place in her own home; inside and outside have become reversed: 'she sensed the strange not-being of a houseful of deserted rooms.'[28] It sends her into a panic and a blind rage. She feels as though she is 'The girl who killed her mother.'[29] Flying into a mad fit of anger, she smashes the mirror and starts to destroy her mother's things, ripping up the wedding photo that she has, just recently, been studying so lovingly. Come morning, she is discovered by the housekeeper, Mrs Rundle, 'Covered with lipstick and mascara', her face 'a formalized mask of crimson and black'; her mouth issues 'a wordless stream of dismay'.[30] The following morning, feeling slightly better, Melanie buries the tattered wedding dress under the apple tree, where the wedding wreath is still hanging. It is then that she finds out her parents have been killed in a flying accident over the Grand Canyon.

In some sense then, this tree climbing episode plays with the conflict-climb relationship found in many other tree climbing episodes Melanie is undergoing the psychological struggles of a teenager coming to terms with her own sexuality and maturity. The complications are carried by the symbolic wedding dress and wreath, and the symbolic burial of the dress, which foreshadows news of the mother's death the following day. Melanie's climb is prophetic in that sense – it sets the symbolic, transformative mood for the real disaster that is about to ensue. But the

'madness' depicted in many tree climbing narratives, here comes *after* the climb; in fact, it is the climb that brings on the fit of rage. This tree is not the benign, solitary, transformational space often found in tree climbing episodes; rather, it is a threatening, violent environment that brings on Melanie's raging destruction once she gets back inside. In this sense, Carter's apple tree is one of those darkly inspirited trees of the forest of folklore and uncanny fairy tale. Nature here, in the form of the apple tree, is not the site of restoration and recuperation; it is malign and symbolic (with its 'poisonous' apples that remind, perhaps, of fairy tales such as the virginal *Snow White*) of the difficulties of sexual awakening and knowledge.

In contrast to negative biblical injunctions against women climbing, and Carter's fraught representations of female awakening in *The Magic Toyshop*, there exist in Western art more romanticized and worshipful images of women in trees. In 1880, just two years before his death, the poet and artist Dante Gabriel Rossetti (1828–82) painted an oil canvas of Jane Morris sitting in the branches of a sycamore tree, with all the usual lavishness of the neo-Renaissance style favoured by the Pre-Raphaelite Brotherhood.[31] The painting, 'The Day Dream', is now in storage at the Victoria and Albert Museum, London, and was painted from an earlier chalk and pastel sketch of Jane, holding a white flower and wearing a white dress, that is now in the Ashmolean Museum, Oxford. Jane Morris was an embroiderer and married to William Morris – the textile designer, writer and social activist who played a key role in the British Arts and Crafts Movement and Socialist movements, from 1880 onwards. Jane epitomized the Pre-Raphaelite ideal of beauty and served as a muse to her husband, as well as posing often for Rossetti's paintings – there are several paintings of her posing as Proserpine, and 'The Syrian Venus', in almost identical green silk robes. At the time Rossetti made this painting, the two were involved in an illicit love affair. It is fair to say that Rossetti was obsessed with Jane's beauty. Art critic Robert Upstone writes, 'by the summer of 1869 they were on increasingly intimate terms [...] and may well have been lovers. Whatever the dynamics of their relationship, which on Rossetti's part involved a passionate attraction, William Morris appears to have tolerated it.'[32] In 'The Day Dream', Rossetti paints Jane's lush chestnut hair tied back behind her head; her opulent green silk dress shimmers with light; the fabric of her robe falls around her in cascades that blend her into the canopy. But the clothing is, again, completely incongruous – how on earth could this woman have climbed into a high bower, wearing such cumbersome clothing? It clearly can't have happened in reality – that robe would be impossible to climb in – and so the image must be one of pure fantasy and imagination. A daydream itself. This woman simply has the power to appear in the trees. She is *of* the trees, like a classical tree nymph and, as such, possesses magical and mythical status. She is symbolic. As is

the tree itself, which has rich meanings that Rossetti must surely have been aware of, deeply involved as he was in the Symbolist art movement that had made its way from Europe to Britain in the second half of the nineteenth century. In the Bible, the character of Zacchaeus climbs into a sycamore tree from which vantage point he is able to get a glimpse of Jesus over the heads of a thronging crowd.[33] Thereafter, the sycamore has become symbolic of 'clear vision'. Other biblical examples include the prophet Amos sitting under a sycamore, and Mary and Joseph seeking shelter from the elements under a sycamore tree, which connote both knowledge and protection, respectively. In the ancient *Egyptian Book of the Dead*, two sycamore trees stood at the eastern gate of Heaven. The Sun God, Ra, shows himself between these two trees each morning. The Egyptian hieroglyph of a tree is similar to a sycamore, and Egyptian burial sarcophagi were often carved from sycamore wood. Sycamores were frequently planted next to Egyptian tombs. So, along with the biblical connotations, the sycamore symbolized protection, eternity and divinity for the Egyptians. Further associations with the tree include longevity (they can live up to 600 years), hope, reliability and love. In the Middle Ages, lovers would present each other with a spoon carved from sycamore wood, ornately decorated with symbols of love and nature. Sycamores also have a fascinating end to their reproductive cycle, producing thousands of winged 'helicopters' that spiral to the ground on the wind. This fecundity of winged seed gives the trees their association with fertility. Sycamore bark has been used in wound dressings and in tinctures to treat a variety of ailments, including cold and cough remedies and dietary, dermatological, gynaecological, respiratory and gastrointestinal problems. It is therefore also a healing tree. In a more esoteric sense, the foliage of the sycamore was used in folklore to ward off the spirits that make men fall to temptation. One may assume that Rossetti must have known of – at least some of – these symbolic meanings and that he therefore did not choose a sycamore tree by accident. No, Jane is there to heighten such romantic meanings.

This particular tree then, in which sits the epitome of Pre-Raphaelite beauty, is in full leaf, creating a soft and cushioning nest, as though the woman were being embraced by the vegetation. Once again, the viewer may recall the tree nymphs of mythology – of Daphne turning into the laurel tree pursued by Apollo. Of 'becoming tree'. Here, the woman is becoming a nature goddess as she sits in the canopy. There is also a great sense of secrecy at play in the painting, perhaps hinting at the idea of treetops (or hollow tree trunks) as secret meeting places for romantic assignations – May and Damian in Chaucer's tale come to mind, although there is no such crudeness in Rossetti's painting as is found in Chaucer, except perhaps for the subtle gesture of her right hand: splayed fingers can suggest an active female sexuality in paintings, just as a raised or proud middle finger is nearly universally symbolic of crude male sexuality.

As well as the idea of the nest-like treetop creating a secret, safe space, the woman also appears to have something secret on her mind that is completely beyond reckoning. She stares out beyond the frame, lost in a deep reverie. Her deeply involved but secret daydream opens the painting up to imagination and greatly involves the viewer. The woman sits high in the branches with a book on her lap. Perhaps she is lost in a daydream of the story, or the poems, that are contained in its pages? Or perhaps she has other things on her mind? More furtive things concerning love. After all, the book lies almost forgotten on her lap and, in the hand that lies across the book, there lies a sprig of honeysuckle which, in Victorian symbolism, represents the vigorous and sensory attachments of love. Its inclusion here suggests a self-conscious reference to the artist's love affair with his model. Given this self-referentiality, one might also ask whether it is the woman who is daydreaming, with her neglected book in her lap; or whether it is the painter himself who is lost in his perpetual daydreams of his beautiful muse?

Rossetti was also a poet and the title of his painting, 'The Day Dream', relates to his poem of the same name, which appeared among the *Sonnets for Pictures*. The poem begins: 'The thronged boughs of the shadowy sycamore / Still bear young leaflets half the summer through,' and continues in lyric mode to create a sylvan scene where dreams are easily conjured 'Within the branching shade of Reverie'. Tree canopies are dreamy, natural spaces, the poem insists. But it is the woman who appears in the canopy towards the poem's end who commands attention, because no dream of nature can be 'Like woman's budding day-dream spirit-fann'd.' It is woman alone, with her fertile spirit, who has the capacity to dream beyond nature, to make her daydreams 'bud' more vigorously than the tree itself, 'till now on her forgotten book / Drops the forgotten blossom from her hand.'[34] It's a beautifully melancholic ending that anticipates the painting exactly. The English novelist, Evelyn Waugh, would later comment on the painting saying that 'All Rossetti's failing concentration and genius was lavished upon this beautiful canvas'.[35] It was one of the last canvases Rossetti would ever paint.

<div style="text-align:center">*</div>

Reading Idra Novey's earlier comments on the *Women in Trees* photographs, it becomes clear what an obvious choice Novey was for the review, since her own first novel, *Ways to Disappear*, begins with a woman in her sixties climbing into an almond tree. 'All I had in mind was her ascent,' Novey comments in her article on tree climbing for *The Paris Review*. 'I thought as far as the decisive "no" she would reply to the man who approaches the tree and asks if she needs assistance. I gave her a cigar and a suitcase and knew the scene would end with her perched in her tree as gracefully as if

she were awaiting a train in a station.'[36] Even in that simple 'No' spoken by her protagonist, Novey claims tree climbing for women, free from male interruption or interdiction. Novey goes on to tell *The Paris Review* a story of how, a month after the US 2016 election, she was visiting her in-laws in Chile, and climbed a tree for the first time in years, incapable of responding to repeated family questions as to how America could have elected a president like Donald Trump. 'I drifted off into the yard and climbed into a lemon tree,' Novey writes. 'It was more the accumulating pressure of my own sense of inadequacy and unease. I knew that wedging my middle-aged behind into the forked branches of a lemon tree would resolve nothing. But the fragrance of the lemons, the sensation of perching like some primal animal in a tree, felt restorative.' Novey hits on several of the key themes that have emerged consistently with tree climbers: she finds solace in the lemon scent of the tree; she senses some atavistic connection with nature and human ancestry, and she taps into the power that trees have to be restorative. And, as with many novels and poems featuring tree climbers, Novey's anecdote reminds that climbing trees is a commonplace way of escaping overbearing families. It is also a way of escaping overbearing, patriarchal men, since her own tree climb came in response to a family argument about a president whose sexist attitudes and predatory behaviours have been repeatedly questioned.

Novey's tree climbing character in *Ways to Disappear* is Beatriz Yagoda, a famous fictional Brazilian novelist. 'In a crumbling park in the crumbling back end of Copacabana, a woman stopped under an almond tree with a suitcase and a cigar.'[37] So begins the novel and Beatriz's ascent. She is watched by a group of men playing dominoes in the park. Julio, a ladies' man, is selected by the players to go and see if the woman needs any assistance. The brief scene that follows recalls some of the tensions in the *Women in Trees* images, as well as the sight of Caddy's underwear in Faulkner's novel: 'the woman climbed higher, exposing the frayed elastic of her cotton underwear and the dimpled undersides of her thighs.' Like Caddy, Beatriz's underwear is on view and in less than pristine condition – the elastic is 'frayed'. Julio, the ladies' man, approaches. 'At the base of the tree, he looked up and found the woman's ample behind looming directly over his head.' Given that the reader is aware of his status as something of a lothario, there is some deliberate sexual tension in Novey's image. Julio asks if he can be of assistance. What, after all, would a woman be doing in a tree? 'Would you look at that,' one of them has already commented. But Beatriz just sits there 'serenely with her open book and cigar', rebuffing the interloper. A demure 'Jane Morris' type with opulent clothing, open book and sprig of honeysuckle she is not.

So begins Beatriz's enigmatic disappearance. Five days later, her American translator, Emma, flies to Brazil to try to solve the mystery of the novelist's vanishing, with the help of Beatriz's two grown children, Raquel and Marcus. Attempting to explain her mother's disappearance, Raquel concludes: 'Her

mother had suffered a sudden onset of amnesia, or was in the throes of a dissociative fugue. How else to explain why a woman in her sixties would drag a suitcase into a tree?'[38] People of sound mind don't climb trees, common propriety demands. Her mother has clearly lost her mind, or her memory, or has lost her own sense of identity and self-awareness and 'gone walkabout'.

It transpires that Beatriz is actually in real trouble – half a million dollars-worth of gambling debts in fact, that lead to a detective chase, kidnapping, pulp fiction violence and a romantic intrigue between Emma and Beatriz's son, Marcus. The local radio station bizarrely broadcasts that a second novelist has also gone missing 'scaling a banyan tree in the lovely Jardim de Alá'.[39] Fictional life imitates fictional life, which imitates real life. It's the kind of layers-within-layers that make Novey's novel charming, with its postmodern self-referentiality: Beatriz's own stories have also contained stories of characters who climb trees. The reader is told of one of Beatriz's earliest stories, set in a prison, with 'a minor character who climbed a palm tree outside the walls to listen to the lizards and found the distance so freeing, sitting there elevated and unseen, away from the other wardens and their prisoners, that he never came down.'[40] Again, the tree climbing imagery is of distancing, elevation, being hidden and remaining connected with nature; a sense of being 'as free as the lizards' that counters the psychological and physical restrictions of imprisonment.

It transpires that the second novelist who has climbed a tree, has done so to disappear after he raped a girl. 'He's exactly the kind of writer who would climb into a tree to imitate someone who is the real thing,' Raquel tells Emma.[41] In the end, this imitator meets a grisly end. Art-imitating-art-imitating-life aside, what these episodes point up are the key elements of tree climbing narratives: conflict, assumed madness, transgression and the desire to disappear, if only for a while. At the novel's end, Beatriz is found, momentarily, by Raquel, in a hotel on a small, out-of-the-way island, and reflects on her tree climbing escape: 'To have climbed higher and higher as you had as a child,' she says, 'and recall the same breeze carrying the same scent of almonds, and before you could fall there was your father below, waiting to catch you.'[42] Here again, the reader is reminded of the powerful agency of the *scent* of trees. Furthermore, almonds are healthy nuts – they lower blood sugar levels, reduce blood pressure and cholesterol, reduce hunger and can assist in weight loss. These things are, of course, not on Beatriz's mind, but the fact that it is an almond tree is surely symbolic. It is a healthy, vigorous, health-promoting tree and, so, the young girl climbs it. Tree climbing is again cast as a throwback to the 'idyllic' days of childhood, before adult cares. And the father in her memory is symbolic also, ready at hand to catch her if she falls – an image that might be read in any number of ways from the literal, to the Freudian, to religious 'fatherliness' even. Climbers climb up, literally, but they also climb metaphorically upwards, ideally towards some form of inspiration or restoration, as well as climbing

metaphorically backwards towards the carefreeness and liberty of childhood. They climb away from the father – from duty, regulation, order, patriarchal rule – towards their own individuated self, which includes sexual realization. But the father remains there as a safety net – he may be stable, providing, instilling confidence, teaching and encouraging. He may be a safe pair of hands. Novey's tree climber, Beatriz, encapsulates and consolidates these commonplace tree climbing features. But, importantly, she captures them and reclaims them *for women*.

If tree climbing is in some ways transgressive, then tree climbing for women has been shown to be doubly so. In the next chapter, that sense of transgression is taken further still, by looking at environmental protestors who climb trees to protect the environment, some of the most notable of whom have been women, and who *en masse*, in India particularly, have had lasting effects on the development of ecofeminist movements.

Notes

1 All lines from this poem from Kathleen Jamie, 'The Tree House', pp.41–3.
2 All quotes here from Cecylia Malik, pp.8–9.
3 Adam Wajrak. In Cecylia Malik, pp.273–5.
4 Jochen Raiß. *Women in Trees*, p.10.
5 Janisse Ray. *Ecology of a Cracker Childhood*, pp.11–12.
6 Idra Novey. 'Women in Trees'. https://www.theparisreview.org/blog/2018/03/22/women-in-trees/
7 Roland Barthes. *Camera Lucida*, pp.26–7
8 Lulah Ellender. 'The Knotty Story of Women in Trees'. https://www.caughtbytheriver.net/2019/04/the-knotty-story-of-women-in-trees/
9 William Faulkner. In David Minter, p.233.
10 Ibid, p.25.
11 Ibid, p.29.
12 Ibid, p.47.
13 Ibid, p.96.
14 André Bleikasten, Ibid, p.421.
15 All quotes from the poem, Hart Crane. 'Garden Abstract'. *The Complete Poems of Hart Crane*. https://poets.org/poem/garden-abstract
16 *Book of Isaiah.*
17 All quotes from Chaucer here, in *Chaucer: The Canterbury Tales*, ed. Neville Coghill, pp.401–5.
18 https://scalar.usc.edu/works/looking-through-the-eastern-frame/media/merchants-tale
19 http://www.artnet.com/artists/elisabeth-frink/the-merchants-tale-ljxxpOSt_sJO5kkg2A3jGw2
20 Angela Carter. *The Magic Toyshop*, p.7.
21 Ibid, p.17.
22 Ibid, p.19.
23 Ibid, p.20.

24 Ibid.
25 Ibid, p.21.
26 Ibid, p.21.
27 Ibid, p.22.
28 Ibid, pp.23–4.
29 Ibid, p.24.
30 Ibid, p.26.
31 https://collections.vam.ac.uk/item/O14962/the-day-dream-oil-painting-rossetti-dante-gabriel/
32 Robert Upstone. *The Age of Rossetti, Burne-Jones & Watts,* p.160.
33 *Gospel of Luke.*
34 Dante Gabriel Rosetti. *Sonnets for Pictures.*
35 Evelyn Waugh. *Rossetti: His Life and Works,* p.204.
36 All quotes in interview from Idra Novey. 'Women in Trees'. https://www.theparisreview.org/blog/2018/03/22/women-in-trees/
37 All quotes here from Idra Novey. *Ways to Disappear,* p.3.
38 Ibid, p.14.
39 Ibid, p.77.
40 Ibid, p.9.
41 Ibid, p.95.
42 Ibid, p.187.

10

'Tree hugger'

The pejorative term 'tree hugger' originates in events in India in 1730. To prevent a palace from being built on their land by a platoon of troops sent by the Maharaja of Jodhpur, 363 men and women of the Bishnoi caste in the village of Prasanna Khamkar, Rajasthan, hugged the condemned Khejri trees in their village to protect them. It ended tragically: the trees were cut down and the protesters were massacred by the Maharaja's soldiers. The only positive outcome was a Royal Decree outlawing the logging of further trees in Bishnoi villages. Two hundred and forty-four years later, in 1974, Indian history almost repeated itself in Uttarakhand, at the foot of the Indian Himalayas, where a group of women hugged the trees in their village to prevent them being felled. The Indian phrase 'satyagraha' ('holding firmly to truth') is a principle of non-violent resistance coined by Mahatma Gandhi. Its principles were essential to the activities of the Chipko Andolan forest conservation movement (meaning 'to cling') in Uttar Pradesh, which was formed that day in 1974, and which went on to be instrumental in protecting trees and reforming forestry practice across the country. One of Chipko's most salient features was the mass participation of women protesters, seen as a guiding principle in the growth of ecofeminism – that branch of environmentalism which foregrounds the important relationships between women and the earth.

Since then, however, in the West at least, the term 'tree hugger' has come to be used in a purely derogatory and comical way – to insult an environmentalist, call them a 'tree hugger'. The term has come to connote irrationality, madness even, 'being a hippie', and caring more for nature than for people. 'Tree huggers' can't get their hugs from – or have meaningful relationships with – other people, the derogation goes, and so they hug trees. Calling someone a 'tree hugger' is meant to belittle them – hugging is something soft and comforting; forestry is supposedly masculine and hard, with little time or room for such messy things as feelings. And hugging trees?

That makes you soft in the head too, the put-down insists. It's meant to sound humorous and inoffensive, but it is not, revealing itself as ignorant of the history behind the term. What is wrong with 'tree protestor', or 'activist'? The non-violent principles of '*satyagraha*' have been turned on their head – environmentalists who engage in such practices are mocked. Yet the spirit is still strong on the Indian subcontinent. In 2014 in Kathmandu, Nepal, 2,001 people took part in an event to break the *Guinness World Record* for the most people hugging trees at one time. It was to raise awareness on *World Environment Day*. This record was smashed in March 2017, when the largest tree hug was recorded in Thiruvananthapuram, India. A total of 4,620 people hugged trees simultaneously for a minute on the United Nations' *International Day of Forests*. People want to reclaim the term. In this Anthropocene age of impending irreversible climate change, surely it can be agreed that it's not *so mad* to care about the environment enough to want to protect it.

This chapter proceeds from this history and language of 'tree hugging' and picks up with a discussion of the tree climbing habits of one significant Victorian environmentalist, Charles Waterton, who walled-in a 'nature reserve' in Yorkshire at the height of the Industrial Revolution, to protect the local trees and wildlife. Waterton's tree climbs were not environmental protests per se, although they were taken in a spirit of stewardship of nature. Such deep connection in spirit is central, also, to a recent account of environmental activism: Julia 'Butterfly' Hill's *The Legacy of Luna*. Hill writes an impassioned account of her historic tree-sit in the canopy of Luna, a thousand-year-old giant redwood tree in California. Hill's tree sit lasted just over two years – her remarkable account is notable for its euphoric revelations, as well as its lessons in how to listen to, and tune into, creation. Hill's revelations about the politics of tree sitting are echoed in fictional form in Richard Powers's Pulitzer Prize-winning novel of 2019, *The Overstory*. The experiences of Powers's characters are often remarkably similar to Hill's account, and echo her radical environmentalism. There are also tree climbing strands in Powers's novel that resonate with earlier discussions of family conflict, and misadventure in tree climbing narratives. Powers's characters also embody the popular scientific research into plant communication found in books such as Peter Wohlleben's *The Hidden Life of Trees*, and Dr Suzanne Simard's research into the 'wood wide web' of intercommunication in *Finding the Mother Tree*. The chapter concludes with a discussion of the American artist, Julie Heffernan, and the American photographer, Ryan McGinley, whose works respectively engage with questions of environmental protection. Heffernan's oil paintings present multiple images of men and women in trees as symbols of hope and human stewardship during times of environmental disruption. McGinley, on the other hand, reclaims the pejorative 'tree hugger' as a positive term, through his rebellious nude photographs of men and women in trees. As with the work of Cecylia Malik in the previous chapter, McGinley reclaims tree climbing for his female subjects while forging a strong connection with 'Mother Earth'.

*

Charles Waterton (1782–1865) was possibly England's first well-known 'conservationist', although to call him that is anachronistic since the term was first used only in 1861, and then only in its ecological sense in the early twentieth century. Yet Waterton certainly represents something in the late Victorian *zeitgeist* that was beginning to see the errors in the ways of the Industrial Revolution. Waterton was an English traveller and ethnologist; a naturalist; a taxidermist and an eccentric. Owning a large country house, Walton Hall, with park grounds in the industrial north of the West Riding of Yorkshire, he began in 1813 to turn his land into a sanctuary for wildlife – and for himself – surrounded by a sixteen-foot-high stone wall, three-miles long, whose construction was completed in 1826 at a cost of £9,000. Waterton was a habitual tree climber. In her biography of the man, Julia Blackburn describes how, as a boy, he would slip out of his bedroom at night and climb the branches of an oak tree which stood beside the lake. While up in the branches, the young Waterton would watch a family of foxes play-fighting on the ground. Such habits occupied him into his seventies, climbing the same trees he had climbed as a child, to find himself 'up in a pine tree with a rook's egg in his mouth'.[1]

Like many tree protestors who would follow much later in his footsteps, Waterton walked around his estate and climbed trees barefoot. At the age of fifty-five, he wrote of himself that he 'was quite free from all rheumatic pains; and am so supple in the joints that I can climb a tree with the utmost facility.'[2] Julia Blackburn describes how, 'Barefoot, he paid his daily visit to the top of a high fir tree where a jackdaw had her nest. Silently he would crouch beside a bluetit sitting on her eggs: she had grown so accustomed to his presence that she did not fly away, even when he stroked the feathers on her back.'[3]

Waterton published his first book of travels, *Wanderings in South America*, in 1826 and three volumes of his *Essays on Natural History* between 1838 and 1857. Three volumes of his *Autobiography* appeared in 1837, 1844 and 1857, respectively. In these works, Waterton writes of his own tree climbing proclivities: 'I often go into the topmost branches of a wide-spreading oak and there, taking the *Metamorphoses* out of my pocket, I read the sorrows of poor Halcyone. A brook runs close by the tree, and on its bank I have fixed a stump for a resting place for the kingfisher.'[4] By fusing the real world and the imagined, Waterton was making, in his mind at least, a literary ecology from his tree climbing.

Although he was visited by Darwin and his writings were held in a certain esteem by Charles Dickens and Thackeray, Charles Waterton was characterized in his lifetime – and long afterwards in several biographies by Robert Hobson (1866), Edith Sitwell (1933), Philip Gosse (1940) and Richard Aldington (1949) – as an eccentric, a crank and something of a curiosity. In short, he climbed trees barefoot, so people thought he was

mad – the common assumption about tree climbers. But there was a quest for sanity and wellbeing in his passion for tree climbing: a teetotaller and devout Catholic, often gentle, sometimes impatient and angry, it is perhaps understandable that his naturalist's adventures into the forests, swamps and plains of the world and, perhaps, his retreats up into the trees of his private parkland, came from his quest 'to find quiet and an inner stillness'.[5] It is that calm which tree climbers repeatedly report finding: the restorative effects of greenery, aromatic compounds and connection with the natural world that science (and experience) attest to.

Although Walton Hall's grounds were opened to the public and local industrial workers, and some 17,000 people visited per annum in the 1840s, Waterton never felt that he had surrendered his privacy. He would often retreat into the branches of a tree to avoid these visitors who were, themselves, amazed at the sight of their host, an aged man, climbing barefoot up the trees of his domain to commune with the wildlife. As his final days approached, Waterton wished to be buried under the huge oak trees beside the lake in his grounds, where he had sat as a boy watching foxes and reading Ovid.[6] In finding his final resting place there, hugged by the roots of his oak tree, Waterton embodied the imaginative transformations of his treetop readings, his body transformed from that of a 'tree hugger' into the tree itself, in a transmuted way akin to Thomas Hardy's graveyard poem, 'Transformations'.

*

On 18 December 1999, Julia 'Butterfly' Hill descended from the canopy of 'Luna', a thousand-year-old giant redwood tree in Humboldt County, California. At 180 feet tall, Luna was the highest tree growing in the district. When she first climbed into the tree some two years earlier, on 10 December 1997, Hill thought that she was taking part in a two week 'tree sit', to stop the Pacific Lumber company from logging the area – there had already been deforestation of the surrounding land and the town of Stafford had been devastated by a mud slide that followed fast on the clear felling of the trees. The trees' roots, as even a basic grasp of forestry science attests, had been stabilizing the soil and the trees' natural processes of transpiration had been cycling the water in the earth and balancing the water table. Take the trees away and the destructive consequences inevitably follow.

Julia 'Butterfly' Hill – the insect being her chosen *nom de plume* in the activists' camp – was just twenty-five. Her book, *The Legacy of Luna*, records the tree sit in personal detail. A 'tree sit' is the continuous occupation of a tree to prevent loggers taking a chainsaw to it. The tactic is usually a stalling one that allows time for the environmentalists' lawyers to battle things out in the courts, thus ensuring longer-term victories. In Hill's case, her two-year tree sit was also a platform for extensive media coverage and

global broadcasting about the activities and vested interests of large-scale logging operations. 'Tree sitting is a last resort,' writes Hill. 'When you see someone in a tree trying to protect it, you know that every level of our society has failed [...] Everything has failed, so people go into the trees.'[7] Hill's actions made her one of *Good Housekeeping*'s 'Most Admired Women of 1998', as well as being featured in *People* magazine's '25 Most Intriguing People of the Year' issue. Hill had endured terrible weather conditions; helicopter harassment from the loggers; a ten-day siege by Pacific Lumber's security guards and general 'tree hugger' abuse: 'crazy, wacko, extremist, far left, terrorist, idiot'.[8] Coming down from Luna, Hill went on to found the *Circle of Life Foundation*, an ecological educational organization, and the Engage Network, which develops programmes in education, conservation, restoration and sustainability. *The Legacy of Luna* documents the incredible inner strength and spiritual fortitude that she discovered while sitting in Luna's canopy.

Like Charles Waterton before her, Hill climbed barefoot. 'I had to abandon my shoes early on in the sit,' she writes. 'I couldn't stand the feeling of separation from the tree. With all that stuff between my foot and the branches, I couldn't tell if what I was about to stand on was strong enough to hold me or if my foot was on the branch securely.'[9] She did not wash her feet either, so that the resins exuded by the tree would help her stick to the branches. Such literal connection with natural materials echoes the inner sense of connection that Hill and other tree climbers testify to. Similarly, she had to learn to attune her body and movements to the movements of the tree itself. In a particularly ferocious storm, Hill writes of how she suddenly understood that what she had to do was not hold herself rigid against the battering, but to just let go: 'I let my muscles go. I let my jaw unlock. I let the wind blow and the craziness flow. I bent and flailed with it, just like the trees, which flail in the wind. I howled. I laughed. I whooped and cried and screamed and raged. I hollered and I jibbered and I jabbered. Whatever came through me, I just let it go.'[10] Hill's use of language here echoes the common descriptions of 'craziness' associated with tree climbers. She describes the storm as though her sanity was 'slipping through my fingers like a runaway rope'.[11] Her safety net – her rope *and* her reason – were being taken from her by the ferocity of the storm. The metaphor is a poignant one. As is the tree's name, Luna, meaning 'moon', and the root of the word 'lunacy' which – in the mid-sixteenth century when the word was first used – was attributed to mental disturbances caused by changes in the phases of the moon. Facing extremes in the crown of a tree will, Hill suggests, take you to the edge of your sanity, but coming through it will leave you stronger, more connected. It is 'that inner urge to find our higher self' that the adversities of tree climbing will let shine forth.[12] Hill's revelations are euphoric. At one point she writes, 'My feet could feel the power of the Earth coming through Luna, while my hands felt the power of the sky. It was magical. I felt perfectly balanced. I was one with Creation,'[13] while, at the book's ending, reflecting

on what it was that her time in the tree had taught her, Hill concludes: 'Luna changed me. Living in this tree, I remembered how to listen, to hear the world and Creation speak to me. I remembered how to feel the connection and conscious oneness that's buried deep inside each of us.'[14] Hill's account of finding a 'higher self', and the 'change' that reconnected her to something 'inside', parallels the many accounts of tree climbing previously discussed in literary and artistic representations of climbers. If a climber ascends a tree in a back garden, in a park near home, or even in a forest or wood while out for a walk, they are certainly not going to stay up there for any great length of time, unlike Julia Hill. But they might ascend for a short while and tap into a little bit of that connected 'oneness' that Julia Hill found in the branches of Luna. The tree itself is now protected under a preservation order that safeguards the trees and the land around Stafford. However, just one year after Hill's tree sit ended, Luna was 'assaulted' by someone wielding a chainsaw, leaving the tree with a gash that destabilized the tree. Luna was rectified by a group of arborists, who shored her up with metal bands and cables. She is still standing. The trees there, for now, are saved, and there have been no more landslides.

Richard Powers's 2019 Pulitzer Prize-winning novel, *The Overstory*, presents its readers with a veritable forest of trees, including narratives of radical environmentalism akin to Julia Hill's. The novel brings together nine protagonists, each of whom has a deep and profound relationship with trees, setting them off on varying courses, to study, live with and protect the natural forests of the United States. Their stories bear notable similarities to Julia Hill's account of her experiences in Luna. In Powers's novel, the writer presents a panoramic scope of these lives, their inhabited landscapes and their extraordinary experiences. At 600 plus pages, it is a forest of a book itself with complex narrative threads, but there are several tree climbing strands pertinent to this discussion.

When the reader first meets him, Adam Appich is a bright young boy who loves watching insects in his garden. Later in life he transfers this fascination for 'the colony' to a study of a branch of human psychology, *cognitive bias* (systematic thinking errors, such as 'jumping on the bandwagon' against the evidence, or the 'halo effect' of making overall judgements based on one quality), and the role of narrative in that bias. He comes to write a thesis on environmentalists, bringing him into contact with the other characters in the novel. Following some explosive protests at the novel's climax, Adam is arrested, tried and sentenced to 140 years in prison, which he considers to be a very short time compared to the life of a giant redwood tree. But at the start of his narrative, the reader simply encounters Adam climbing a tree. As in other literary examples, Adam's retreat into the branches comes at a time of family conflict: he has had a fight with his mother and slapped her. 'Adam's father learns of the slap that evening. He teaches the boy a lesson that involves twisting his wrist until it fractures,'[15] a brutish and disproportionate punishment. The wrist is cast in plaster and finally heals. In

one of his kinder moments, the father has already planted a tree to celebrate the birth of each of his five children. Adam's tree is a maple. As soon as the cast comes off his healed wrist in late spring, 'Adam climbs up into his maple as high as he can and doesn't come down until dinner.' While up in the branches he takes 'bitter comfort' knowing 'how much better life is above ground level'. Watching the bird and insect life in his tree canopy, Adam marvels at how many more lives there are up there in the natural world than there are people in his home town. His childhood retreat into his maple tree after a time of family conflict prefigures the action much later in the novel, when Adam will climb a 200-foot giant redwood tree to interview the tree sitters who are trying to protect it and will 'look down on a knot of people no bigger than bugs, a democratic majority of whom want him dead'.

There are other significant childhood tree climbing episodes in Powers's novel. Neelay Mehta is the son of Indian immigrants. Later in life he becomes the brains behind some globally successful computer games: the *Mastery* franchise. But Neelay comes to this career in a roundabout way since, as a child, he falls from a tree, cracks his spine and is paralysed for life. Thereafter, computers become his salvation. As with other fictional climbers, Neelay's climb into the tree comes after a moment of conflict. At school, he swears at his teacher when she confiscates his personal notebook in which he is developing plans for his computer programs. She puts him in detention the following morning before school starts and sends him home to think about what they will need to discuss the next day. Infuriated, Neelay leaves school and walks home through his tree-lined neighbourhood. Seeing a huge beam hanging down he 'shimmies up into the roost, where he sits like he's seven again. There he takes stock of his ruined life.'[16] The reaction is melodramatic, but the feeling is real enough: Neelay, like so many tree climbing characters, goes aloft because he feels his life has gone wrong. The canopy is once again a safe, separate space in which to sit and think, away from teachers and parents who will be angry, away from the prospect of detention and family shame. But he slips, falls and cracks his coccyx. 'Time stops. He lies on his shattered back, looking upward.' In his shocked vision, the tree becomes 'the most perfect piece of self-writing code that his eyes could hope to see. Then his eyes close in shock and Neelay shuts down.'[17] Strangely, the genetic coding metaphor of the tree's complexity becomes his salvation, in his career in computer game design, which is ultimately geared towards environmentalism – *Mastery* is a colonization game that deals with trees, world-building and deforestation.

The tree-sitting protests in the novel are centred on the tree sit of two other characters. Nicholas Hoel is a struggling Norwegian artist. Oliva Vandergriff is a young environmental activist. Like Julia 'Butterfly' Hill, they give themselves tree names in the camp of environmental protesters whom they have joined. Nick becomes 'Watchman'; Olivia is 'Maidenhair'. There are detailed tree climbing scenes in which both learn how to climb the redwoods using ropes, stirrups and harnesses. Watchman looks up to

see Maidenhair climbing above him and casts her in terms of Nordic myth: 'She's the squirrel, Ratatoskr, scaling Yggdrasil, carrying messages between hell, heaven and here.'[18] There is also something erotic in the scene: 'The intimacy – her body writhing above him – makes his soul flush', echoing the eroticism of tree climbing episodes in the previous chapter. The couple are tree-sitting a tree called Mimas, personalized in the same way that Luna was christened in Julia Hill's protest. Watchman and Maidenhair are supposed to be there for only a fortnight but, again like Hill, they find themselves in the tree for much longer. Their tree sit lasts over a year.

Re-enter Adam Appich, and his academic study of the psychology of environmentalists. Adam climbs up to join Maidenhair and Watchman to interview them. He 'puts his right foot into an imaginary niche and steps up. Slides the rope's slipknot, steps again with his left. Fights to forget how many vaporous steps he has already taken. Tells himself: I *used to climb trees all the time*. But Adam isn't climbing a tree. He's climbing the air.'[19] When he joins them on their tree top platform, 'The altitude doesn't bother him as much, now that he can't see the ground.' He feels 'content, a stylite perched on top of the night sky'.[20] Powers refers here to those Christian ascetics, common in the Byzantine era, who underwent the bodily mortification of sitting atop a pillar to commune with god. The first and best-known of these was Simeon Stylites, who climbed a pillar in AD 43 and sat there for thirty-seven years, as celebrated in Alfred Lord Tennyson's poem of 1841 'St. Simeon Stylites': 'Patient on this tall pillar I have borne / Rain, wind, frost, heat, hail, damp, and sleet, and snow.'[21] Similar mortifications were performed by the dendrite monks, such as Saint David of Thessalonika (450–540 AD), who spent three years living in an almond tree, contemplating spiritual matters. There are also echoes here of Kiran Desai's satirical portrait of the sham guru, Sampath Chawla, in his guava tree.

Richard Powers's novel is rich with the details of the biology and ecology of trees – the kind of information that one reads in books such as Peter Wohlleben's *The Hidden Life of Trees*, or Suzanne Simard's *Finding the Mother Tree*. One of Powers's characters, the dendrologist, Dr Patricia Westerford, publishes an academic study on such matters. Her imagined work, *The Secret Forest*, echoes much of Simard's research and Wohlleben's accounts. Early in her research career, Patricia discovers that trees communicate with each other. She publishes her research, although it is widely derided. In reaction, she even contemplates taking her own life. But later in life, when she is living the relatively secluded life of a park ranger, she discovers that her ideas have, in fact, become widely accepted in the scientific community and have been developed by others. So it is that Dr Patricia Westerford is based upon the scientist who first researched the way trees communicate through underground networks, Dr Suzanne Simard, and who popularized the term 'the Wood Wide Web' to describe the interconnectedness of trees in the forest.[22] Giving a lecture, late in the novel, Dr Westerford says: 'A forest knows things. They wire themselves

up underground. There are brains down there, ones our own brains aren't shaped to see. Root plasticity, solving problems and making decisions. Fungal synapses. What else do you want to call it. Link enough trees together, and a forest grows *aware*.'[23] In these comments, Dr Westerford's lecture also echoes Darwin's ideas about the 'root brains' of plants. She goes on: 'This isn't mystical. The "environment" is alive – a fluid, changing web of purposeful lives dependent on each other [...] Our brains evolved to see the forest. We've been shaped by forests for longer than we've been *Homo sapiens*.' In these comments, William Golding's *Inheritors* are brought to mind, along with other atavistic throwbacks that might form some unconscious part of the tree climber's motivation.

The final tree climbing revelation in Powers's novel belongs to the character Douglas Pavlicek. Douglas grew up an orphan, was imprisoned early in life and participated in the Stanford Prison Experiment, that used prisoners as both 'guards' and 'prisoners' to test the psychology of 'perceived power'. These early experiences give him an (at least) ambivalent relationship with authority. On release, he enlists in the Air Force and, after those experiences, returns to the United States where he essentially becomes vagrant. He comes to work in re-forestation programmes planting saplings, but becomes disillusioned with the mass deforestation of commercial logging companies. His plantings – he has planted over fifty thousand trees – do nothing to stop the deforestation of old forests, and are a mere drop in the ocean of trees that are removed. He joins the environmentalists, calls himself Doug-Fir and starts to protest at logging sites and tree-sits. Doug-Fir suffers excruciating injuries after being Mace-sprayed by the authorities at an organized protest. The novel then culminates in some disastrous action when the environmentalists shun their non-violent ethos and start to take retaliation against the logging companies, in the form of setting fires and sabotage. Doug is arrested by the FBI: he has documented all of the actions of the group in his diaries. Imprisoned at the novel's end, he gazes out of his cell window at a tree. His climb is therefore imaginary, but no less symbolically powerful for that:

> Again he steps up into the branches, like a ladder leading someplace above the blind and terrified. He covers his closed eyes with one hand and says 'I'm sorry'. No forgiveness comes, or ever will. But here's the thing about trees, the greatest thing: even when he can't see them, even when he can't get near, even when he can't remember how they go, he can climb, and they will hold him high above the ground and let him look out over the arc of the Earth.[24]

Everyone can climb the trees of the mind, Powers suggests; everyone can dream and use the power of imagination to take themselves up. And perhaps this is what tree climbers are doing when they make their ascents: climbing into the external branches of the actual tree, but making an inward,

imaginative journey of restoration, held 'high above the [metaphoric] ground' and looking 'out over the arc of the Earth' with a radically altered and healing perspective, that is directed towards healing themselves in some way but, crucially, also, healing their relationship with the Earth.

American artist Julie Heffernan is Professor of Fine Arts at Montclair State University, New Jersey, whose work involves itself deeply with questions of this healing relationship with the Earth. Heffernan paints in oils on canvas, mostly depicting subjects that deal with human stewardship of the planet and of environmental change and catastrophe. Heffernan's work contains imagery such as explosions, meteors, fires and floods, domestic objects and waste, and mistreated animals. 'I've shifted my work entirely to the tortured landscape,' she comments online.[25] Her style is Baroque and allegorical, surreal even, with fantastical elements, although the catastrophes that she depicts are far from fantasy: some respond to specific natural disasters such as Hurricane Katrina and large-scale oil spills, while other more generalized ecological disasters are prevalent and, of course, increasingly real. Heffernan has also painted many images of people in trees. Her 2010 painting, 'Tender Trapper', for example, shows a young man, naked to the waist, sitting high in the branches of a tree, entwined in garlands of fruit, looking out over a surreal, dream-like tree-scape, where ships hang in the branches and a huge swinging censer of fruit, flowers and other objects dominates the foreground. But most remarkable of her works, certainly in relation to the question of environmental tree sits, is her 2013 canvas 'Self Portrait as Catastrophic Failure'.

The woman in this painting is a witness to catastrophic events. She sits high in the canopy of a tall tree, Eve-like, naked, with long red hair, fair skin and a kind of natural innocence in her bearing. This Eve looks almost pre-lapsarian, although the implication here is that any 'fall' will be from a great height, both for the sitter herself and for humanity more generally. In her left hand she holds a hose with which she is trying to douse a fire that has engulfed a whole city; the city itself being contained within a net bag that hangs in the tree above her. The hose is wrapped around the tree like a snake. If this *is* an Eden, then it is a debased one. In her right hand she holds a pair of scissors and is trying to cut that net bag free. She seems caught between the two courses of action: which will be more beneficial? Does it even matter anymore, she might be thinking? Her gaze is distracted and turned away from the burning city, however. She gazes up at another building of some kind, a dwelling that has been frozen in a huge block of ice and which sits in the branches above her to the other side. Already the block of ice has begun to melt. Beside her there is a radio-like device, through which she presumably receives broadcasts on the state of the world, or is attempting to broadcast her own message. The painting encapsulates in one complete image the ticking time bomb of global warming, climate extremes and melting icecaps. Below the woman, in the background, is a

FIGURE 10 *'Self-Portrait as Catastrophic Failure' (2013). Julie Heffernan. Oil on canvas. 68 × 68".* © Julie Heffernan.

watery world of houses, causeways and inlets that look as though they will be washed away in the impending floods.

The title of the painting is one in a catalogue of 'Self Portrait As ...' paintings in Heffernan's oeuvre. It begs questions of the viewer as an individual. What responsibility does one bear for causing the environmental disasters that are happening with recurring regularity? And what responsibilities does one bear for sorting them out? What can one woman do, the painting asks us? What agency does an individual have in face of global forces that are setting fire to the planet and melting its ice caps at an alarming rate? The work has a prophetic quality. Humanity came from the trees it suggests, and to the trees it may well return, even as it fights against its own most destructive, self-harming urges. The woman in this painting is not so much a 'barefoot tree hugger', as a completely naked steward of the world. No outlandishly

cumbersome dresses and clothing here restricting this woman's climb; she is stripped to her essence, to her humanity. In her climb into the trees, what is felt is the essential need *to do something about it,* balanced with the quandary in which all individuals are caught: *But I'm just one person!* In her catalogue essay 'Dandelion Clocks and Time Bombs' – written for Heffernan's 2013 exhibition *Sky Is Falling,* at the P.P.O.W Gallery, New York City – writer Rebecca Solnit writes that Julia Heffernan's paintings 'are her testimony in a language more immediate than words, to the fires, to the falling, to the disorder, to the anxious mix of fear and hope, and to our stance as complicit witness.'[26] In the words of the artist herself, paintings such as this are 'a continuation of my interest in climate change and the kinds of changes we are going to have to consider in order to deal with some of its eventualities – perhaps an opportunity for some creativity in how we approach habits and lifestyles [...] in order to start the work of change.'[27] This woman, sitting in the trees in her nakedness, reclaims the tree climb and tree sit not only for women, but for humanity, embodying 'the kinds of changes we are going to have to consider' to shift patterns, attitudes and behaviours.

The young American photographer, Ryan McGinley, develops similar themes in his photographs. McGinley lives in New York City's East side and began taking photographs there in 1998. Five years later, at the age of twenty-five, he was one of the youngest artists to have a solo show at the Whitney Museum of American Art. McGinley was named Photographer of the Year in 2003 by American Photo Magazine and, in 2007, Young Photographer of the year at the International Centre of Photography's Infinity Awards. He is known for his casual, irreverent, sometimes shocking nude photographs of his friends, and his documentation of New York's gay scene. His early photos are hedonistic and convey what the artist calls 'evidence of fun'. In a recent interview for *The Guardian,* McGinley says, 'The human body is beautiful. It was created by Mother Earth, our goddess. But posing nude is still an act of rebellion.' While there is an erotic, urban euphoria to his early work, it is unsurprising that McGinley has gone on to photograph his friends, in the nude and climbing trees: both the act of climbing and the nudity symbolize the 'rebellion' that he wishes to capture. 'I was born a child of the woods,' McGinley says.[28] Elsewhere, he has commented that his photographs celebrate 'life, fun and the beautiful. They are a world that doesn't exist. A fantasy. Freedom is real. There are no rules. The life I wish I was living.'[29] Again, given this insistence on fantasy, escape and freedom, it seems fitting that McGinley should choose to photograph his models climbing trees – the epitome of those qualities.

To capture this tree climbing fantasy and freedom, McGinley has spent five years driving into the American wilderness with groups of friends and assistants. The resulting images are 'as playful as they are voyeuristic, straddling a line between exuberance and disorientation'.[30] In one image, 'Beans' (2020), a naked man clings to the trunk of a dead tree, which rises between his legs like a monolithic phallus. Beyond, the wilderness spreads in

a patchwork of autumnal colours and blue distances. In another, 'Marieke (Fall Foliage)' (2011), a nude woman appears to run through the branches of a tree at night, the dark sky setting off the under-lit branches and deep red canopy. She becomes like a tree nymph floating through a dream or a myth. While in 'Orange Light' (2011) taken in the same year, a nude male is seen falling from the canopy of a brightly lit tree at night. His starkly-lit, naked form seems to capture something of human vulnerability and, indeed, McGinley has taken many photographs of his friends falling. Whether this is a fall from grace, through misadventure, or a simple surrendering to the inevitabilities of human embodiment, is left ambiguous. The photos feel all the more natural for that. In 'India (Monkey Brains)' (2013), a red-headed nude hangs upside down in the filigree branches of a tree just coming in to (or just shedding) leaf – her tumbling hair mimics the 'fall' of autumn, or perhaps vice versa. In the 'Tree' series of 2003, individuals and groups of naked men and women are seen high in the branches of dark forests, like the cavorting nudes in Hieronymus Bosch's painting *The Garden of Earthly Delights* (1515). McGinley's figures, like Bosch's, are rebelliously nude and seemingly out of place among the branches. They are hairless apes, trying to reconnect with 'the goddess', their creator, as he comments in interview. The atavistic urge of these images is clear. 'Dead Forest' (2012) is also an allegorical photograph – a nude sits in the branches of a forest of ghostly white birch trees; the background is a uniform blue; the trees are like the skeletal remains of life; the woman's fleshy tones are the only warmth in the image. She nests there like a beacon of ecological hope in a dying world.

But the photograph that is most apposite to discussion here is the one McGinley has titled 'Tree Hugger' (2017).[31] In this image, a full-bodied nude woman is captured high in the branches of a tree, in the dappled autumn sunlight. Her head is shaved. She wears a look of benign serenity on her face, gazing into the distance, as she lovingly wraps her arms and legs around the tree in a comfortable embrace; a true tree hug. The sky is lightly clouded. A lake glitters in the low background. The woman's large thighs, bottom and breast are bathed in light and shadow – she is Rubens-esque in her voluptuousness, the softness of her body contrasting beautifully with the hard scratchiness of the trunk and bark, yet mirrored in the soft billowing of the foliage. It looks as though she has been placed there – posed there – rather than climbed the tree herself but, nonetheless, the position of her feet creates the illusion that this is a woman who is most comfortable in her roost. She is at once a real woman and also a fertility goddess, perhaps the 'goddess' or 'Mother Earth' of whom McGinley spoke in interview, or William Golding's *Oa*. But she also reclaims the tree for women, in a way that the absurd clothing of the *Women in Trees* photos can never do. Her nakedness *is* rebelliousness itself; it snubs its nose at that old biblical tension between trees and female disobedience. 'I am Eve and I reclaim this tree!' it seems to say and, in so doing, also reclaims the 'tree hugger' pejorative: I am woman, I am naked and I am up a tree, hugging it. What are you going to do about it?

Notes

1 Julia Blackburn. *Charles Waterton 1782–1865*, p.13.
2 Cited in Roger Deakin. *Wildwood*, p.56.
3 Julia Blackburn. *Charles Waterton*, pp.1–2.
4 Charles Waterton. *Essays on Natural History*, vol.1, p.166, cited in Blackburn, p.56.
5 Julia Blackburn. *Charles Waterton*, p.106.
6 Ibid, p.202.
7 Julia Butterfly Hill. *The Legacy of Luna*, p.23.
8 Ibid, p.163.
9 Ibid, p.95.
10 Ibid, p.114.
11 Ibid, p.114.
12 Ibid, p.123.
13 Ibid, p.123.
14 Ibid, p.237.
15 All quotes here on Adam Appich, from Richard Powers. *The Overstory*, pp.64–5.
16 Ibid, p.127.
17 Ibid, p.129.
18 Ibid, p.327.
19 Ibid, p.395.
20 Ibid, pp.405–6.
21 Sir Alfred Lord Tennyson. 'St Simeon Stylites'. *Poems: Vol. 2*. 1842.
22 Suzanne Simard. *Finding the Mother Tree*.
23 References here to Patricia Westerford's lecture, from Richard Powers. *The Overstory*, pp.566–7.
24 Ibid, p.612.
25 Julie Heffernan. 'Artist Statement'. http://www.artnet.com/artists/julie-heffernan/
26 Rebecca Solnit. 'Dandelions and Time Bombs'. https://www.ppowgallery.com/exhibition/1944/press-release
27 Julie Heffernan. 'Self Portrait Exhibition Notes'. https://www.artworksforchange.org/portfolio/julie-heffernan/
28 All interview quotes here from Tom Seymour. 'Photographer Ryan McGinley'. https://www.theguardian.com/artanddesign/2020/apr/21/ryan-mcginley-photographer-satan-brad-pitt-beyonce
29 Philip Gefter. 'A Young Man with an Eye, and Friends up a Tree'. https://www.nytimes.com/2007/05/06/arts/design/06geft.html
30 Ibid.
31 https://ryanmcginley.com/cvd539r0io11f6xcqy5oqij9yhw2mw

11

Enthusiasm and attitude: Recreation, work, folly

Tree climbers are often extremely enthusiastic about what they do, throwing themselves into it; climbers like Jack Cooke, who writes in his book *The Tree Climber's Guide* of 'the noble practice of climbing trees.'[1] Cooke's climbing practice leads him through the parks and secret gardens of London in an aerial pilgrimage that puts him in search of an 'unlikely utopia' where he can escape into a realm that replenishes the senses; where 'we taste cleaner air and see further than the end of the road'.[2] Cooke is almost evangelical in his passion for the activity: 'Climb often and climb widely', he urges at his book's conclusion, 'and you will gain a country all of your own, a secret garden in the sky'.[3] Time and again one reads of recreational tree climbers, teachers, arborists and others who work with trees, whose zeal is infectious. Such climbers like to quote Robert Fulgham's often-cited pronouncement that tree climbing is 'an attitude, a place to be, rather than something to do', which contains a paradoxical Zen-like knowingness.[4] Listening to the American arborist, Brian French, talk about his work, the same enthusiasm is detected. French's fascination with trees is lifelong – he became one of the country's youngest certified arborists at just twenty-two. 'It's life-changing, to climb a tree', he comments in an interview. 'When you get someone up into a tree, in contact with it, people aren't the same afterwards.'[5] This is indeed why many people go up trees to try and change themselves – and why novelists and poets also send their characters into the canopy; to elicit that essential ingredient that every good story requires … the possibility of change.

This chapter investigates the zeal of tree climbing and explores its representation in tree climbing narratives of work and recreation. There has, in recent years, been an explosion in the number of recreational tree climbing schools, particularly in the United States and Japan, and tree climbing has

become popularized through the books of climbers, such as James Aldred, a natural history filmmaker and cameraman. Aldred's book, *The Man Who Climbs Trees*, verges on spiritual epiphany in its enthusiastic representations, a tone that is reflected in other texts, such as John Fowles's *The Tree*. Fowles's argument focuses on the differences between 'wildness' and his father's orchards; between 'utility' and what he calls 'unusing' nature. The pruning implicit to the orchards of John Fowles's father finds echoes in a discussion of tree surgery in Thomas Hardy's *The Woodlanders*, in which the recovery of a tree outside a patient's window is equated with the recovery of the self. In fact, scientific research and anecdotal literary accounts point towards the healing properties of trees situated outside windows. In *The Woodlanders*, Giles Winterbourne spends a long time up in the protected space of a canopy which needs surgery – the tree's crown becomes a generative space within which Giles can work through his conflicts towards a point of change. And yet, as well as providing change and resolution, tree climbing can, in either work or recreation, sometimes lead to misadventure. The chapter therefore moves on to explore some stories and images that speak of the folly of some tree climbers, including real-life egg collectors, a family of boys in BB's 1944 children's novel, *Brendon Chase*, and as represented in two Renaissance works of art by Pieter Bruegel, in which tree climbing to rob birds' nests comes to represent a transgression of the social order, a desecration of nature and an individualistic act of folly. It may be that these combined attitudes, displayed in Bruegel, go some way to bolstering the commonly held view that adults who climb trees are not in complete control of themselves or their senses.

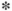

Tree climbing, as discussed previously, is often thought of as a childhood activity. Something nostalgic. Climbing later in life brings back childhood adventures and freedoms. Over recent years, however, climbing has become a rapidly expanding social activity, as well as an increasingly professionalized one – there even exist competitive tree climbing awards. In her article 'Taking to the Trees', in *High Country News*, Morgan Heim discusses the explosion in the number of vocational tree climbing schools in the United States. 'Climbing schools are popping up all over,' she writes, 'and there are no signs of the sport slowing down.'[6] In 1983, Peter 'Treeman' Jenkins founded *Tree Climbers International Inc.*, buying a plot of land near Atlanta, Georgia, home to two huge white oaks named Diana and Nimrod. He has taught tens of thousands of people to climb on these two trees alone. Heim continues: 'In the last five years, Jenkins has watched his class load jump from one a month to nearly three times that many.' Other tree climbing leaders, such as Harv 'Ponderosa' Teitelbaum, also regularly lead classes that are burgeoning: Heim cites Teitelbaum's own school, *Tree*

Climbing Colorado, along with *Dancing With Trees* LLC in Alto, Georgia, and New Tribe's *Tree Climbing Northwest*, in Grants Pass, Oregon, along with several other websites and chat rooms devoted to tree climbing. 'Most estimates place the number of recreational tree climbers at around 50,000 worldwide,' she notes, 'but New Tribe co-founder Sophia Sparks says the sport is mushrooming.' Sparks's company saw a huge growth in sales of tree climbing equipment and, according to an article by Jim Morrison in the *Smithsonian Magazine*, March 2002, titled 'Lofty Aspirations', have had 'trouble keeping up with orders'. The numbers have increased hugely since this 2008 estimate. They include large numbers in Japan, many of whom participate in John Gathright's climbing school – *Tree Climbing Japan*. Morrison's article also documents the huge increase in the popularity of tree climbing programmes such as Peter Jenkins's,[7] and discusses the many new tree climbing businesses now providing activities for adults and families. A further article in the *New York Times*, by Gary Andrew Poole, also documents the burgeoning state of the US tree climbing business in 2005.[8] Much of this tree climbing is done with harnesses and ropes, to minimize the impacts upon the trees, with good tree locations being guarded to protect the trees and their local environment.

Natural history cameraman, James Aldred, climbs trees for a living. His book *The Man Who Climbs Trees* documents his lifetime's work as a wildlife cameraman. The book centres around a number of trees that he has climbed and remembers well, from the UK to Borneo, from Peru to Australia, via Costa Rica and the Congo. He endures tropical storms and horrific illnesses brought on by the assault of treetop insects. He climbs a tree to escape a hunting leopard. 'Every one of us alive today,' he writes, 'is only here because one of our ancestors listened to their instincts when it mattered most.'[9] Climbing tropical trees can be dangerous but, for Aldred, the treetop is also a place of 'sanctuary and removal',[10] of 'safety and retreat'.[11] It gives him 'a glimpse of a half-remembered ancestral world [...] It helps me remember my place in the scheme of things.'[12] Aldred is often humbled by his experiences in the crowns of trees and repeatedly uses the language of 'acceptance and belonging' while climbing.[13] For this man who has made a life of working high in the rainforest's canopy, tree climbing is a form of immersion in the natural world: 'To sit back and watch the natural world carry on around you as if you weren't there is one of the real joys of being in the canopy,' he writes.[14]

Aldred's language is practical when it comes to his descriptions of *how* to climb trees – the ropes and clasps, the harnesses and foot straps – but when he wants to write of the *why*, his language veers strongly towards the spiritual: 'spirituality is where you find it, and I myself find it most easily when up in the trees,' he writes.[15] He notes that on certain climbs he was 'experiencing a kind of baptism – my first immersion in the canopy'.[16] Talking of rainforest trees, Aldred describes how 'climbing one is nothing short of a pilgrimage for anyone passionate about the natural world,'[17] while climbing endangered

cedar trees in Morocco, Aldred comments that 'The Atlas cedar is one of the most beautiful trees on the planet'. He goes on: 'Maybe it's something to do with the wonderful smell of their sap or the meditative solitude of their mountain home, but for me, just spending time around these ancient trees helps soothe the soul.'[18] Such spiritual reflections (bolstered here by the scientific, aroma-therapeutic benefits of evergreen trees' compounds) are common among tree climbers.

Of his own special tree, a New Forest redwood named Goliath, Aldred writes that the point of tree climbing is not for the adrenaline and the danger, but to feel at home in the branches; to feel free to let the mind wander as you climb the branches and arrive 'back on the ground somehow rejuvenated, and all the better for it'.[19] Climbing trees gives the opportunity to rediscover ourselves and to spend 'a few precious hours beyond the reach of other intrusions.' Aldred also climbs a yew tree close to his home and reports on coming down from his short tree climbs in his yew, 'feeling calmer of spirit and somehow all the better for having spent time in its branches'. He talks his worries away 'letting the wind carry away what it can' and finding that calm place to retreat to. It is a space

> beyond the borders of my busy modern life within which I can reflect on what's been lost, or focus on what lies ahead [...] When things grow almost too dark to bear – as they can for anyone on occasion – it helps me on the journey towards coming to terms with events[...] That yew tree is where I go to look for answers when things grow rough, but also where I go to say thank you for everything else that is wonderful and positive.

The Tree Climbing Cure has presented many examples of such places where people go to 'look for answers', and shown just how many times those places can be found in the hollows, or the branches, of a tree. Sometimes that place might be a whole woodland, and readers may well be familiar with woodland sites that attract visitors in this way close to their own locale. In the South West of England, close to my own home, there is a wood like this; a regular site of such pilgrimage (so much so that the National Park authorities are now looking to restrict visitor access to protect the woodland).[20] Wistman's Wood on Dartmoor is one of the few remaining pockets of ancient upland oak woodland left in the country. Its name probably derives from the old Devonshire dialect word *wisht*, meaning melancholy, uncanny, and 'pixie-led' or 'ghostlike'. *Wisht* also refers to the free-roaming hounds of Dartmoor's myths – the Wisht Hounds, on which Conan Doyle based the *Hound of the Baskervilles*. Not only is Wistman's Wood a pocket of ancient primeval forest left over from the pre-Mesolithic period (about 9,000 BP), making it a site of special scientific interest (SSSI), but it is also a gothic fantasy. The wood is now mostly made up of dwarf pedunculate oak trees, *Quercus robur*, that reach no more than fifteen feet

in height, compared to normal oaks which grow to six times that height. The wood is also made remarkable by the large number of 'clatter' boulders that litter the forest floor – giant and irregular boulders of granite. Most of these are covered in a thick blanket of moss, lying beneath the trees which are, themselves, covered in thick, hanging drapes of lichen. There are ferns and grasses everywhere and Dartmoor's common whortleberries. Nestled down in the valley beneath Longford Tor, Wistman's Wood is an eerie, silent place. In his short book, *The Tree*, John Fowles writes that culturally 'it is comparable with a great Neolithic site: a sort of Avebury of the tree, an *Ur*-wood.'[21] Fowles's book is a paean to trees and, being an inhabitant of the South West for many years of his life, it seems fitting that he should end *The Tree* with a visit to Wistman's Wood. He describes it as possessing 'such inturned peace, such profound harmlessness, otherness, selflessness, such unusing'.[22]

The Tree, however, begins away from Dartmoor, among the apple and pear trees of John Fowles father's garden, when he was growing up. His father was an ordered, philosophical man who returned from the First World War traumatized by events, in need of great order in his life. He created this order in the tamed fruit trees of his garden. The young John Fowles was his opposite: a wild, unruly child with a love of the disorderly natural world. His father's trees were unnatural; the trees he favoured, in woodlands, were real. When John Fowles bought his own house, a 'derelict farm' with 'thirty acres of scrub and rough pasture' in Devon, his father thought he had gone mad. The father abhorred chaos and natural disorder, while the son loved that disorder and 'saw no need to take it on, only to leave it largely alone'.[23] Ordinary experience, Fowles argues, is essentially wild; it is 'unphilosophical, irrational, uncontrollable, incalculable. In fact, it corresponds very closely [...] with wild nature.'[24]

*

In Thomas Hardy's novel *The Woodlanders* (1887), Marty South's father, John South, lies in bed worrying about the tall elm tree that stands outside their house. 'I should be all right by to-morrow if it were not for the tree!' he exclaims, lapsing into an irrational, yet prophetic, state of torpor. 'And the tree will do it – that tree will soon be the death of me.'[25] It will fall to the tragic Giles Winterbourne, who trades in apples and cider, to act as the tree's surgeon and, ultimately, to bring about, albeit unknowingly, the death of the old man John South. Although for the purposes of this discussion, it is Giles Winterbourne who climbs the tree as tree surgeon and spends the best part of a day up there, it is not his own mental state that is at question. To the contrary, it is old John South who has lapsed into a malaise about the tree, listening to the 'melancholy Gregorian melodies which the air wrung out of it'. Here the description 'melancholy' transfers between man and tree;

a melancholy fear 'rather than any organic disease, which was eating away at the health of John South.'[26]

Tree surgery as a metaphor for the recovering self recurs in the literature of trees. In her book on gardening and mental health, *The Well Gardened Mind*, psychiatrist and psychotherapist Sue Stuart-Smith recounts a tale of the paediatrician and psychologist, Donald Winnicott, climbing a tree. 'At the age of seventy-four, a few months before he died, his wife found him in the garden up a tree,' Stuart-Smith writes. When she asked him what he was doing up there he replied 'I've always wanted to top this tree off. It spoils the view from the window.' Stuart-Smith concludes that 'the symbolism is striking – he was not ready to die, he wanted a longer view of life ahead'.[27] The parallel with John South's tree in *The Woodlanders* is clear. John South complains, 'There he stands, threatening my life every minute that the wind do blow. He'll come down upon us, and squat us dead; and what will ye do when the life on your property is taken away!'[28] This becomes a pressing problem in the novel, for both Giles Winterbourne and Marty South stand to lose the tenure on their properties to Felice Charmond, once old man South passes away.

What is more, in discussions of trees and wellbeing, the image of a tree outside a window recurs again and again. A 1980s study by the American professor of healthcare design, Roger Ulrich, found that 'patients whose room looked out on to trees recovered more quickly than those whose room faced the wall',[29] while in his book on the loss of Britain's forests, *Oak Ash and Thorn*, Peter Fiennes notes that 'The recovery time of patients in hospitals can be greatly reduced if only they are given a view of the trees'.[30] The evidence that trees outside windows are beneficial to health is both scientific and anecdotal. In her essay 'The Room with a Tree', writer Eve Ensler, author of *The Vagina Monologues*, describes how a tree outside her hospital room as she was recovering from cancer actually helped her to recover more fully. Ensler describes how American culture has a predominantly commoditized view of trees – as lumber, timber, building material and so on. But she continues:

> [T]o actually lie in my hospital bed and see a tree, enter the tree, to find green life inherent in the tree, this was awakening. Each morning I opened my eyes. I could not wait to focus on tree. I would let the tree take me. Each day it was different, based on the light or wind or rain. The tree was a tonic and a cure, a guru, and a teaching.[31]

To *enter the tree* [my emphasis] in an echo of those hollow 'latibules', and 'becoming tree' narratives, already discussed.

In *The Woodlanders*, it is as though Hardy and his characters have some special awareness of this relationship between trees, windows and patients, although in Hardy's novel, Marty is acutely aware that the tree is causing consternation where it should be providing her father relief. 'Father is

still so much troubled in his mind about that tree,' she tells Giles, that she asks him to come to the house 'and see if you can persuade him out of his notion? I can do nothing.'[32] Giles puts forward his plan to cut back the tree and, therefore, save John South from his melancholy and his fear. 'I'll climb up this afternoon, and shroud off the lower boughs, and then it won't be so heavy, and the wind won't affect it so.'[33]

The tree surgery commences, and Hardy describes the climbing and the work in some detail, with Giles creating a ladder of branch stumps 'cutting away his perches as he went, and leaving nothing but a bare stem below him'.[34] Giles works throughout the afternoon: the work is 'troublesome', being watched by both Marty and John South from the old man's bedroom window. While up the tree, he has to make a choice: he can continue to cut the tree, thus saving old man South's life, but hastening a conflict with the tree's owner, Mrs Felice Charmond, or he can protect his own interests with Felice Charmond, but leave the tree, thus endangering the old man's life:

> He was operating on another person's property to prolong the years of a lease by whose termination that person would considerably benefit. In that aspect of the case he doubted if he ought to go on. On the other hand he was working to save a man's life, and this seemed to empower him to adopt arbitrary measures.[35]

In other words, being up the tree and in his suspended state between the real-world concerns of the ground and the hypothetical world of the mind (the sky) allows him to come to a decision and 'adopt arbitrary measures'. Thus it is that, while Giles Winterbourne is up in the tree coming to his moral decision, the young woman to whom he has been promised, Grace Melbury, passes by beneath the tree. Giles cries out: 'Miss Melbury, here I am', thinking, perhaps, that she might not have noticed him. But caught up in her own ruminations about difficulties in her relationship with her father who has recently told her to break off her relations with Giles, in favour of the newcomer Dr Fitzpiers, Grace passes back and forth beneath the tree, ignoring him, even when he directly asks her to speak to him. Understanding her need for her own quiet thoughts, Giles continues with his work 'climbing higher into the sky and cutting himself off more and more from all intercourse with the sublunary world. At least he had worked himself so high up the elm, and the mist had so thickened, that he could only just be discerned as a dark grey spot on the light grey zenith.'[36] It is when he reaches this highest point that Grace returns and calls up to him, telling him 'My father says it is better for us not to think too much of that – engagement, or understanding, between us' and that their relationship should remain as a platonic one.[37] Once again Giles is forced, in his between-worlds position up the tree, to deal with a moral matter, replying 'in an enfeebled voice which hardly reached down the tree' that he has nothing to say until he has had time to think. And there he remains 'till the fog and the night had completely

inclosed him from her view'. His physical retreat and isolation up the tree become a metaphor for his withheld and isolated emotions; the canopy becomes an external metaphor for the internal thinking space of his mind.

Beneath him on the ground, Grace wonders whether she might capitulate in doing her father's bidding and accept Winterbourne again as her lover. 'Something might have been done by the appearance of Winterborne on the ground beside Grace. But he continued motionless and silent in that gloomy Niflheim or fog-land which involved him, and she proceeded on her way.' Suspended as he is, in the air, away from the grounded world of action, he remains inactive in the boughs of the tree until 'the tree seemed to shiver, then to heave a sigh: a movement was audible, and Winterborne dropped almost noiselessly to the ground', worrying now not about his tenure of his property, but about his relations with Grace. The tree has become a site of quandary and mental anxiety for Giles Winterborne.[38]

The ultimate irony of these scenes, for John South at least, is that the old man's mental health does not improve and, in fact, worsens, so much so that the doctor must be called. It is at this point in the narrative that the reader is introduced to the new doctor, Edred Fitzpiers, who becomes Giles's nemesis in his relationship with Grace. On examining his patient, Dr Fitzpiers concludes decisively (where Giles had failed to finish the job) that the tree must be cut down and, by the following morning, the job is done 'and the elm of the same birth-year as the woodman's [John South] lay stretched upon the ground'. The parallelism between man and tree is enough to foreshadow the immediately ensuing action: 'As soon as the old man saw the vacant patch of sky in place of the branched column so familiar to his gaze, he sprang up, speechless; his eyes rose from their hollows till the whites showed all round, he fell back, and a bluish whiteness overspread him.'[39] By evening, John South is dead. 'Damned if my remedy hasn't killed him!' murmurs the doctor. The irony of these scenes for Giles Winterborne is that within a short space of time, despite his efforts with the tree, he loses his tenure on his property to Mrs Felice Charmond and, later still, loses Grace to Edred Fitzpiers. Ultimately, he will lose his own life to respect the honour of Grace while she sleeps in his woodland hut, and he must sleep outside in the wet and cold as propriety dictates. These former two losses, and then his ultimate loss, stem from his symbolic time spent in the elm's branches. For so many climbers, whether climbing for pleasure or for work, the canopies of trees are pivotal sites of decision-making and change. They seem to exert an almost magical power over the changes in the lives of the men, women and children who climb them.

*

But what of those situations when working in trees turns from being both the site and engine of change, and results instead in misadventure and poor decision-making? In those circumstances, the folly of the tree climber's

zeal comes to the fore. In 2006, for example, the UK's most infamous egg collector, Colin Watson, fell to his death while attempting to climb to a nest high up in a larch tree in woods near Campsall, South Yorkshire. Watson fell 12 metres. Although he survived the immediate fall, Watson died before paramedics arrived and he was pronounced dead on the scene.[40] Before this tragedy, Watson had been convicted six times under modern laws prohibiting the disturbance of birds' nests and the stealing of eggs.

In his book *Beechcombings*, Richard Mabey remembers his childhood growing up in the 1950s and his view of trees back then, 'from the inside, as hiding places, campsites, birds'-nesting opportunities, mines for firewood and spears.'[41] Such bucolic childhood memories are not uncommon although, in today's climate, a sense of unease is raised by such activities. And with good reason. With nearly 2 billion birds killed annually from window and turbine collisions, hunting, poisoning, car strikes, oil spills, electrocution and countless other means including domestic animal predation, there are enough wild birds perishing without further decimating their numbers by raiding their nests.[42] Under the Wildlife & Countryside Act 1981, it is now 'an offence in the UK to intentionally kill, injure or take any wild bird, or take or destroy their eggs or nest, or damage a nest, while that nest is in use or being built'. In the UK it is only legal to possess wild birds' eggs if they were collected before 1954, or with a permit for scientific research. Selling wild birds' eggs is illegal full stop. Mabey's childhood activities were a sign of the times and, in any case, not then illegal. As naturalist and poet Helen Macdonald, the author of *H Is for Hawk*, writes in *The Guardian*: 'Naturalists of the nineteenth and early twentieth centuries had routinely collected birds' eggs, and most children who grew up in semi-rural or rural surroundings in the 1940s and 50s had done it too. "We only used to take one from each nest," a female friend told me, abashed. "Everyone did it".'[43] Today, the Countryside and Rights of Way Act 2000 allows for six months' imprisonment for the possession of wild bird's eggs, and a number of people have been imprisoned under the Act. Including Colin Watson. There have been other fatalities too. But before these laws, there was a free-for-all on collecting nests and eggs, as Helen Macdonald describes. Egg collecting and its associated science (known as 'oology') resulted in some sizeable collections in major museums around the world that have contributed to a greater understanding of bird ecology.

In his 1944 adventure novel for children, *Brendon Chase*, written before any legislation was passed, the novelist and nature writer known as 'B.B.' (Denys James Watkins-Pitchford MBE, 1905–90) sends one of his protagonists – the young boy, Robin – climbing up a fir tree in pursuit of a honey buzzard's nest. Robin and his two brothers, John and Harold, have run away from home to live like outlaws in an ancient oak tree camp in the English forest, Brendon Chase. Serialized in a 1980s TV drama series for children, the novel is an 'old school' escapist adventure in which the young boys develop considerable resourcefulness in the wild, having been downtrodden by their cold and distant Aunt Ellen, who was looking after

them while their parents were away on Empire duties in British India. It is tempting to find a parallel: while the parents are abroad harvesting the metaphoric fruits of Empire for the home nation, their boys are out in the woodlands harvesting the very fruits of nature. In the chapter, 'The Honey Buzzard's Nest', Robin climbs a tall fir tree to steal a bird's egg: 'It was a difficult tree to climb for there were no branches for the first ten feet or so and their climbing irons were, of course, eight miles away in Cherry Walden.'[44] The description is quaintly old-fashioned and privileged – runaway children with sets of climbing irons. The place name (Cherry Walden) also contains hark backs – most notably to Henry David Thoreau's classic 1854 work *Walden: or, Life in the Woods*. In fact, one of Robin's favourite books, the reader learns, is his beloved Thoreau's *Life in the Woods*, among others.

After some difficulties and false starts getting up into the tree, Robin begins his climb. He has a bad head for heights and the climb is both vertiginous and challenging. When he stops to look down, he feels 'a horrible wave of sickness pass through him', but he clings to the fir tree's trunk and 'The feel of that massive breadth of wood gave him comfort'. He climbs on, spurred on by the fact that he will not be able to look his brothers in the eyes if he fails to reach the bird's nest. As with many tree climbing episodes, the ascent offers the character a renewed sense of perspective: 'He was now looking down into the tops of some of the smaller oaks, and there, on all sides, stretched the unbroken surface of the Chase. It stretched away endlessly.'

Robin freezes and unable to climb on any further: 'His head swam and his mouth felt like an old boot.' He stays stricken like this, motionless, for ten minutes, until the honey buzzard suddenly quits her nest and Robin feels suddenly reinvigorated to complete his climb, spurred on by his brothers' cries from below. But all the while 'he wanted to be back, back again on the good firm earth'. Nonetheless, he manages to reach the nest and feels around inside, discovering two eggs. One of these he pockets and then, closing his eyes, begins his climb down: 'Descending a tall tree is worse than going up because you have to look where you are putting your feet. The return to earth was a nightmare, indeed that climb of Robin's recurred for many years afterwards in the form of a terrible dream.' What goes up must come down, to cite the old adage: no tree climb can last forever and, although the route up and the route down are basically the same, the psychological difference between them – both the literal and the inner perspective taken on each journey – are different. What will it take to come down? Robin has gone up, but at what cost?

The mention of 'the terrible dream' gives Robin's tree climb/descent an added dimension. In Freudian dream analysis, trees are often associated with sexual potency. In fact, one of Sigmund Freud's most famous cases is that of Sergei Pankejeff, or 'The Wolf Man', who famously reported to Freud that he had had a childhood dream in which six or seven white wolves were sitting in an old walnut tree outside his childhood window. Freud published an analysis of the Wolf Man's Dream in 1918, positing

that it was the result of the child witnessing his parents having sex from behind (i.e. like dogs/wolves). Freud also posits that it might be a result of the boy seeing dogs copulate, which he then displaced onto his parents. Whichever way, the dream played a significant role in Freud's theory of psychosexual development. But the interpretation of dreams is inexact and subjective. Current scientific thinking describes dreams as the random brain activity that is either keeping the brain ticking over while asleep, or cleaning out the mind, in much the same way as one 'de-fragments' the hard drive of a computer. At most, dreams may simply reflect something of the things that have been thought about during the day, some of which will undoubtedly be anxieties. But psychoanalysts, and particularly Freudian analysts, believe that dreams reveal the workings of a person's unconscious mind. In this sense, dream analysts claim that dreams of climbing trees *could* indicate success in life or business, and a 'terrible dream' such as Robin's might indicate the opposite. Pride in success, or a family's pride in you for your achievements may also have something to do with it. It may symbolize progression or its opposite if the dream is anxious. Some dream interpreters think of tree dreams as representing desires, knowledge, hopes and sense of personal growth. Tree-climbing dreams represent fearlessness – 'I will not fall' – or perhaps anxieties about its opposite. The tree dream emphasizes family relationships and a sense of 'rootedness'. Psychoanalysts also equate the tree with the mother through the tree's stability, strength and protection, as well as acknowledging the tree's phallic connotations with the father. Trees in dreams may also be seen as portents of death and rebirth, or spiritual and intellectual growth. Carl Jung saw the tree as a symbol of the higher self, when the child has become fully individuated in adulthood and has integrated the feminine and masculine principles, as well as the light and the shadow aspects of the psyche. On the other hand, a climbing dream might be interpreted as a desire to escape from ourselves, responsibilities and relationships, or whatever it is that needs attention. All in all, interpreting dreams is an often contradictory business. Whatever it was in *Brendon Chase* that gave Robin his 'terrible dream' is pure speculation – was it some psychosexual drama, or was his brain simply de-fragmenting random information, and this piece simply got stuck in a loop? It can never be known, and Robin is a fictional character anyway.

Whatever it was, descending to his brothers, Robin calls it 'an awful climb' and imagines that his brothers 'could never guess what sickening agony he had been through up there in the pine top'. The traumatic language of 'awful', 'agony' and 'nightmare' accentuates the importance of the experience for Robin and, perhaps, account for his recurring bad dream in later life. Furthermore, Robin is suddenly wracked with guilt for having stolen the bird's egg: 'he felt rather a mean beast [...] It was a shame to take it, a rotten shame! Up there in the pine top the true significance of his act had not been apparent.' He knows that stealing the bird's egg is a small crime against nature – he knows that honey buzzards are rare because they

lay so few eggs. The nightmare of his climb is therefore compounded by the guilt of his act; a guilt that is, thankfully, relieved when the brothers realize that the egg is 'blotched and clouded' with a 'slop slop of liquid inside' – a sure sign that it was rotten. Relieved, Robin heaves a sigh of satisfaction and relief: he has survived the ordeal of his climb and done no harm to the honey buzzard population.

Pieter Bruegel the Elder's painting *'Vogeldieb'/*'The Peasant and the Nest Robber' (1568) presents a rural scene common enough in the Flemish paintings of the time.

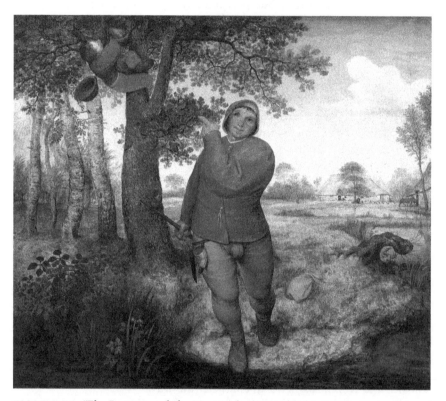

FIGURE 11 *'The Peasant and the Nest Rober'/*'Vogeldieb' *(1568). Pieter Bruegel the Elder. Oil on canvas.*

Painted in the year before the artist's death, the foreground is taken up by the almost monolithic figure of the eponymous 'peasant', dressed in grey britches, soft shoes and a brown topcoat. The everyday male clothing of the time. He carries a stick. A knife case and horn hang from his belt. With his child-like smile and ruddy cheeks, he is pointing knowingly towards another man, the nest robber, clambering up into the trees. The

robber's hat has fallen from his head (captured mid-fall), and he looks as though he too might be about to take a tumble. His bag lies on the path, over which the peasant has just stepped. The splash of red that denotes the nest robber's britches helps bring the viewer's attention to him quickly, as does the raised and pointing finger of the peasant. In the distance, an airy scene of everyday rural life goes on under the open sky and leafy trees of a perfect summer's day, just as it has done for years, the painting seems to suggest.

Yet on closer inspection, the viewer notices then that a second 'splash' is implied by the main figure. He is about to step off the path into a stream of water that curves around in front of him. Caught up in pointing the accusatory finger at the folly of the nest robber, the peasant cannot see his own imminent downfall. It's a common enough moral, of the 'people in glasshouses shouldn't throw stones' type – a proverb based on the *Gospel of Matthew*: 'Why do you look at the speck of sawdust in your brother's eye and pay no attention to the plank in your own?'[45] Don't go pointing the finger at other people, the painting warns, if you are unsure of the security of your own footing. In fact, the painting is said to be based on a popular Flemish proverb of the time: *'Dije den nest Weet dijen weeten, dijen Roft dij heeten'* – 'He who knows where the nest is, has the knowledge, he who robs, has the nest.' It has also been said that, with his recently acquired knowledge of Italian art, Bruegel was parodying the gesture of Leonardo da Vinci's *St John*, who also points upwards with a crook in his elbow.[46] In his unorthodox art criticism of the painting, Rudy Rucker writes that the proverb may have profane connotations: 'The Flemish proverb means the pushy guy gets the girl,' asserting that 'nest' is a euphemism for a woman's sex.[47] Given the commonplace ribaldry of the Flemish paintings of the time, the idea is not beyond the bounds of possibility: the painting does, after all, appear to be crudely phallic in several instances. One cannot help but notice the prominent codpiece of the peasant's britches in the centre of the painting, and the contrary drooping phallic symbol of the willow tree stump to the right foreground. There certainly seems to be something going on here concerned with masculine virility. But critics on the whole agree that the interpretation of the painting has everything to do with the religious Reformation in Europe, far more so than it does men's sexual behaviours: the nest robber represents the over-zealous Reformers raiding the churches and monasteries of Europe. Art critic, Margaret A. Sullivan, summarizes many of the other contested interpretations of the painting: the theft of the nest represents death; the brambles in the undergrowth represent the precariousness of life; the painting depicts multiple binaries, such as activity/passivity and prudence/stupidity and so on.[48] Climbing too high has always been a popular metaphor for over-reaching ambition and, at the time of painting, Bruegel would have presumably been aware of how well the metaphor could be applied to the protestant Reformers with their spiritual claims to a new religious knowledge. Margaret A. Sullivan again points out

that havoc was being wreaked in the Reformation 'as the iconoclasts invaded convents, churches and centres of ecclesiastical wealth, abusing clergy and nuns, burning books, breaking up organs, destroying paintings, smashing sculptures, and getting drunk on consecrated wine'.[49]

Some of the same themes also appear in Bruegel's pen and ink drawing of 'Die Imker' / 'The Beekeepers and the Bird Nester' (c.1568).

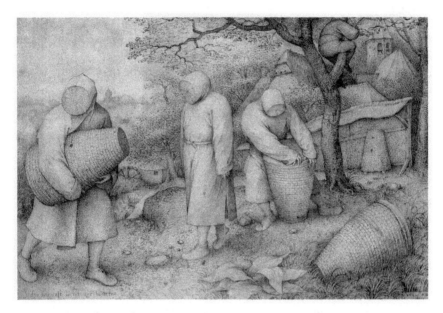

FIGURE 12 'The Beekeepers and the Bird Nester'/'Die Imker' (c.1568). Pieter Bruegel the Elder. Pen and ink. 203 × 309 mm.

Three beekeepers fill the main space of the drawing, with their faces masked by protective gear. One carries a wicker skep of bees, another is opening a skep to the rear, while a third walks in between them. There is something otherworldly and uncanny about these figures; they are almost inhuman, with their hidden, yet flattened faces and their anonymous capes. Perhaps they are meant to symbolize the officials of the new Protestant church in their headgear, white albs and vestments? The central one seems to float almost, while the one to the fore appears somewhat furtive in his stance – as if he were stealing the hive he has stashed under his arm. The line created by these beekeepers draws the viewer's eye to the right of the composition, where a man can be found climbing a tree. Unlike the beekeepers, he is dressed in everyday clothes, singling him out from the group. The drawing also contains the proverbial lines of text written in the bottom left-hand corner, the same proverb on which 'The Peasant and the Bird's Nester' is based: 'He who knows where the nest is, has the knowledge; he who robs it, has the nest.' Some have suggested that 'The Beekeepers' is a representation of communal village work

and cooperation, as opposed to the opportunistic individualism of the nester. The beehive was also a common metaphor for the church at the time, with the society of industrious bees inside representing the human congregation. Here the beehive echoes the symbolic associations of honey and religious ecstasy in Piero Di Cosimo's painting of Bacchus and the discovery of honey, as well as its primitive incarnation in Golding's novel, *The Inheritors*.

Whichever interpretation these enigmatic images yield, tree climbing in both is certainly presented as both a transgression of the normal social order *and* as an act of folly. As such, both images echo lines in a famous poem about human folly, Sebastian Brant's *Narrenschiff* (*Ship of Fools*), written in German and published in Basel, Switzerland, in 1494. Brant's satirical allegory contains the following lines, which are accompanied by a woodcut illustration of a jester/clown falling from a tree he has climbed to rob:

> A fool may tumble painfully
> Who climbs for nests upon a tree,
> Or seeks a road where none is found.[50]

Bruegel's painting, with the nest robber about to take a tumble and the moralizing peasant about to step off the road into the water, does the same thing. The fool will fall, just as the other fool will step into the stream, unawares. Religious connotations aside, tree climbing to rob nests in these two images is presented as foolhardy and anti-social, as a desecration of nature (and the church) and demonstrative of human folly. It is seen as individualistic and open to disaster. Such attitudes may, in part at least, account for some of the complications of feeling previously discussed, concerning the advisedness, recklessness and even 'sanity' of grown adults climbing trees.

Notes

1 Jack Cooke. *The Tree Climber's Guide*, p.34.
2 Ibid, p.1.
3 Ibid, p.270.
4 Cited in Jim Morrison. 'Lofty Aspirations'. *Smithsonian Magazine*. March 2002, pp.53–60. https://www.smithsonianmag.com/issue/march-2002/
5 In Evelyn Schlatter. 'Ascending Giants'. https://www.hcn.org/issues/368/17647
6 All quotes here from, Morgan, Heim. 'Taking to the Trees'. https://www.hcn.org/issues/368/17635?b_start:int-0#body
7 Jim Morrison. 'Lofty Aspirations', pp.53–60. https://www.smithsonianmag.com/issue/march-2002/
8 Gary Andrew Poole. *Up a Tree, for the Fun of It. New York Times*. 7 January 2005. https://www.nytimes.com/2005/01/07/travel/escapes/up-a-tree-for-the-fun-of-it.html
9 James Aldred. *The Man Who Climbs Trees*, p.101.
10 Ibid, p.4.
11 Ibid, p.27.

12 Ibid, p.13.
13 Ibid, p.51.
14 Ibid, p.283.
15 Ibid, p.293.
16 Ibid, p.27.
17 Ibid, p.126.
18 Ibid, p.265.
19 All quotes here, ibid, pp.290–2.
20 Howard Lloyd. *Devon Live*. 25 June 2021. https://www.devonlive.com/news/devon-news/visitor-ban-dartmoors-wistmans-wood-5575804
21 John Fowles. *The Tree*, p.87.
22 Ibid, p.93.
23 Ibid, p.26.
24 Ibid, p.41.
25 Thomas Hardy. *The Woodlanders*, p.15.
26 Ibid, p.91.
27 Sue Stuart-Smith. *The Well Gardened Mind*, pp.218–19.
28 Thomas Hardy. *The Woodlanders*, p.91.
29 In Qing Li. *Into the Forest...*, p.111.
30 Peter Fiennes. *Oak and Ash and Thorn*, p.148.
31 Eve Ensler. *In The Body of the World*, p.101.
32 Ibid, p.90.
33 Thomas Hardy. *The Woodlanders*, p.91.
34 Ibid, p.92.
35 Ibid, p.92.
36 Ibid, p.93.
37 Ibid, p.93.
38 All quotes here, ibid, p.94.
39 All quotes here, ibid, p.102.
40 Wesley Johnson. 'Egg Collector Died in Tree Fall, Coroner Rules'. https://www.independent.co.uk/news/uk/crime/egg-collector-died-in-tree-fall-coroner-rules-413947.html
41 Richard Mabey. *Beechcombings*, p.33
42 Figures from Sibley Guides. 'Causes of Bird Mortality'. https://www.sibleyguides.com/conservation/causes-of-bird-mortality/
43 Helen Macdonald. *The Guardian*. https://www.theguardian.com/books/2017/sep/09/helen-macdonald-birds-nests-eggs
44 All quotes here from B.B. *Brendon Chase*, pp.109–15.
45 *Matthew*,VII:3.
46 Todd M. Richardson. *Pieter Bruegel the Elder*.
47 Rudy Rucker. 'Notes for *Ortelius and Bruegel*'. http://www.rudyrucker.com/bruegel/bruegelnotesposted.pdf
48 Margaret A. Sullivan. 'Peasant and Nestrobber'.
49 Ibid.
50 Sebastian Brant. *Narrenschiff* (*Ship of Fools*), p.1494.

Conclusion: Descent

Ascending a tree, a climber comes to know its difficulties and its imperfections and, hence, their own. Climbers experience a series of small pleasures, tests and successes, and a new kind of solitude that offers a tranquil place of realization where they can pay attention to small details, alongside the big picture that stretches away to the horizon. Tree climbing awakens the child inside. 'We must train ourselves not to come down when civilisation calls,' as Jack Cooke writes.[1]

In his 1996 travel book, *Savage Pilgrims*, British travel writer Henry Shukman hears the call of a great writer who has preceded him, D.H. Lawrence, and sets off in Lawrence's footsteps on the road to New Mexico. In the small town of Taos, the author finds himself 'suddenly overcome with fatigue'[2] in the midday heat and climbs into the branches of a large willow tree to have a nap. There he sleeps, beyond the reach of some threatening-looking snakes that he has seen crawling through the grass there on previous days. 'The perch worked well,' Shukman writes, 'with my back against the trunk and my feet on the branches. I quickly fell into a deep sleep.' While sleeping, Shukman has an odd dream. Although it was a cloudy day in reality, in the dream the sunshine turns a bright orange and he believes he can feel its comforting warmth all over his face. He smiles and feels warmly satisfied. Then, in the dream, a native American Indian man appears to him, pointing at him in the tree, calling out 'Sunshine Tree'. At first, the dreaming travel writer thinks that the man is naming the tree but, on reflection, he realizes that the man is naming *him*: 'This was how the native Americans chose and bestowed names. It was the first time he had seen me [...] So my name was "Sunshine Tree".' Shukman then wakes up and, to his surprise, finds that it is still an overcast and cloudy afternoon. But he nonetheless feels 'deeply refreshed', as though 'I had been welcomed to Taos'. In this short tree climbing episode the tree is again symbolic – in this case, it speaks of a sense of belonging and, as with many tree climbers, that

sense of realizing one belongs somewhere is deeply restorative, as though one has woken up from a sleep and can see the world with fresh eyes.

But one doesn't have to travel across the globe to New Mexico to come to such an awakening. In his prize-winning book of 2007, *The Wild Places*, Robert Macfarlane writes: 'There was as much to be learned in an acre of woodland on a city's fringe as on the shattered summit of Ben Hope.'[3] Nature and wildness are not only found in the Romantic retreat from civilization; they can be found among trees on the edges of towns and cities, as much as on the sublime top of a mountain or rolling hillside. Fittingly, Macfarlane begins *The Wild Places* at the top of a beech tree just a mile from his home. 'I had climbed the tree many times before, and its marks were all familiar to me,' Macfarlane begins and, as if to confirm the general mistrust afforded to adult tree climbers: 'People don't generally expect to see men in trees.'[4] Like so many people, Macfarlane describes how he used to climb trees as a child, but stopped as he aged. In the few years before writing *The Wild Places*, however, he says that he took up tree climbing again, and 'explored the literature of tree climbing'. What Macfarlane acknowledges about his beech tree echoes one of the central contentions of *The Tree Climbing Cure* that there is a remarkable congruity between trees and the contented mind: 'There was nothing unique about my beech tree [...] But it had become a place to think. A roost. I was fond of it, and it – well, it had no notion of me.'[5] Here again is that 'ultrahuman' idea that trees are indifferent to human thought, to human problems, and that is paradoxically liberating. 'Climbing the tree,' Macfarlane writes, 'was a way to get perspective, however slight,' presumably what Cody Lee Miller was doing when he climbed the Seattle sequoia – getting perspective on some pressing personal problems. Before one climbs, one has to make the decision *to climb*, and that momentary act of imagining is powerful and liberating. Thinking can, of course, be liberating and the tree climb itself is the physical embodiment of that liberated strength of will. As Jack Cooke writes in his *Tree Climber's Guide*: 'To climb a tree in your mind, before ever setting foot in its branches, is a powerful exercise in imagination.'[6] All the writers and artists encountered in these pages have, in some sense, exercised their imagination and their freedom by climbing a tree in the mind. Lucy Jones, by way of a final example on this theme, describes a powerful childhood memory of a visit to her grandmother's garden, pointing out the close relationship between tree climbing and imagination: 'I wanted to be free to ascend the sycamore and sit in the tree house alone,' Jones writes. 'I started to climb. I was in the canopy of a rainforest, monkeys on my left, toucans on my right. I was a monkey, in fact. Or I was Maid Marian, hiding from an army, bow and arrow on my back, safe in a tree.'[7] Jones goes on to describe her childhood imaginings of dinosaurs, the castle at Cair Paravel in C.S. Lewis's fictional land of Narnia, and the making of childhood magic potions, before climbing down for lunch and Granny's broth.

So it is with this potent equating of tree climbing with imagination and childhood vigour and wellbeing that we turn to, perhaps, the best-known tree climbing poem of the twentieth century, with its childhood memories of climbing, and its adult reflections on climbing as metaphor. Written in 1913–14, Robert Frost's much-anthologized poem, 'Birches', first appeared in the magazine *Atlantic Monthly* in 1915, and was later collected in Frost's third book *Mountain Interval* (1916). Growing up in Massachusetts, Frost's childhood was filled with memories of swinging birch trees – climbing a birch tree until it bent down to the ground, then jumping off to let the tree spring back upright. He would likely also have been aware of another popular American poem by Lucy Larcom, 'Swinging on a Birch Tree' (1867), which recounts the simple pleasures of this common child's play. Many years after Frost's poem was written, American ecologist and natural history writer Robert Michael Pyle writes, in *The Thunder Tree*, of the related American childhood game of 'bouncing' on aspen trees – 'the supple trunks of the saplings made fine teeter-totters'[8] – in an activity that sounds remarkably similar to 'swinging birches', and so it would appear that such tree-based pursuits may well have been a common part of the American rural upbringing.

In Frost's poem, the speaker sees a row of bowing birch trees and, in his mind, imagines a boy, much like himself, has been swinging them.

> When I see birches bend to left and right
> Across the lines of straighter darker trees,
> I like to think some boy's been swinging them.[9]

But immediately he realizes, 'when truth breaks in / With all her matter of fact', that it was not a boy who bent the trees down but, in fact, an 'ice storm' – freezing rain has crusted the branches with ice, dragging them down 'to the withered bracken' where the ice shatters and falls to the ground, scintillated by the sunlight: 'Such heaps of broken glass to sweep away / You'd think the inner dome of heaven had fallen.' Still, he prefers to think that it was a boy who swung the trees down, just as he did himself as a boy: 'So was I once myself a swinger of birches. / And so I dream of going back to be.'

The poem offers a brief lesson in how to swing a birch tree: it should be the kind of play that one finds alone; it 'subdues' the father's trees (i.e. it is free from parental stricture); it should be done 'over and over again / Until he took the stiffness out of them' and so forth. In swinging the trees, the boy learns not to 'launch out too soon' and to:

> keep his poise
> To the top branches, climbing carefully
> With the same pains you use to fill a cup
> Up to the brim, and even above the brim –

with such a perfectly balanced image of containment and excess, before 'Kicking his way down through the air to the ground.' And then to do it all over again.

At this point in the poem, the speaker begins to air their more metaphysical concerns, confessing that, when life becomes wearisome, they get this urge to climb 'toward heaven' and swing birch trees, in that common temporary relief from adult cares. It is the early 'ice storm' of the poem that represents the shattering heaviness of the adult world and which bends all young trees down to 'the withered bracken' of old age. Once more, the reader is presented with the common and recurrent depiction of tree climbing as a return to a state of childhood, to escape the conflicts and cares of adulthood; or, as Frost has it, in his metaphor, to swing the tree, rather than be weighed down with heavy falls of worry, of ice and snow. It's the second mention of 'heaven' in the poem – earlier the reader finds the phrase, 'You'd think the inner dome of heaven had fallen', which expresses some doubt about belief in an afterlife, since heaven has 'fallen'. Whereas here, towards the poem's end, the older narrator is imagining 'climbing toward heaven' up a birch tree. There is a rich ambiguity in the speaker's uncertainty. He wants to believe in a heaven, in an afterlife, in a 'return' even, but has balanced that with the 'truth' of the poem's beginning.

It is an uncertainty that finds echoes, once again years later, in the writing of Robert Michael Pyle who, in speaking of his *Thunder Tree*, writes: 'Countryside means a place of brown uncertainty and green chance, where life is not all spelled out like the squares on our bedroom floor, where surprise still lives.'[10] Playing outdoors as a child is a rewarding sensory game of uncertainty and chance, Pyle suggests, whether swinging birches or 'bouncing aspens', as previously mentioned. For the narrator of Frost's poem, what he is certain of, is that climbing a birch tree is a way to free the imagination from all the weight of that truth and reality; a way to 'get away from earth awhile / And then come back to it and begin over.' Frost desires to gain that brief respite from the conflicts and cares of life; a central urge in nearly all of the tree climbers encountered in this book. Learning to do this successfully, like not forgetting how to climb or swing a tree perhaps, is one of the great tensions of adulthood – as the poem concludes, 'One could do worse than be a swinger of birches.'

Anglo-American artist Marcus Vergette's oil painting, 'Swinging on Birches', captures a personal response to Frost's poem. It is one of a series of canvases that the artist painted while living in London, reflecting on his childhood in the woods of the American Mid-West. Vergette came across Robert Frost's poem, which he read with surprise, thinking that he had invented the activity for himself as a boy.[11] Vergette's canvas depicts a row of older, more established trees ('his father's trees', perhaps, as Frost has it) fronted by a row of smaller, younger birches. On the final tree, a young boy swings himself in a carefree manner from the whip-like tip.

FIGURE 13 *'Swinging on Birches' (1987). Marcus Vergette. Oil on board. 86 × 86 cm.*

The painting is very fluid, wet on wet (or *alla prima*, 'first attempt'), with no over-painting or changes made by the artist. This gives the image a direct sense of energy and candid expression appropriate to its subject matter. The palette of the painting – rich ochres, reds and shadowy browns – suggests warmth, although the planes of blue grey between the birches, the white highlights and clouds, and the flurry of white to the fore, suggest Frost's wintery morning. Just as in Frost's poem, Vergette's painting captures that temporary return to a youthful, carefree state, evoking ideas of transition and choice within the frame of a static, unchanging image. The more mature trees seem to represent the adult world, while the nascent energy of the boy and the bent birch sapling together seem to symbolize the 'spring' of youth, and the potential launching of imagination that comes with climbing trees and, of course, swinging birches. There is then, in Vergette's painting, a parallel for tree climbing in general as discussed here in *The Tree Climbing*

Cure – just as the painting evokes ideas of energetic change and choice within the static frame of the image, so the tree climber enacts their choice, towards an idea of transition and transformation, within the steadfast frame of a static, immovable tree.

'Trees are at the heart of all the necessary debates: ecological, social, economic, political, moral, religious,' writes literary ecologist Colin Tudge. It has been the ambition of *The Tree Climbing Cure* to show that they are also at the heart of Western literary and visual concerns as well, especially where questions of wellbeing are concerned. Time and time again, the authors and artists gathered in these pages attest to the simple fact that, when people have things to sort out in life, or in the head and heart, they often head for the trees. As Colin Tudge writes, trees are 'at the centre of all terrestrial ecology [...] In the future of humanity, and of all the world in all its aspects, trees are key players.'[12] As cultural representations of that humanity, novels, poems and artworks feed back the attitudes societies hold about themselves, about nature and about the relationship between them. These are things that fictionalized climbers consider each time they are represented either climbing a tree or simply 'upgazing' into one.

Climbing a tree may, as discussed, have something to do with the climber's ambition to, in some way, *become tree*, or *return to the trees* themselves. But it may also have a more reciprocal function. As a tree climber, the climber becomes a kind of 'epiphyte' on the tree, even if only momentarily. An epiphyte is a plant that grows on another plant, such as the many mosses, liverworts, lichens and algae that grow on trees in temperate woodlands, or the many ferns, bromeliads, air plants and orchids that grow on the trunks of trees in the tropical rain forest. An epiphyte derives its water and nutrients from the other plant, by absorbing them from the surface of the tree and from the organic matter that settles around it. An epiphyte is *not* a parasite; it does absolutely no harm to the tree – the relationship between an epiphyte and its host is benign. When one is in a tree, it is only a small stretch of the imagination to see the climber as an epiphyte against the trunk. The tree *gives* to the climber, in all its sensory generosity: aromatherapeutic scents that are scientifically proven to enhance wellbeing and reduce stress hormones and levels; bacteria that enhance both gut and mind; colours that calm and soothe eyes and brains; sounds that reduce stress levels; complex fractal patterns that enhance modes of 'paying attention', and all the other benefits that the research points to. Being an epiphyte in a tree is a form of what Richard Mabey calls 'simultaneous existence', tuning in to 'other kinds of mind that operate on the earth without the privilege of self-consciousness.'[13] In other words, tuning in to the 'ultrahuman', the 'more than human'; finding solace in the benign indifference of nature. Being up a tree permits the climber to do this. It is a 'transcorporeal' activity and state, as described in earlier chapters by Stacy Alaimo: through the spontaneity and active engagement of tree climbing, climbers tap into a sense of connectedness with nature, with other beings, with memory and feeling. Climbers exercise the

body, improve skills, and take satisfaction in both the success of the climb and the simple *being* that is experienced while sitting up in a tree. Climbers enter that in-between space of myth, folklore and psychology that ties them into narratives that are much bigger than themselves, putting momentary concerns into perspective, perhaps even into the long perspective of human evolution. Through poems, stories and works of art, writers and artists share these images and ideas with their readers and viewers. To return to where this discussion began, with Cody Lee Miller up the sequoia tree in downtown Seattle, an adult isn't 'mad' if they *do* climb trees; rather, as the examples discussed in *The Tree Climbing Cure* have shown, they may well be much better off for having imagined the climb in the first place, and then made the ascent and descent for themselves, returning to the ground cured by the climb, or at least knowing that they have made the first steps towards positive change in relation to themselves and to the Earth.

Notes

1 Jack Cooke. *The Tree Climber's Guide*, pp.268–9.
2 All quotes here from Henry Shukman. *Savage Pilgrims*, pp.57–8.
3 Robert Macfarlane. *The Wild Places*, p.316.
4 Ibid, p.4.
5 Ibid, p.6.
6 Jack Cooke. *The Tree Climber's Guide*, p.208.
7 Lucy Jones. *Losing Eden*, pp.53–4.
8 Robert Michael Pyle. *The Thunder Tree*, p.101.
9 All quotes from this poem here, from Robert Frost. 'Birches', p.1233.
10 Robert Michael Pyle. *The Thunder Tree*, p.103.
11 Marcus Vergette. Private correspondence.
12 Colin Tudge. *The Secret Life of Trees*, p.369.
13 Richard Mabey. *Nature Cure*, p.225.

BIBLIOGRAPHY

Alaimo, Stacy. (2018). 'Transcorporeality', in Rosi Braidotti and Maria Hlavajova (eds). *Posthuman Glossary*. London: Bloomsbury Academic. https://www.academia.edu/32205792/Alaimo_Trans_corporeality_for_The_Posthuman_Glossary

Aldiss, Brian. (1961). *Hothouse*. London: Penguin Modern Classics. 2008, pbk edition.

Aldred, James. (2017). *The Man Who Climbs Trees*. London: Penguin/Random House.

Alloway, Ross G. and Tracy Packham Alloway. (2015). 'The Working Memory Benefits of Proprioceptively Demanding Training: A Pilot Study'. *Journal of Perceptual and Motor Skills*, 120(3), pp.766–75. https://journals.sagepub.com/doi/10.2466/22.PMS.120v18x1

Angwin, Roselle. (2021). 'Tongues in Trees'. *A Spell in the Forest*. London: Moon Books/John Hunt Publishing.

Appleton, J. (1975). *The Experience of Landscape*. London: John Wiley & Sons.

Atwood, Margaret. (2009). *Oryx and Crake*. London: Virago.

BBC. (2020). 'You Can Leave Your Problems on the Ground'. 22 June. https://www.bbc.co.uk/news/av/uk-england-hampshire-53090381/coronavirus-social-tree-climbing-boosts-mental-health

Baluška, František *et al.* (2009). 'The "Root-brain" Hypothesis of Charles and Francis Darwin'. *Plant Signalling and Behaviour*. December, 4(12), pp.1121–7. https://www.ncbi.nlm.nih.gov/pmc/articles/PMC2819436/

Banns, Gavin. (2020). 'Artist's Statement'. Saatchi Gallery. https://www.saatchiart.com/banns

Barkham, Patrick. (2018). 'Branching Out: Why Artist Andy Goldsworthy Is Leaving His Comfort Zone', *The Guardian*. Friday, 3 August. https://www.theguardian.com/artanddesign/2018/aug/03

Barthes, Roland. (1980). *Camera Lucida*. London: Vintage. 1993 pbk edition.

Batchelor, Paul. (2006). 'Tree Climbing'. *The Poetry Ireland Review*. December 2006, 88, p.8.

Beatty, Laura. (2008). *Pollard*. London: Chatto & Windus.

Bennett, Jane. (2010). *Vibrant Matter: A Political Ecology of Things*. Durham, NC: Duke University Press. https://www.jstor.org/stable/j.ctv111jh6w.6

Blackburn, Julia. (1989). *Charles Waterton 1782–1865: Traveller and Conservationist*. London: The Bodley Head.

Bladen, Victoria. (2021). *The Tree of Life and Arboreal Aesthetics in Early Modern Literature*. New York and London: Routledge.

Blake, William. (1987). *The Complete Poems*. London: Penguin Books.

Borghese Gallery. (2020). 'Apollo and Daphne'. https://borghese.gallery/collection/sculpture/apollo-and-daphne.html

Bragg, R., C. Wood, and J. Barton. (2013). *Ecominds Effects on Mental Wellbeing: An Evaluation for* MIND. https://www.scie-socialcareonline.org.uk/ecominds-effects-on-mental-wellbeing-an-evaluation-for-mind/r/a11G00000030djIIAQ

Bronte, Charlotte. (1847). *Jane Eyre.* London: Penguin Classics. 2006 edition.

Bujak, Anna. (2020). 'Hubert Bujak's Restored Images'. https://www.hubertbujak.com/articlesartyku322y.html

Bujak, Hubert. (2020). 'Artist's Statement'. https://www.hubertbujak.com/hubert-bujak-artist-statement.html

Burnside, John. (1997). 'Poetry and a Sense of Place'. *Nordlit. Arbeidstidsskrift I litteratur*, 1, Tromsö: May 1997, pp.201–22.

Burnside, John. (2005). 'Appleseed', in *The Good Neighbour.* London: Jonathan Cape.

Burnside, John. (2007). *Gift Songs.* London: Jonathan Cape.

Burton, Anna. (2021). *Trees in Nineteenth-Century English Fiction: The Silvicultural Novel.* New York and London: Routledge.

Byron, Lord. (1812–18). *Childe Harold's Pilgrimage.* Canto III: LXXII. http://knarf.english.upenn.edu/Byron/charold3.html

Cadnum, Michael. (1988). 'Climbing a Tree'. *The Centennial Review.* Winter 1988, 32(1), p.39.

Calvino, Italo. (1957). *The Baron in the Trees.* (*Il Barone Rampante*). in Archibald Colquhoun (trans). *Our Ancestors.* London: Minerva. 1992 pbk edition, pp.77–284.

Carson, Ciaran. (1982). 'Sweeney Astray: Escaping from Limbo', in Tony Curtis (ed.). *The Art of Seamus Heaney.* Bridgend: Seren Books. 1994, 3rd edition, pp.141–8.

Coghill, Nevill. (1951). *Chaucer: The Canterbury Tales.* London: Penguin Classics. 1984 edition.

Coldwell, Paul. 'Paula Rego – Printmaker'. https://ualresearchonline.arts.ac.uk/id/eprint/817/1/Paula_Rego.pdf

Concilio, Carmen and Daniela Fargione. eds. (2021). *Trees in Literatures and the Arts: Humanarboreal Perspectives in the Anthropocene.* Lanham/Boulder/New York/London: Lexington Books.

Cooke, Jack. (2016). *The Tree Climber's Guide: Adventures in the Urban Canopy.* London: HarperCollins.

Cowper, William. (1791). 'Yardley Oak', in Christopher Middleton. '*Poet on Poet of the Week*'. Monday, 18 January 2021. Manchester: Carcanet press. https://www.carcanet.co.uk/cgi-bin/scribe?showdoc=21;doctype=2

Crane, Hart. (1926). *The Complete Poems of Hart Crane.* ed. Mark Simon. New York/London: W.W. Norton/Liveright Books. Centennial edition. 2001.

Dalton, Amanda. (1999). 'Room of Leaves', in *How to Disappear.* Newcastle Upon Tyne: Bloodaxe Books, pp.28–46.

Dalton, Amanda. (2001). '"Room of Leaves": Voice and Character in a Sequence of Poems', in Julia Bell and Paul Magrs (eds). *The Creative Writing Coursebook: Forty Writers Share Advice and Exercises for Poetry and Prose.* London: MacMillan, pp.110–16.

Darlington, Miriam. (2012). *Otter Country.* London: Granta Books.

Darwin, C. R. (1859). *On the Origin of Species by Means of Natural Selection, or, the Preservation of Favoured Races in the Struggle for Life.* London: John Murray.

Darwin, C. R. (1880). *The Power of Movements in Plants*. London: John Murray.
 http://darwin-online.org.uk/

Deakin, Roger. (2007). *Wildwood: A Journey through Trees*. London: Penguin
 Books.

Desai, Kiran. (1998). *Hullaballoo in the Guava Orchard*. London: Faber & Faber.
 1999 pbk edition.

Dillard, Annie. (1974). *Pilgrim at Tinker Creek*. Norwich: Canterbury Press.
 UK edition, 2011.

Ellender, Lulah. (2019). 'The Knotty Story of Women in Trees', in *Caught by the
 River* online. 20 April. https://www.caughtbytheriver.net/2019/04/the-knotty-
 story-of-women-in-trees/

Enright, Robert. (2006). 'The Eye of the Painting: An Interview with Peter Doig'.
 Border Crossings (98). June. https://bordercrossingsmag.com/article/the-eye-of-
 the-painting-an-interview-with-peter-doig

Ensler, Eve. (2013). *In the Body of the World*. London: Virago.

Faulkner, William. (1929). *The Sound and the Fury: A Norton Critical Edition*.
 ed. David Minter. New York/London: W. W. Norton & Co. 1994. 2nd
 edition.

Ferreira, Aline. (2007). 'Paula Rego's Visual Adaptations of *Jane Eyre*', in
 Margarete Rubik and Elke Mettinger-Schartmann (eds). *A Breath of Fresh Eyre:
 Intertextual and Intermedial Reworkings of Jane Eyre*. Amsterdam: Rodopi,
 pp.305–6.

Fiennes, Peter. (2017). *Oak and Ash and Thorn: The Ancient Woods and New
 Forests of Britain*. London: Oneworld Publications. 2018 pbk edition.

Fitzgerald, Robert. trans. (1910). *Homer, the Odyssey*. New York/London/Toronto:
 Alfred A. Knopf. 1992 edition.

Fowles, John. (1979). *The Tree*. London: The Aurum Press Ltd. This edition,
 St Albans: The Sumach Press. 1992.

Frazer, Sir James. (1922). *The Golden Bough: A Study in Magic and Religion*.
 Ware, Hertfordshire: Wordsworth Editions. 1993 edition, based on the 1922
 edition.

Fromm, E. (1964). *The Heart of Man*. London: Harper & Row.

Frost, Robert. (2005). 'Birches', 'Stopping by Woods on a Snowy Evening' and 'The
 Road Not Taken', in Margaret Ferguson, Mary Jo Salter, and Jon Stallworthy
 (eds). *The Norton Anthology of Poetry*. New York/London: W. W. Norton &
 Company. Fifth edition, pp.1232–3.

Gathright John & Yamada, Yozo, and Miyako Morita. (2006). 'Comparison of the
 Physiological and Psychological Benefits of Tree and Tower Climbing'. *Urban
 Forestry & Urban Greening*, 5, pp.141–9.

Gathright John & Yamada, Yozo, and Miyako Morita. (2007). 'Recreational
 Tree-Climbing Programs in a Rural Japanese Community Forest: Social
 Impacts and "Fun Factors"'. *Urban Forestry & Urban Greening*, 6,
 pp.169–79.

Gathright John & Yamada, Yozo, and Miyako Morita. (2008). 'Tree-Assisted
 Therapy: Therapeutic and Societal Benefits from Purpose-Specific Technical
 Recreational Tree-Climbing Programs'. *Arboriculture & Urban Forestry*, 34(4),
 pp.222–9.

Gathright John & Yamada, Yozo, and Miyako Morita (2014). 'Treehab: The
 Healing Power of Climbing Trees'. *Americanforests.org*. Spring/Summer 2014.

Gefter, Philip. (2007). 'A Young Man with an Eye, and Friends up a Tree'. *New York Times*. 6 May. https://www.nytimes.com/2007/05/06/arts/design/06geft.html

Golding, William. (1965). 'The Ladder and the Tree', in *The Hot Gates*. London: Faber & Faber. 1970 pbk edition, pp.166–75.

Golding, William. (1955). *The Inheritors*. London: Faber & Faber.

Gooley, Joshue J. *et al*. (2010). 'Spectral Responses of the Human Circadian System Depend on the Irradiance and Duration of Exposure to Light'. *Science Translational Medicine*. 12 May, 2(31), pp.31–3. https://stm.sciencemag.org/content/2/31/31ra33.abstract

Grimm, the Brothers. (1857). *The Complete Fairy Tales*. London: Book House Publishing. 2016 edition.

Gull, Carla, Suzanne Levenson Goldstein, and Tricia Rosengarten. (2017). 'Benefits and Risks of Tree Climbing on Child Development and Resiliency'. *International Journal of Early Childhood Environmental Education*, 5(2), pp.10–29.

Gunn, Thom. (1993). 'The Cherry Tree', in *Collected Poems*. London: Faber & Faber, pp.294–6.

Guterson, David. (1994). *Snow Falling on Cedars*. London: Bloomsbury. 1996 pbk edition.

Hardman, Isabel. (2020). *The Natural Health Service*. London: Atlantic Books.

Hardy, Thomas. (1887). *The Woodlanders*. ed. Patricia Ingham. London: Penguin Classics. 1998 edition.

Hardy, Thomas. (1917). 'Transformations', in Thomas Hardy (ed.). *Moments of Vision*. London: MacMillan Publishing Company, p.89.

Harrison, Tony. (1984). *Selected Poems*. London: Penguin Books. 1997 2nd edition, pp.230–4.

Heald, Claire. (2008). 'What Can We Learn from Climbing Trees'. *BBC News Magazine*. 22 April 2008. http://news.bbc.co.uk/1/hi/magazine/7358717.stm

Heaney, Seamus. (1980). 'The God in the Trees', in *Preoccupations: Selected Prose 1968–1978*. London: Faber & Faber, p.186.

Heaney, Seamus. (1983). *Sweeney Astray*. London: Faber & Faber. 1990 edition.

Heffernan, Julie. (2020). 'Self Portrait Exhibition notes'. *Artworks for Change*. https://www.artworksforchange.org/portfolio/julie-heffernan/

Heffernan, Julie. (2020). 'Artist Statement'. on *artnet.com* http://www.artnet.com/artists/julie-heffernan/

Heim, Morgan. (2008). 'Taking to the Trees'. *High Country News*. 14 April. https://www.hcn.org/issues/368/17635?b_start:int=0#body

Hill, Julia Butterfly. (2000). *The Legacy of Luna*. San Francisco: HarperCollins.

Huxley, T. H. (1871). 'On The Physical Basis For Life'. *Vanity Fair*. 28 January. https://mathcs.clarku.edu/huxley/CE1/PhysB.html

Jamie, Kathleen. (2004). 'The Tree House', in *The Tree House*. London: Picador.

Johnson, Wesley. (2006). 'Egg Collector Died in Tree Fall, Coroner Rules'. *The Independent*. Wednesday 30 August, pp.41–3. https://www.independent.co.uk/news/uk/crime/egg-collector-died-in-tree-fall-coroner-rules-413947.html

Jones, Lucy. (2020). *Losing Eden: Why Our Minds Need the Wild*. London: Allen Lane/Penguin Books.

Jung, Carl. (1973). *Letters of C. G. Jung, Volume 1: 1906–1950*. London: Routledge.

Kaplan, Stephen. (1995). 'The Restorative Effects of Nature – Toward an Integrative Framework'. *Journal of Environmental Psychology*, 15, pp.169–82.

Kaza, Stephanie. (1993). *The Attentive Heart: Conversations with Trees*. Boston, MA: Shambala Publications, Inc.

Kraft, Thomas S., Vivek V. Venkataraman, and Nathaniel J. Dominy. (2014). 'A Natural History of Human Tree Climbing'. *Journal of Human Evolution*. March 2014, 71, pp.105–18. http://dx.doi.org/10.1016/j.jhevol.2014.02.002

Larkin, Philip. (1988). *Collected Poems*. ed. Anthony Thwaite. London: Faber & Faber.

Lawrence, D. H. (1922). *Fantasia of the Unconscious*. New York: T. Seltzer. http://www.gutenberg.org.

Lawrence, D. H. (1926). 'Pan in America'. *Southwest Review*. January, 11(2), pp.102–15. https://www.jstor.org/stable/43461405

Lawrence, D. H. (1950). *Selected Poems*. London: Penguin Books. The Penguin Poets series. 1966 edition.

Levertov, Denise. (2001). *This Great Unknowing: Last Poems*. Tarset, Northumberland: Bloodaxe Books Ltd.

Li, Qing. (2010). 'Effect of Forest Bathing Trips on Human Immune Function'. *Environ Health Prev Med*. January, 15(1), 9–17.

Li, Qing. (2019). *Into the Forest: How Trees Can Help You Find Health and Happiness*. London: Penguin Random House.

Li, Qing and Simon Bell. (2018). 'The Great Outdoors: Forests, Wilderness and Public Health', in Van den Bosch, Matilda, and William Bird (eds). *Oxford Textbook of Nature and Public Health*. Oxford: Oxford University Press, pp.147–53.

Laster, Paul. (2018). 'If Andy Goldsworthy Climbs a Tree and There's No One There to Hear Him ...' *GARAGE*. 18 March. https://garage.vice.com/en_us/article/evqg9m/if-andy-goldsworthy-climbs-a-tree-and-theres-no-one-there-to-hear-him

Lee, Jessica. (2016). '#ManInTree: Why It Went Viral'. *Seattle Times*. 24 March. https://www.seattletimes.com/seattle-news/manintree-why-it-went-viral/

Lock, Samantha. (2016). 'The Tree of Life: A Review of the Collective Narrative Approach'. *Educational Psychology Research and Practice*. March, 2(1), pp.2–20.

Mabey, Richard. (2008). *Beechcombings: The Narratives of Trees*. London: Vintage Books.

Mabey, Richard. (2005). *Nature Cure*. London: Pimlico/Random House. pbk edition. 2006.

Macdonald, Helen. (2017). 'The Forbidden Wonder of Birds' Nests and Eggs'. *The Guardian*. Saturday, 9 September.

Macfarlane, Robert. (2008). *The Wild Places*. London: Granta Books.

Maitland, Sara. (2012). *Gossip from the Forest: The Tangled Roots of Our Forests and Fairy Tales*. London: Granta Books.

Malik, Cecylia. (2011). *365 Drzew (365 Trees)*. Warsaw: Fundacja Bęc Zmiana.

Mathews, Thomas F., (1963). 'Piero Di Cosimo's Discovery of Honey'. *The Art Bulletin*. 1963, 45(4), pp.357–60. *JSTOR*, www.jstor.org/stable/3048117

McEwan, Ian. (1992). *The Child in Time*. London: Vintage.

McGinley, Ryan. (2017). 'Tree Hugger' https://ryanmcginley.com/cvd539r0io11f6xcqy5oqij9yhw2mw

Mckimm, Michael. ed. (2017). *The Tree Line: Poems for Trees, Woods & People*. Tonbridge, Kent: The Worple Press.

Mikaelsen, Ben. (2004). *Tree Girl*. London: HarperCollins. Ebook edition.

Miller, Andrew. (1997). *Ingenious Pain*. London: Hodder & Stoughton.

Moore, Ben. (2020). '"You Can Leave Your Problems on the Ground'. *BBC News*. 22 June. https://www.bbc.co.uk/news/av/uk-england-hampshire-53090381/coronavirus-social-tree-climbing-boosts-mental-health/

Muir, John. (1894). *The Mountains of California*. New York: The Century Co. http://www.yosemite.ca.us/john_muir_writings/the_mountains_of_california/

Nadkarni, Nalini. (2008). *Between Earth and Sky*. Berkeley: University of California Press.

Natural England. (2019). 'The Economic and Health Impacts of Walking on English Coastal Paths: A Baseline Study for Future Evaluation'. NECR283. 23 December.

Novey, Idra. (2016). *Ways to Disappear*. London: Daunt Books.

Novey, Idra. (2018). 'Women in Trees'. *The Paris Review*. 22 March. https://www.theparisreview.org/blog/2018/03/22/women-in-trees/

O'Brien, Flann. (1939). *At Swim-Two-Birds*. London: Penguin Books. 1967 edition.

Packham, Chris. (2020). *Springwatch*, BBC South. Thursday 28 May.

Person, Daniel. (2016). 'How #ManInTree Showed Us the Reality of Mental Health Treatment in 2016'. *Seattle Weekly*. 21 December. https://www.seattleweekly.com/news/how-manintree-showed-us-the-weaknesses-and-strengths-of-mental-health-treatment-in-2016/

Petrova, Sasha. (2019). 'Should I Let My Kid Climb Trees?' *The Conversation*. 27 October. https://theconversation.com/should-i-let-my-kid-climb-trees-we-asked-five-experts-125871

Philpot, J. H. (1897). *The Sacred Tree; or the Tree in Religion and Myth*. London/New York: MacMillan and Co.

Pogue Harrison, Robert. (1992). *Forests: The Shadow of Civilisation*. Chicago, IL: University of Chicago Press. New edition, 1993.

Pound, Ezra. (1908). 'The Tree', in *Collected Shorter Poems*. London: Faber & Faber Ltd. 1987 edition, p.3.

Powers, Richard. (2018). *The Overstory*. London: Vintage. 2019, pbk edition.

Preston, Richard. (2007). *The Wild Trees*. New York: Random House. This edition, London: Penguin Books, 2008, for Kindle.

Pyle, Robert Michael. (1993). *The Thunder Tree: Lessons from an Urban Wildland*. Corvallis, OR: Oregon State University Press. 2011 edition.

Rackham, Oliver. (2006). *Woodlands*. London: HarperCollins/New Naturalist Series. 2015 edition.

Raeburn, David. (2004). [Ovid]. *Metamorphoses*. London: Penguin Classics. New edition.

Raiß, Jochen. (2016). *Women in Trees*. Berlin: Hatje Cantz Verlag.

Ray, Janisse. (1999). *Ecology of a Cracker Childhood*. Minneapolis: Milkweed Editions.

Readdick, Christine A. and Jennifer J. Park. (1998). 'Achieving Great Heights: The Climbing Child'. *Young Children*. November, 53(6), pp.14–19

Richardson, Todd M. (2011). *Pieter Bruegel the Elder: Art Discourse in Sixteenth-Century Netherlands*. Aldershot, UK: Ashgate.

Riedelsheimer, Thomas. (2019). *Leaning in to the Wind: Andy Goldsworthy*. Magnolia Pictures: New York.

Rilke, Rainer Maria. (1903–1908). *Letters to a Young Poet*. trans. M.D. Herter Norton. New York: W.W. Norton & Company. 1964 revised edition.

Robbins, Tom. (1971). *Another Roadside Attraction*. New York: Random House/ Bantam Dell. 2003 edition.

Rose, Kathryn A, Ian G. Morgan, Jenny Ip, Annette Kifley, Son Huynh, Wayne Smith, and Paul Mitchell. (2008). 'Outdoor Activity Reduces the Prevalence of Myopia in Children'. *Ophthalmology*. August, 115(8): 1279–85. https:// pubmed.ncbi.nlm.nih.gov/18294691/

Rossetti, Dante Gabriel. (1875). 'The Day Dream', in *Sonnets for Pictures*. London: The Athenaeum. Part II, p.331. source: http://www.rossettiarchive.org/docs/2-1881.1stedn.rad.html#p330.

Rucker, Rudy. (2011). 'Notes for *Ortelius and Bruegel*'. 17 June. http://www. rudyrucker.com/bruegel/bruegelnotesposted.pdf

Saatchi Gallery. (2020). 'Paula Rego Exhibited at the Saatchi Gallery'. https://www. saatchigallery.com/artists/paula_rego.htm

Sacks, Oliver (1991). *A Leg To Stand On*. London: Picador.

Sacks, Oliver (2019). 'Why We Need Gardens', in *Everything in Its Place: First Loves and Last Tales*. New York: Alfred A. Knopf, p.245.

Sandseter, Ellen Beate Hansen and Leif Edward Ottesen Kennair. (2011). 'Children's Risky Play from an Evolutionary Perspective: The Anti-Phobic Effects of Thrilling Experiences'. *Evolutionary Psychology*. 1 April. https:// journals.sagepub.com/doi/full/10.1177/147470491100900212

Schama, Simon. (1995). *Landscape and Memory*. London: HarperCollins.

Schlatter, Evelyn. (2008). 'Ascending Giants'. *High Country News*, 14 April. https:// www.hcn.org/issues/368/17647

Searle, Adrian. (2019). 'Paula Rego Review – A Monumental Show of Sex, Anger and Pain'. *The Guardian*. 12 June. https://www.theguardian.com/ artanddesign/2019/jun/12/paula-rego-obedience-defiance-milton-keynes-gallery

Seymour, Tom. (2020). 'Photographer Ryan McGinley: "I Was Taught to Believe in Satan. It Scared Me"'. *The Guardian*. Tuesday, 21 April. https://www. theguardian.com/artanddesign/2020/apr/21/ryan-mcginley-photographer-satan-brad-pitt-beyonce

Shelley, Percy Bysshe. (1819). *The Poems of Shelley. Vol.3*. eds. Jack Donovan, Cian Duffy, Kelvin Everest, and Michael Rossington. Abingdon, Oxon: Routledge.

Shukman, Henry. (1996). *Savage Pilgrims: On the Road to Santa Fe*. London: HarperCollins.

Sibley Guides. (2010). 'Causes of Bird Mortality'. https://www.sibleyguides.com/ conservation/causes-of-bird-mortality/

Simard, Suzanne. (2021). *Finding the Mother Tree: Uncovering the Wisdom and Intelligence of the Forest*. London/New York: Penguin Books.

Solnit, Rebecca. (2013). 'Dandelions and Time Bombs'. Quoted in P.P.O.W. Gallery press release. https://www.ppowgallery.com/exhibition/1944/press-release

Sport England. (2009). 'Active People Survey 2007/08: Individual Sports Participation'. http://direct.sportengland.org/media/1123/2007-2008sport_ england_annual_report.pdf

Stuart-Smith, Sue. (2020). *The Well Gardened Mind*. London: HarperCollins.

Studente, Sylvie, Nina Seppala, and Neomi Sadowska. (2016). 'Facilitating Creative Thinking in the Classroom: Investigating the Effects of Plants and the Colour Green on Visual and Verbal Creativity'. *Thinking Skills and Creativity*. March, 19, pp.1–8. https://www.sciencedirect.com/science/article/abs/pii/S1871187115300250

Sullivan, Margaret A. (2015). 'Peasant and Nestrobber: Bruegel as Witness of His Times'. *Journal of Historians of Netherlandish Art*. Summer, 7(2). DOI: 10.5092/jhna.2015.7.2.3

Szymborska, Wislawa. (2015). *MAP: Collected and Last Poems*. trans. Clare Cavanagh and Stanisław Barańczak. Boston/New York: Houghton Mifflin Harcourt.

Szymborska, Wislawa. (2012) 'Nobel Prize-Winning Author Szymborska Dies Aged 88'. https://www.france24.com/en/20120201-nobel-prize-polish-poet-wislawa-szymborska-dead

Taylor, Andrea Faber and Frances E. (Ming) Kuo. (2011). 'Could Exposure to Everyday Green Spaces Help Treat ADHD? Evidence from Children's Play Settings'. *Applied Psychology: Health And Wellbeing*, 3(3), pp.281–303. https://www.gwern.net/docs/nature/2011-taylor.pdf

Tennyson, Sir Alfred Lord. (1833). *Poems: Vol. 2*. London: Edward Moxon. 1842. https://www.english.cam.ac.uk/multimedia/tennyson/simeon.htm

Thomas, Dylan. (1937). 'The Force That through the Green Fuse Drives the Flower', in Daniel Jones (ed.). *The Poems*. London: JM Dent & Sons Ltd. 1989 edition, p.77.

Tolkien, J. R. R. (1937). *The Hobbit*. London: George Allen & Unwin Ltd. 1966 pbk edition.

Tree, Isabella. (2018). *Wilding: The Return of Nature to a British Farm*. London: Picador.

Tudge, Colin. (2005). *The Secret Life of Trees: How They Live and Why They Matter*. London: Allen Lane/Penguin.

Twichell, Chase. (1999). 'White Pine', in *The Snow Watcher*. Newcastle Upon Tyne: Bloodaxe Books Ltd, p.106.

University of Essex. (2020). 'How We started the Green Exercise Revolution'. https://www.essex.ac.uk/research/showcase/how-we-started-the-green-exercise-revolution

University of Iowa. (2016). 'Cellular Tree with Healthy Branches: Biologists Show How Brain Cells Get the Message to Develop a Signalling Network'. *ScienceDaily*. 27 April. www.sciencedaily.com/releases/2016/04/160427150908.htm

Upstone, Robert and Andrew Wilton. (1997). *The Age of Rossetti, Burne-Jones & Watts: Symbolism in Britain 1860–1910*. London: Tate Gallery Publishing.

Van den Bosch, Matilda and William Bird. (2018). *Oxford Textbook of Nature and Public Health: The Role of Nature in Improving the Health of a Population*. Oxford: Oxford University Press.

Vidal, John. (2015). 'Conservationists Appalled at Illegal Killing of 25m Birds a Year in the Mediterranean'. *The Guardian*. 26 August. https://www.theguardian.com/environment/2015/aug/26/conservationists-appalled-at-illegal-killing-of-25m-birds-a-year-in-the-mediterranean

Wagoner, David. (2005). 'Tree House' and 'Climbing a Tree', in *Good Morning and Good Night*. Champaign, IL: University of Illinois Press, pp.33–4.

Walton, Samantha. (2021). *Everybody Needs Beauty: In Search of the Nature Cure*. London: Bloomsbury Circus.

Waugh, Evelyn. (1928). *Rossetti: His Life and Works*. London: Duckworth. This edition London: Methuen, 1991.

White, Mathew P. *et al.* (2019). 'Spending at least 120 Minutes a Week in Nature Is Associated with Good Health and Wellbeing'. *Nature,* 9, p.7730. https://doi.org/10.1038/s41598-019-44097-3 1

World Health Organization. (2020). 'Depression Factsheet'. 30 January.

Williams, Florence. (2017). *Nature Fix: Why Nature Makes Us Happier, Healthier and More Creative*. New York/London: W.W. Norton & Company.

Wilson, Edward O. (1984). *Biophilia*. Cambridge, MA: Harvard University Press. 1990 edition.

Winnicott, D.W. (1953). 'Transitional Objects and Transitional Phenomena'. *International Journal of Psychoanalysis*, 34(2), pp.89–97.

Wise, Jeff. (2010). '"Go Toward the Light": The Science of Near Death Experiences'. *Psychology Today*. 16 April. https://www.psychologytoday.com/us/blog/extreme-fear/201004/go-toward-the-light-the-science-near-death-experiences

Wohlleben, Peter. (2016). *The Hidden Life of Trees*. London: William Collins. 2017 pbk edition.

INDEX